A LINE OF BEAUTY

ANDREW BOLTON

"Fashion does not belong in a museum, it belongs in the street—on the backs of living women, not motionless mannequins," Karl Lagerfeld exclaimed in a meeting arranged by The Costume Institute to discuss the possibility of organizing an exhibition on the house of Chanel at The Metropolitan Museum of Art in the spring of 2005. "I have no interest in the past," he added. "I'm only interested in the present and what the future holds." For a designer with a deep respect and thorough understanding of history, we knew this not to be true, or at least not the whole truth; it seemed more a statement of bravado than one of certainty or conviction. Lagerfeld was relieved to hear, however, that the focus of the show would be neither the founder of the *maison*—Gabrielle Chanel—nor himself but, rather, an examination of the house codes through the lens of the German Jewish art historian Erwin Panofsky's theories of iconography and iconology. We explained that our thesis would explore Gabrielle Chanel's interpretation of the house codes through the language of modernism, and his through that of postmodernism, an approach he thought was interesting, but he forewarned us: "I'm not in the habit of analyzing or intellectualizing my work. I leave that to the professionals." Although he had the good manners and self-confidence not to ask how many of his fashions would be represented in the exhibition compared to those of Chanel, we volunteered the information: one third—an amount based on the number of years he had held the position of creative director of the house (twenty-three) as opposed to Chanel (sixty-one). He liked our logic and was generally enthusiastic about our curatorial groupings and overall conceptual organization of the exhibition.

For any curator of contemporary fashion—as, indeed, for any curator of contemporary works in general—the advantage of working with a living maker on an exhibition is that it provides the privileged opportunity to discuss their work in greater detail and gain a deeper

understanding of their creative process. The ultimate goal, of course, is to enhance a visitor's appreciation of the designer's contributions to the history of fashion and, by extension, the experience of contemporaneity, of which fashion is a, if not the, defining feature. Lagerfeld, however, while always quick to engage in a dialogue about Chanel's work, was less inclined to discuss his own. He would answer our questions with his usual candor and clarify any facts or details about a specific ensemble or particular collection, but he became most animated during our conversations about his predecessor. These talks, however, proved just as enlightening about Lagerfeld's approach to fashion as they did about Chanel's—sometimes more so—because they invariably disclosed his own interests and aesthetic judgments.

On one of his visits to the Museum, we showed Lagerfeld an embroidered dress that we had recently acquired and that we had dated to 1922, the period of Chanel's association with the Kitmir embroidery firm of Russia's Grand Duchess Maria, the sister of Grand Duke Dmitri, Chanel's lover at the time. Lagerfeld immediately lifted its hem and examined the reverse of the lavish embroidery: "This is not handwork," he declared. "It is machine." His observation created some confusion about the dating of the piece (and, more worrisomely, its authenticity), as according to our understanding, Kitmir was established so that the aristocratic women in the expatriate White Russian community might profit from their refined hand-sewing skills. Further research, however, revealed that while Kitmir began with time- and labor-intensive hand stitching, Chanel had eventually dismissed the benefits of such efforts and purchased three machines for her paramour's sister so that the grand duchess might produce her embroideries more efficiently. Lagerfeld found the dress fascinating, for, as we discovered, he shared Chanel's belief that artisanal effects were not diminished by the fact that they were the product of industrial processes.

This insight later proved invaluable when we were working on our exhibition *Manus x Machina: Fashion in an Age of Technology* (May 5–September 5, 2016), which questioned the dialectical relationship between the hand and the machine within the haute couture and prêt-à-porter (ready-to-wear), and suggested a continuum of practice whereby the hand and the machine are equal and mutually creative protagonists in the production of fashion. The show featured nine works by Lagerfeld, including the finale wedding dress from Chanel's autumn/winter 2014–15 haute couture collection, which formed the centerpiece of the exhibition. Originally, the train measured three meters in length, but at our request, Lagerfeld extended it to six

meters for the show so visitors could better understand and appreciate the hand and machine techniques involved in its production. This generosity was typical of the designer, for although he believed that fashion did not belong in a museum, he never declined a single request to borrow one of his designs for inclusion in an exhibition. In fact, cumulatively, if you were to add up the works designed by Lagerfeld that we have included in our exhibitions over the years, they would amount to a retrospective.

However, planning an actual monographic exhibition on Lagerfeld is quite a different endeavor altogether. How best to represent a designer whose career spanned a remarkable and incomparable sixty-five years? How best to represent a designer who worked as the creative director for multiple design houses during the course of his career, including Fendi (1965–2019), Chloé (1974–83, 1992–97), Chanel (1982–2019), and his eponymous label (1984–2019), not to mention his freelance work for, as an example, the fast-fashion global retailer H&M in 2004? How best to represent a designer who was a weathercock—the personification of the zeitgeist—embracing and commanding several styles simultaneously? How best to represent a designer who was the "total designer," creating bags, shoes, gloves, jewelry, and cosmetics in addition to clothing? And how best to represent a designer who was the "ultimate polymath designer"—a writer, publisher, photographer, interior designer, theatrical designer, and collector-connoisseur as well as a fashion designer?

As with *Rei Kawakubo: Art of the In-Between* (May 4–September 4, 2017), The Costume Institute's most recent monographic exhibition, we decided in *Karl Lagerfeld: A Line of Beauty* to present a centered, thematic, and conceptual "essay" on the designer's work rather than a traditional retrospective organized chronologically and by the various design houses that he served as creative director, in the hope that such an approach might prove more revelatory and enlightening about his creativity. We did not want to emphasize "Lagerfeld the man," who, like Gabrielle Chanel, has long been the subject of breathless mythologizing and hagiography, largely as a result of his own audacious self-invention or self-reinvention(s). Rather, we wanted to focus on "Lagerfeld the designer"—his works, not his words—and to isolate and draw attention to a critical aspect of his design process that made him unique among his peers—namely, his practice of sketching. Of course, other designers sketch as part of their design process, but it is usually a means to an end, not an end in itself as it was with Lagerfeld. "My sketches look like the final thing, I am not draping and listening to Verdi," he remarked in *Madame Figaro*, the magazine

supplement to the French daily newspaper *Le Figaro* (July 9, 2015). To underscore the premise of the exhibition, the catalogue follows the unconventional structure of a portfolio comprised of four "books" that the reader can peruse in any order.

Before he thought of becoming a fashion designer, Lagerfeld considered a career as an illustrator, specifically a caricaturist; his aspiration was nurtured by his obsession with the German satirical weekly magazine *Simplicissimus* (1896–1967), which he collected as a child and which continued to inspire him as an adult. Lagerfeld actually fulfilled his childhood ambitions in 2012, when he began contributing caricatures to the German daily newspaper *Frankfurter Allgemeine Zeitung* and its magazine supplement, *F.A.Z.* In total, Lagerfeld produced seventy-five "Karlikaturen," the last published in January 2019, just weeks before his death on February 19. The drawing referenced former German chancellor Angela Merkel, a popular subject for Lagerfeld whom he often portrayed alongside former French president François Hollande in an ongoing commentary on Franco-German relations. Indeed, Lagerfeld's fascination with caricatures extended to himself: "When I was younger I wanted to be a caricaturist. In the end I've become a caricature," he once said, referring to his carefully constructed "black-and-white" image (*The World According to Karl: The Wit and Wisdom of Karl Lagerfeld*).

Lagerfeld moved to Paris in 1952, just shy of his nineteenth birthday, as noted in the timeline comprising Book Four, a detailed account of his biography that attempts to disentangle fact from fiction. At the time, his drawing skills were largely self-taught: "I never learned to draw," he remarked. "That came by itself." He described his skill as an innate ability: "I draw just as I breathe. You don't breathe to order. It just happens" (*The World According to Karl*). However, in 1953 Lagerfeld enrolled in fashion illustration classes taught by Andrée Norero Petitjean at her school Cours Norero on the place Pereire (now the place du Maréchal-Juin) in the seventeenth arrondissement. Norero, daughter of the painters Edmond Marie Petitjean and Jeanne Lauvernay, studied fine art at L'École Duperré and worked as an illustrator for the French designer Nicole Groult (sister of the designer Paul Poiret) before establishing her own school.

While studying with Norero, Lagerfeld submitted sketches with fabric swatches to the International Woolmark Prize, a fashion illustration competition organized by the International Wool Secretariat (now the Woolmark Company). For one of his sketches, he won first prize in the coat category, with Yves Saint Laurent winning the dress category and Colette Bracchi the suit category, each beating out six thousand

other entrants. The winning designs were produced by three leading couturiers who participated in judging the competition: Lagerfeld's coat was executed by Pierre Balmain, Saint Laurent's dress by Hubert de Givenchy, and Bracchi's suit by Jacques Fath. Unfortunately, Lagerfeld's coat—made from yellow wool from the French textile manufacturer Gerondeau and titled "Longchamps" after the racecourse in the Bois de Boulogne—is no longer extant. However, at the request of The Costume Institute, the atelier at Balmain created for the exhibition a toile of the coat based on existing drawings and photographs, featured in Book Three of this catalogue.

Lagerfeld winning the International Woolmark Prize resulted in Pierre Balmain offering him his first official full-time position: design assistant at the house of Balmain (1955–58). It was here, and later in his role as artistic director at the house of Patou (1958–63), that Lagerfeld developed and continued to refine his particular style of sketching, comprising a combination of a detailed technical drawing and an expressive fashion illustration that he described as the purest and most undiluted, unadulterated representation of his creative vision: "I see in three dimensions and I have a technique that I can put it on paper and the people that I work with can read the sketch as if they see the dress" (*ArtReview*, September 10, 2014). The rudiments of this style were already in evidence in the illustration for his "Longchamps" coat, which Lagerfeld conceived in the round, presenting both front and back views—the only winner to do so, which he believed resulted in a design more superior to those of Bracchi and Saint Laurent. This ability to "see in three dimensions" is reflected in the drawings found in Book Two of this catalogue: when extant, a sketch is reproduced adjacent to its finished garment. (Most garments that Lagerfeld designed during the course of his career began as sketches, but not all have survived—hence, the omissions.)

Sketching was not only Lagerfeld's primary mode of creative expression but also his primary mode of communication. To the untrained eye, his sketches appear spontaneous and expressionistic—like the seemingly impromptu brushstrokes of a modernist painting. But to the practiced eyes of his *premières d'atelier*, who were responsible for translating Lagerfeld's two-dimensional drawings into three-dimensional garments, the drawings convey precise details and almost mathematical instructions. They exist as a kind of secret language between the designer and his collaborators, who knew exactly how to decipher every line, every mark, and every notation. For the catalogue and exhibition, we approached Chloé, Fendi, Chanel, and Lagerfeld's

eponymous label to interview *premières d'atelier* with whom the designer had a long-established relationship—namely, Anita Briey, formerly of Chloé and Lagerfeld's eponymous label; Stefania D'Alfonso of Fendi; Olivia Douchez of one of Chanel's ateliers *flou*; and Jacqueline Mercier, formerly of one of Chanel's ateliers *tailleur*. The interviews, which appear in Book Three of this catalogue, were conducted by the French filmmaker Loïc Prigent, who has followed and documented Lagerfeld's collections since 1997. Alluding to specific garments chosen by The Costume Institute, each *première* discusses how she decoded Lagerfeld's encrypted drawings to transform them into finished pieces, disclosing fascinating and revelatory insights into the designer's creative process and working methodology.

Lagerfeld had a close bond with and deep respect for his *premières d'atelier*, whom he regarded as the architects of his vision. He expressed this admiration and appreciation publicly in Chanel's autumn/winter 2016–17 haute couture collection, for which he recreated Chanel's *maisons particulières* at 31, rue Cambon under the glass dome of the Grand Palais in Paris. "The inner world of seamstresses is put under the spotlight," the show notes for the collection explain, "animated . . . by the premières [sic] of the ateliers, followed by their seconds and the 78 seamstresses from the House of Chanel which counts more than 120." As Lagerfeld remarked in the *New York Times*: "They never get to see the show, and they should be honored" (July 10, 2016). At the close of the presentation, Lagerfeld posed for photographs with his *premières d'atelier*, including Olivia and Jacqueline; Lagerfeld always addressed and referred to his *premières* by their first names, which is how they are credited on some of the sketches in Book Two, appearing alongside the names of the *petites mains* workshops that executed the embroideries.

The plate section of Book Two follows the structure and organization of the exhibition, which was designed by the Japanese architect Tadao Ando, who discusses his design concept in "Reflections," the segment of Book Three that also includes essays by Anna Wintour, Patrick Hourcade, and Amanda Harlech in which they reflect on their friendships with Lagerfeld. The plates and the exhibition are governed by two "through lines" that represent conceptual expressions of Lagerfeld's sketches: the serpentine line and the straight line. Like Lagerfeld himself, the two lines designate opposing yet complementary forces in the designer's work: the serpentine line signifies his historicist, romantic, and decorative impulses, while the straight line indicates his modernist, classicist, and minimalist tendencies. These two lines are divided into nine "sublines" presented as dualities: feminine/masculine;

romantic/military; rococo/classical; historical/futuristic; ornamental/structural; canonical/countercultural; artisanal/mechanical; floral/geometric; and figurative/abstract. Bridging the dualities are what we call "explosions": garments that represent moments of convergence, in which the competing aesthetics of these contrasting dichotomies are resolved and reconciled.

Reflecting Lagerfeld's interest in numerology, each mutually exclusive grouping within the nine dualities features seven garments, the designer's lucky number. Furthering this numerical construction, Book Two concludes with a tenth section—the "satirical line"—that, combined with the nine dualities, signifies Lagerfeld's birth date: September 10 (9/10). Although the "satirical line" is not a dualism, it does comprise two parts: the first includes garments that communicate Lagerfeld's razor-sharp wit through ironic, playful, and whimsical embroideries; the second features ensembles that mirror his self-presentation through various representations of his iconic black-and-white "uniform"—immediately recognizable and endlessly reproducible. The latter grouping is juxtaposed with items from Lagerfeld's personal wardrobe, connecting them to their "satirical sisters." On the surface, it might seem that the "satirical line" is the most personal of the lines, given its focus on Lagerfeld himself—the carefully constructed persona that he projected to the outside world through his larger-than-life image and equally fearless (and sometimes fearsome) words. However, it is the nine dualities that are the most edifying, revealing as they do the complexity of Lagerfeld's dichotomous and often contradictory personality. They also expose the breadth of his intellect and the broad-mindedness of his imagination, reflecting influences drawn from art, film, music, design, fashion, literature, and even philosophy; quite a few of these influences are illustrated in a section of the catalogue titled "Inspirations," found in Book Three.

We commissioned the Swedish artist Julia Hetta to photograph all the garments in Book Two. Hetta is known for her poetic and highly nuanced lighting inspired by the serenity and quietude of old master paintings, specifically those of the Dutch Golden Age, which was one of Lagerfeld's favorite periods in art history. She infused every image with a Vermeer-like virtuosity, often shooting a single garment using multiple lighting techniques to emphasize specific details or highlight variances of color or particular textural qualities. The intention was to present each garment as an individual portrait that, when viewed collectively, would represent the "portrait of a man." For the "explosions," which Hetta shot against a backdrop inspired by the curtains

hanging in Lagerfeld's house in Louveciennes, she inverted and solarized the images to make them look like puffs of smoke. (Hetta used the same backdrop for the black-and-white garments in the "satirical line" to highlight their personal connection to Lagerfeld.) To complement the bodies of the standard Schläppi mannequins, we commissioned the Italian company Bonaveri to sculpt heads and hands inspired by Gerhard Schliepstein's porcelain figurines (see Book Three, p. 30, fig. 1), which Lagerfeld collected and displayed in his various homes. Each of the four heads—one for the serpentine line, one for the straight line, another for the "explosions," and yet another for the "satirical line"—matches the color and finish of Schliepstein's porcelain figurines.

The theoretical framework for the exhibition was inspired by William Hogarth's book *The Analysis of Beauty*, the engravings of which illustrate this introduction. Written in 1753, the treatise describes the English painter's theories of art and aesthetics, centering around his concept of the "line of beauty," an S-shaped curved line appearing within an object or as the boundary line of an object. For Hogarth, S-shaped curved lines represented liveliness and movement in contradistinction to straight lines, which signified stillness, inactivity, and even death. Lagerfeld, however, was much too magnanimous to hold such aesthetic judgments. For him, the straight line and the serpentine line were just as beautiful, exciting and engaging his imagination in equal measure. In Roman mythology, a straight line entwined by a serpentine line symbolizes Mercury, the god of commerce and communication. Known as the "caduceus," the insignia (see Book Three, p. 2) could not be more appropriate for Lagerfeld, who, in many ways, was the modern incarnation of Mercury. Speaking of his creative directorship at Chanel, he once said, "In the end, I am just a mercenary paid to perpetuate the label. You can't go wrong with that" (*The World According to Karl*). Ultimately, however, Lagerfeld achieved much more than he ever set out to achieve—or perhaps exactly what he set out to achieve. With the expertise that he brought to fashion as an art and a business, he created the identity of the fashion designer-impresario that has become the blueprint for contemporary fashion, one that many designers aspire to but very few will achieve, and even fewer will surpass.

2	William Hogarth (British, 1697–1764). Title page of *The Analysis of Beauty* (detail), 1753
5, 7–10, 14	William Hogarth (British, 1697–1764). *The Analysis of Beauty, Plate 1* (detail), 1753. Etching and engraving, 15¼ × 19⅝ in. The Metropolitan Museum of Art, New York, Harris Brisbane Dick Fund, 1932 (32.35[22])
13	William Hogarth (British, 1697–1764). *The Analysis of Beauty, Plate 2* (detail), 1753. Engraving, 15⅜ × 20⅝ in. The Metropolitan Museum of Art, New York, Harris Brisbane Dick Fund, 1932 (32.35[23])

I

FEMININE LINE

MASCULINE LINE

Typically, a couture house is composed of two ateliers: one devoted to the feminine art of dressmaking (*flou*), the other dedicated to the masculine practice of tailoring (*tailleur*). This classification, combined with the fashion system's tradition of dividing the prêt-à-porter, or ready-to-wear, calendar into biannual menswear and womenswear collections, underlies the feminine/masculine dichotomy prevalent in the fashions of Karl Lagerfeld. Having worked in both institutions—first in his roles as design assistant at Balmain (1955–58) and as art director at Patou (1958–63), and later as creative director at Fendi (1965–2019), Chloé (1974–83, 1992–97), Chanel (1982–2019), and his eponymous label (1984–2019)—Lagerfeld not only understood but appreciated the rubrics of the haute couture and prêt-à-porter.

The substance of dressmaking is crafting sculptural form from pliant materials, usually achieved through draping and often resulting in a softness of silhouette, as demonstrated in the garments in the "feminine line." Across the design houses at which he worked as creative director, Lagerfeld consistently employed lace, tulle, crepe, and chiffon in his articulation of supple apparel. For him a large part of the attraction was their propensity to reveal a garment's structure and inner layers. This revelation and the ensuing mediation between private and public presentation are particularly conspicuous in the black lace dress from Chanel's spring/summer 1991 collection (pl. 2). Based on a 1950s baby doll dress—inspired by and named for short baby doll nighties—it offers a repository of intimate lingerie techniques, such as picot edging and self-fabric buttons, details also present in the 1950s-style tiered lace dress with asymmetric sleeve from Chloé's autumn/winter 1995–96 collection (pl. 3). In the ensemble from Chanel's autumn/winter 2004–5 haute couture collection (pl. 7), a modernist reinterpretation of the designer Paul Poiret's "Minaret" lampshade tunic forms (see p. 30, fig. 2), Lagerfeld provides a virtuoso effect of layering—akin to a reverse striptease—by superimposing a knee-length bustier dress of black chiffon edged with Chantilly lace from Maison Sophie Hallette over a floor-length sheath dress of black guipure lace. "I had the idea one day in Biarritz when Amanda Harlech turned up wearing a black dress with a white dress pulled over it," explained Lagerfeld in a September 1, 2004, article in American *Vogue*. The ensemble involved 305 hours of workmanship by the atelier *flou*: 140 hours for the overdress, which features buttons from Maison Desrues, and 165 hours for the underdress.

A characteristic of Lagerfeld's lace and chiffon dresses is the dynamic interplay between opacity and transparency, especially in movement, as seen in the black lace dress from Chanel's spring/summer 1995 haute couture collection (pl. 5), a tour de force of dressmaking techniques accompanied with consummate lingerie skills. The dress features lace from Maison Hurel and required 200 hours of work by the atelier *flou*. This seductive, infra-apparel comingling of body and dress, flesh and fabric is also apparent in the tiered dress from Chanel's autumn/winter 1988–89 haute couture collection (pl. 9). Made from black silk crepe, it was inspired by a French hand-blocked wallpaper panel dating to the early nineteenth century that depicts a Greek goddess. For Lagerfeld the appeal of lace, crepe, and chiffon was their sheerness, while

the allure of tulle was its potential for sculptural forms, evident in the dress from Chanel's autumn/winter 2004–5 haute couture collection, which required 287 hours of work (pl. 11), and the dress from Chanel's autumn/winter 2006–7 haute couture collection, entailing 1,180 hours of work (pl. 13), both of which manifest one of the principal ambitions of the haute couture: volume with lightness. The former reveals inspirations from the 1930s and the latter from the 1950s, both eras defined by an explicit sartorial gender divide, with women's fashions of the thirties characterized by an emphasis on the natural contours of the female body and those of the fifties by the amplification of those attributes through boning, corsetry, and crinoline-style petticoats.

In contrast to dressmaking, the essence of tailoring is the simulation of line on the body that proceeds from cutting the segments that constitute the pattern. As seen in the ensembles in the "masculine line," tailoring is planar and relies on relatively robust materials. In his designs for Chanel and his own label in particular, Lagerfeld privileged two silhouettes: the modernist "Schlemmerian" and the historicist "Brummellian." The former—named after the German artist and choreographer Oskar Schlemmer—features broad shoulders, a narrow waist, and rounded hips, conspicuous in the streamlined figures portrayed in the 1932 painting *Bauhaus Stairway* (see p. 30, fig. 3). An exemplar of the Schlemmerian silhouette is the black wool suit from Chanel's spring/summer 1995 haute couture collection (pl. 16), which entailed 205 hours of workmanship by the atelier *tailleur*. The Brummellian silhouette—named after the Regency dandy Beau Brummell (George Bryan Brummell)—features an attenuated neck, short torso, and long legs, as seen in the ensemble from Chanel's autumn/winter 2003–4 haute couture collection (pl. 26), requiring 180 hours of work by the atelier *tailleur*. Redolent of Robert Dighton's 1805 portrait of Brummell (see p. 30, fig. 4), it comprises a black wool double-breasted cutaway frock coat with elongated sleeves and horse-hoof cuffs that is accessorized with a white organza "camellia cravat" by Maison Lemarié and an embroidered belt by Maison Lesage, paired with fetish-inspired beige leather trousers with integrated stilettos by Maison Massaro—a nod to Brummell's practice of wearing stirrup straps under his feet to keep his pantaloons from wrinkling, thus achieving a modish "classical" tautness.

Lagerfeld's own self-presentation was indebted to Brummellian dandyism (see pls. 246–65), as was that of Gabrielle Chanel, the embodiment of the "female dandy" in both appearance and comportment. She paid the dandy lasting homage in her iconic suit of two or three pieces, which celebrated the dandiacal ideals of austerity, simplicity, and discipline. Lagerfeld's thirty-seven-year tenure as creative director of Chanel was marked by his continual reinterpretation of the signature Chanel suit, always original and always reflective of the zeitgeist. With their knotted cravats and ascetic black-and-white color palette, the suits from Chanel's autumn/winter 2002–3 (pl. 24) and spring/summer 2005 (pl. 22) haute couture collections, which combined necessitated 700 hours of work by the atelier *tailleur*, complement the rigorous elegance of the dandy, whom the French writer Charles Baudelaire described as "the Black Prince of Elegance." This stark sobriety is also the defining feature of the tweed suit from Chanel's autumn/winter 2016–17 haute couture collection (pl. 20), which entailed 340 hours of workmanship. The jacket's lining extends to its revers and cuffs, a typical design element of Chanel's signature suits. Borrowed from military uniforms, it results in a blurring of the boundaries between the outer and the inner, the known and the unknown, the revealed and the concealed. Lagerfeld's eponymous label incorporates the same detail into the silk rayon suit from its spring/summer 1990 collection (pl. 18). The jacket's asymmetric, deconstructed lapel is a characteristic feature of the label's suits from the 1990s, as seen in the example from the spring/summer 1991 collection (pl. 17), featuring a jacket with contrasting tipped edges that highlight its angularity. Bridging the aesthetics of the masculine and feminine lines is the "explosion" garment from Chanel's spring/summer 2018 haute couture collection (pl. 14), a *Victor/Victoria* wedding ensemble that artfully juxtaposes a cotton piqué tuxedo vest and trousers with a cape and skirt embroidered by Maison Lemarié with white ostrich feathers, white organza camellias, and silicone camellia petals that involved 750 hours of handwork; the ensemble in total required 1,150 hours of workmanship.

FEMININE LINE

2 3 5 7 9 11 13

MASCULINE LINE

16 17 18 20 22 24 26

EXPLOSION

14

SKETCHES

1 4 6 8 10 12

15 19 21 23 25

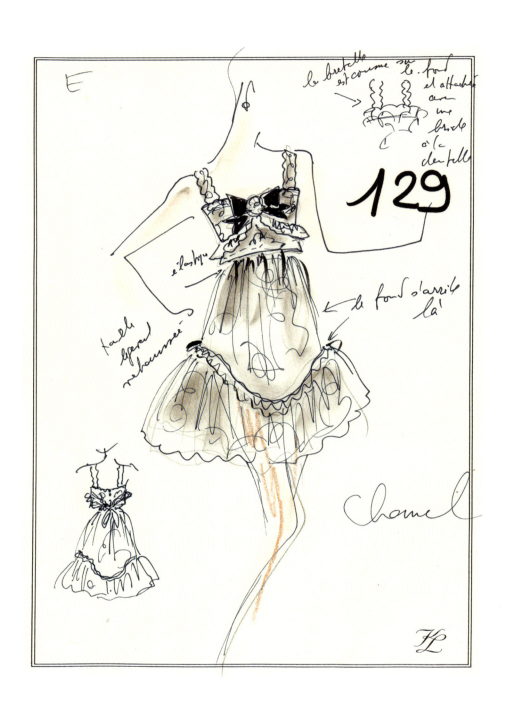

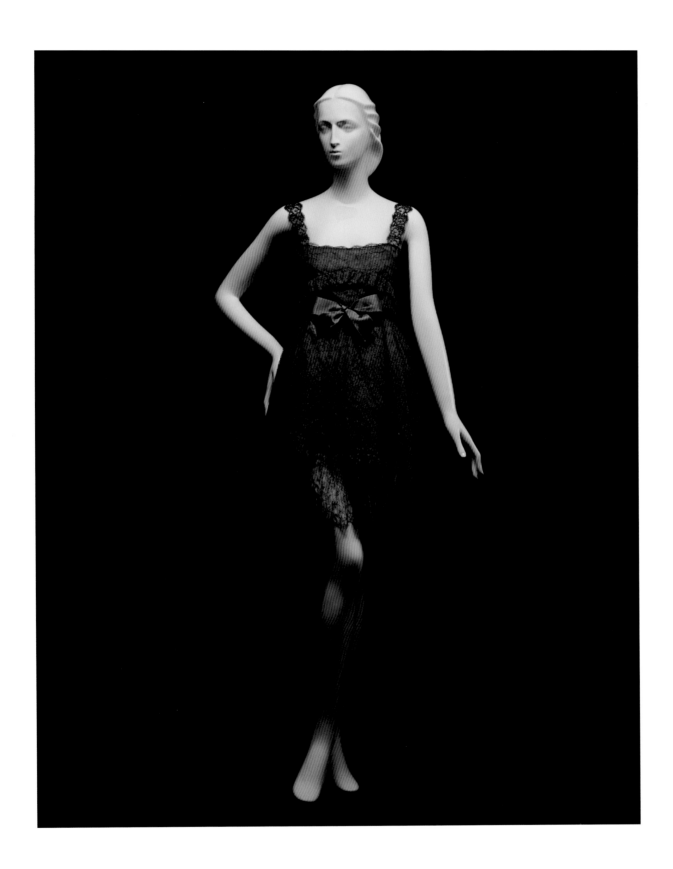

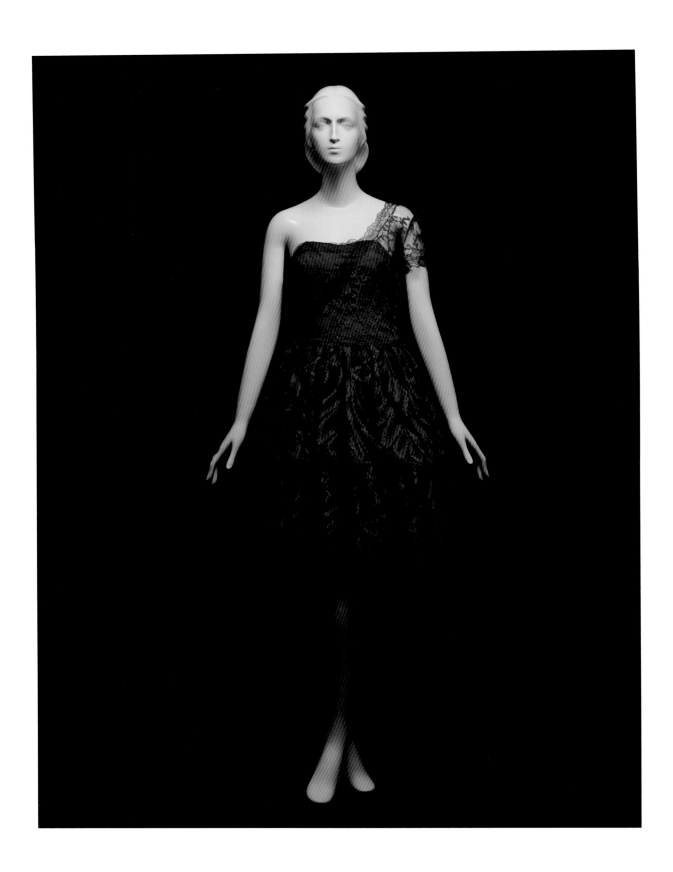

Brandi **74** 2568

Robe : Christiane

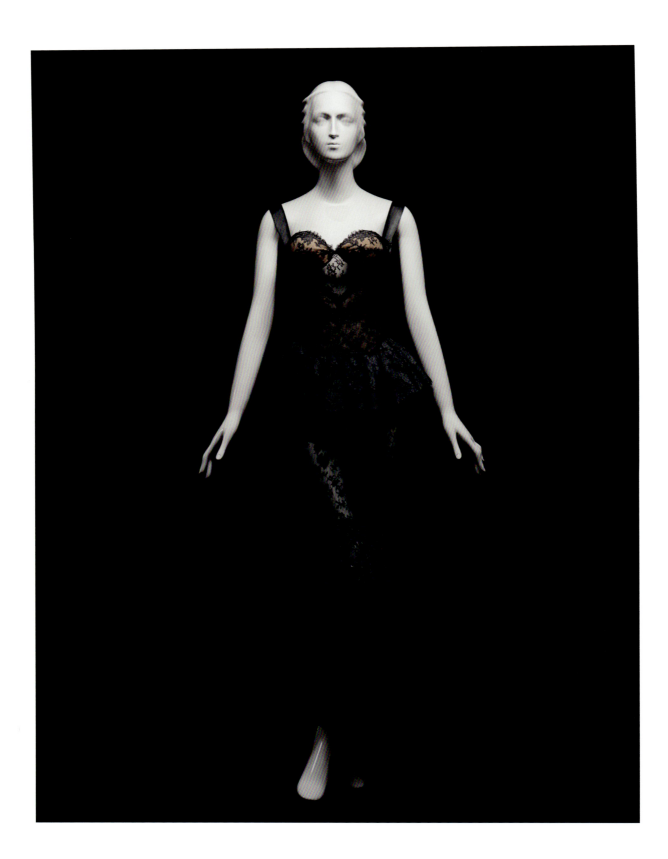

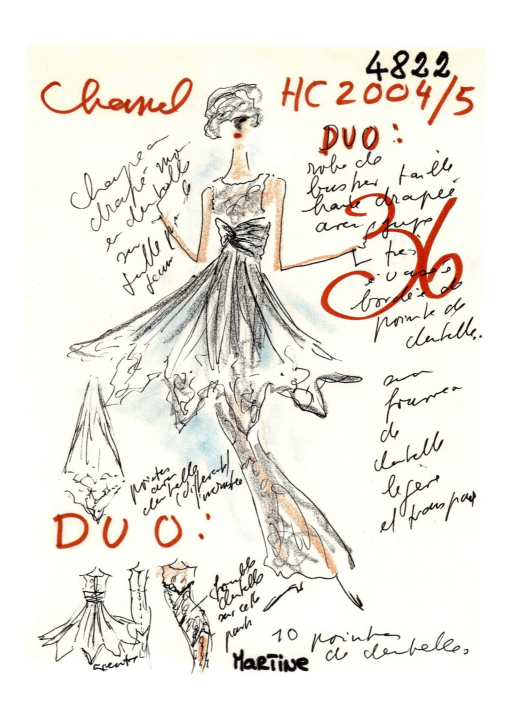

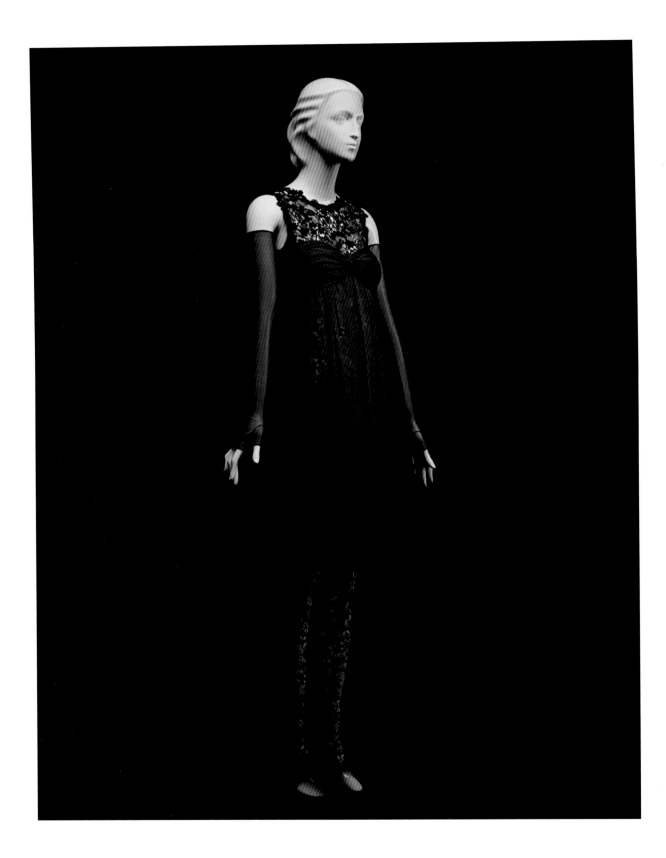

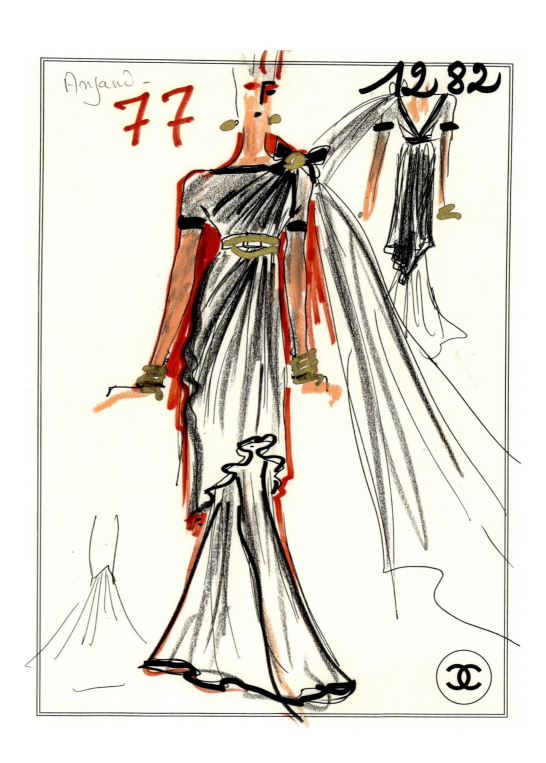

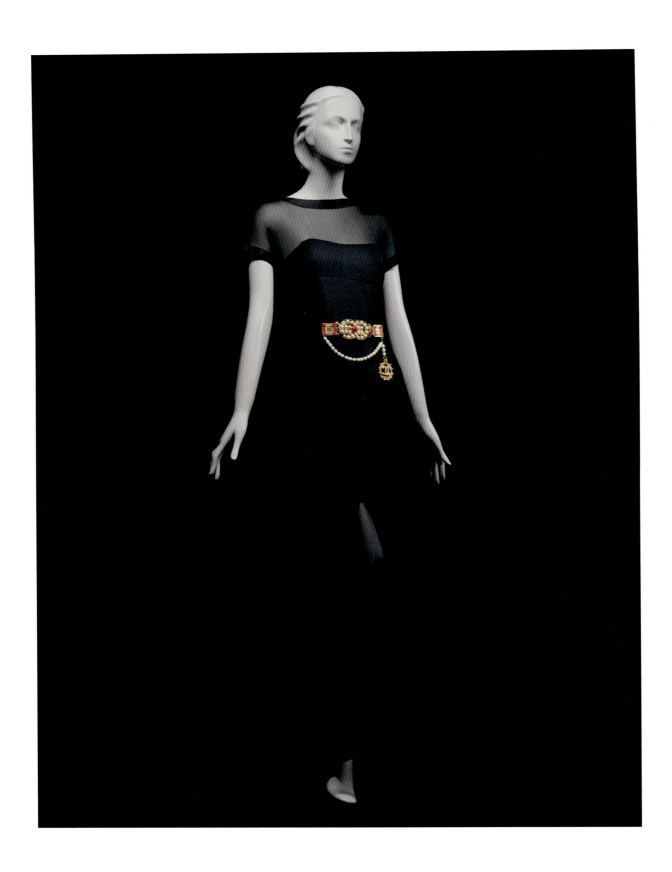

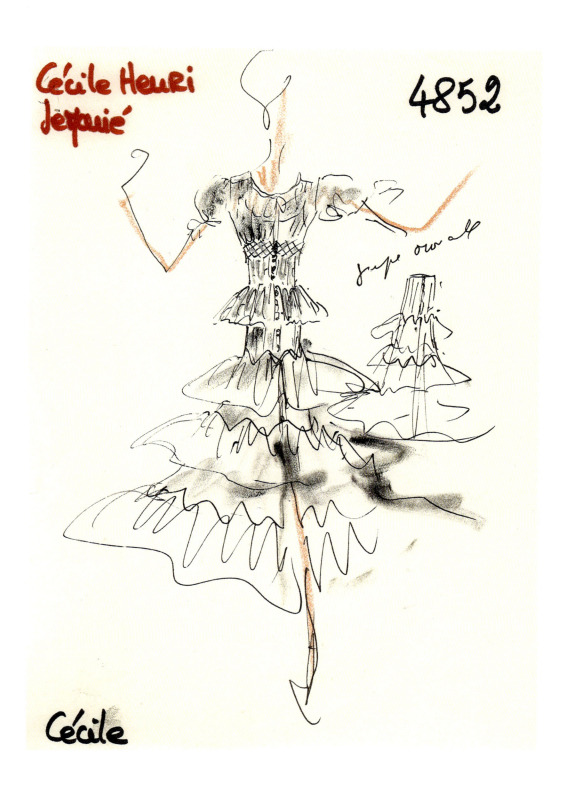

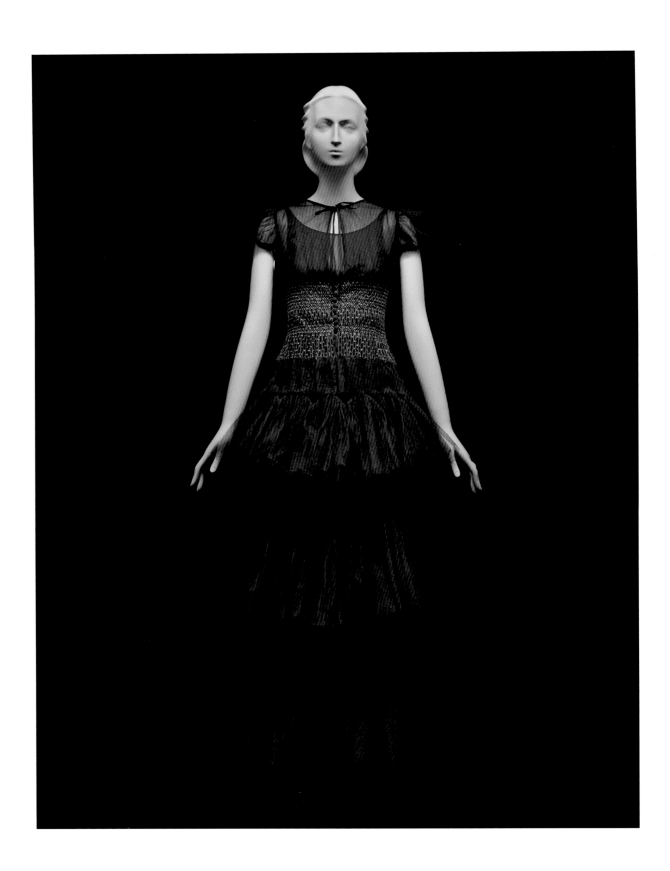

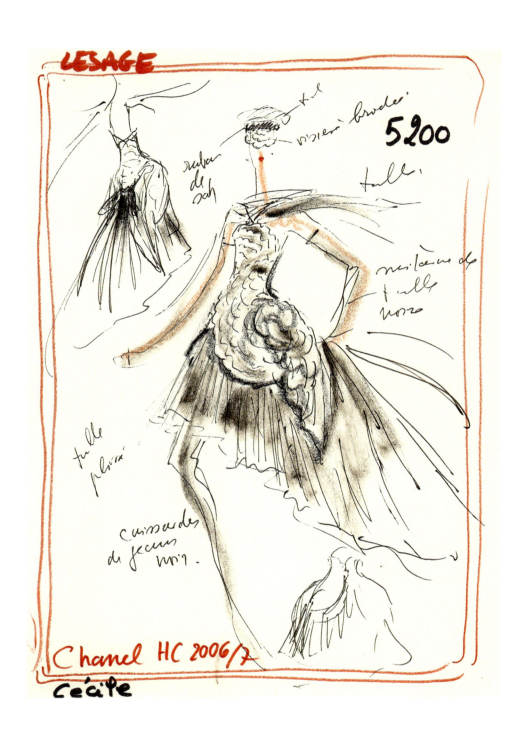

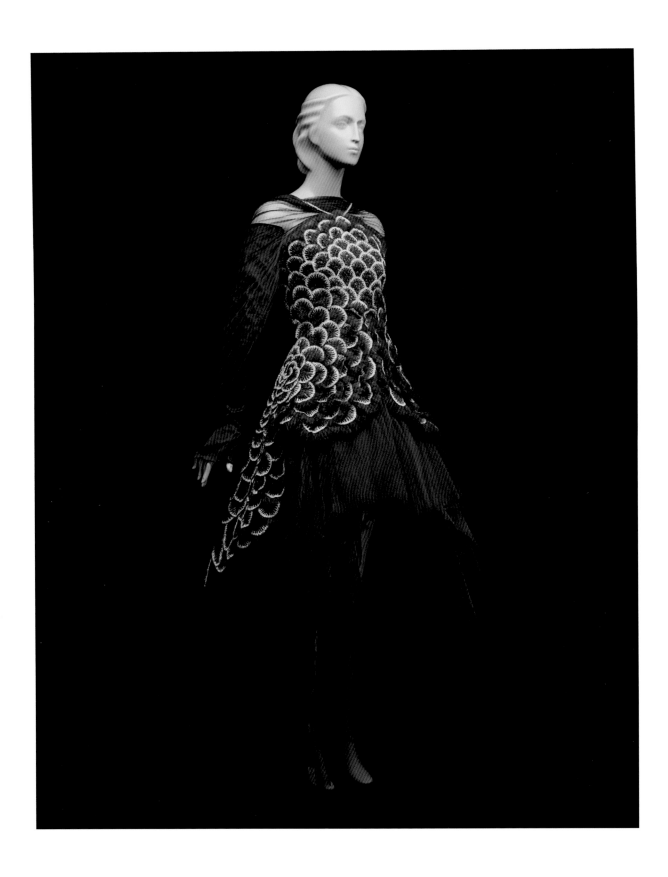

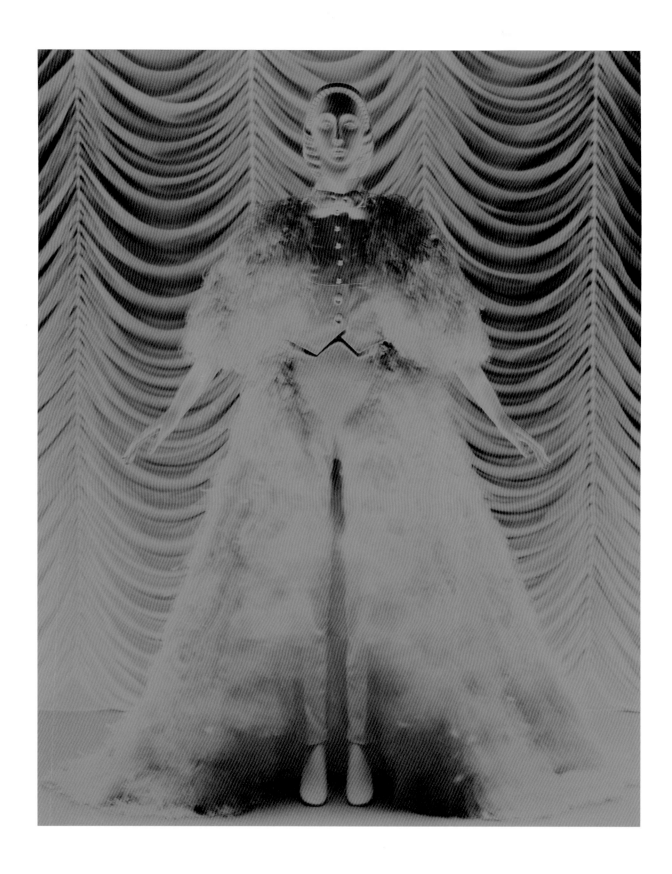

2574
2

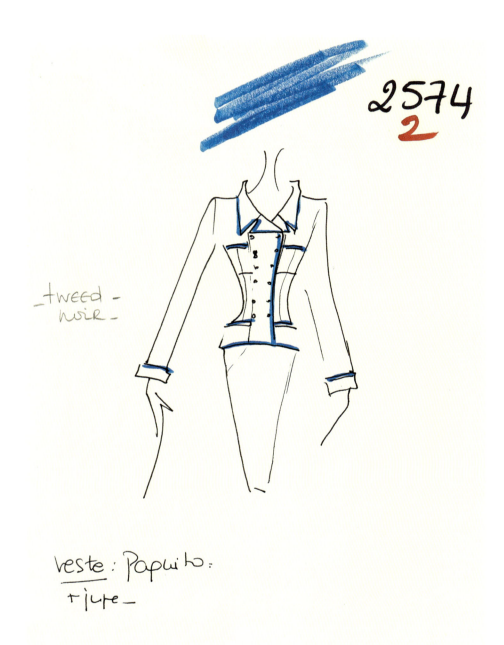

— tweed —
noir —

veste: Paquito
+ jupe —

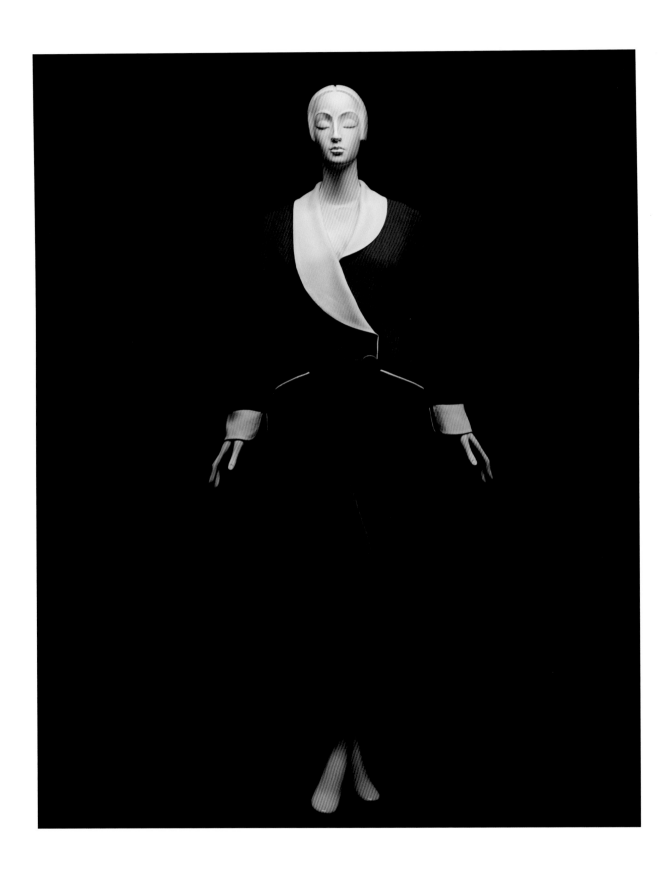

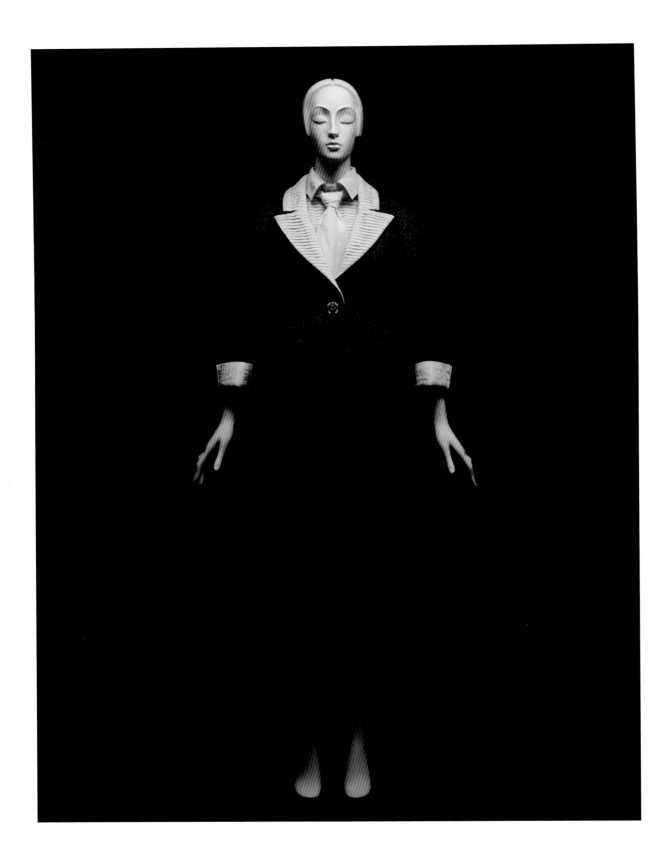

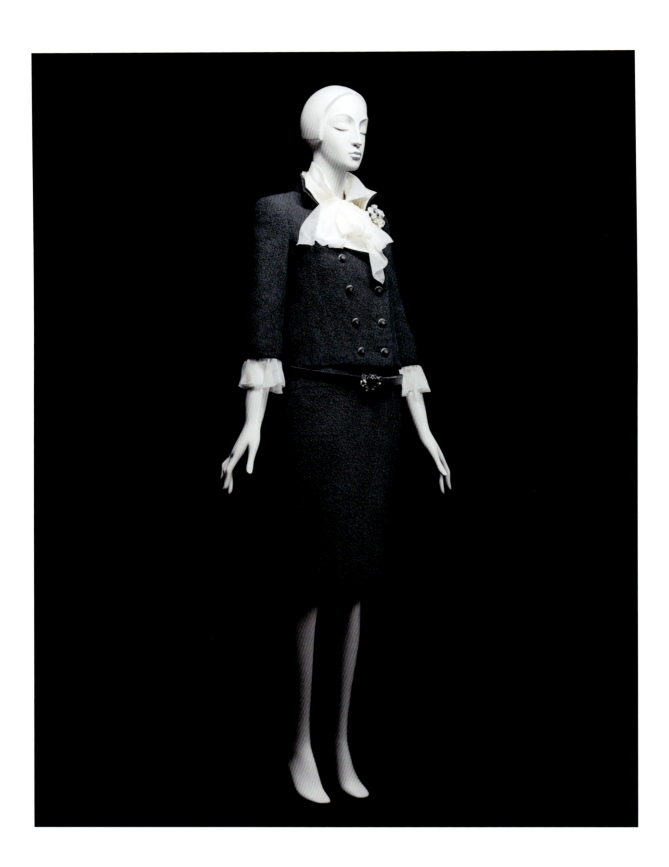

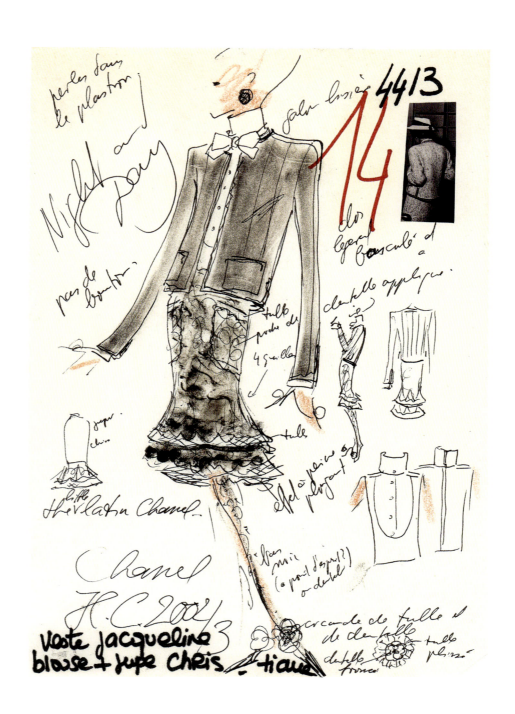

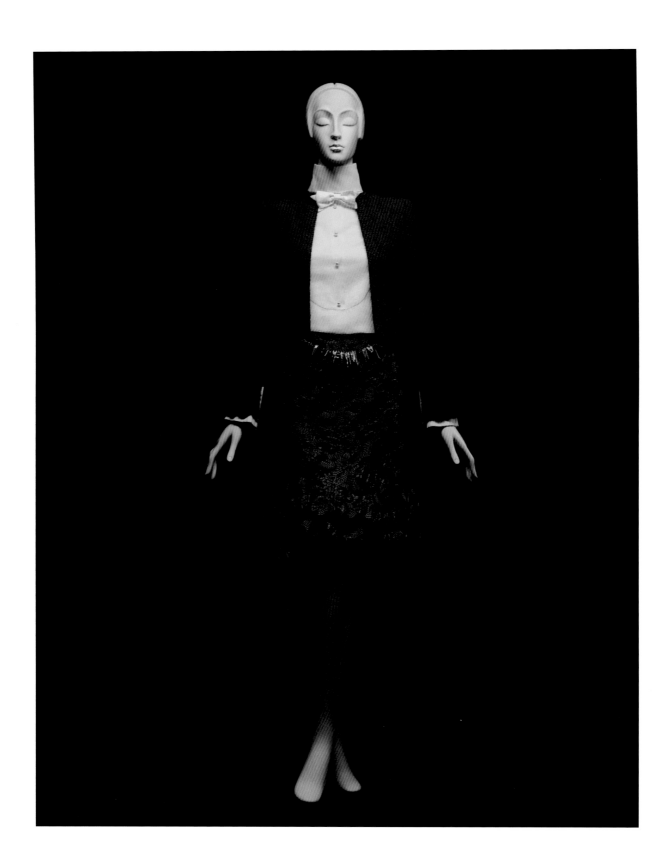

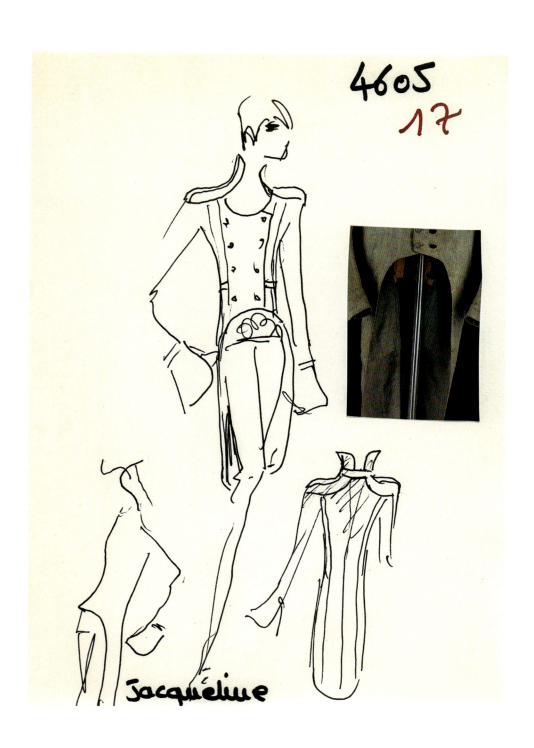

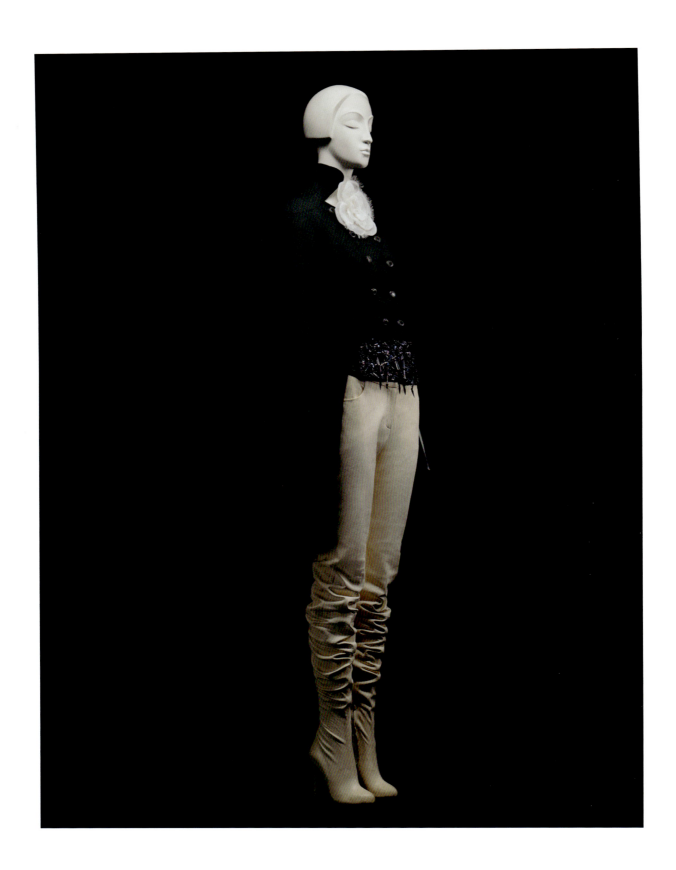

II

ROMANTIC LINE

MILITARY LINE

The Romantic era, beginning in the late 1700s and lasting through the 1850s, was a constant source of inspiration for Karl Lagerfeld, particularly its idealization of nature, reflected in fashions that celebrate a pastoral lifestyle. This pastoralism permeates the garments in the "romantic line," beginning with a simple white crepe de chine chemise dress and red obi-cum-dirndl wrapped bodice—christened a "waist maker" by American *Vogue*—from Chloé's spring/summer 1977 collection (pl. 28). Titled "Enfance," it was redolent of a style promoted by designer Paul Poiret in the early 1910s and adopted by his wife and muse, Denise (see p. 30, fig. 5). Hand painted by Nicole Lefort and embroidered by Maison Chaste, it was a style that Lagerfeld revisits in an ensemble from Chanel's 2014–15 "Paris-Salzburg" métiers d'art collection (pl. 30), presented at the Schloss Leopoldskron, one of the most notable rococo palaces in Austria, built for the Prince Archbishop of Salzburg, Leopold Anton Freiherr von Firmian, and now known as the "*Sound of Music* palace" after being used as the home of the Trapp family in the 1965 film. In keeping with the Austrian theme of the collection, the ensemble comprises a black leather dirndl-style bodice and a white silk crepe chemise dress that is entirely embroidered by Maison Lesage with seed beads and crystals, requiring 1,800 hours of handwork. A dominant motif is the clover leaf, which held superstitious significance for both Gabrielle Chanel and Lagerfeld—the name of his father's canned-milk company was *Glücksklee*, which translates as "four-leaf clover."

With their straight, T-shaped silhouettes, the dresses from Chloé's spring/summer 1977 and Chanel's 2014–15 métiers d'art collections are reductive versions of the late eighteenth-century *robe en chemise*. Formerly an undergarment, it was a style popularized by Marie Antoinette in her search for a Rousseau-inspired freedom and one immortalized in a 1783 portrait of the French queen by Elisabeth Louise Vigée-LeBrun (see p. 30, fig. 6). Lagerfeld references the painting and the style of the *robe en chemise* (also called the *chemise à la reine* after its royal devotee) in a dress from Chanel's autumn/winter 2016–17 collection (pl. 36) that he executed in white silk tulle rather than white cotton muslin. Typical of the designer's hybrid historicism, however, Lagerfeld laminates the strata of costume history in his modified *chemise à la reine*: while its silhouette is indebted to mid-nineteenth-century fashions, the self-fabric decorative applications with their curving lines reflect the rococo aesthetic of a mid-eighteenth-century formal sack gown, or *robe à la française*, with its serpentine meanderings of three-dimensional trimmings or furbelows. Always the master of reinvention, Lagerfeld offsets the garment's historical flavor of decorous grace with aggressive bands of brown patent leather lacings, bisecting and lacerating the body with a distinct air of fetishistic contemporaneity.

Lagerfeld was often inspired by the picturesque resplendence and overwrought grandiloquence of Second Empire fashions in his sartorial expressions of Romanticism, as seen in the two dresses from Chloé's spring/summer 1983 collection (pl. 32, titled "Armide," and pl. 34, titled "Arc en ciel") that the design house press notes described as a "game of volume." This game plays out in the skirts and sleeves (dubbed "hammer sleeves") that are made all the more buoyant by their airy organza. The dresses' full-skirted silhouettes—embellished with tiered, self-fabric welt tucks ornately embroidered by Maison Hurel and mirrored in the sleeves—directly reference the dome-shaped skirts of the mid-nineteenth century that were enhanced by crinolines, emphasized by tiered flounces, and trimmed with elaborate passementerie. Lagerfeld's revised crinoline silhouette, however, is filtered through the 1910s and specifically through Georges Lepape's illustrations of 1850s-revival-style *jeune fille* dresses depicted in Lucien Vogel's *Gazette du Bon Ton* (1912–25; see p. 31, fig. 7), which was a constant source of inspiration for the designer, who owned several complete volumes of the short-lived but hugely influential fashion magazine.

The ensembles from Chanel's spring/summer 1995 haute couture collection (pl. 40) and 2014–15 "Paris-Salzburg" métiers d'art collection (pl. 38) reference two royal style icons of the Second Empire, namely, Empress Eugénie of France and Empress Elisabeth "Sissi" of Austria, respectively. For the former garment—a wedding dress made of white silk chiffon and organza—Lagerfeld looked to Franz Xaver Winterhalter's 1855 painting *Empress Eugénie Surrounded by the Ladies of Her Court* (see p. 31, fig. 8), which depicts the sovereign and her *dames du palais* in a rustic setting reminiscent of Jean-Antoine Watteau's pastoral paintings of the early eighteenth century. On the runway, the wedding dress was shown alongside two identical bridesmaids' dresses—one in pink and the other in blue silk tulle and organza. Their off-the-shoulder necklines and frothy, dome-shaped skirts with tiered flounces embody and encapsulate the lush, languorous grandeur of Winterhalter's masterpiece.

As the official portraitist for the royal courts of Europe, Winterhalter also painted Empress Sissi, most famously in an 1865 portrait in which the twenty-eight-year-old sovereign is depicted wearing a white satin and tulle evening gown embroidered with thousands of sparkling edelweiss-shaped silver foil stars. Lagerfeld re-created the dress in a scene from *Reincarnation*, the seven-minute film he made to accompany his "Paris-Salzburg" métiers d'art collection, with Cara Delevigne as Empress Elisabeth and Pharrell Williams as Emperor Franz Joseph I. The ensemble that closed the show (pl. 38)—a dress with a ivory silk organza and chiffon crinoline-style skirt with graduated flounces and matching capelet—is reminiscent of a modish daytime dress of white silk and Chantilly lace worn by the empress in an 1860 photograph by the imperial court photographer Ludwig Angerer (see p. 31, fig. 9). Lagerfeld's version, however, is shorter, falling to mid-calf, a length more reflective of styles worn by young girls of the period.

In Lagerfeld's imagination, the costumes of Romantic heroines coexisted alongside the uniforms of military heroes, whose severity, sobriety, and rationalism stand in stark contrast to the buoyancy, exuberance, and sentimentality of Romantic-era fashions. As reflected in the "military line," Lagerfeld's borrowings of war's fiery raiment are more formal than symbolic. They are usually restricted to ornamental components, such as the braids on the cuffs and front openings of the two-piece tweed suits from Chanel's autumn/winter 1991–92 and spring/summer 1988 haute couture collections (pls. 43, 45), inspired by the decorative braids of hussar uniforms that began as a layer of protection to deflect sword blades but quickly became a cipher of estimable distinction (see. p. 31, fig. 10). Of note are the braids adorning the suit in plate 43 that are rendered in delicate silk ribbons by Maison Lesage and entailed 600 hours of work. Hussar-inspired decorative braids also appear on the black wool jacket in the "explosion" ensemble (pl. 41) from Chanel's autumn/winter 2009–10 collection, titled "Chanel Belle Brummell" after the Regency dandy Beau Brummell (see p. 30, fig. 4). Paired with a cream silk jersey skirt overlaid with black silk crepe that recalls Gabrielle Chanel's romantic evening gowns of the 1930s, the jacket is trimmed with a detachable collar and cuffs, conventional elements of working-class clothing that Chanel also usurped for her signature suits.

An observant student of fashion history, Lagerfeld would not have failed to realize that fashions of the mid-nineteenth century—especially walking dresses and tailored outerwear—often featured braided tabs simulating the closures on eighteenth- and early nineteenth-century uniforms. Similar tabs adorn the cream silk cotton suit from Chanel's spring/summer 1986 haute couture collection (pl. 47), a detail sanctioned by the precedent of Gabrielle Chanel's Brandenburg-style jackets from her autumn/winter 1960–61 collection. The white linen suit from Chanel's 1994 cruise collection (pl. 50) references early twentieth-century military history, its large pockets with scalloped flaps inspired by World War I uniforms. Similar pockets appear on the white leather coat from Fendi's autumn/winter 2006–7 collection (pl. 48), while the three strips with central buttons above the breast pockets are reminiscent of the dolmans and pelisses worn by light cavalry of the eighteenth and nineteenth centuries.

Lagerfeld's creative ingenuity, however, extended beyond the military to civilian forces, as seen in the two ensembles he created with the Fendi sisters for a 1983 competition organized by Rome's city council to redesign the policewomen's uniforms. One proposal comprises a cream wool jacket with four pockets and a navy blue wool wrap skirt (pl. 52) and the other features a navy blue wool overcoat with removable capelet (pl. 54), which was described by the journalist Daniela Iacono for United Press International (July 20, 1983) as a "Dr. Zhivago swaggering military-style coat." In designing the costumes, Lagerfeld explained in a press release issued by Fendi at the time that he interpreted the policewoman as a "guardian angel of the city . . . an expression of quiet elegance and constant dignity in the town traffic." Judged by Rome's then mayor Ugo Vetere, Lagerfeld's proposals—along with those of Gucci—were chosen above the designs of Mila Schön, Laura Biagiotti, and the Fontana sisters.

ROMANTIC LINE

28　30　32　34　36　38　40

MILITARY LINE

43　45　47　48　50　52　54

EXPLOSION

41

SKETCHES

27　29　31　33　35　37　39

42　44　46　49　51　53

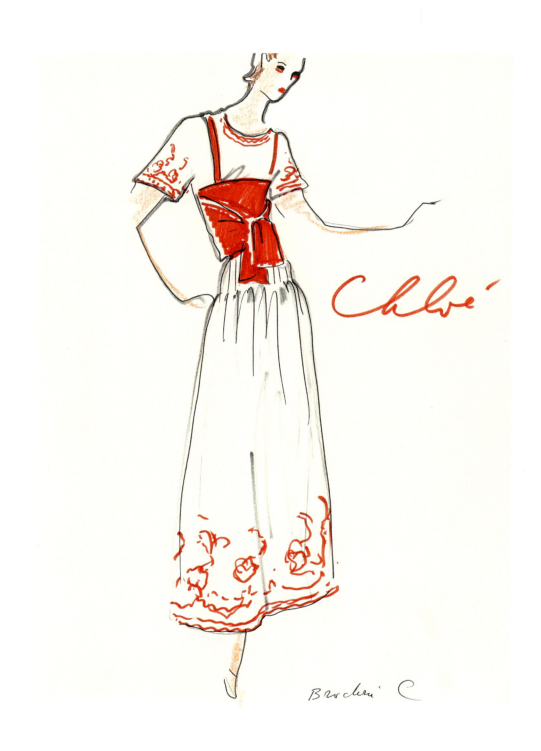

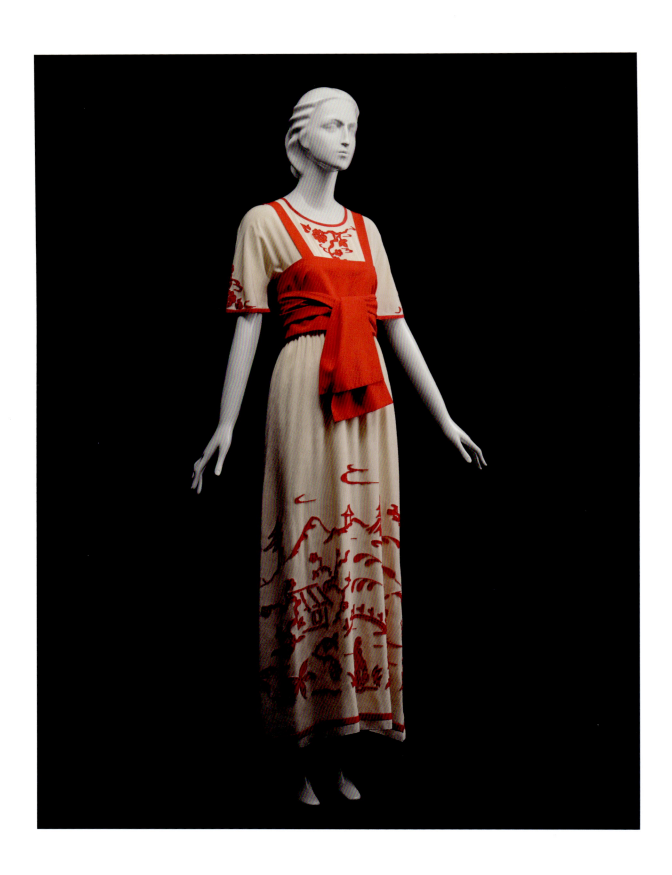

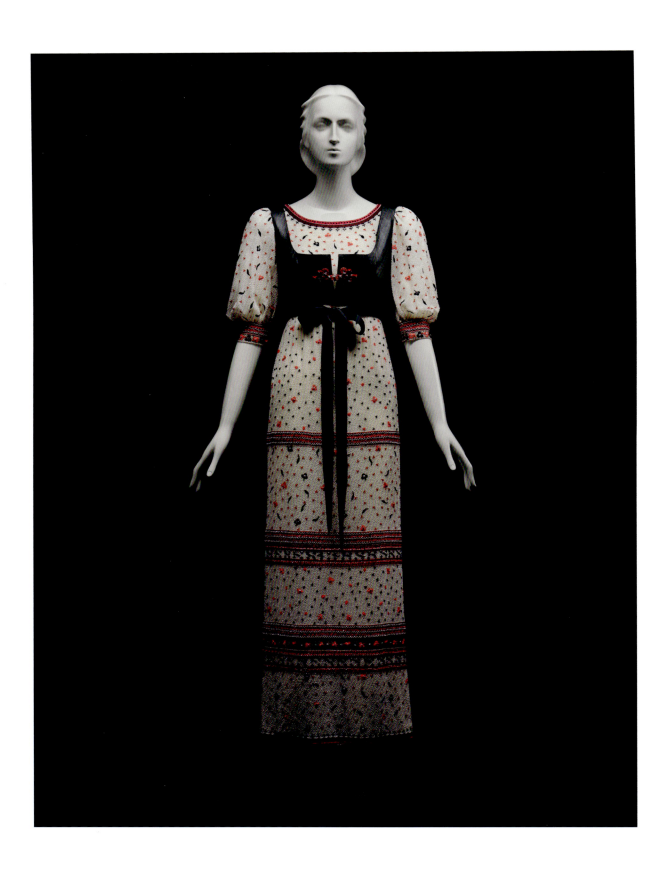

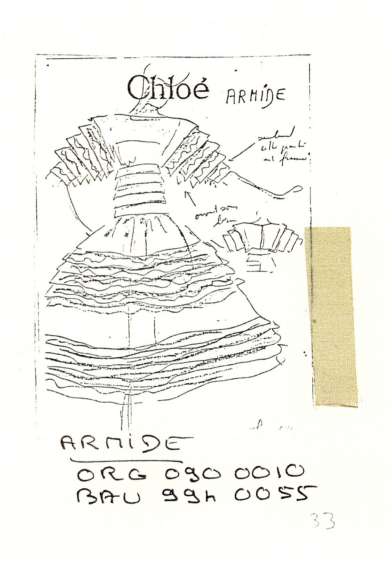

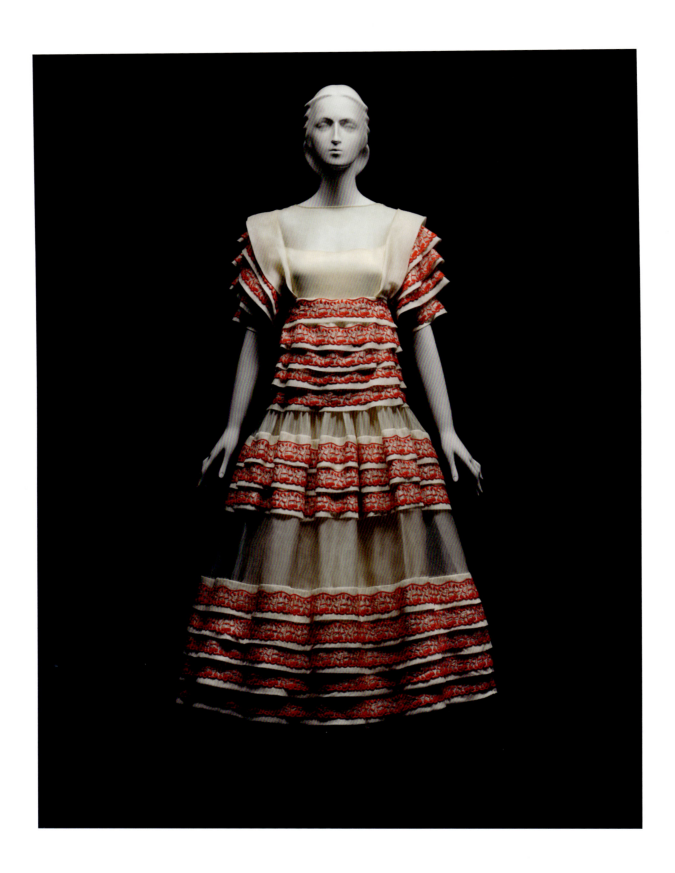

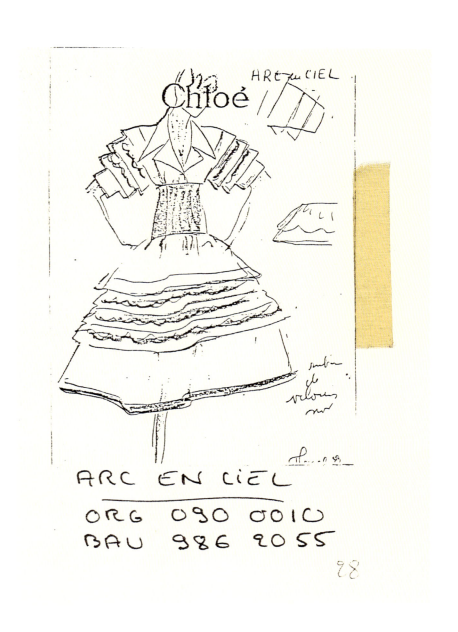

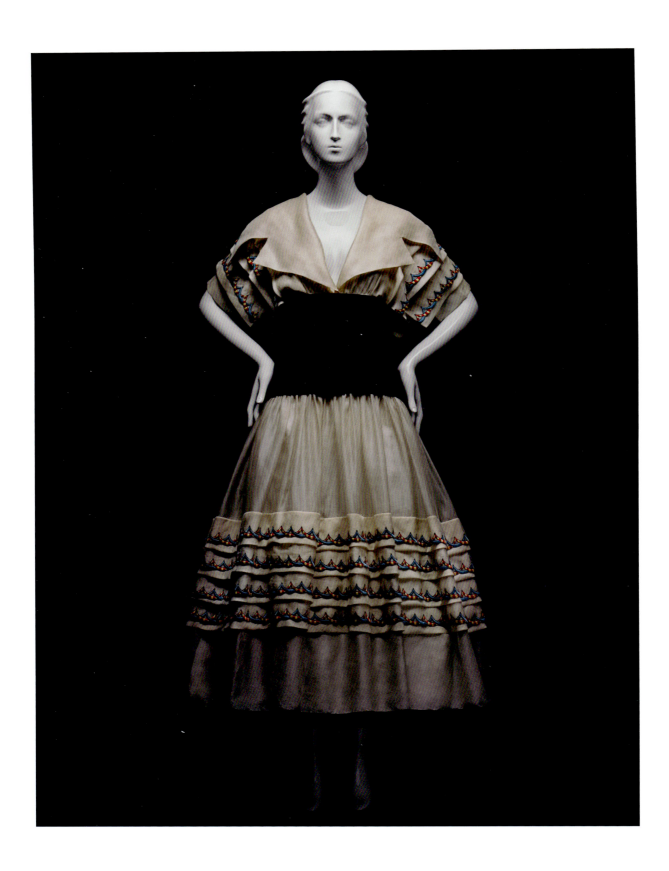

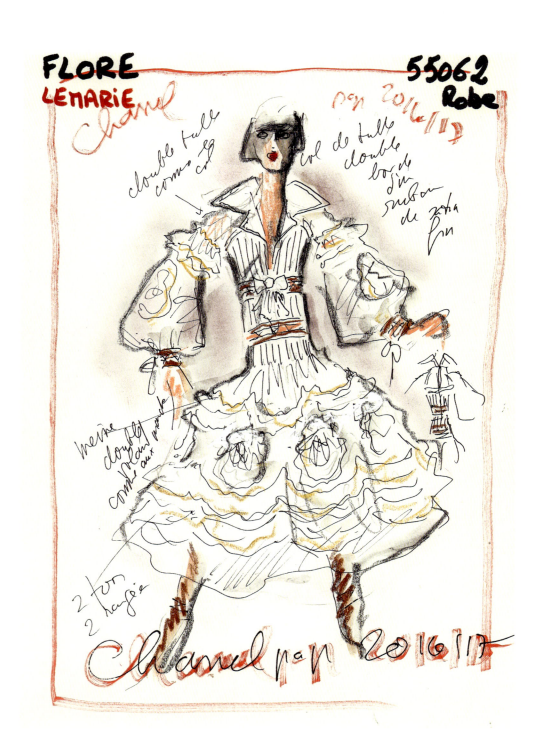

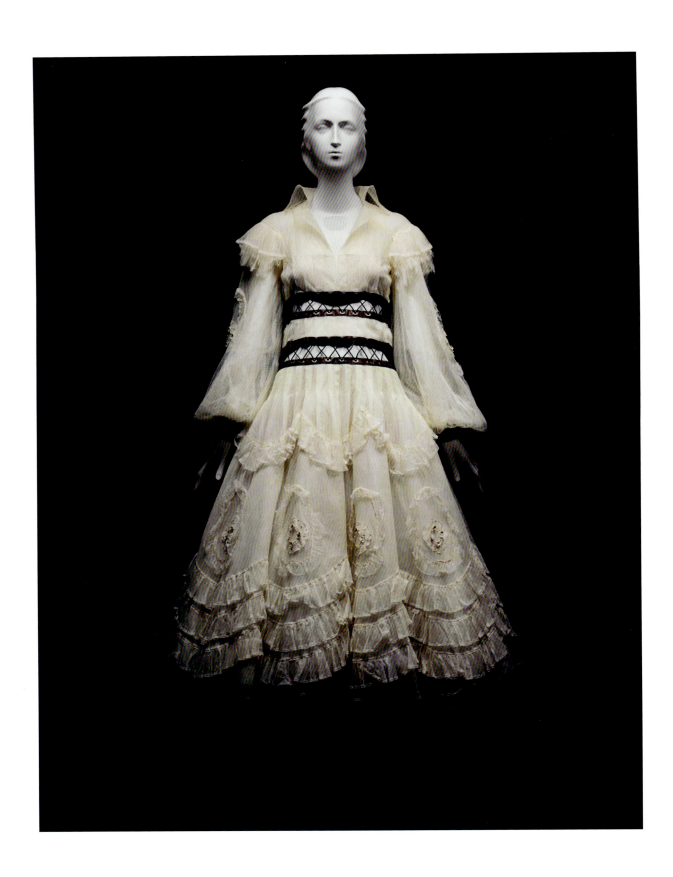

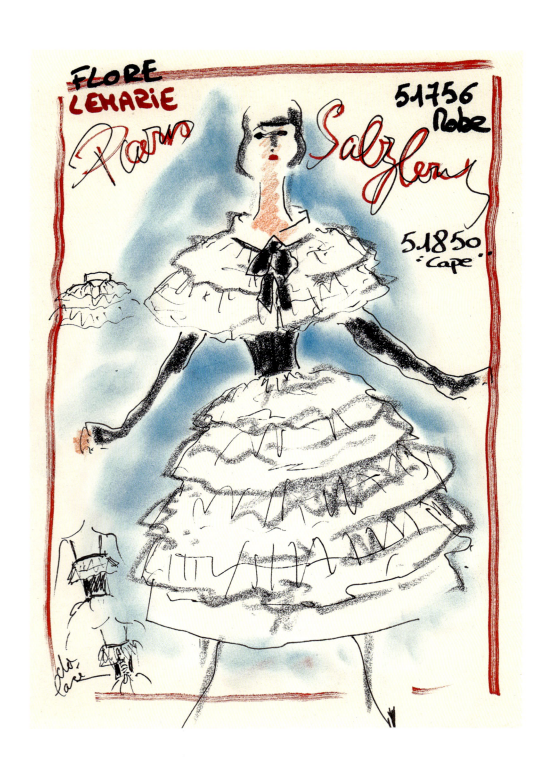

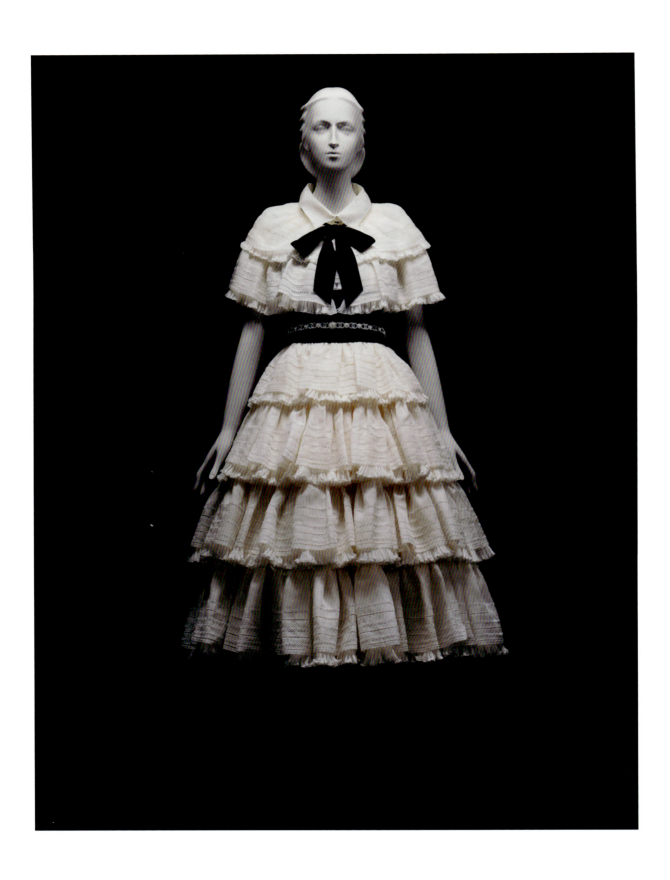

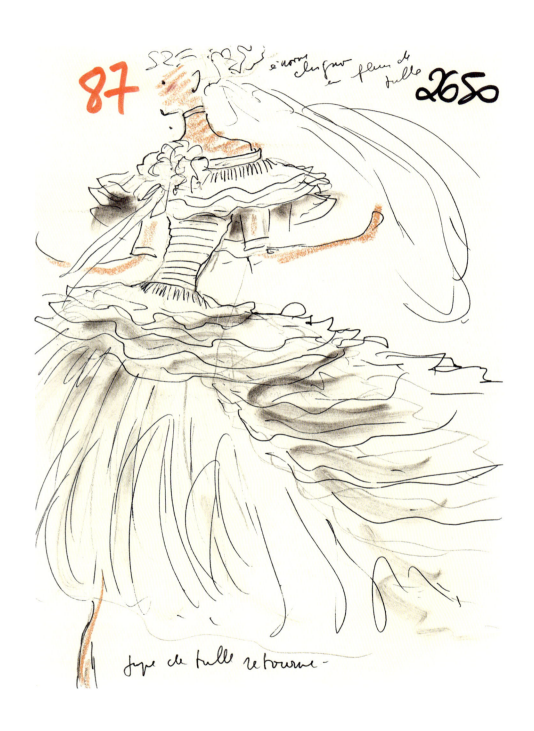

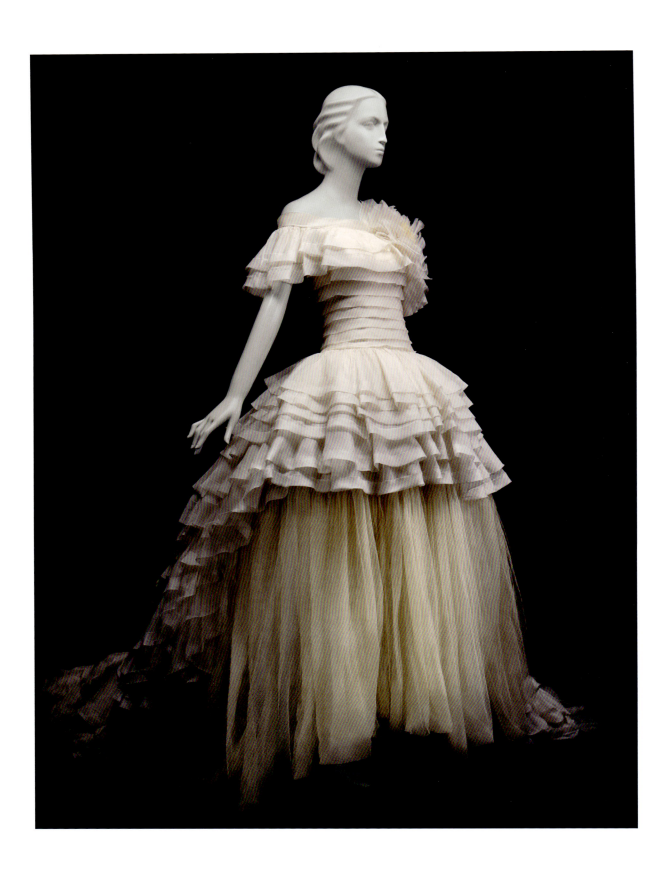

27 *Sketch of CHLOÉ "Enfance" dress*, spring/summer 1977

28 CHLOÉ (French, founded 1952). *"Enfance" dress*, spring/summer 1977. Ivory silk crepe de chine with red chinoiserie figures and landscapes hand painted by Nicole Lefort, embroidered with red seed beads; sash of red silk crepe de chine

29 *Sketch of CHANEL ensemble*, 2014–15 métiers d'art

30 House of CHANEL (French, founded 1910). *Ensemble*, 2014–15 métiers d'art. Dress of white silk crepe embroidered with black, white, and red seed beads, pink and black silk thread, and clear crystals; vest of black leather trimmed with black silk satin, silver metal, clear crystals, and red and blue silk thread

31 *Sketch of CHLOÉ "Armide" dress*, spring/summer 1983

32 Chloé. *"Armide" dress*, spring/summer 1983. White silk organza embroidered with red nylon-cotton-rayon thread

33 *Sketch of CHLOÉ "Arc en ciel" dress*, spring/summer 1983

34 CHLOÉ. *"Arc en ciel" dress*, spring/summer 1983. White silk organza embroidered with red, blue, yellow, and black cotton thread

35 *Sketch of CHANEL dress*, autumn/winter 2016–17

36 House of CHANEL. *Dress*, autumn/winter 2016–17. White silk tulle embroidered with white leather and white silk organza and pieced with brown leather trimmed with silver metal grommets and brown leather cord

37 *Sketch of CHANEL ensemble*, 2014–15 métiers d'art

38 House of CHANEL. *Ensemble*, 2014–15 métiers d'art. Dress and bolero of ivory silk organza embroidered with ivory silk thread and trimmed with black silk velvet and ivory silk chiffon; bow of black silk velvet; belt of black silk velvet embroidered with clear and gray crystals

39 *Sketch of CHANEL dress*, spring/summer 1995 haute couture

40 House of CHANEL. *Dress*, spring/summer 1995 haute couture. White silk chiffon and tulle

41 House of CHANEL. *Ensemble*, autumn/winter 2009–10. Jacket of black wool-nylon ottoman with black silk passementerie; blouse of black silk jersey and white silk taffeta; skirt of cream silk jersey overlaid with black silk crepe

42 *Sketch of CHANEL suit*, autumn/winter 1991–92 haute couture

43 House of CHANEL. *Suit*, autumn/winter 1991–92 haute couture. Jacket and skirt of white wool-synthetic bouclé

44 *Sketch of CHANEL suit*, spring/summer 1988 haute couture

45 House of CHANEL. *Suit*, spring/summer 1988 haute couture. Jacket of cream wool tweed trimmed with polychrome silk grosgrain ribbons, and white chenille yarn, clear bugle beads, and purple silk bows; skirt of cream wool tweed

46 *Sketch of CHANEL suit*, spring/summer 1986 haute couture

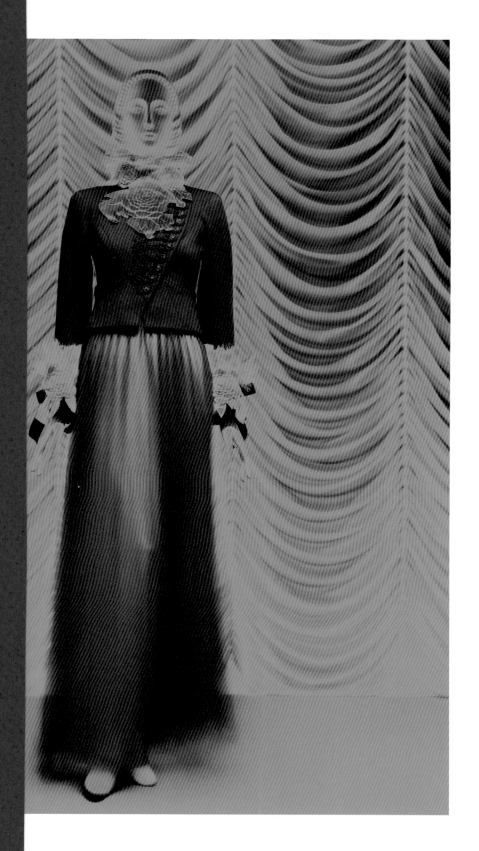

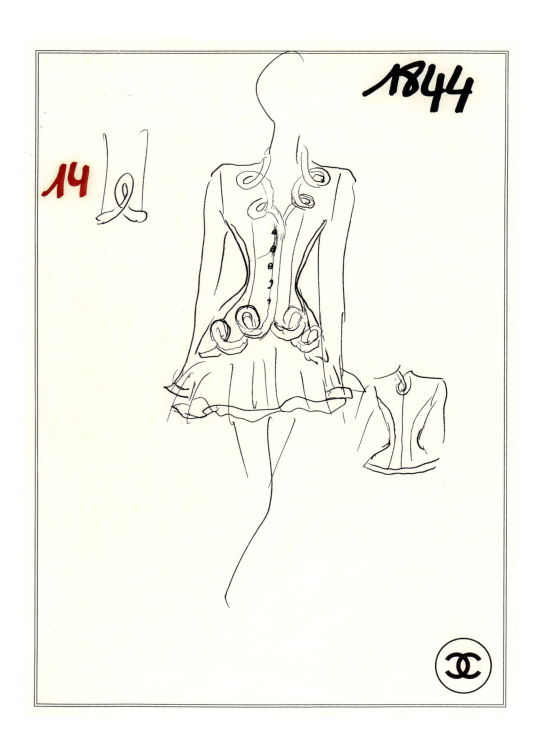

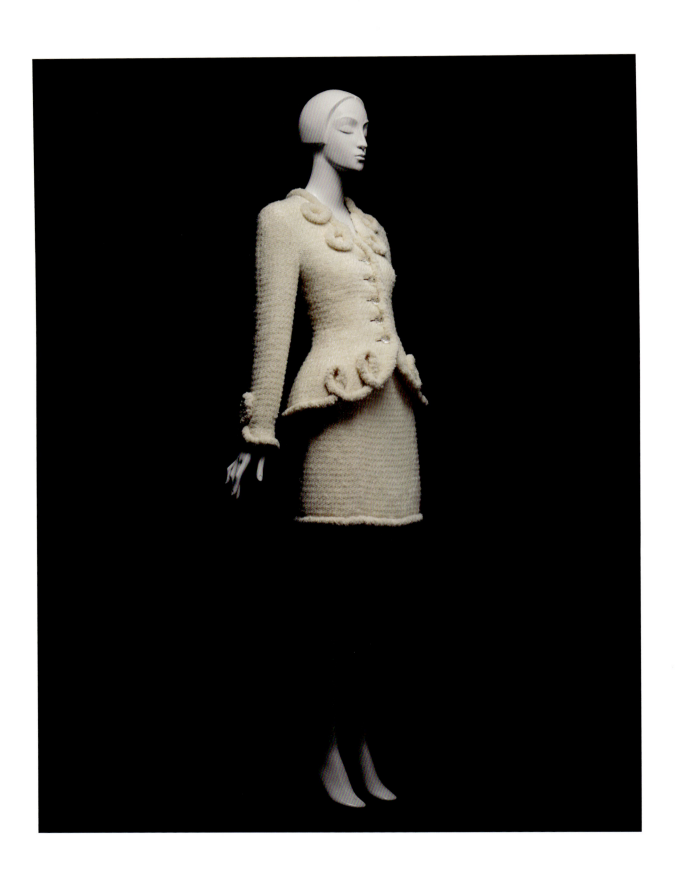

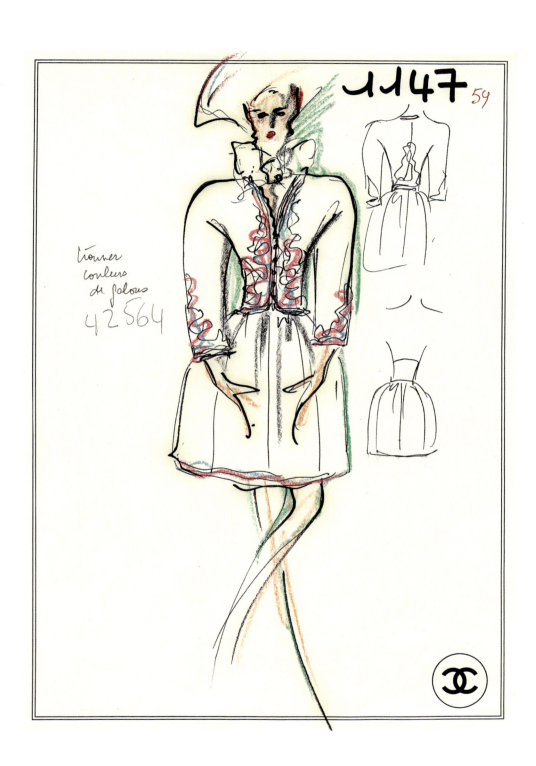

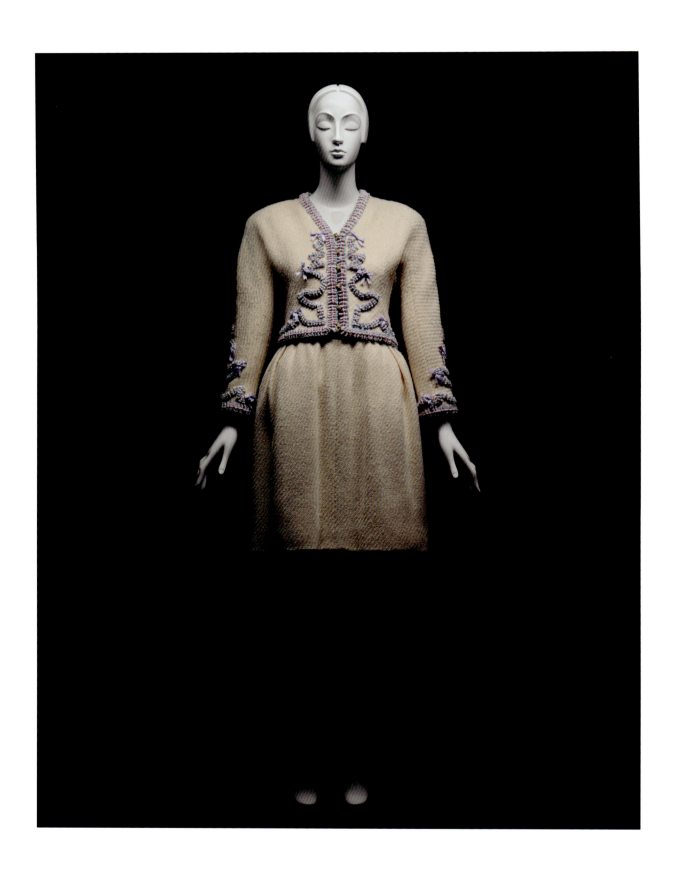

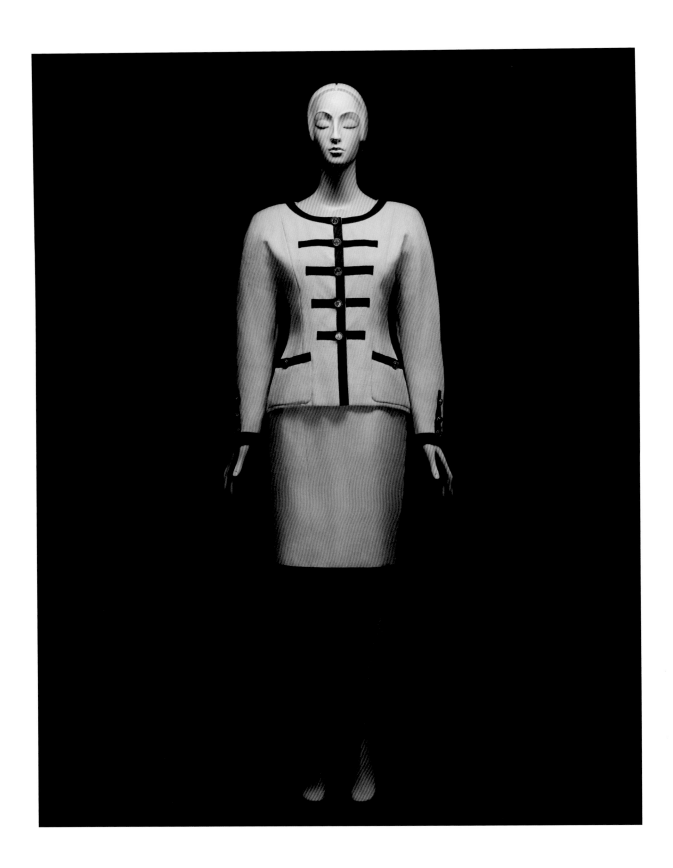

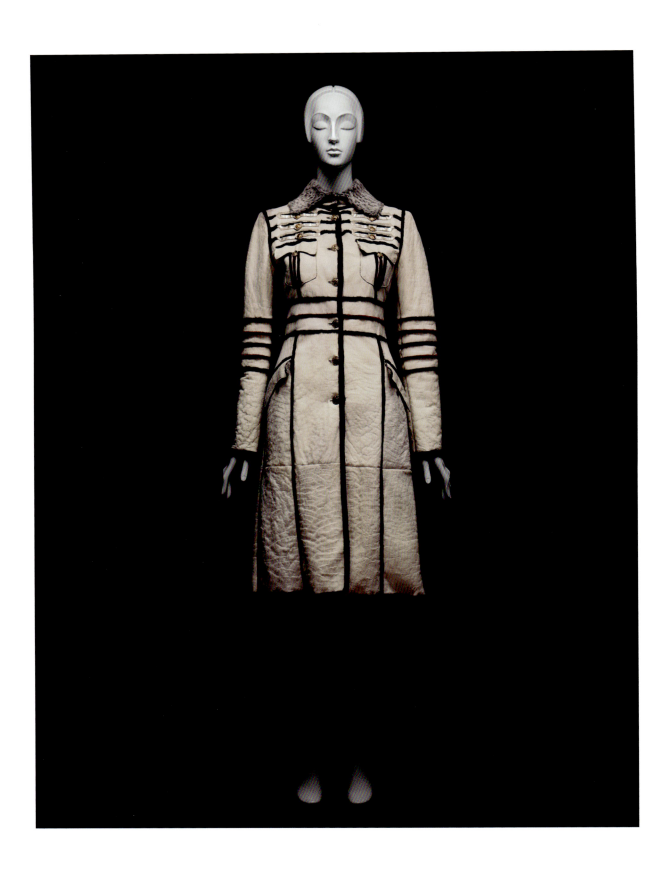

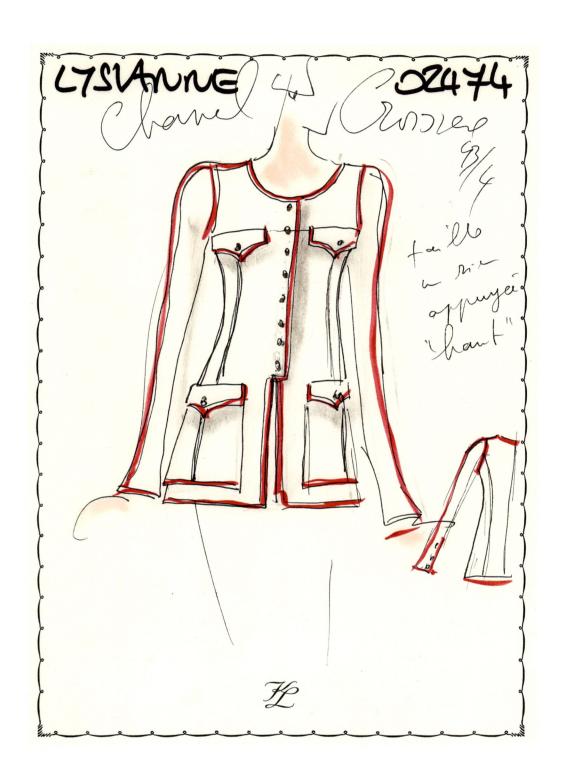

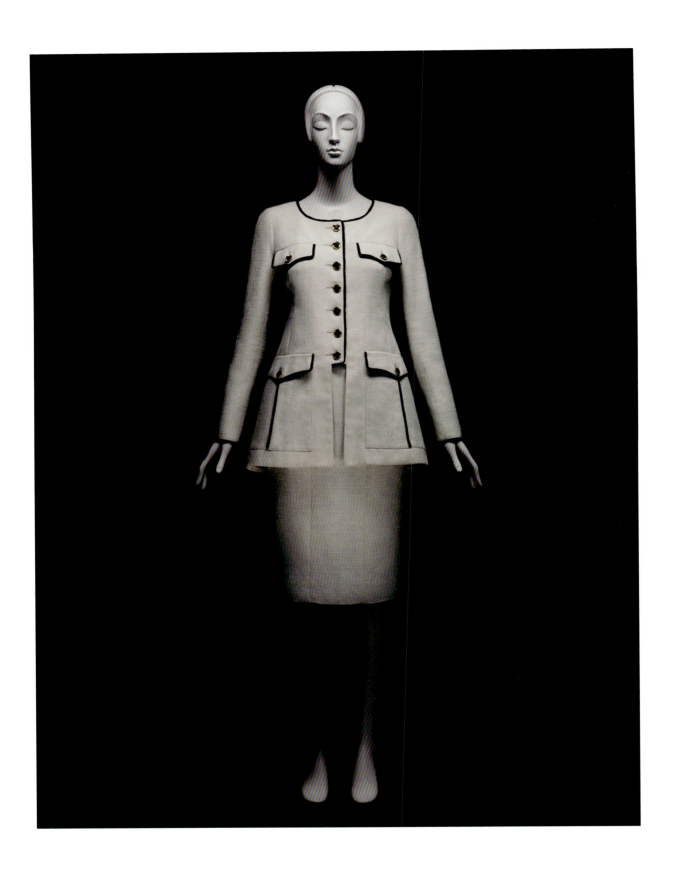

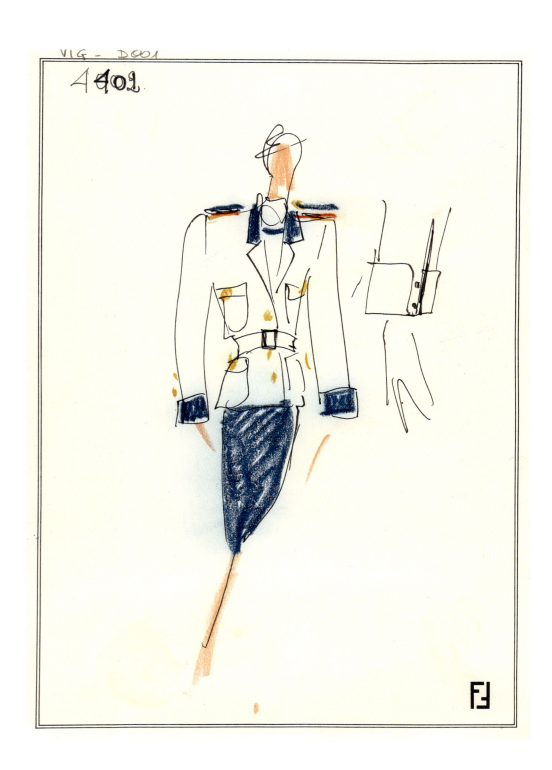

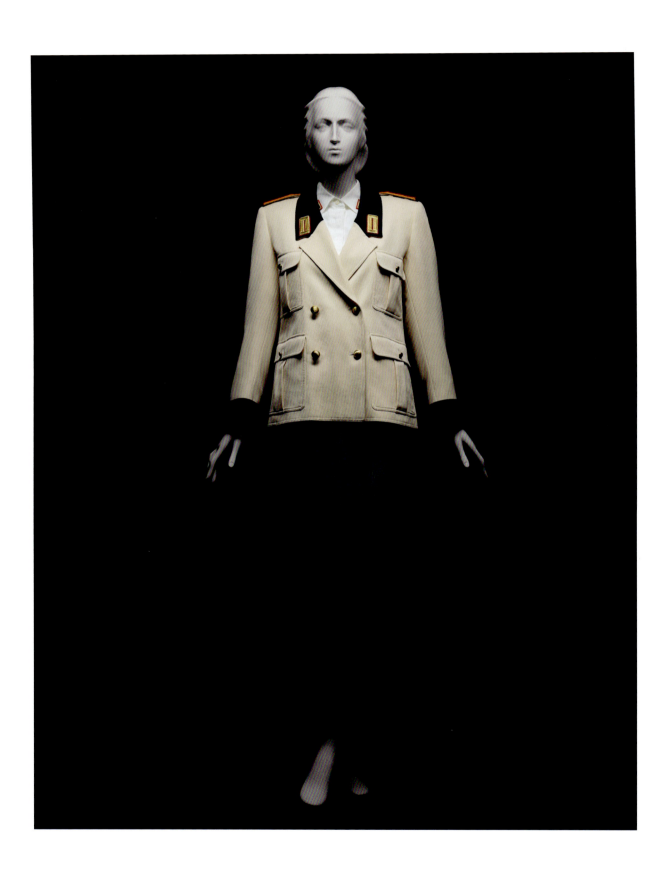

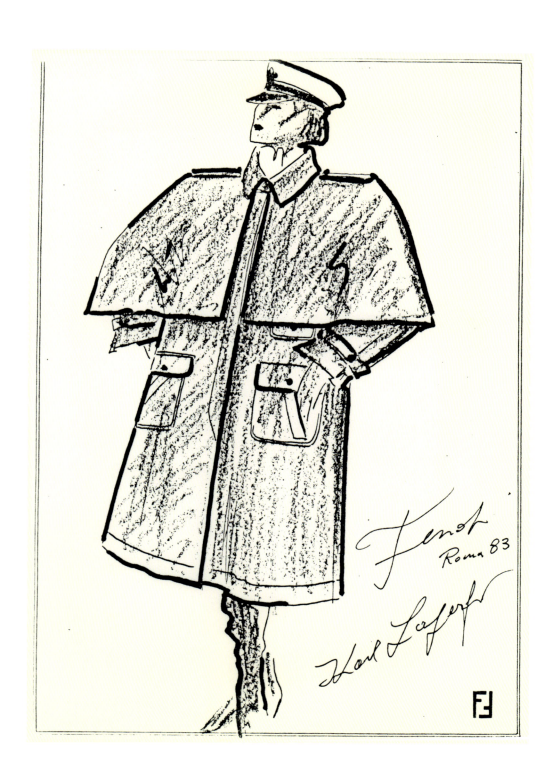

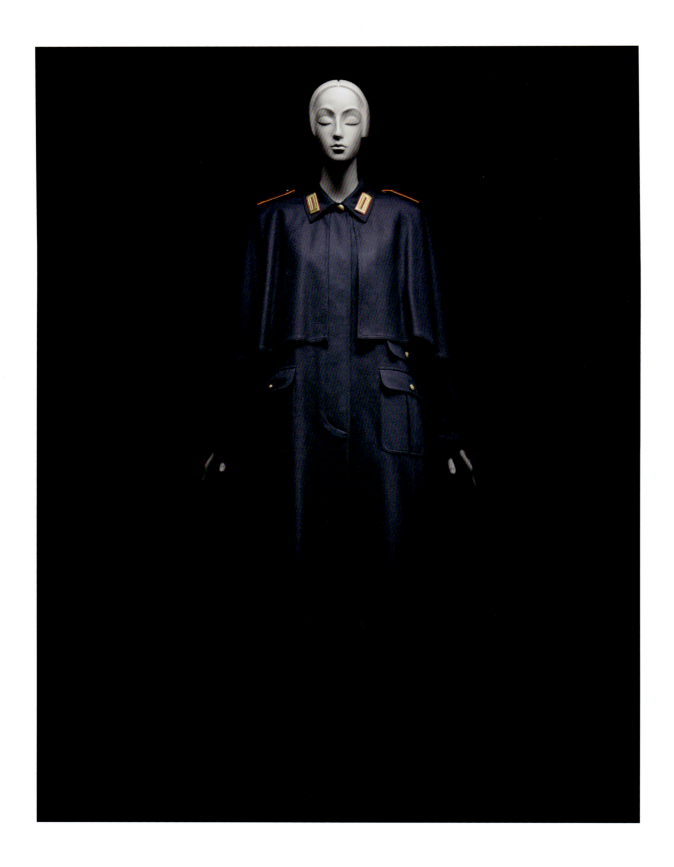

III

ROCOCO LINE

CLASSICAL LINE

Karl Lagerfeld's rococo tendencies—as reflected in the "rococo line"—were perhaps most fully realized in his enthusiastic and often uncritical embrace of Orientalism, as the West's fascination with and assimilation of the ideas and styles of the East has historically been termed. Unlike the exotic comingling that inspired eighteenth-century carousels, court masques, and fêtes galantes, Lagerfeld's Orientalist impulses were fueled by possibility rather than colorful pageantry and masquerade—namely, the potential of revisioning, reinventing, and ultimately expanding the canon of Western fashion. Lagerfeld understood, almost instinctively, that the power of fashion lies in its ability to absorb and be absorbed—dress, in fact, has long expressed an intense multiculturalism avant la lettre. For him the East (or various Easts)—confected from his seemingly inexorable imagination—presented a new looking glass for fashion, offering a sumptuous wardrobe charged with enchantment, enlightenment, and even assimilation, as, indeed, it had for designers before him, including Gabrielle Chanel herself.

As with rococo artists and artisans of the eighteenth century, Lagerfeld's Orientalism was expressed most frequently through his passion for chinoiserie (from *chinois*, French for "Chinese"), which similarly conveys an image of China that was as fictional and as fanciful as that described in Samuel Taylor Coleridge's 1797 poem "Kubla Khan," said to have been inspired by an opiate-induced dream the poet had after reading Samuel Purchas's description of Xanadu in *Purchas His Pilgrimes* (1625). The exotic scenes of Chinese life with imaginary figures and fantastical landscapes that appear on the two garments from Chloé's autumn/winter 1976–77 collection (pls. 56, 58) reference the picturesque Cathay (the medieval term for China) as portrayed in eighteenth-century chinoiserie decorative arts: the cream silk crepe de chine dress titled "Du rêve" evokes painted wallpaper (pl. 56); the gold Lurex and brown silk crepe de chine ensemble titled "D'or," lacquered furniture (pl. 58). In effect, Lagerfeld presents the garments as rarefied artifacts, reflecting all the consumer-laden values associated with a work of art. The fact that the scenes are hand painted by Nicole Lefort furthers their appreciation as art objects. Lagerfeld's intention was not lost on critics at the time, with Marylou Luther stating in the *Los Angeles Times* (April 9, 1976), "They're collector's items, pure art in fashion."

This affiliation of fashion with the decorative arts—and its subsequent elevation in the hierarchy of the arts—is even more compelling in the ensemble from Chanel's autumn/winter 1996–97 haute couture collection (pl. 60), which is similarly wrapped in an aura of art and power. The jacket's emphatic chinoiserie embellishment—a tour de force of embroidery by Maison Lesage, rendered in bronze seed beads and red, gold, and black paillettes requiring 800 hours of handwork—was inspired by an eighteenth-century French cabinet decorated with European japanned panels in imitation of Chinese coromandel lacquer (see p. 31, fig. 11) and intended to simulate one of the coromandel lacquered screens that furnished Gabrielle Chanel's Parisian apartment at 31, rue Cambon (see p. 31, fig. 12). Typical of Lagerfeld's layered and multivalent Orientalism, the jacket's form represents an ebullient reconciliation of Eastern and Western dress styles: a marriage of the aesthetics of a cheongsam and a cardigan-style coatdress. Lagerfeld christened this slender, vertical, etiolated silhouette the "stiletto body," explaining in a July 2, 1996, article in *WWD* that "the silhouette is elongated to death, because it makes a woman look endless." The "endless suit" is how he referred to the coromandel jackets in the collection—a style that "never finishes." They are cut so tightly that they require a specially designed black bodysuit to be worn underneath; "nothing else would fit," Lagerfeld explained, dubbing the bodysuits "the body beautiful" in *WWD* (July 10, 1996).

Lagerfeld often indulged his Orientalist fantasies in Chanel's métiers d'art collections, as with his 2011–12 "Paris-Bombay" collection, of which he remarked in an interview for *Chanel News* (December 20, 2011), "India for me is an idea. I know nothing about the reality, so I have a poetic vision of something that is perhaps less poetic in reality." Inspired by the heyday of the British Raj as seen through the eyes of Lady Curzon, vicereine of India from 1899 to 1905, Lagerfeld's Parisian version of an India that doesn't exist was presented in the Galerie Courbe at the Grand Palais, Paris, which had been transformed into "a luxurious Maharaja's palace" with guests seated at "an almost surreal banquet," according to the design house's show notes. The finale to the collection was a white silk crepe ensemble cannibalized from the sari (pl. 63) and comprising a tailored, short-sleeved dress with a Nehru collar and an integral wrapped

skirt worn draped over the shoulder, a nod to the sari's single, continuous cloth swaddling the body. It was directly inspired by a sari-style dress that Gabrielle Chanel designed for her spring/summer 1939 collection, a sketch of which Lagerfeld had seen in the summer 1939 edition of the quarterly fashion magazine *Excelsior Modes*. The caption read, "Chanel, her new spiral draped dress rising to wrap the bust in a sari"; a photograph of the same model appeared in the June 1939 edition of *Femina*, bearing the caption "Chanel's Hindu-style drape" (see p. 31, fig. 13). Chanel frequently looked to the clothing traditions of India to express her "moderne Orientalism," such as her pantaloons of the 1920s, Mughal jewelry of the 1930s, and lamés and brocades of the 1950s and 1960s. Lagerfeld amalgamates all these references in the ensemble from Chanel's autumn/winter 1996–97 collection (pl. 61): a gold lamé evening pantsuit with Nehru-style jacket lavishly encrusted with multicolored rhinestones.

Usually Lagerfeld staged his Chanel métiers d'art collections in locations that reflected the theme of the collection, such as "Paris-Tokyo" (2004–5) and "Paris-Shanghai" (2009–10). The latter collection, which was shown on an eighty-five-meter-long barge on the Huang River, included the "explosion" ensemble of black silk tulle that integrates Lagerfeld's Orientalizing and classicizing tendencies by combining classical drapery and Chinese-inspired jadeite jewelry, including a belt with oxidized *qian* coins (pl. 68). His 2018–19 "Paris-New York" métiers d'art collection, which, according to a statement on Chanel's website, endeavored to "renew the codes of the house with references to ancient Egypt and the spirit of New York," was presented in the Temple of Dendur at The Metropolitan Museum of Art. The collection includes garments inspired by the vernacular dress of ancient Egypt, including skirts cut to resemble the *shendyt*, a kilt-like loincloth worn by all classes of men. One of the highlights is an ensemble comprising a short white bouclé and tulle dress embroidered by Maison Montex with beads, sequins, and leather in an overall lozenge pattern worn over a close-fitting, ankle-length sheath dress of white silk and net (pl. 67)—the former inspired by beadnet dresses (see p. 31, fig. 14) and the latter by the *kalasiris*, female garments often depicted in ancient Egyptian sculptures and hieroglyphics.

Like his Orientalism, Lagerfeld's classicism often referenced particular garment types, namely, the chiton, peplos, and himation, the most typical forms of women's apparel in ancient Greece. The himation, a large cloak with a range of draping and wrapping possibilities, was the source for the ensemble from Chanel's autumn/winter 2009–10 haute couture collection (pl. 80). Inspired by classical statuary, Lagerfeld's modified himation—made of brown silk crinkle chiffon with a gossamer insubstantiality—is draped over the left shoulder, revealing a nude bodysuit underneath that is embroidered by Maison Montex with flowers and trompe l'oeil breasts, the right bared in a display of classical naturalism. Generally, when worn by women in ancient Greece, the himation was a garment of decorous modesty; Lagerfeld's version, however, carries the provocation of hetaerae. The designer also employs the device of trompe l'oeil with deliberate classicizing intent in the ivory crepe dress from Chloé's spring/summer 1984 collection titled "Crétoise" (pl. 82). A masterwork of embroidery by Maison Henry, its illusory himation, draped over a chemise-like chiton and inspired by figures depicted on an Attic red-figure vase, establishes a transcendent association with the Hellenic antique.

The peplos, with its distinctive overfold, or *apoptygma*, and brooch-like pins, or fibulae, at the shoulders, was the inspiration for the white silk jersey dress Lagerfeld designed with the Fendi sisters as part of a series of costumes associated with the 1990 FIFA World Cup in Rome (pl. 78). Worn by dancers at the final game, it was accessorized with a headdress inspired by the bronze sculpture of the Capitoline Wolf; other costumes were similarly paired with headdresses inspired by buildings and monuments from the Italian capital. The peplos was also the inspiration for the dress (pl. 76) from Chanel's 2017–18 cruise collection, titled "The Modernity of Antiquity"; it was presented in the Galerie Courbe at the Grand Palais against a backdrop of a ruined temple that alluded to the Parthenon and the Temple of Poseidon on Cape Sounion. Made from white silk crepe chiffon girdled at the waist with a corset belt embroidered by Maison Montex to imitate marble, Lagerfeld's revised peplos is more evocative of Gilbert Adrian's Hollywood "goddess" gowns with their signature fluidly draped silhouettes than its antique precedent. But historical accuracy was never Lagerfeld's ambition, as he explained to *WWD* in a May 3, 2017, article: "Reality is of no interest to me. I use what I like. My Greece is an idea."

Classical antiquity as reflected in fashion history similarly informed the dress from Chanel's spring/summer 1993 haute couture collection (pl. 74), which was inspired by a 1952 dress by Madame Grès made from silk jersey with a swag of pleated fabric draped over the right shoulder and threaded through an elaborately twisted and pleated section at the chest, giving a high-waisted Empire-line effect (see p. 31, fig. 15). Unlike her body-skimming, supple silk jersey gowns of the 1930s, Grès's dresses from the 1950s were structured with an underbodice, allowing her to create pieces of complex drapery and pleating by tacking her difficult medium onto a rigid form. In his version of black silk chiffon, Lagerfeld has exposed the shaping underbodice, transforming it into a cage-like corset made of plastic and gilt and leather straps borrowed from Chanel's iconic 2.55 quilted handbag. The black dress from Chanel's spring/summer 1995 collection (pl. 72) is also infused with memories of the founder, referencing the bandage-like costumes that Gabrielle Chanel created for the male characters in Jean Cocteau's 1937 production of *Oedipus Rex*, the title role of which was played by Jean Marais (see p. 32, fig. 16). With a modernist's strategy, Lagerfeld, like Chanel before him, has extrapolated the basic element of classical dress: the ancient practice of wrapping rather than tailoring cloth to fit the body. This minimalist impulse is also evident in the black nylon bathing costume from Fendi's spring/summer 1993 collection (pl. 70) that suggests an almost atavistic, primitivistic Hellenism.

ROCOCO LINE

56 58 60 61 63 65 67

CLASSICAL LINE

70 72 74 76 78 80 82

EXPLOSION

68

SKETCHES

55 57 59 62 64 66 69

71 73 75 77 79 81

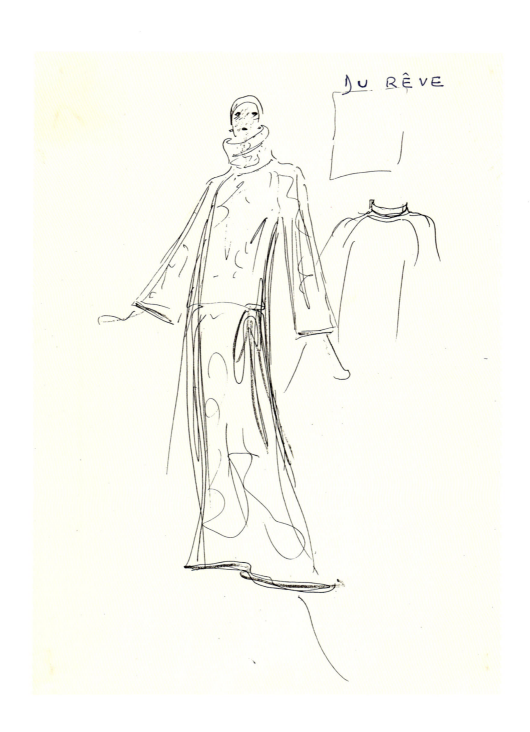

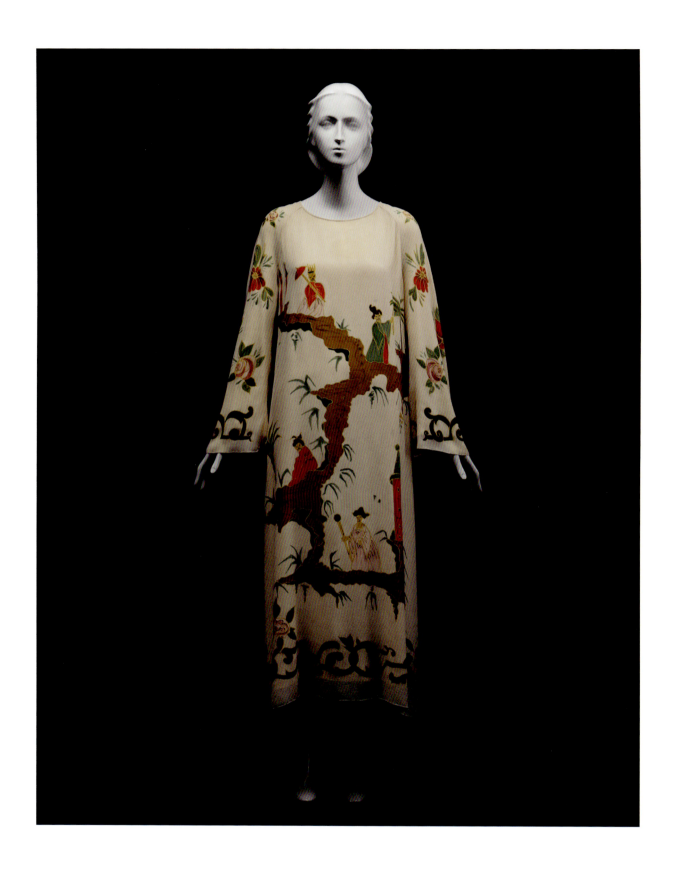

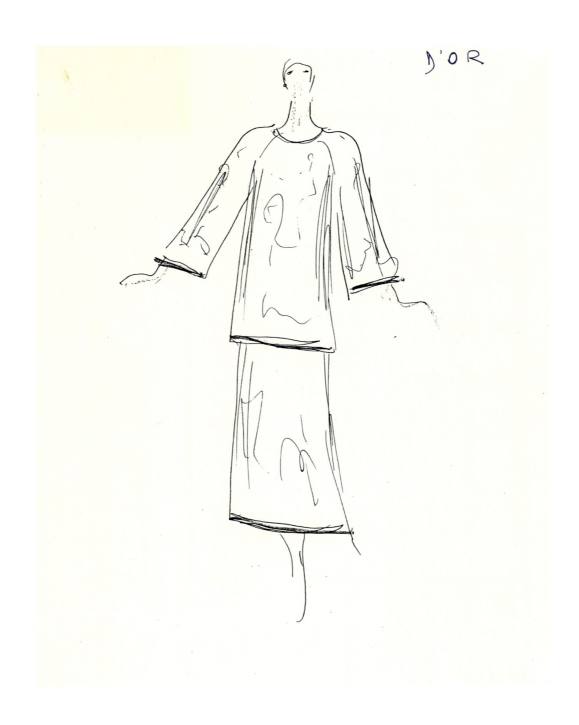

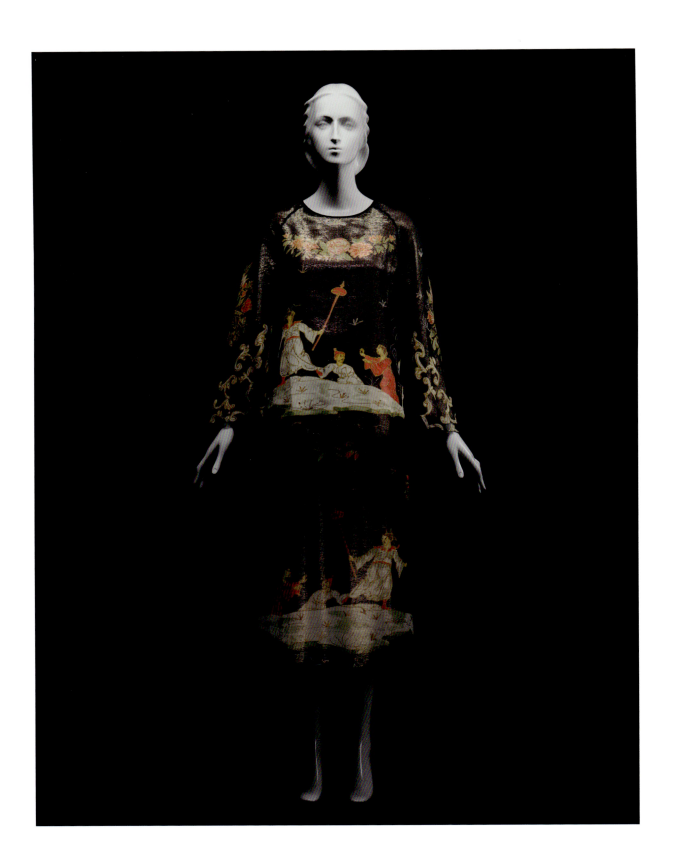

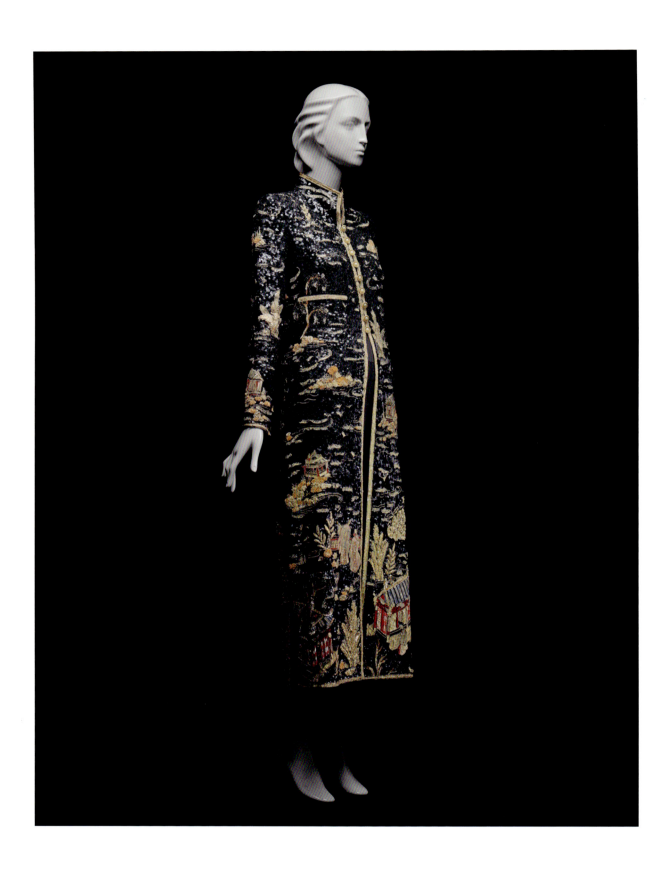

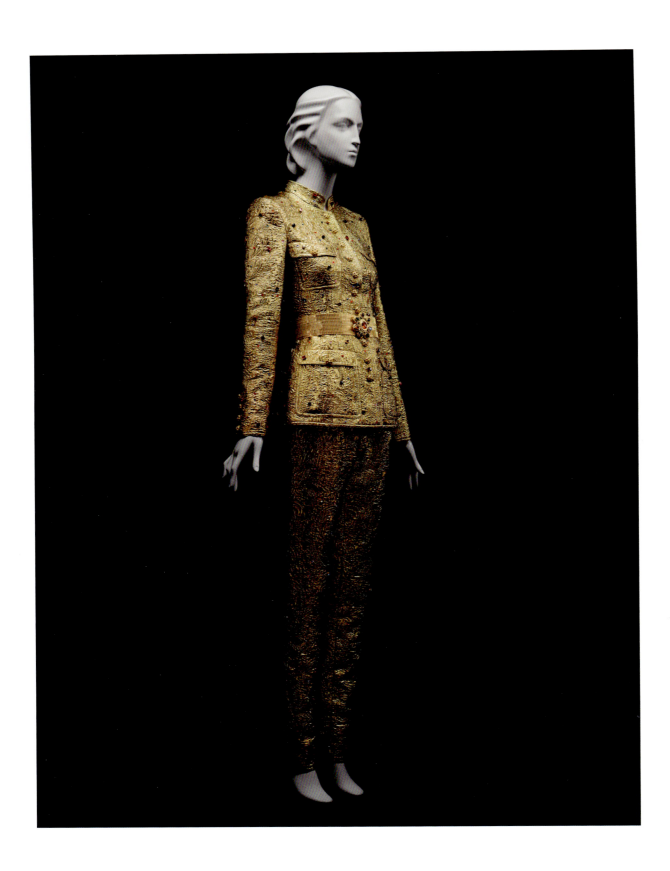

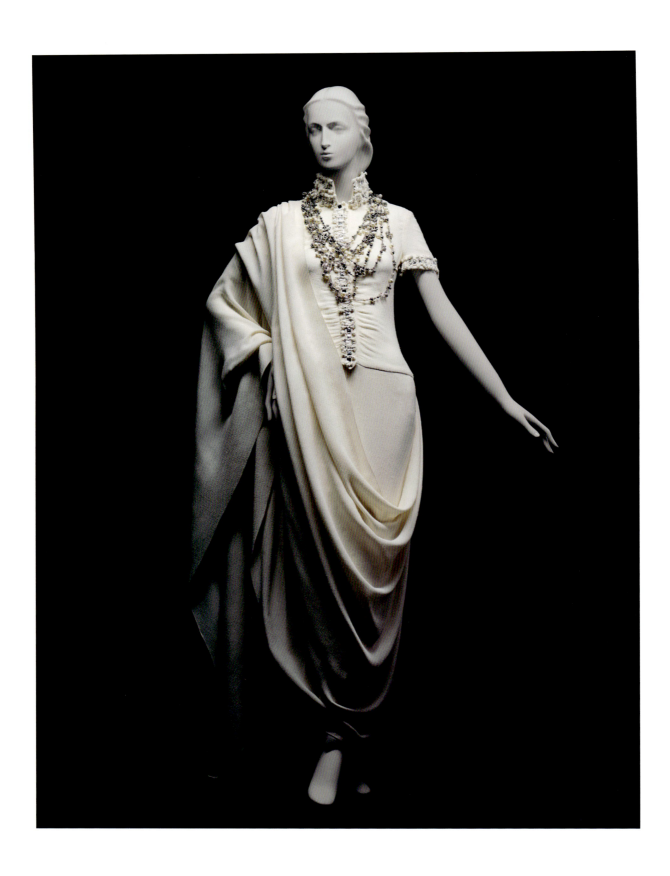

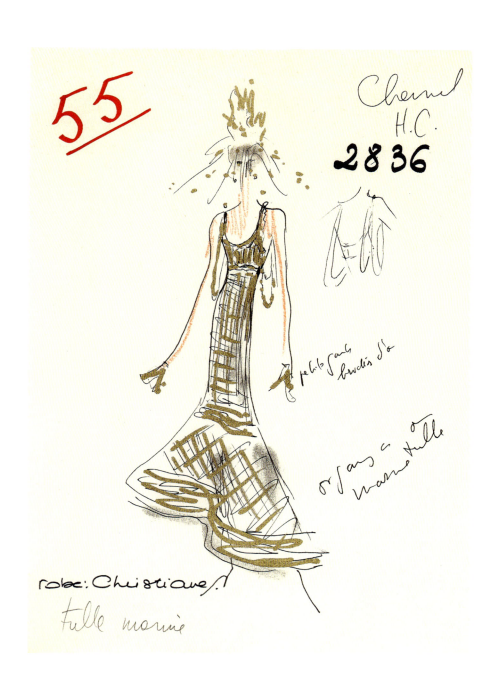

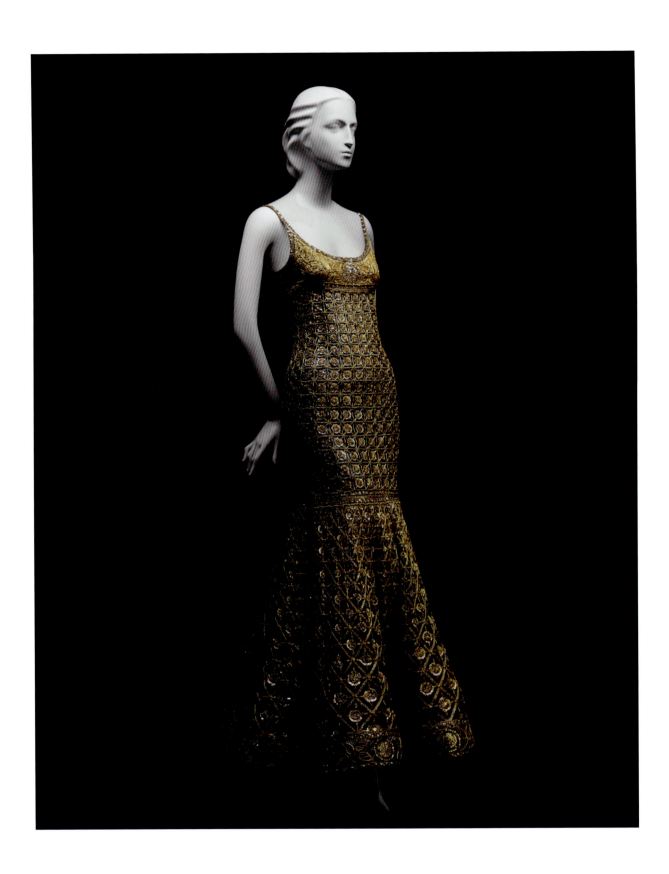

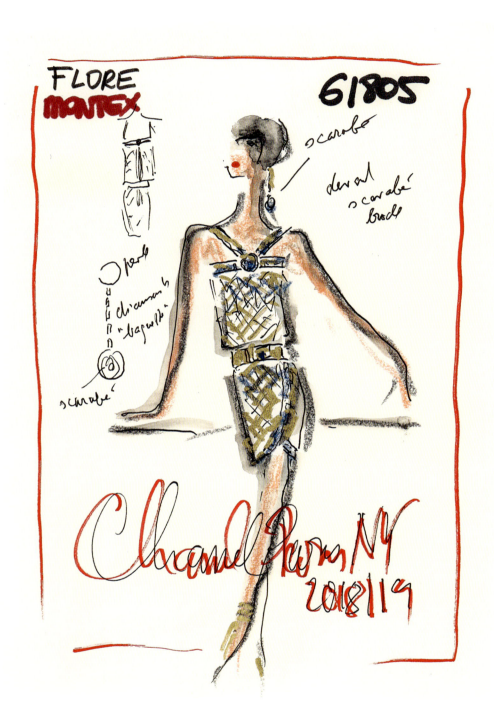

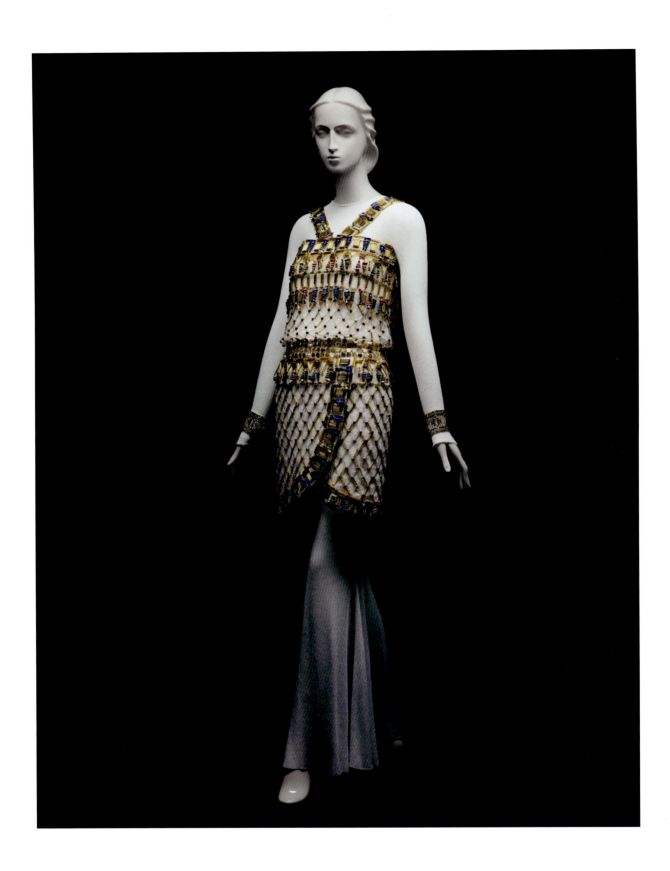

67

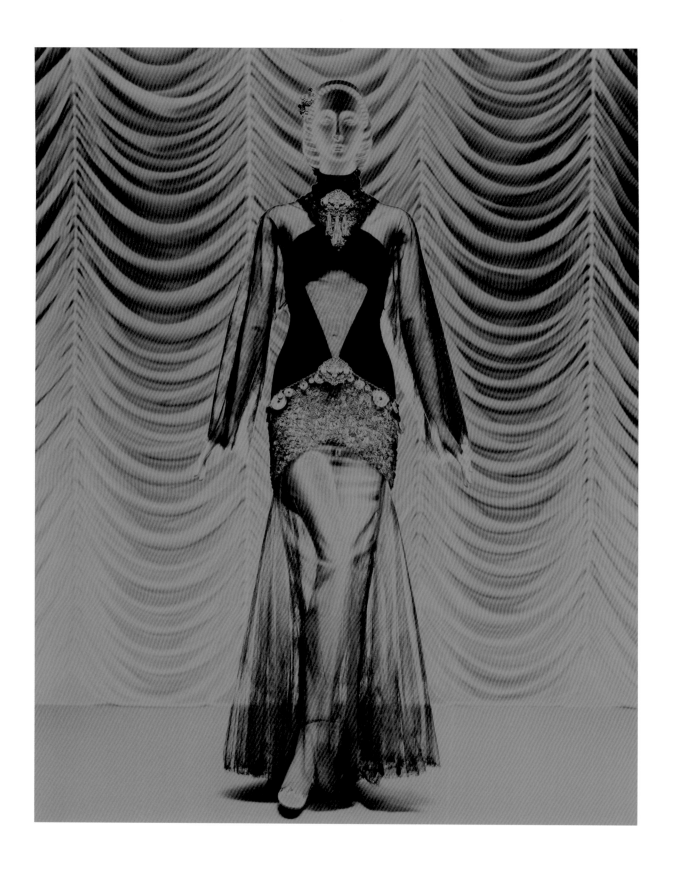

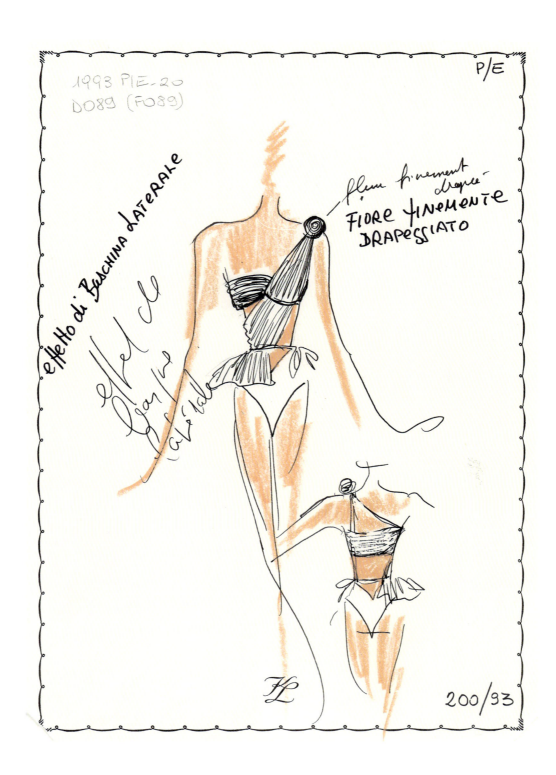

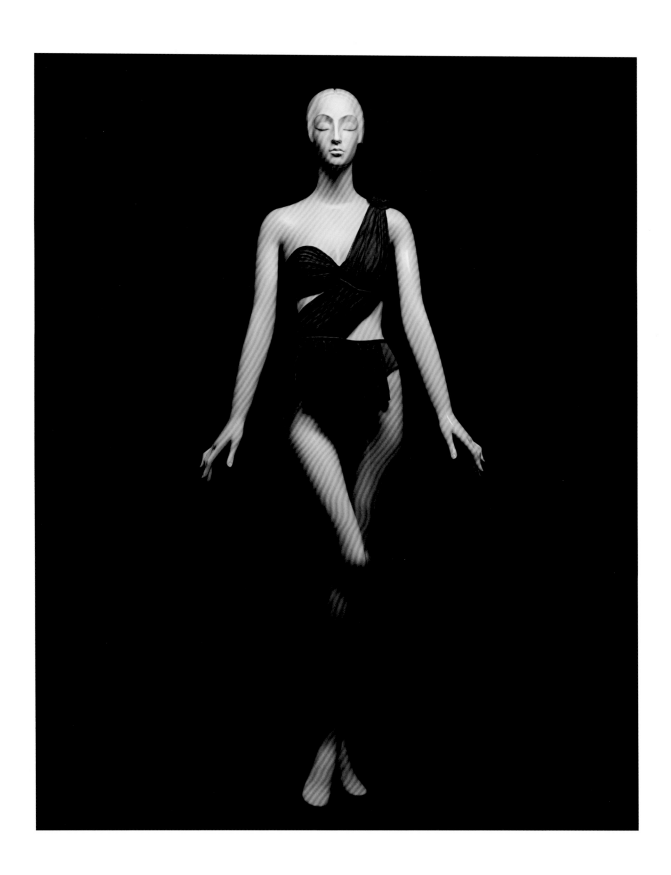

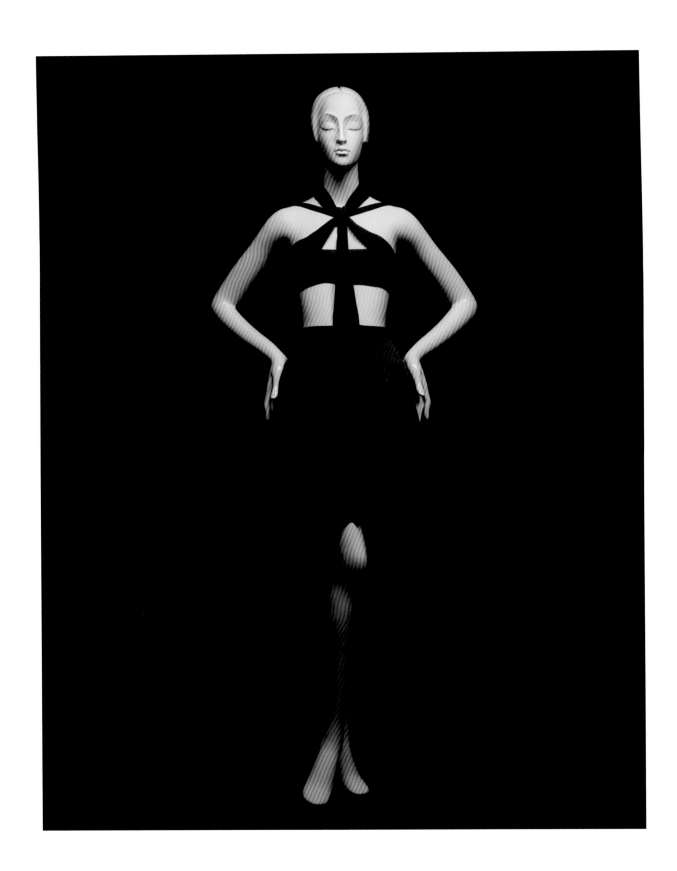

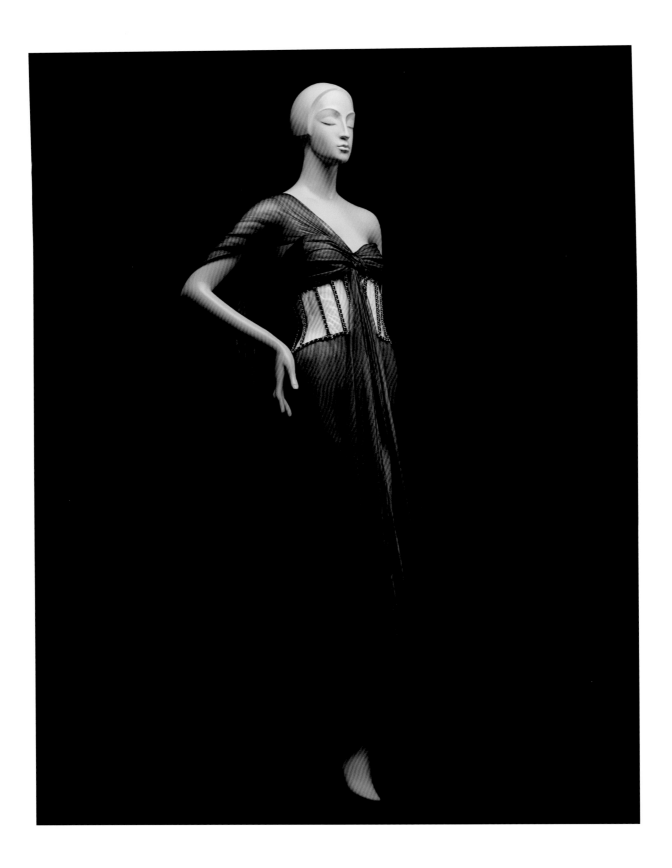

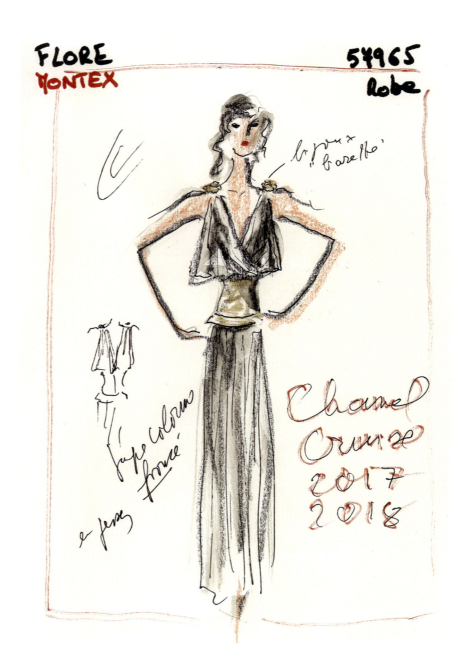

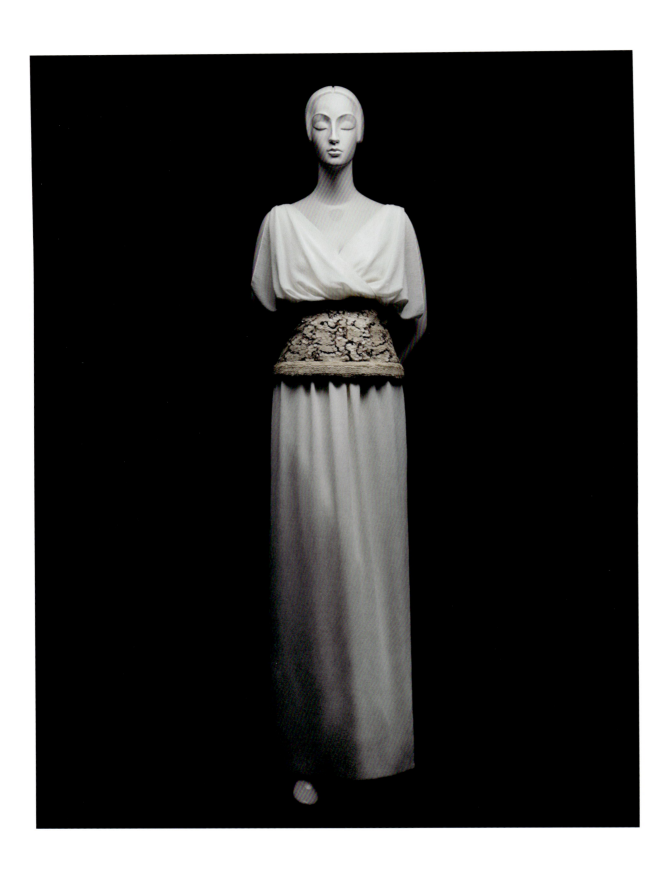

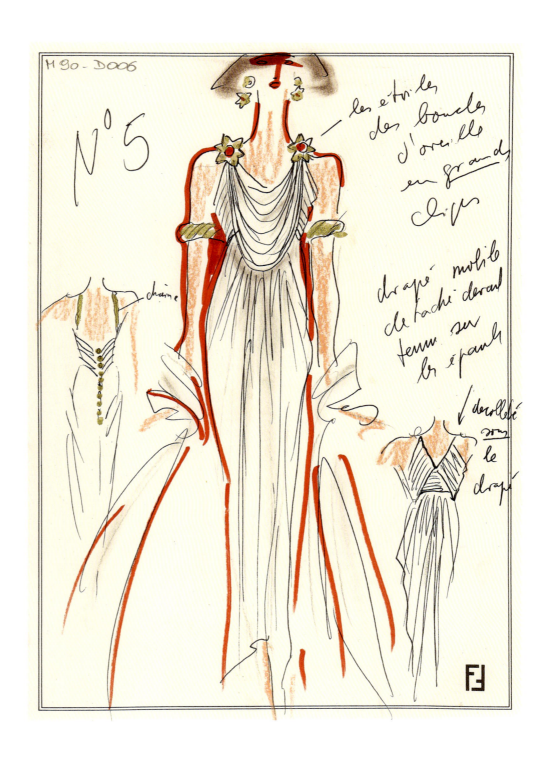

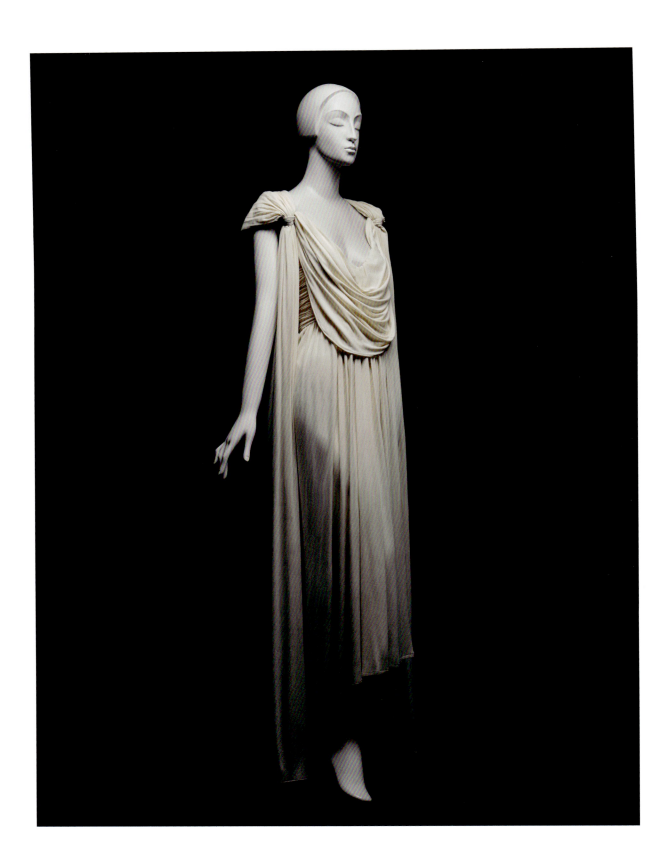

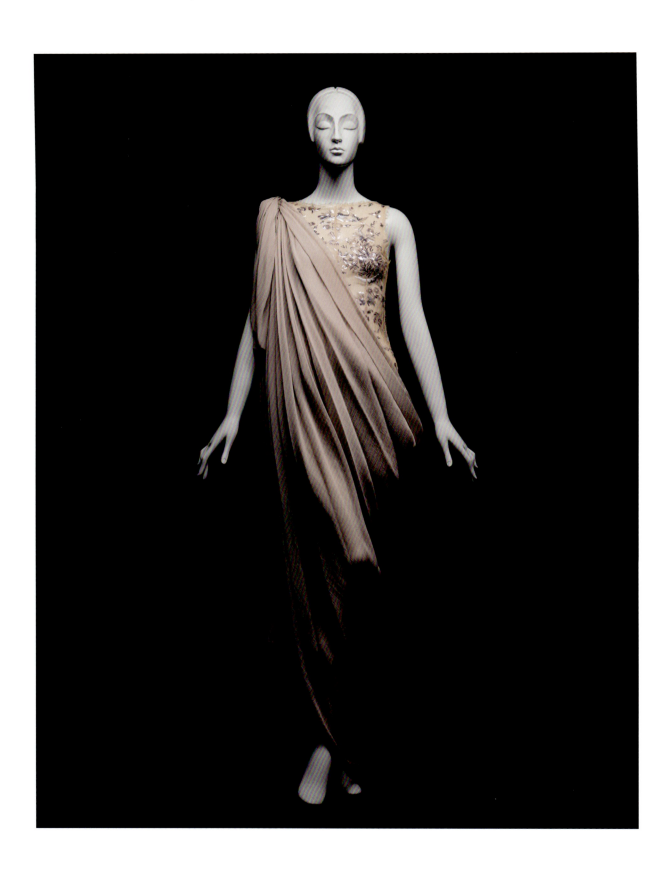

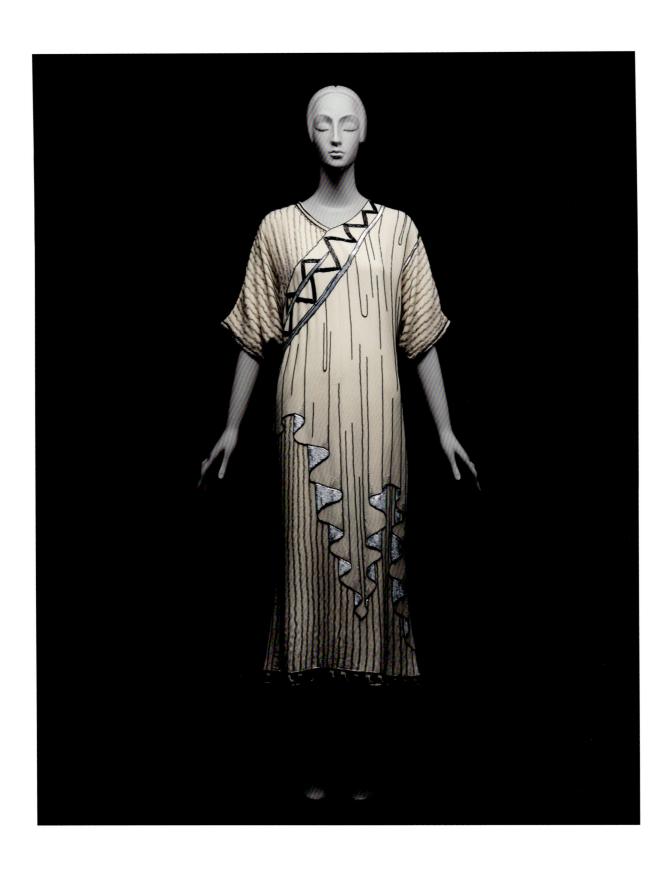

IV

HISTORICAL LINE

FUTURISTIC LINE

Karl Lagerfeld had a shrewd and elastic knowledge of costume history, exercising it liberally in past-present juxtapositions that established a give-and-take reciprocity between the old and the new, with the old informing the new and the new enlivening the old. The designer's knowing and buoyant historicism—palpably evident in the "historical line"—was at once magnanimous in that no time periods were off limits or out of bounds, and conditional in that he demanded the past to be fully assimilated into the present and the present to wholly integrate the past only if it was relevant to the zeitgeist.

Lagerfeld's promiscuous historicism was especially marked at Chanel, most notably in his collections of the 1980s, a decade that acceded history as an active and abiding presence in the contemporary imagination under the banner of postmodernism. For Chanel's 1988–89 haute couture collection, Lagerfeld was inspired by the medieval period after visiting the exhibition *Age of Chivalry: Art in Plantagenet England, 1200–1400* at the Royal Academy of Arts in London (November 6, 1987–March 6, 1988). Most pieces, however, reveal influences of the Elizabethan era, the apogee of the English Renaissance that observed a flowering of the arts, especially the theater, which Lagerfeld acknowledged by naming every outfit after a Shakespearean character. The ensemble "Biondello" (pl. 84) features a black silk velvet jacket inspired by a doublet with slashed and embroidered sleeves and front placket, a popular sixteenth-century decorative technique. "Thurio" (pl. 86) includes another doublet-inspired jacket, whose allover gold bead embroidery imitates chains; the simulation is clearly indebted to the doublet depicted in Isaac Oliver's watercolor *A Young Man Seated Under a Tree* (ca. 1590–95; see p. 32, fig. 17).

While Lagerfeld flirted with the fashions of the Tudor period in numerous collections for Chanel, his historical gaze was directed primarily at the dress styles of European royal courts of the seventeenth, eighteenth, and nineteenth centuries. The lavish ensemble from Chanel's autumn/winter 1987–88 haute couture collection (pl. 88) was inspired by William Christie's production of *Atys* with Les Arts Florissants in 1987. *Atys*, Jean-Baptiste de Lully's 1675 *tragédie lyrique*, is also known as *l'opéra du Roy* because of Louis XIV's fondness for it. Lagerfeld's "Atys" ensemble features a jacket sumptuously embroidered by Maison Lesage that was based on a costume worn by the ballet dancer and choreographer Serge Lifar at Count Etienne de Beaumont's 1939 Bal du tricentenaire de Racine (see p. 32, fig. 18). Lifar's attire was designed by Gabrielle Chanel, who took inspiration from engravings of the French dancer Auguste Vestris. Chanel herself attended the party in a costume inspired by Jean-Antoine Watteau's *L'Indifférent* (1717), which depicts a male dancer about to execute a dance step.

Watteau's art was a constant source of inspiration for Lagerfeld, evident in the cream silk crepe ensemble from Chanel's spring/summer 1985 haute couture collection (pl. 90) that directly references *Pierrot* (ca. 1718–19), a painting depicting a Pierrot surrounded by other commedia dell'arte characters (see p. 32, fig. 19). A relatively faithful and reverential representation of the Pierrot's brilliant white costume, the ensemble comprises a jacket with dropped shoulders and pushed-up, elongated sleeves. Watteau's depictions of the *robe volante* (also known as the *robe battante*) informed the dress of

white washed faille from Chanel's spring/summer 2005 haute couture collection (pl. 94), which mirrors the original's unstructured, figure-obscuring silhouette with flowing front and back pleats. In contrast to the informal elegance of the *robe volante*, the silk satin evening ensemble from Chanel's autumn/winter 1990–91 haute couture collection (pl. 95)—featuring Lesage embroidery inspired by a German Boulle work table of the 1700s—captures the bravura assertion of eighteenth-century formal dress so closely associated with Versailles and the French court that it was universally described as a *robe à la française*. While Lagerfeld's version retains the basic silhouette of fitted overdress opening up at the center front, he has radically shortened its petticoat, thus combining the wardrobe of the ancien régime aristocrat with the stereotypical uniform of the modern-day prostitute. A similar iconoclastic historicism is apparent in the silk satin dress from Chanel's autumn/winter 1991–92 haute couture collection (pl. 92) that was inspired by Diego Velázquez's 1656 painting *Las Meninas, or The Family of Felipe IV*, which depicts the Infanta Margarita Teresa surrounded by her entourage (see p. 32, fig. 20). However, by shrinking the infanta's wide-hipped farthingale, or *guardainfante*, Lagerfeld propels it forward in time to the 1960s.

As seen in the "futuristic line," Lagerfeld mined the sixties for his vision of the future in the present, specifically space-age fashions that reflected the decade's preoccupation with space exploration fueled by Cold War aspiration and competition. The minidress he designed for Chloé's autumn/winter 1966–67 collection (pl. 97)—made of brilliant white silk crepe and embroidered with shiny silver paillettes and simulated pearls—is a sartorial expression of the futurism of the space race and the utopian thinking it generated. Thirty-five years later, Lagerfeld channeled a similar utopianism in a collection for Fendi that reflected all the hope, idealism, and optimism of the new millennium. The ensemble from this autumn/winter 2001–2 collection (pl. 99) is reminiscent of Pierre Cardin's "Cosmos" outfits from his 1964 "Cosmocorps" collection with its ribbed sweater and belted, geometrically cut leather tunic featuring porthole cutouts. A similar streamlined sensibility pervades Chanel's "intergalactic" autumn/winter 2017–18 collection presented at Paris's Grand Palais, where Lagerfeld had custom built a "N°5 Launch Pad" punctuated by a thirty-seven-meter-high rocket inscribed with the double-*C* logo. In a March 7, 2017, article in *Fashion*, Lagerfeld described the collection as "a journey through the sky, to the heart of constellations, in the wake of the astronaut Thomas Pesquet." It included the ensemble made from black "sparkling tweed," woven with iridescent thread and embroidered with silver sequins in the manner of the Milky Way (pl. 104). Echoing an astronaut's spacesuit, it features a funnel-necked white satin collar with a metal ring that appears ready to receive a pressure helmet. At the close of the show, models encircled the Chanel rocket that, in a feat of pyrotechnics and hydraulics, was launched to the strains of Elton John's "Rocket Man."

The destination of the rocket may well have been the Cambon Club, which served as the theme of Chanel's spring/summer 2014 haute couture collection and which Lagerfeld described as a "nightclub in another galaxy," as noted in a January 22, 2014, article in *France 24*. A highlight of the collection was the ensemble embroidered with iridescent sequins and ostrich feathers by the *maisons* Montex and Lemarié, which required 818 hours of workmanship (pl. 106). Tightly corseted to produce "flexibility between the top, the skirt, the waist" (*Chanel News*, January 22, 2014), it evokes images of celestial birds of paradise or, perhaps, their human counterparts: interstellar showgirls. Lagerfeld continued his voyage into outer space with Fendi's autumn/winter 2014–15 collection that featured a dress printed with a wondrous starry constellation (pl. 107). Janus-like, it features a front panel made of silk velvet and a back of nylon mesh. The "explosion" ensemble from Chanel's autumn/winter 2013–14 haute couture collection (pl. 96), selected to reconcile Lagerfeld's historicist and futuristic predilections, reveals a similar aesthetic schizophrenia. In the design house's show notes, Lagerfeld described the collection as "between yesterday and tomorrow . . . a transition between the old world and the new world," a conceit realized in this dress that conflates influences of the 1880s and the 1960s—the former evident in the silhouette à la the painter James Tissot, and the latter in the kinetic, origami-style pleating executed by Maison Lemarié and recalling Paco Rabanne's chain-mail fashions, which Lagerfeld described as "graphical postmodern refinement . . . Chanel, but for another century" in an interview for *Chanel News* (July 3, 2013).

HISTORICAL LINE

84 86 88 90 92 94 95

FUTURISTIC LINE

97 99 101 102 104 106 107

EXPLOSION

96

SKETCHES

83 85 87 89 91 93

98 100 103 105

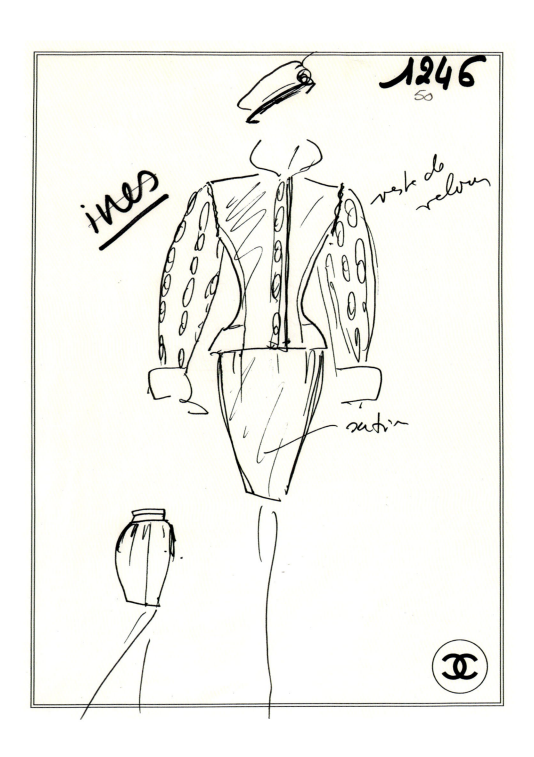

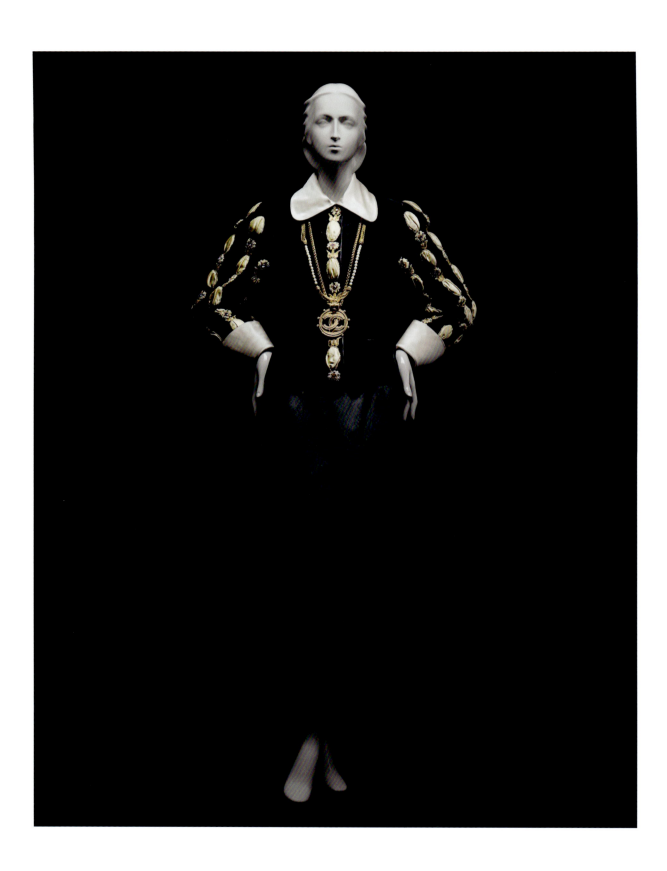

84

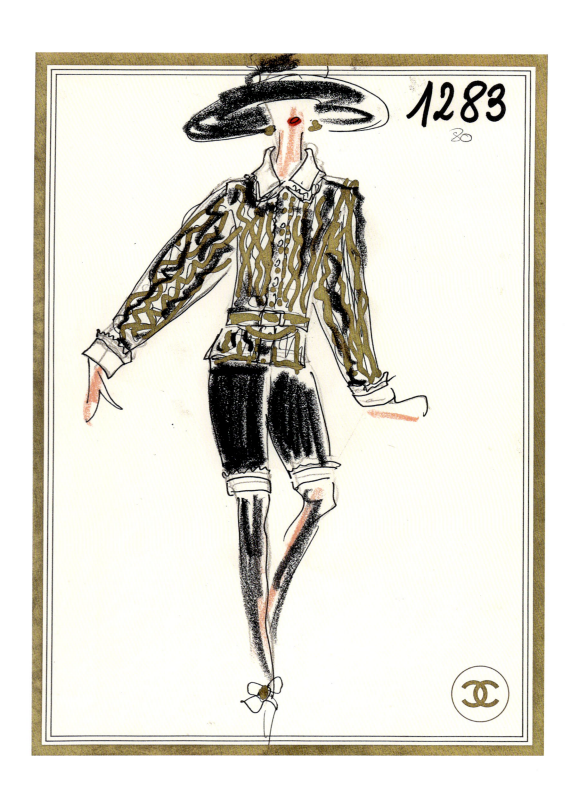

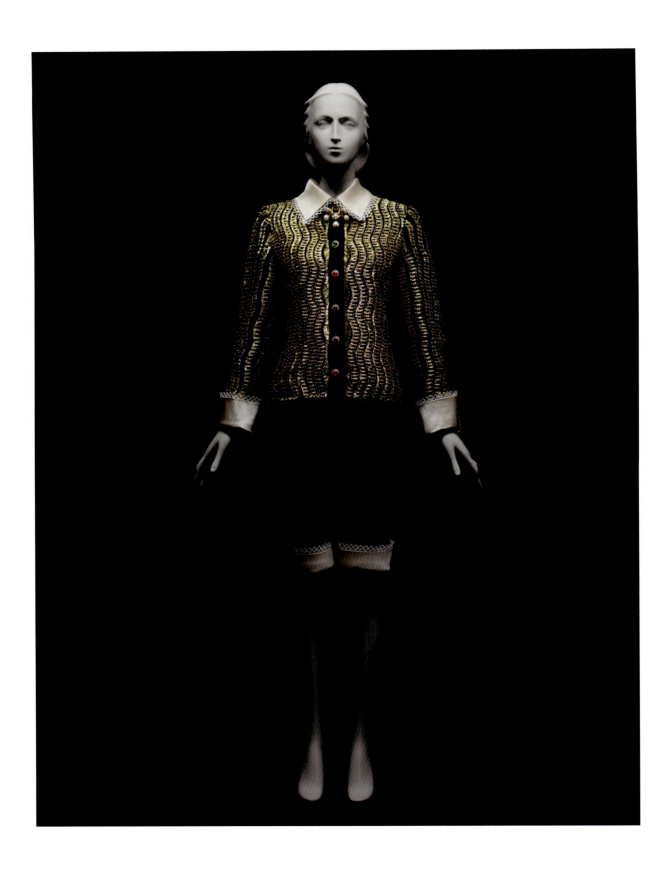

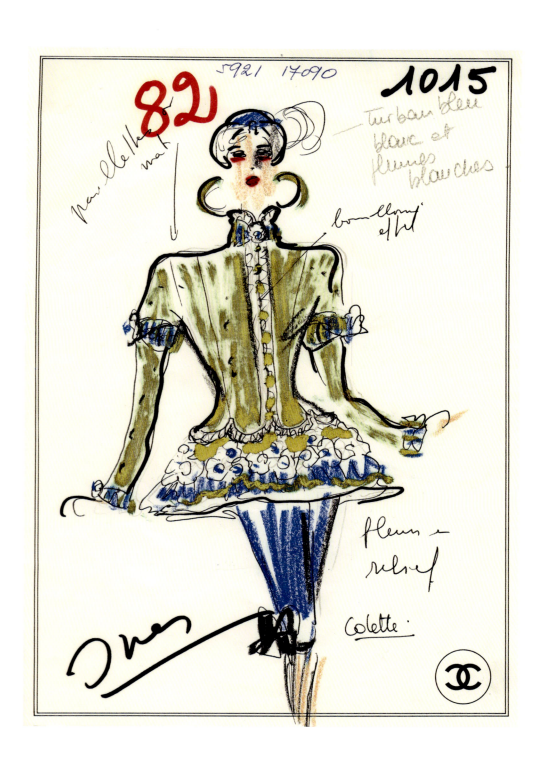

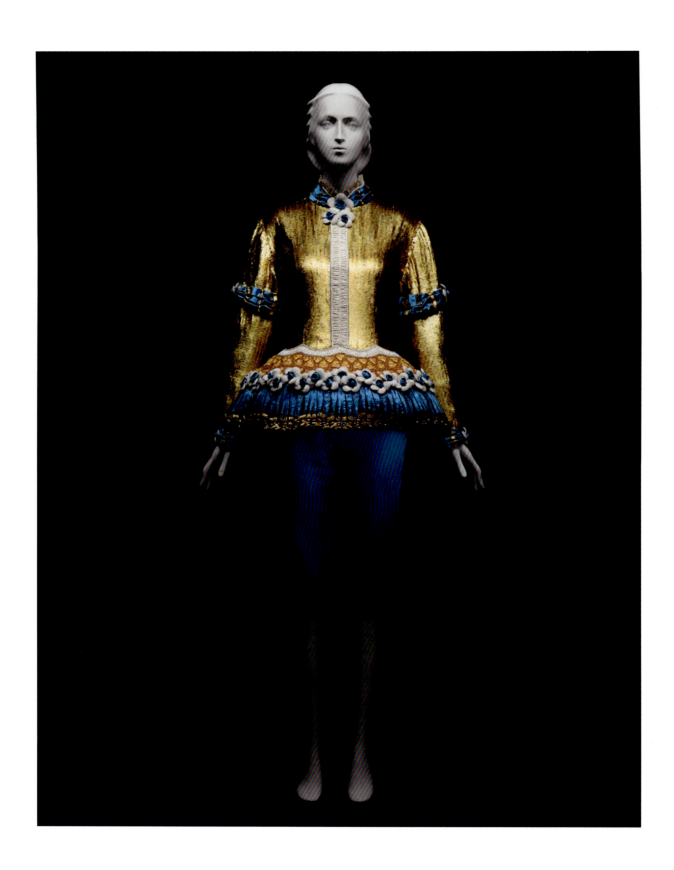

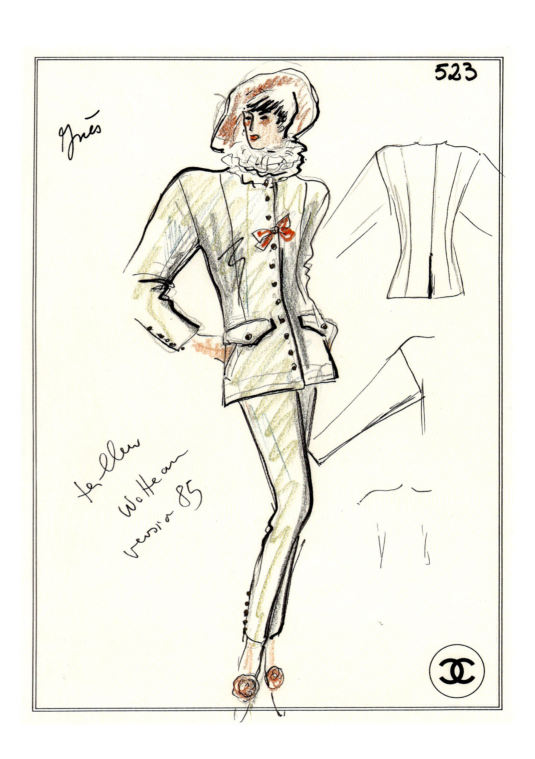

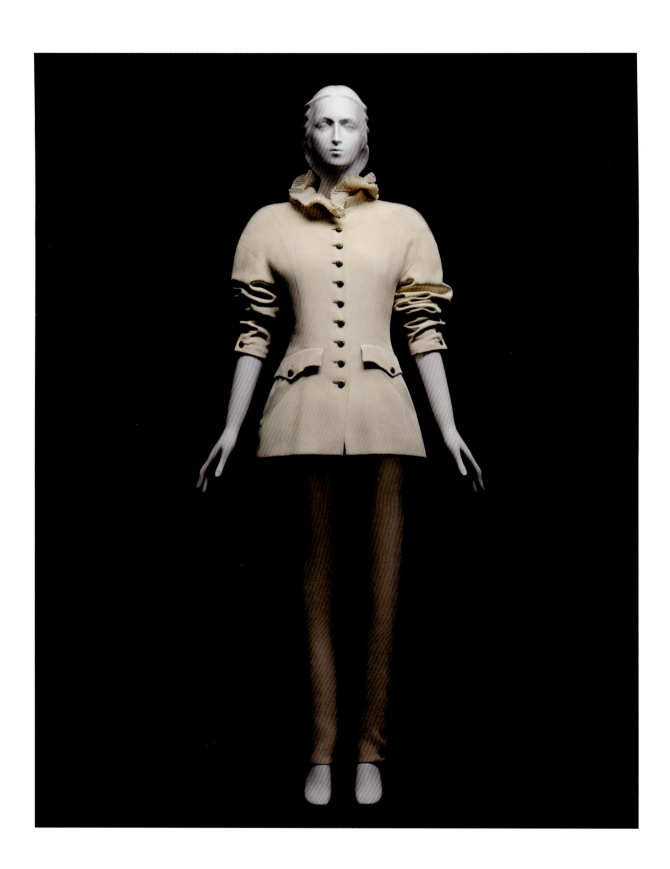

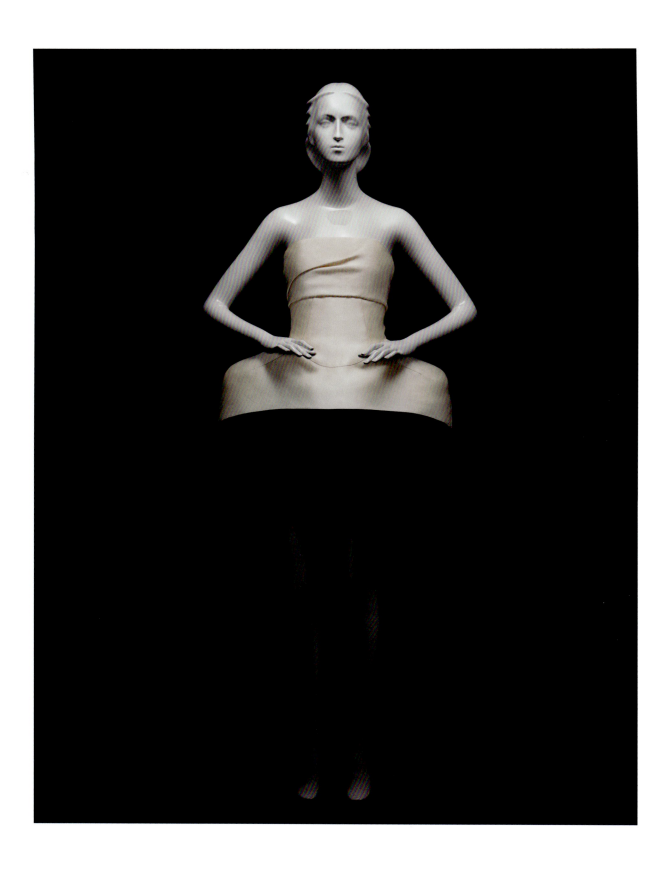

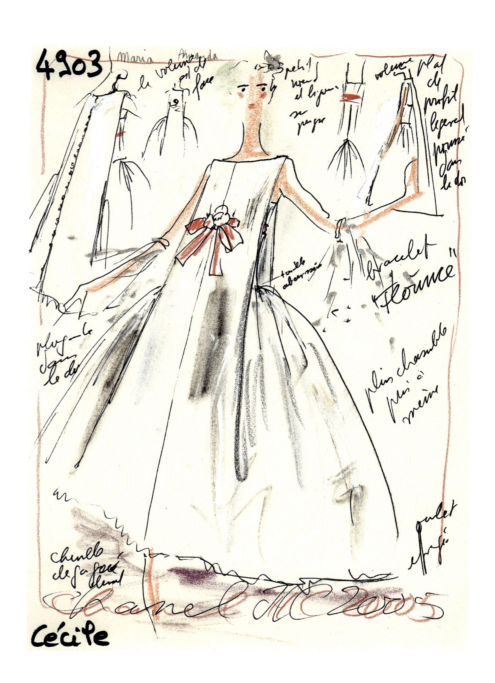

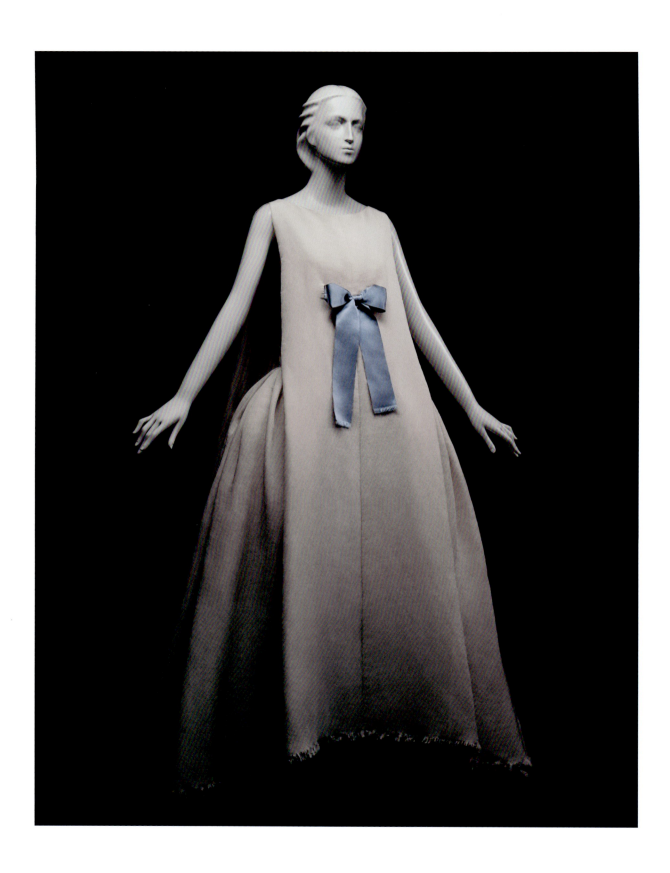

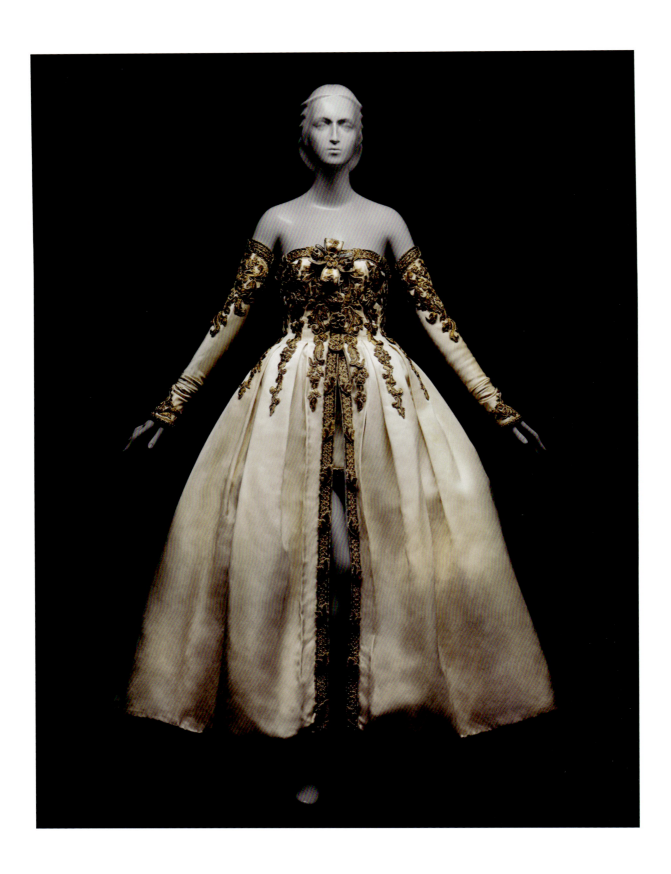

84 House of CHANEL (French, founded 1910). *"Biondello" ensemble*, autumn/winter 1988–89 haute couture. Jacket of black silk velvet and white silk satin appliquéd with white silk satin and embroidered with gold silk-and-metal thread, gold polymer strips, ivory simulated seed pearls, polychrome crystals, and black seed beads; skirt of black silk satin; necklaces of simulated pearls, gold metal, and gold metal CHANEL logo pendant

85 *Sketch of CHANEL "Thurio" ensemble*, autumn/winter 1988–89 haute couture

86 House of CHANEL. *"Thurio" ensemble*, autumn/winter 1988–89 haute couture. Jacket of black silk velvet and white silk satin embroidered with gold bugle beads, gold metal seed beads, gold

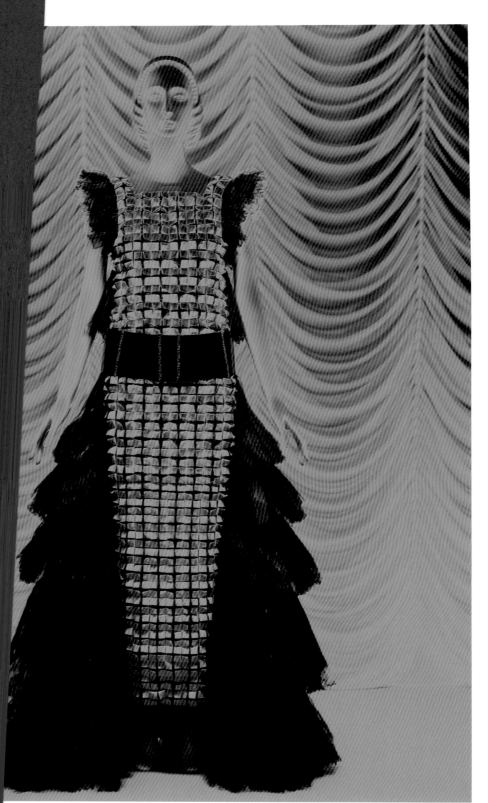

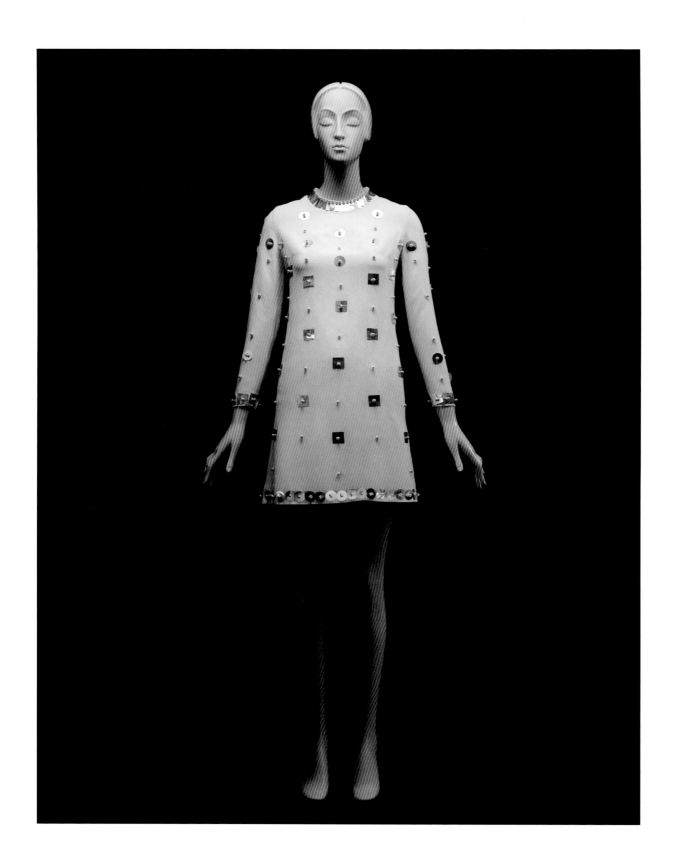

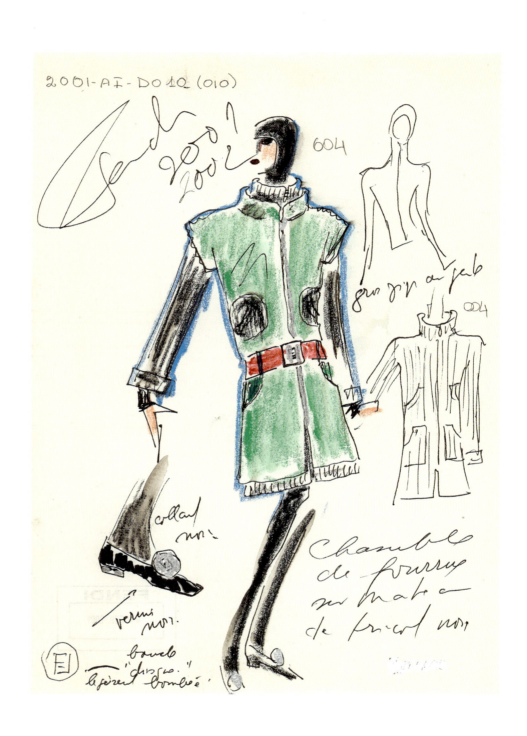

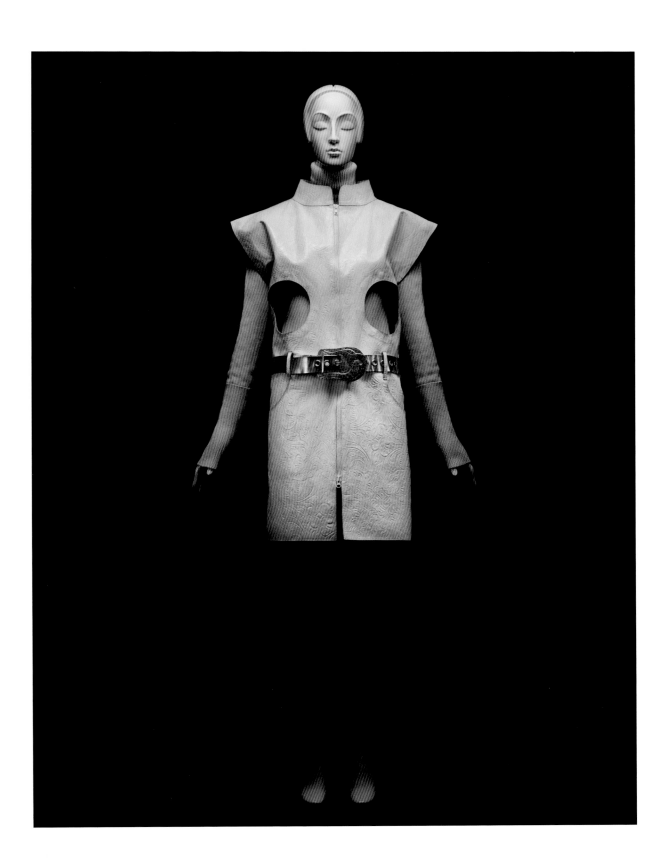

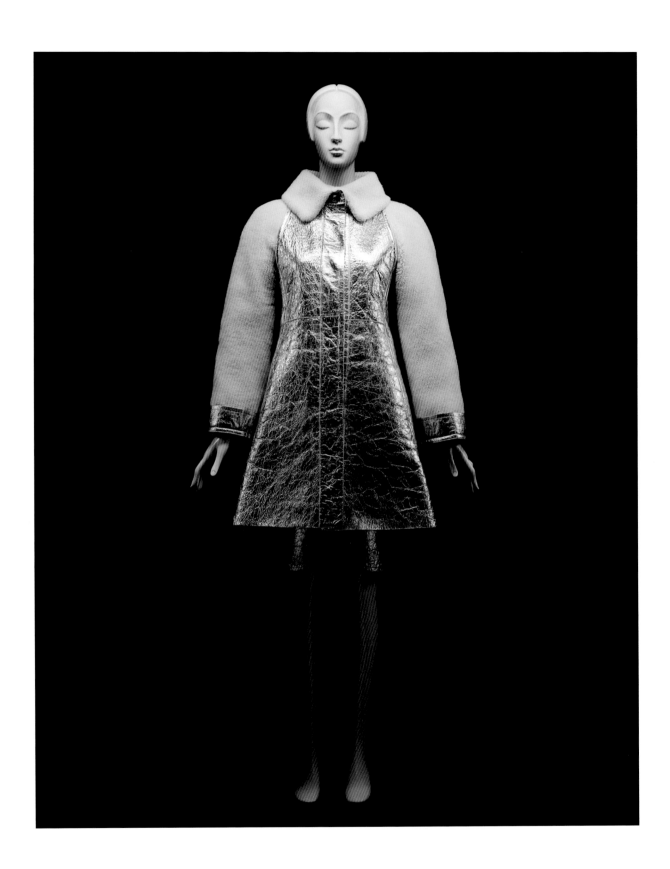

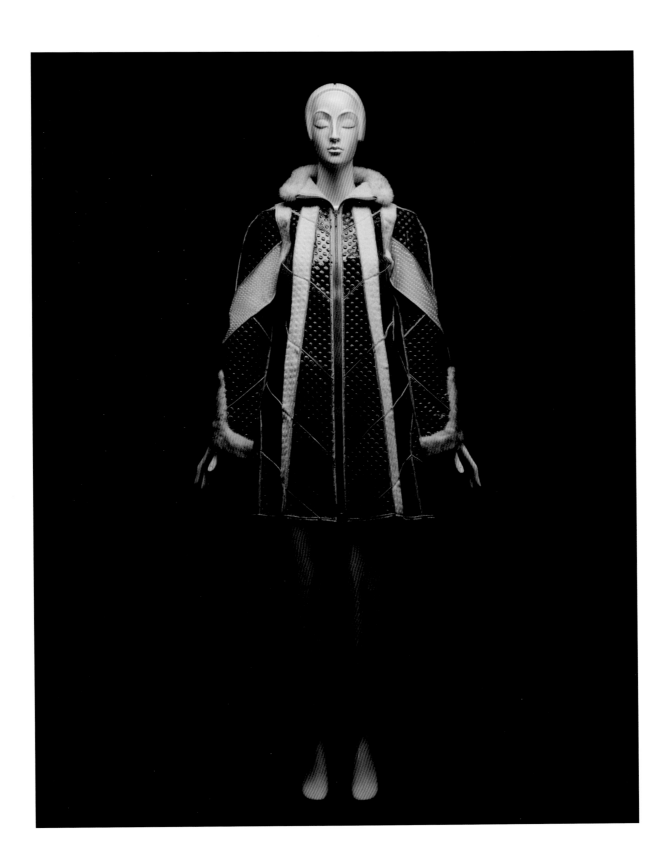

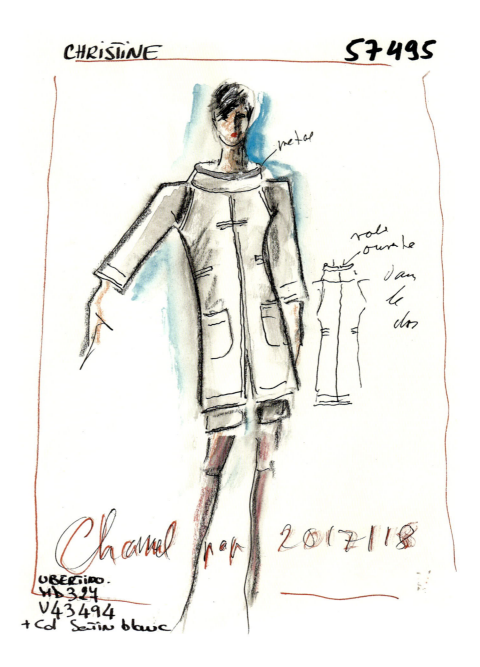

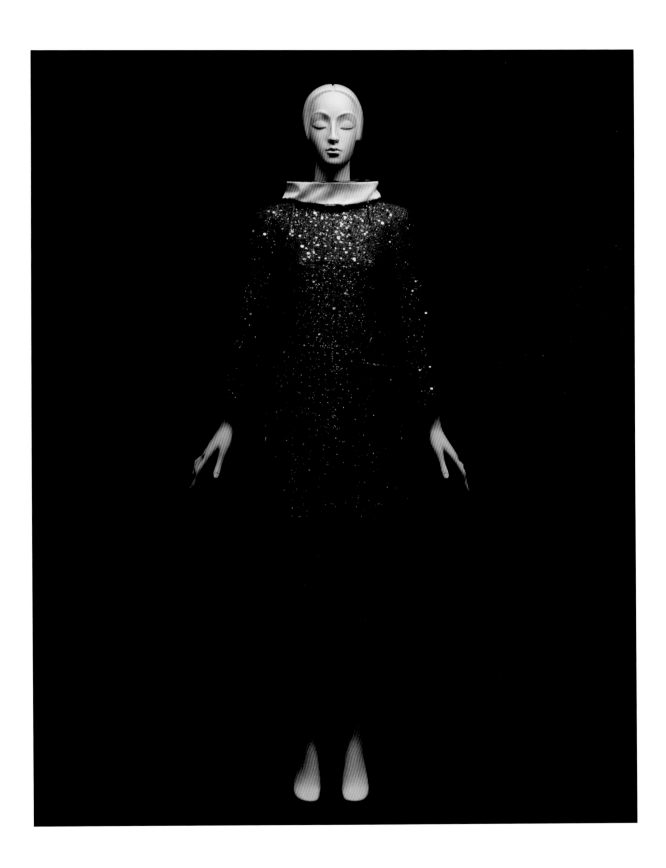

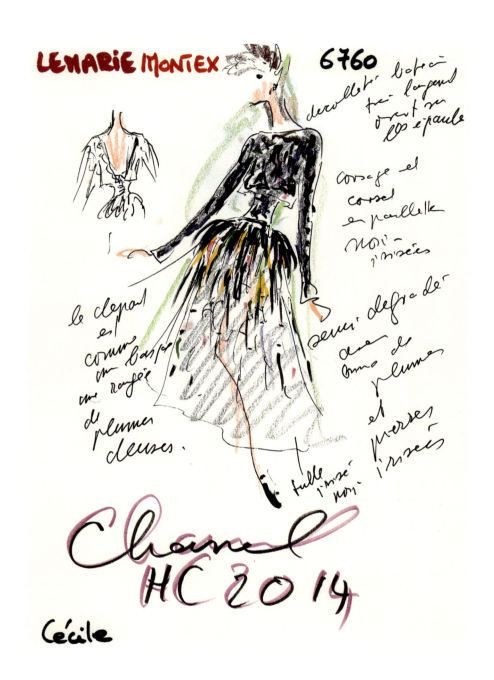

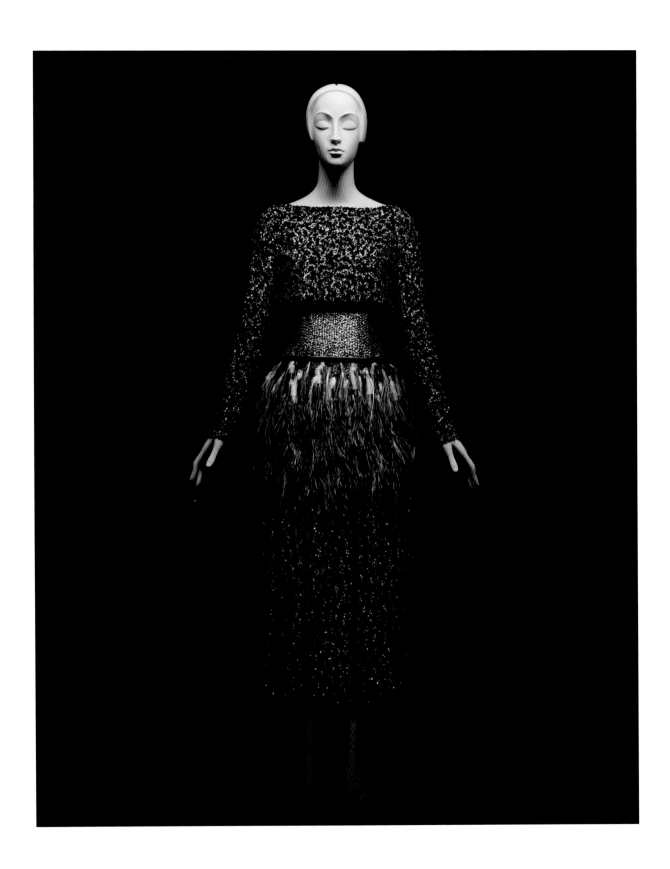

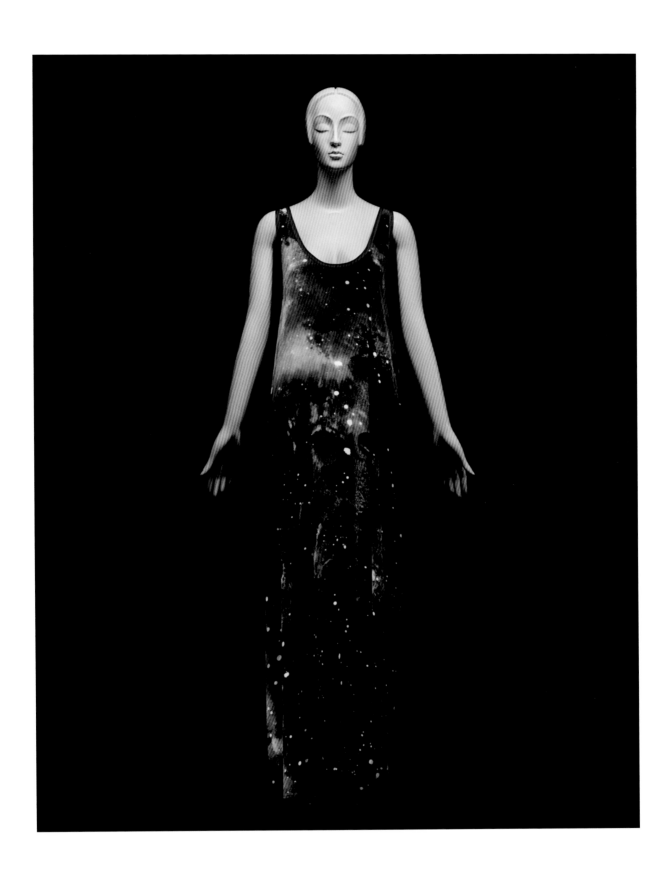

V

ORNAMENTAL LINE

STRUCTURAL LINE

Not unlike Jacques Doucet, the great couturier of the belle epoque, Karl Lagerfeld was a consummate connoisseur. His collecting practices were as eclectic as his fashion inspirations and ranged from Art Deco to Memphis, from Biedermeier to the Wiener Werkstätte. The designer's greatest affinity, however, was for the arts of the eighteenth century, which he took as a leitmotif of *l'art de vivre*. This passion began at the young age of seven after he saw a copy of Adolph Menzel's painting *Voltaire in the Court of Frederick II of Prussia at Sanssouci* (1850; see p. 32, fig. 21), which he implored his parents to purchase for him as a Christmas present. In an interview with Bertrand du Vignaud in 2000, Lagerfeld described the moment as a coup de foudre: "I decided on the spot that this scene of elegance and refinement showed life as it deserved to be lived; a sort of ideal in fact, which from then on I sought to attain."

For Lagerfeld it was the style of Louis XV—which he regarded as the epitome of elegance and restraint—that incited and impelled his connoisseurship. This vertu spilled over into his fashions, evident in the garments in the "ornamental line," which begins with a dress from Fendi's spring/summer 2017 collection (pl. 109) that is printed with a pattern Lagerfeld described as "modern rococo": a pastiche of the painter Jean-Baptiste Pillement's feathery and fanciful designs (etched a la poupee by Anne Allen) filtered through the rococo fantasies of the Ballets Russes. The dress's silhouette references the eighteenth-century-inspired robe de style of the 1920s, the panniers of which Lagerfeld has collapsed to create an apron-like effect. The robe de style was a silhouette that he returned to frequently, as reflected in the ensemble from Chanel's spring/summer 1993 haute couture collection (pl. 111). It comprises a pink silk crinkle chiffon underdress and an overdress of clear plastic artfully painted and embroidered by Maison Lesage with a foliate and scrolling pattern, requiring 800 hours of work. The pattern resembles eighteenth-century Lyons silk designs used for upholstery and wall hangings, as seen in the Billiard Room of Marie-Antoinette in the Palace of Versailles (see p. 32, fig. 22).

Lagerfeld's well-furnished imagination is particularly demonstrable in Chanel's autumn/winter 2010–11 haute couture collection, which features hand-embroidered pieces that *British Vogue* described as "carrying all the details of a Fabergé egg" (July 7, 2010). A highlight of the collection is the ensemble (pl. 115) designed to resemble an eighteenth-century Meissen plate decorated with an intricate pierced border known as the *Brühlsche-Allerlei*, or "Brühl mixed" pattern (see p. 32, fig. 23). It comprises a knee-length white organza dress embroidered to resemble the plate's openwork rim, and a short-sleeved white organza bolero embroidered with three-dimensional painted Rhodoid flowers to replicate the painted floral sprays of the plate's central well. The embroidery was executed by Maison Montex and required 995 hours of handwork. Montex also created the flowers that bloom on the 1950s-style, bell-shaped crinoline dress from Chanel's spring/summer 2019 haute couture collection (pl. 117), entirely embroidered with pale green sequins in the Lunéville crochet technique. Inspired by ceramic flowers produced by Vincennes in the mid-eighteenth century that Lagerfeld had seen in the exhibition *La Fabrique du luxe: Les marchands merciers parisiens au XVIIIe siècle* at the Musée Cognacq-Jay (September 29, 2018–January 27, 2019) (see p. 32, fig. 24), each flower petal is cut from foam or molded in ceramic powder and then hand painted and enameled. In total, the dress entailed 1,650 hours of workmanship: 250 hours by the atelier *flou* and 1,400 hours by Maison Montex.

The collection, the mood of which *WWD* (January 23, 2019) described as "celebratory" and an "embrace of joyfulness," also includes the ensemble (pl. 119) comprising a jacket whose intricate embroidery was inspired by a mid-eighteenth-century blue-and-white lacquered corner cabinet from Madame de Mailly's Blue Room at Château de Choisy (see p. 33, fig. 25). A tour de force of workmanship, equaling that of the skilled artisans represented in the exhibition *La Fabrique du luxe*, the embroidery was executed by Maison Lesage and required 400 hours of workmanship. The skirt is a no less complex accretion. Realized by Maison Lemarié

and necessitating 46 hours of work, it comprises shaved ostrich feathers—their filaments stripped and dyed white and blue—that have been applied individually to the silk ground, creating an animated field as soft and dense as swansdown. Concluding the ornamental line is a dress from Chanel's spring/summer 1984 haute couture collection (pl. 121) inspired by a hexagonal blue-and-white porcelain vase from the Qianlong period (1736–95; see p. 33, fig. 26). Entirely embroidered in crystal beads with rococo-style flowers by Maison Lesage that entailed 1,800 hours of work, the dress was described by Lagerfeld as being "straight out of a portrait by Sargent," as noted in a January 23, 1984, *WWD* article.

The "structural line" features a series of tailored suits and coats from Lagerfeld's Chanel collections that reveal a fundamental difference between the designer and the founder of the house. Whereas Gabrielle Chanel was chiefly interested in tailoring finishes, Lagerfeld was more concerned with tailoring construction. The garments also highlight two of the designer's anatomical obsessions: the shoulders and the side of the rib cage—that is, the serratus anterior, also known as the "boxer's muscle" or, as Lagerfeld referred to it, the *chute du foie*, which literally translates to "fall of the liver." The "structural line" begins with a tweed suit embroidered by Maison Montex with beads, sequins, and crystals from Chanel's spring/summer 2017 haute couture collection (pl. 124), the silhouette of which references Alberto Giacometti's *Spoon Woman* (1926–27; see p. 33, fig. 27), a life-size sculpture inspired by a type of anthropomorphic ceremonial spoon of the West African Dan people. Lagerfeld approximates Giacometti's totemic silhouette with its emphatic frontality by raising the waist of the trompe l'oeil, peplumed jacket and cinching it with a silver belt, and by molding the hips of the tapered high-waisted tulip skirt with internal crinoline. To evoke the formal simplicity of the small blocks that define the sculpture's head and torso, Lagerfeld extends Chanel's signature decorative braiding from the pockets to the chest and shoulders.

For the suit from Chanel's spring/summer 2016 haute couture collection (pl. 126), Lagerfeld inverts his "spoon" silhouette by rounding and widening the shoulders with voluminous, oval sleeves that fall just below the elbow, and by narrowing the hips with a straight-cut, mid-calf-length pencil skirt with a back slit, accessorized with a belted "phone-friendly" pouch that the designer described for *Chanel News* as Chanel's "new bag . . . , identical to those used by 15th century [*sic*] ladies of the manor to carry their keys." The shape of the sleeves is achieved with complex seaming trimmed with braiding, and the entire suit is elaborately embroidered by Maison Hurel with wood, raffia, and crystal, requiring 2,500 hours of workmanship and marrying form, function, and ornamentation. In stark contrast, the tweed suit (pl. 128) from Chanel's autumn/winter 2016–17 haute couture collection, titled "Graphic Cuts," is a study in angularity. The jacket's shoulders are extended and flattened into two dimensions without any internal padding, the effect achieved through a technique called *biseauté*—tucking or pleating at an angle to create a raised, beveled appearance. Reflecting Lagerfeld's profound understanding of proportions, the three-quarter-length sleeves are balanced by the seven-eighth turned-up hems of the wide culottes.

Just as both suits reveal Lagerfeld's fascination with the serratus anterior, so do the tailored tweed coats from Chanel's autumn/winter 2017–18 (pl. 134) and spring/summer 2018 (pl. 132) haute couture collections, which are closely fitted to the rib cage to convey what the designer felt was a sense of youthfulness. The latter features the "faceted shoulder," constructed with multiple seams and outlined with braiding to create a prism shape with little internal structure. A similar technique is employed in the coat from Chanel's autumn/winter 2017–18 collection, resulting in an emphatically arced shoulder line that is almost semicircular in silhouette (see p. 33, fig. 28). The collection, which Lagerfeld imagined as a love letter to Paris, was shown against a backdrop of a thirty-eight-meter-high model of the Eiffel Tower that disappeared into a cloud of dry ice under the glass dome of the Grand Palais in Paris. It was a gesture intended to draw attention to the structural complexity of Lagerfeld's impeccable tailoring, a declarative statement loudly pronounced in the tweed suit with tromp l'oeil sleeves constructed to resemble upturned Eiffel Towers and suggestive of the cornucopia or horn of plenty of classical antiquity.

Lagerfeld's ornamental and structural compulsions coalesce in the "explosion" coat from Chanel's autumn/winter 2014–15 haute couture collection (pl. 122), which the designer described as "Le Corbusier goes to Versailles." The shape of the coat—straight, right-angled shoulders, narrow rib cage, and voluminous bell-shaped skirt—reflects the clean lines and stark geometry of Corbusier's modernist architecture. By contrast, the decoration—featuring embroidery by Maison Lesage at the chest, arms, and back in the style of a trompe l'oeil bolero, requiring 450 hours of work—recalls the Baroque interiors of Louis XV's gilded residence. The coat is made from scuba knit that has been molded rather than seamed via a technique that Lagerfeld referred to as "Haute Couture without the Couture," another twist on the Baroque-Brutalist coupling. In a 2016 interview published in the exhibition catalogue *Manus x Machina: Fashion in an Age of Technology*, Lagerfeld explained the technique as it applies to the wedding dress that closed the Chanel autumn/winter 2014–15 haute couture show: "It does have seams, but very minimal ones compared to traditional couture dresses . . . The fabric was worked over a construction, and then the construction was removed afterward. So the dress is a kind of sculpture."

ORNAMENTAL LINE

109 111 113 115 117 119 121

STRUCTURAL LINE

124 126 128 130 132 134 136

EXPLOSION

122

SKETCHES

108 110 112 114 116 118 120

123 125 127 129 131 133 135

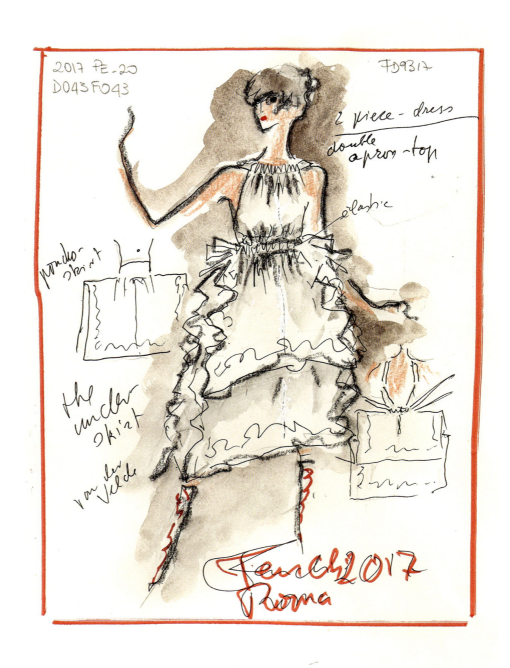

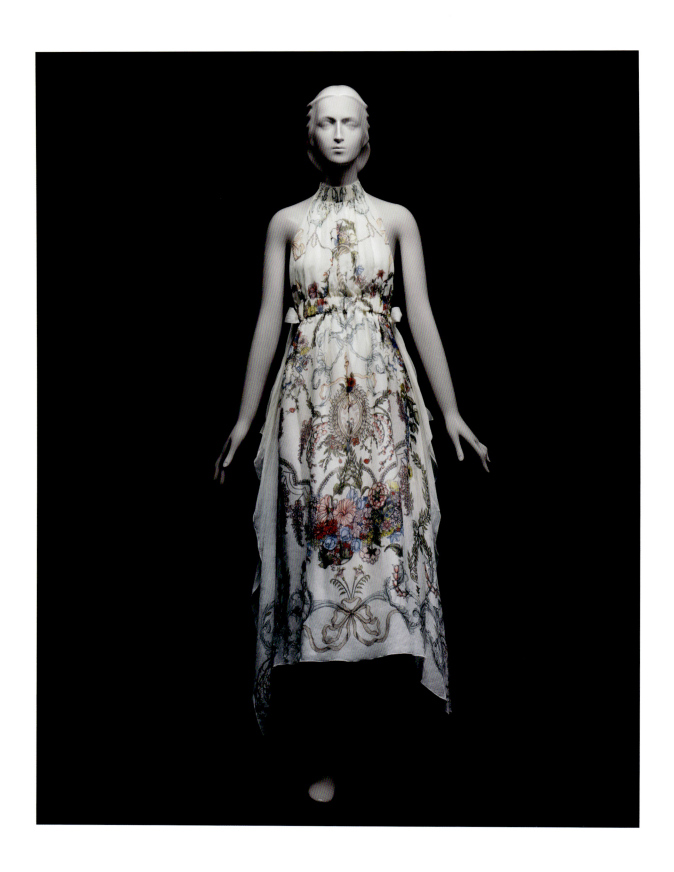

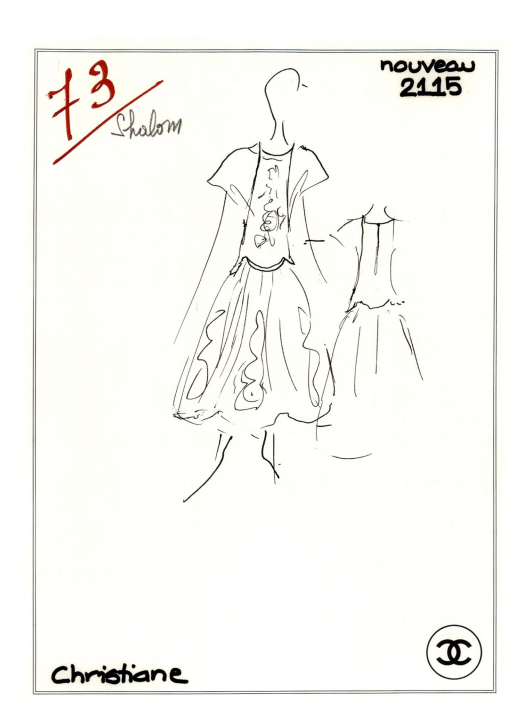

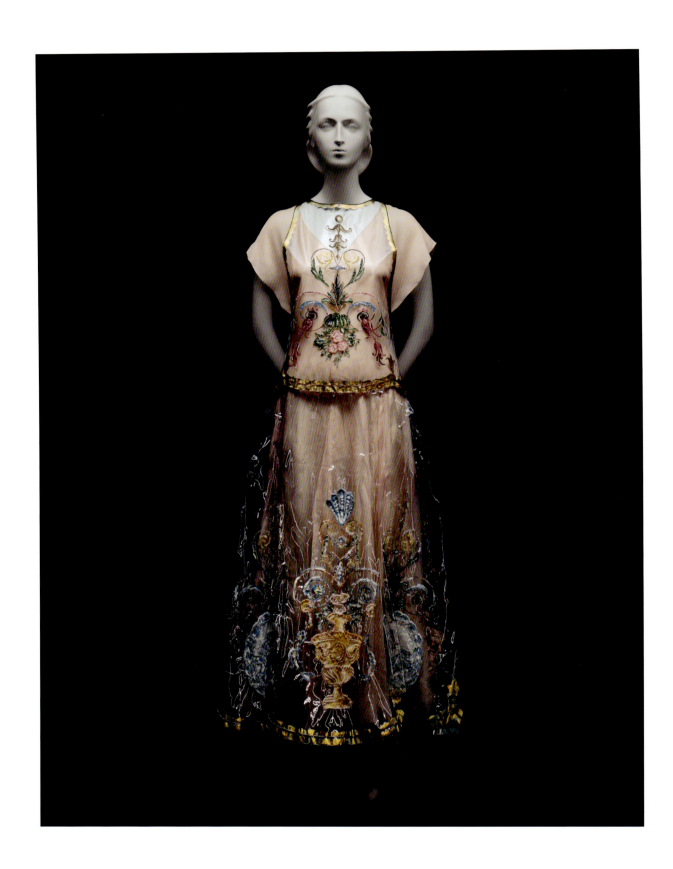

III

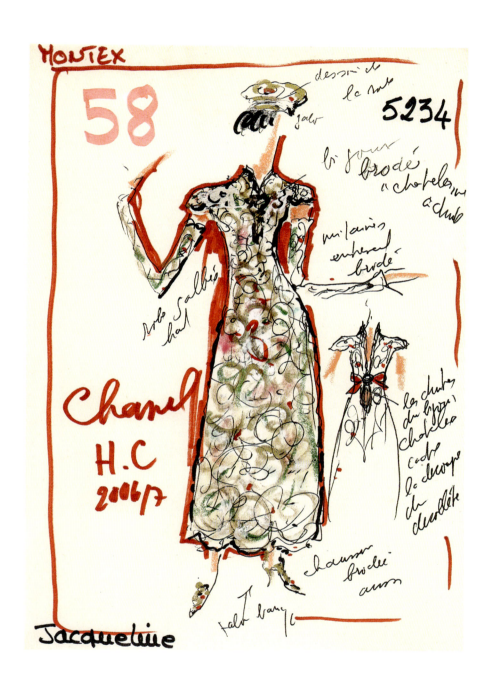

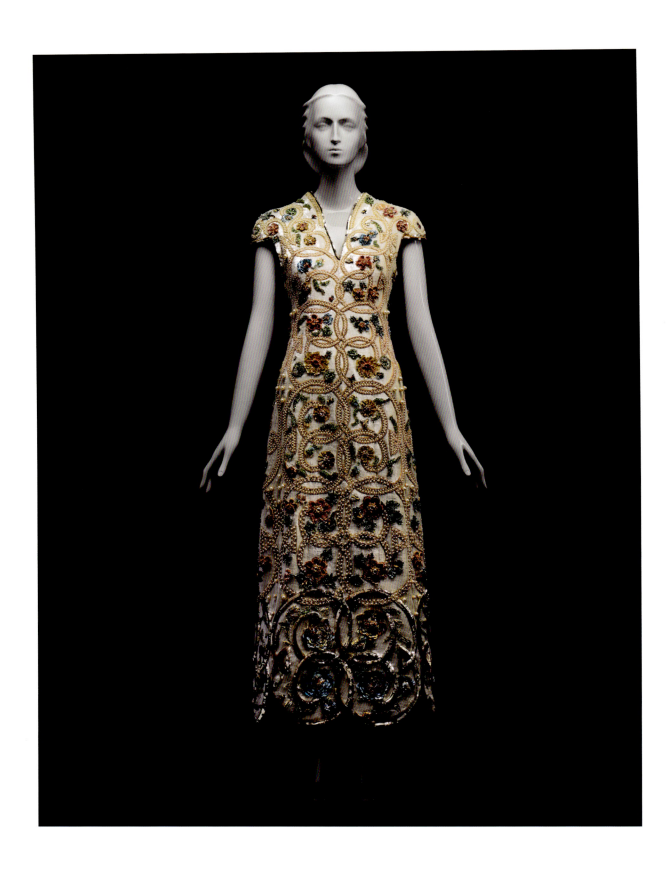

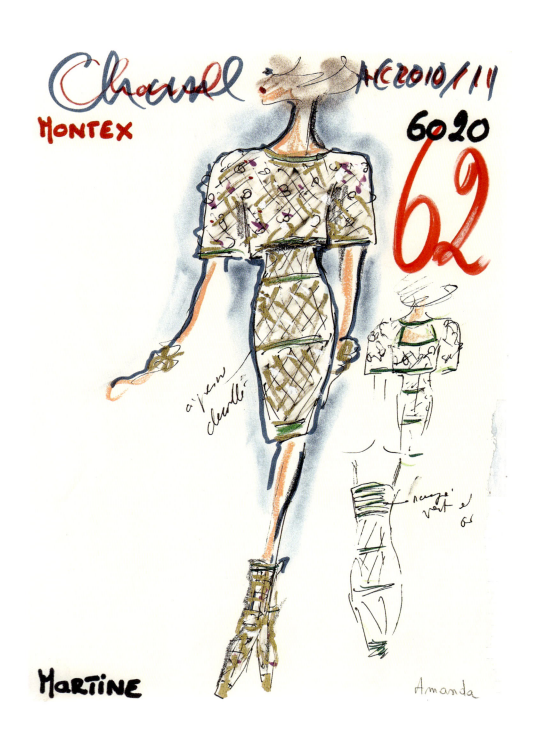

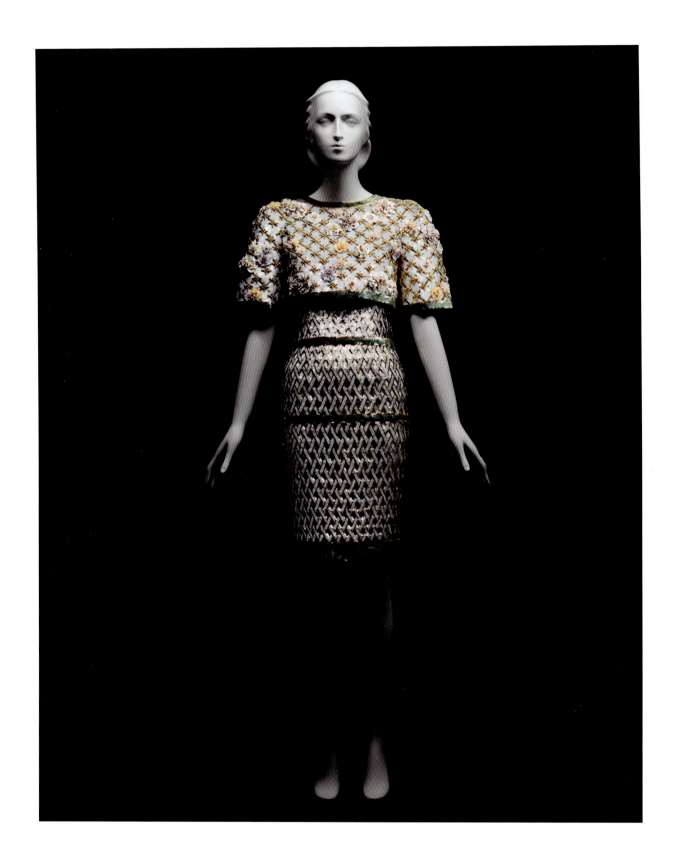

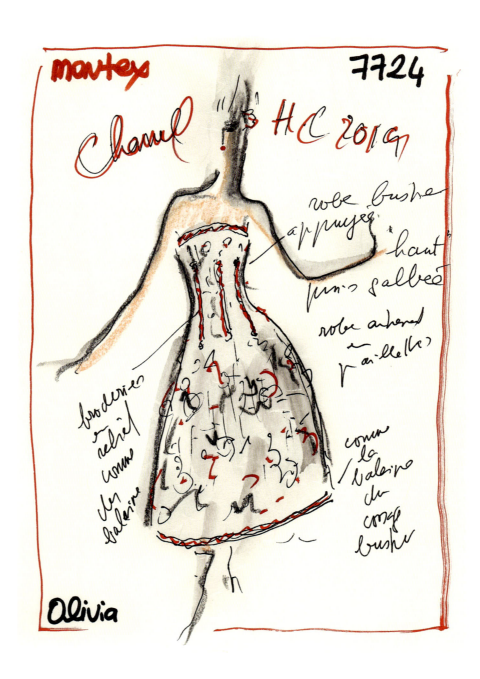

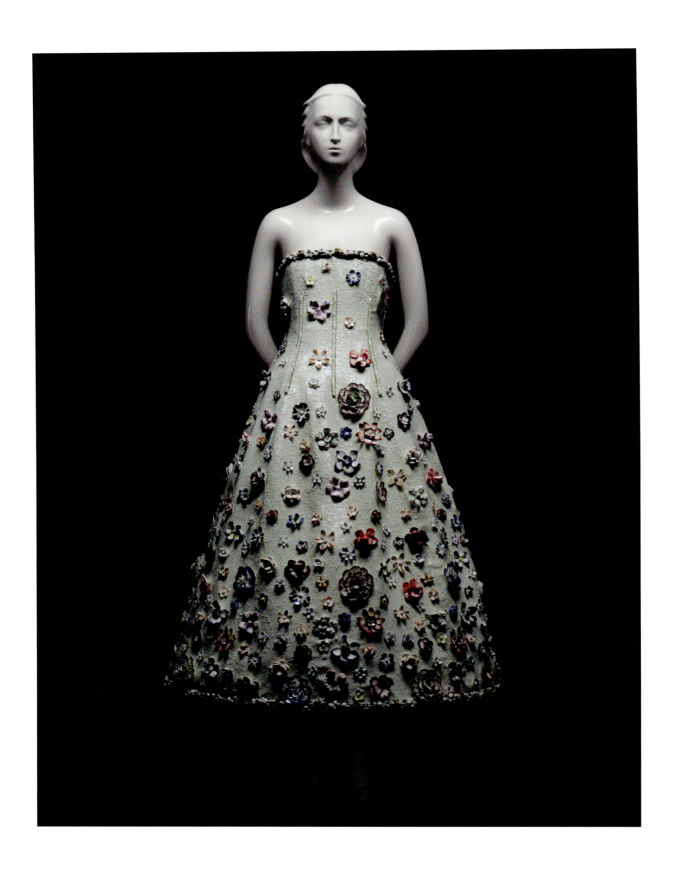

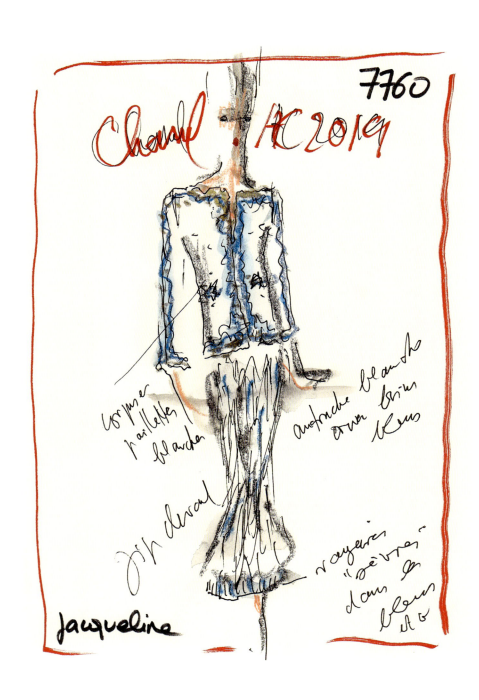

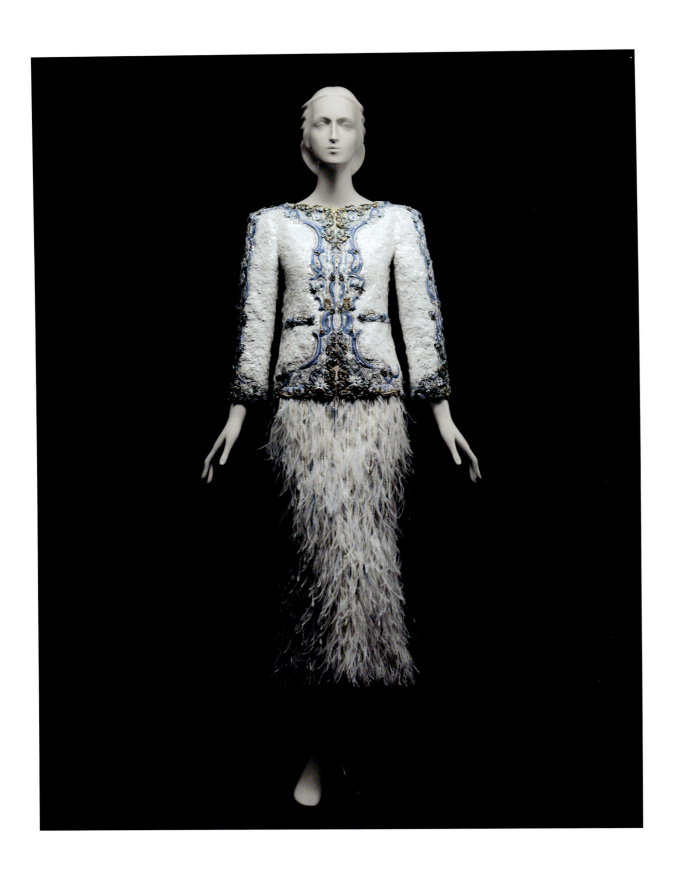

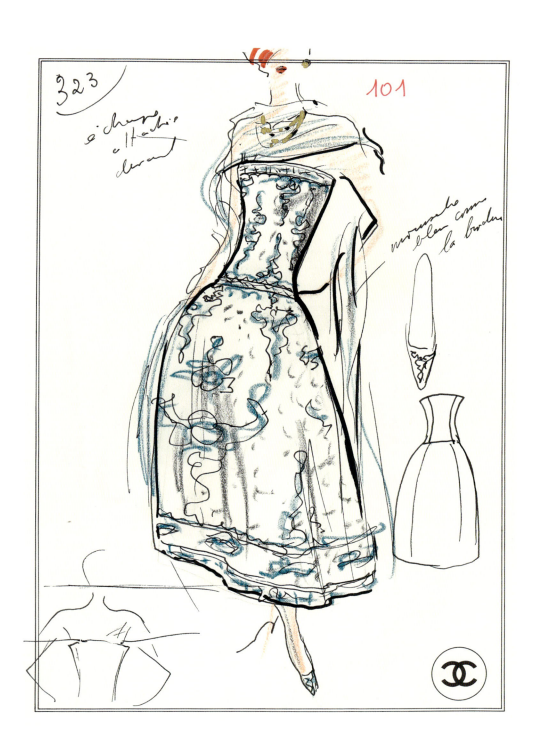

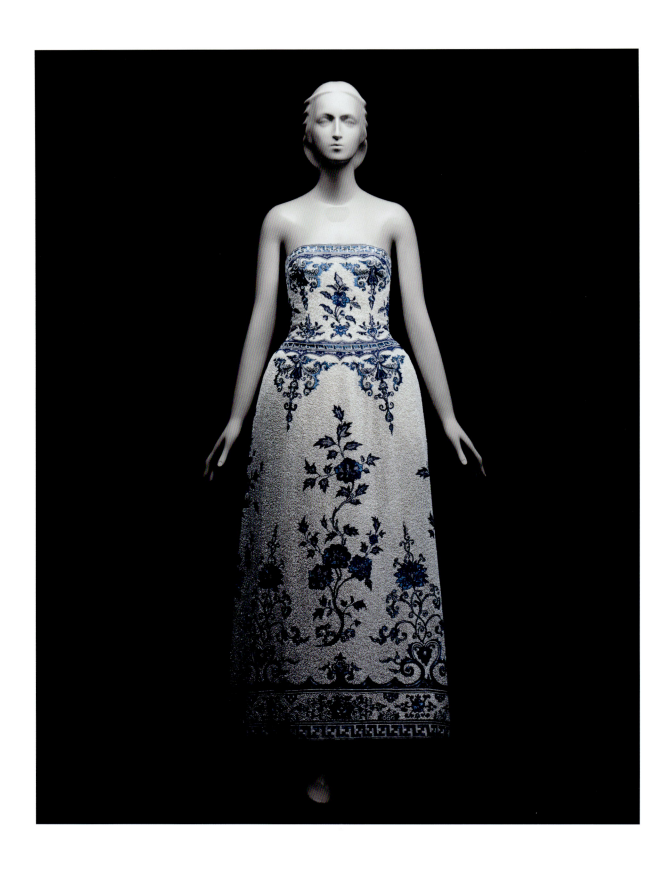

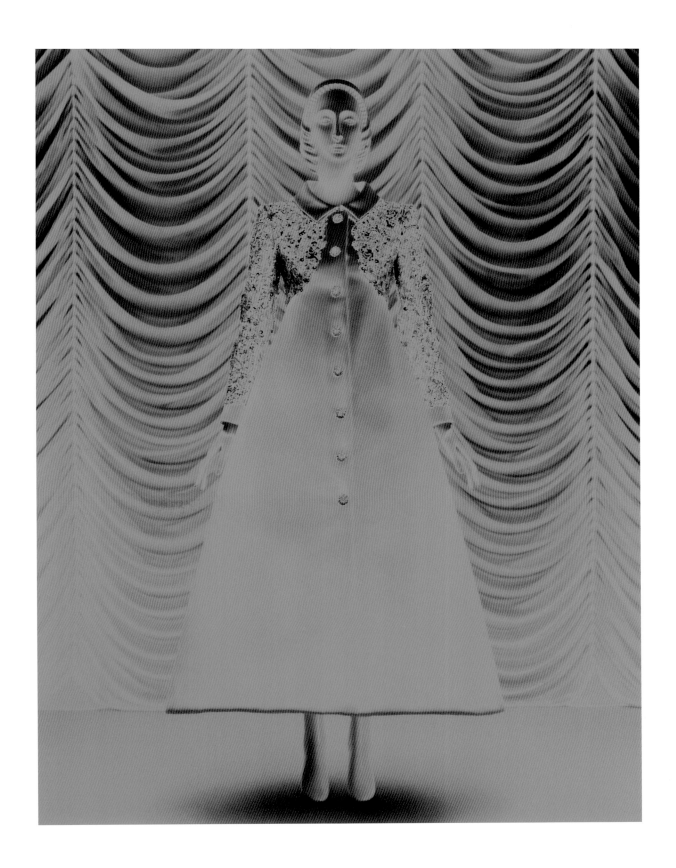

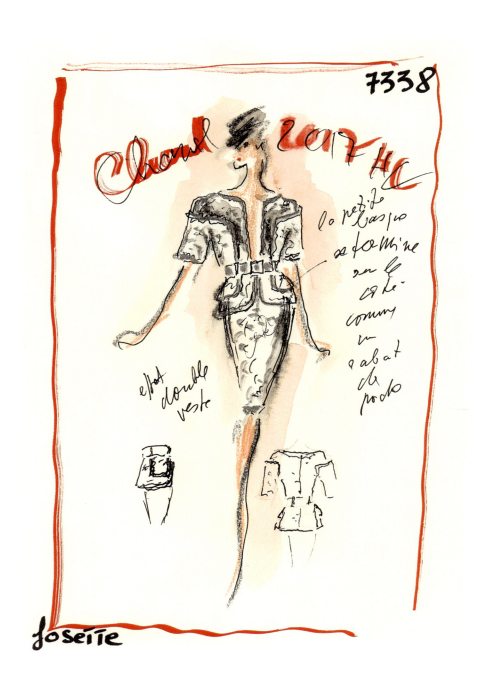

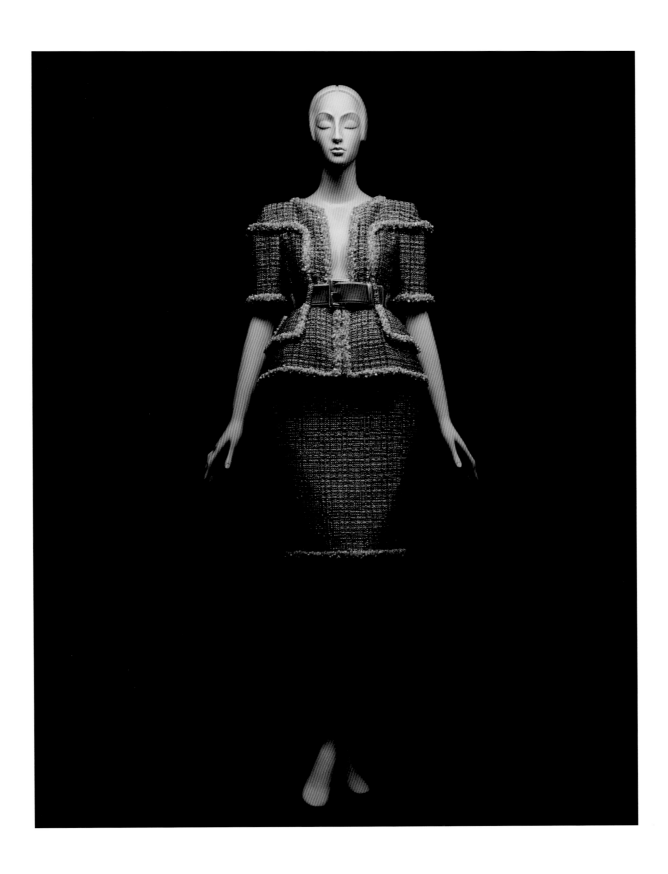

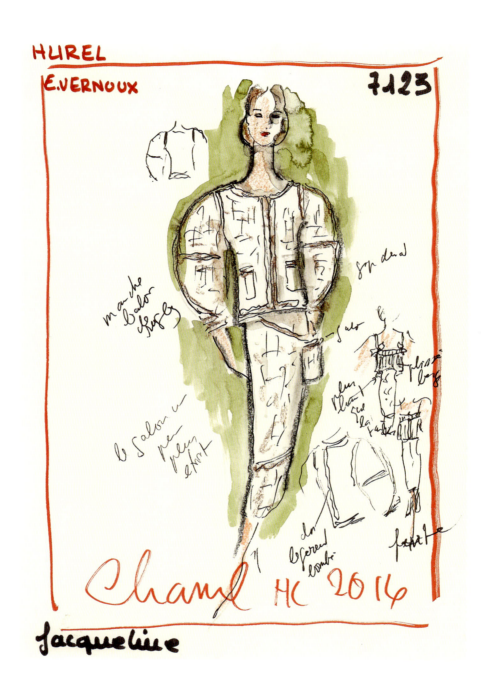

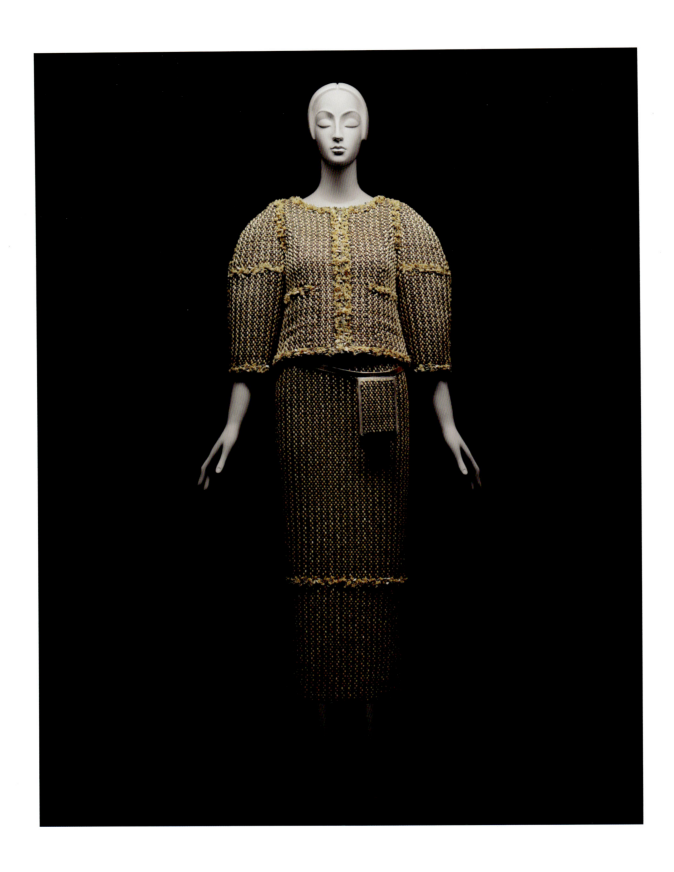

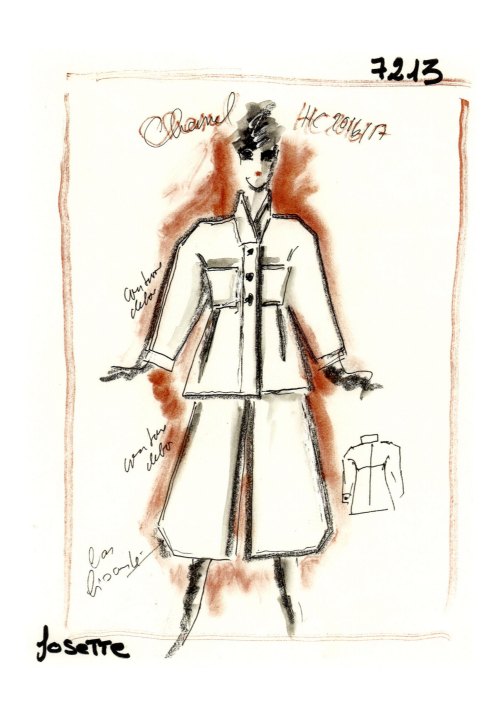

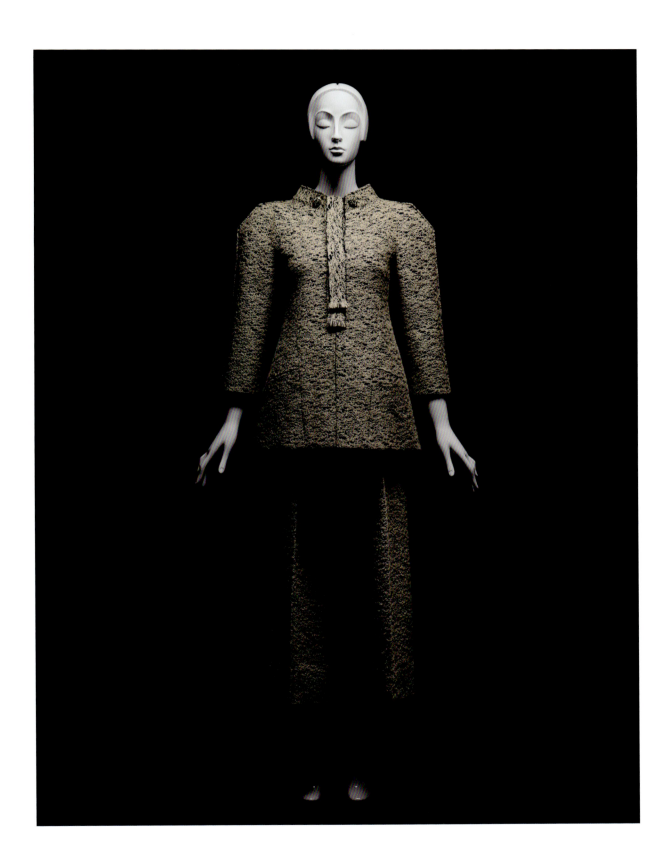

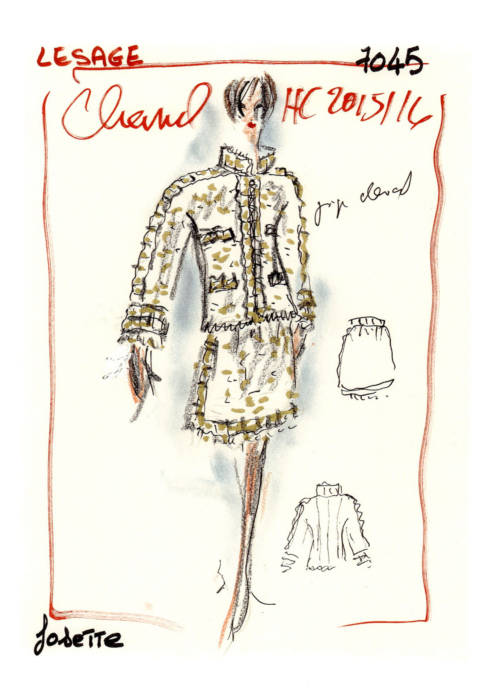

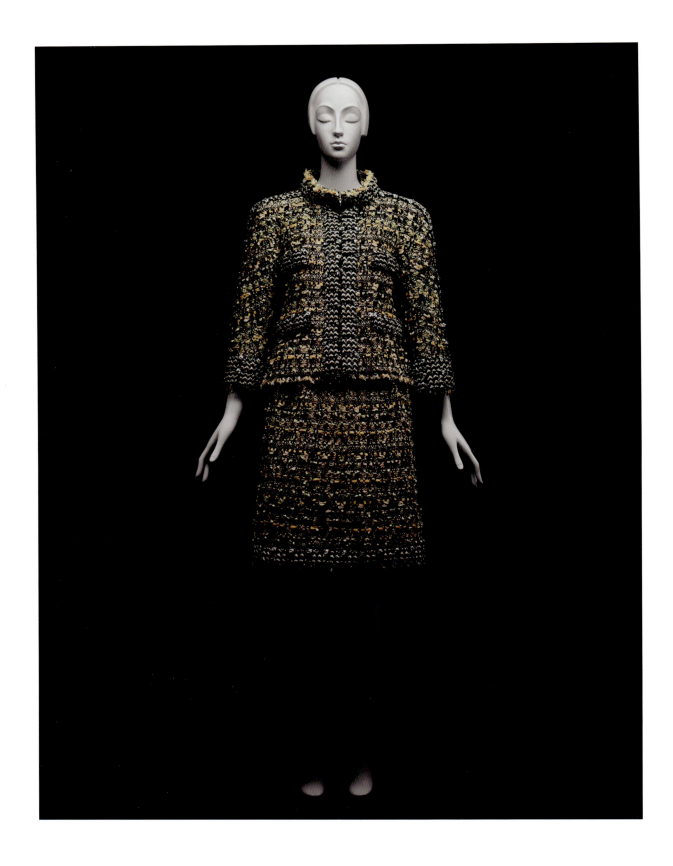

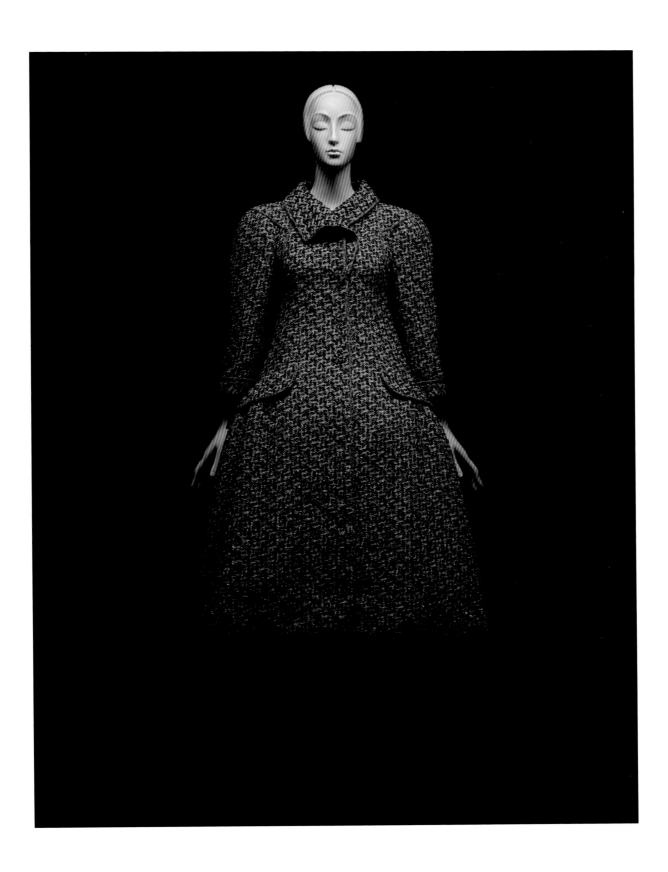

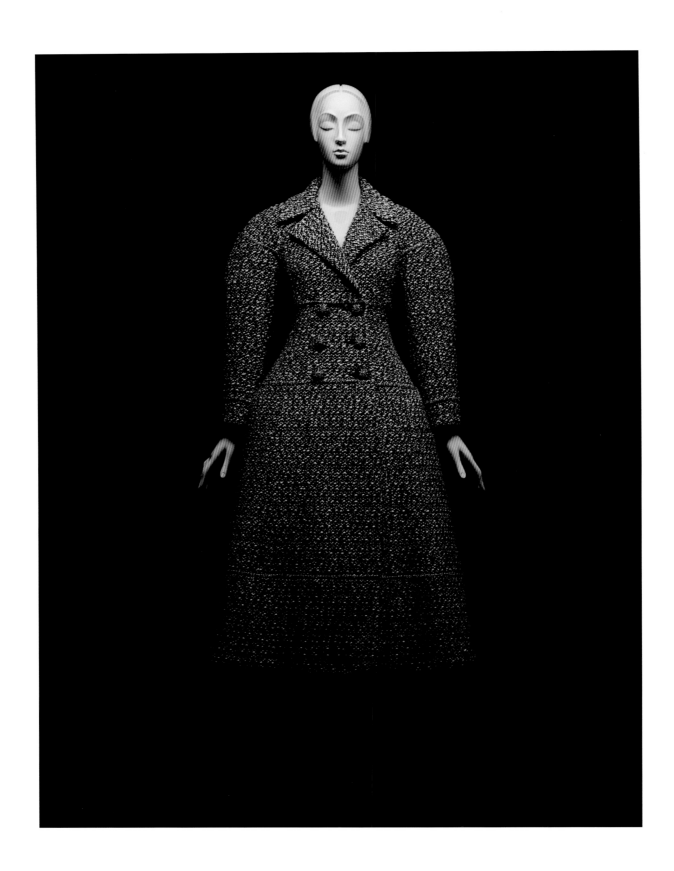

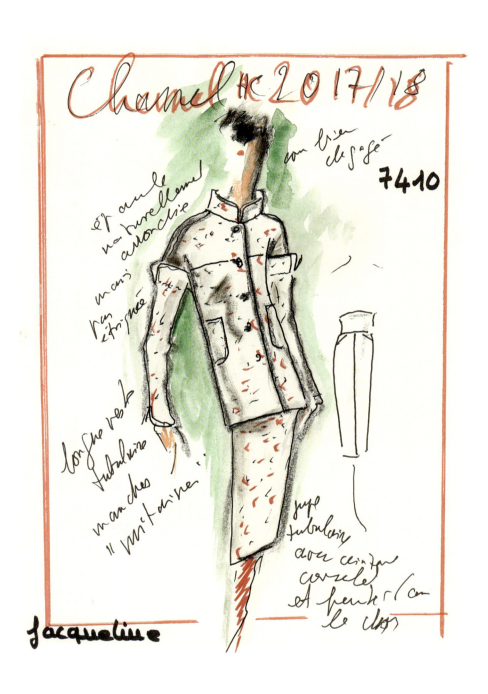

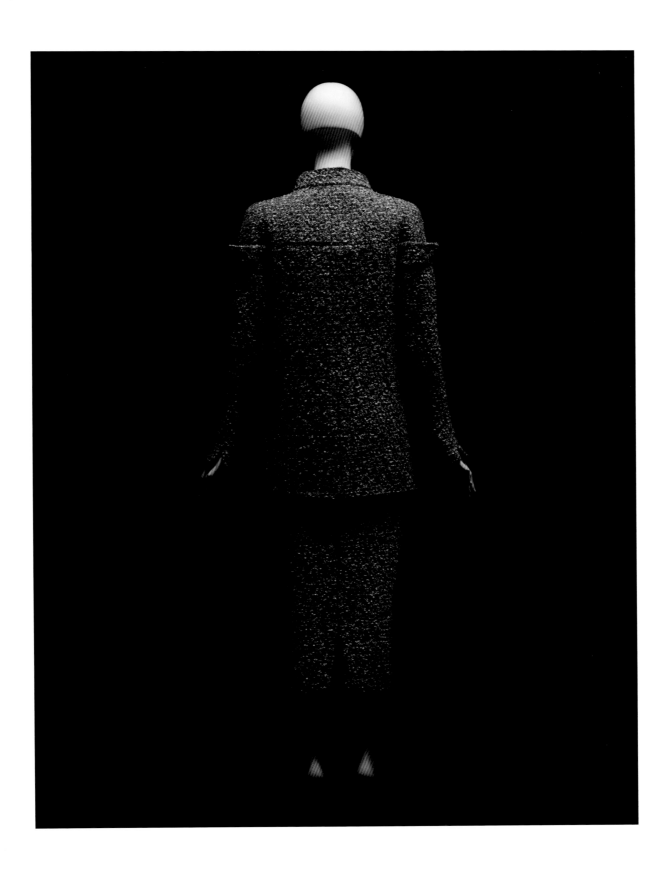

One of Karl Lagerfeld's most enduring and distinctive stylistic interests was the postmodern combination of the traditional proprieties of the couture with the transgressive provocations of the edgiest and wildest street styles. This gleeful confrontation between the salon and the street, good taste and bad taste, high culture and low culture, conformity and nonconformity, and the establishment and the antiestablishment is exemplified in the "explosion" ensemble from Chanel's autumn/winter 1991–92 collection (pl. 150) that Lagerfeld described as "nouveau rapper" and that reflects his belief that modern dressing means a "complete rethinking of the established standards" (American *Vogue*, July 1, 1991). It comprises an eclectic mash-up of a black quilted leather bomber jacket paired with a 1950s-style pink silk taffeta ball gown with a ruched sweetheart neckline and a petal-shaped bouffant skirt, and accessorized with motorcycle boots and a belt with a weightlifter buckle—borrowed from biker and hip-hop styles, respectively, with hints of Madonna's 1980s "Like a Virgin" phase in the layers of oversize gilt-chain belts and necklaces. These overt street-style references were amplified in the now-iconic and gritty editorial "Wild at Heart" in the September 1991 issue of American *Vogue* (see p. 33, fig. 29). Photographed by Peter Lindbergh and styled by Grace Coddington, the editorial features Claudia Schiffer wearing the "explosion" ensemble and five other supermodels dressed in similar versions from the collection, all posing with beat-up, overturned oil drums and Triumph motorbikes in the then-barren, rat-infested back streets beneath the Manhattan Bridge, the caption reading, "*On the Waterfront* rough but romantic styles."

The pieces in the "canonical line/countercultural line" represent the dueling stylistic forces at play in Lagerfeld's "explosion" ensemble. Simultaneously asserting and enhancing their refined elegance, all of the garments in the "canonical line" were shown in the rarefied context of a salon, with its ambience of wealth and status, privilege and power, and privacy and exclusivity. Presented to a crowd that was "as social as a theater premiere," according to the *International Herald Tribune*, the dress from Chanel's autumn/winter 1984–85 haute couture collection (pl. 138), for example, was shown in the Grand Foyer of the Opéra Garnier, a hall originally designed to serve as a drawing room for the Parisian beau monde and that features an elaborate vaulted ceiling painted by Paul-Jacques-Aimé Baudry. An ascetic, almost monastic, long-sleeved, high-necked, floor-length black silk velvet column, the dress belies its modest silhouette but befits its majestic surroundings owing to its embroidered trompe l'oeil crystal ceremonial sash and red silk cockade, bringing to mind the highest and noblest of royal orders.

Following in the footsteps of Gabrielle Chanel, Lagerfeld's spring/summer 1983 haute couture collection—his first for Chanel—was presented in the intimacy of the haute couture salons of 31, rue Cambon, with its iconic mirrored staircase. One of the highlights of the collection, worn by the house's exclusive and aristocratic model Inès de La Fressange, is a black silk crepe de chine dress adorned with trompe l'oeil jewelry—necklaces, bracelets, and belts—intricately embroidered by Maison Lesage with a mix of beads, pearls, and crystals that involved 600 hours of work (pl. 140). It was an act of deliberate irony that cited Gabrielle Chanel's personal and sardonic penchant for layering real and artificial jewelry, which in its day was a radical challenge to accepted notions of good taste and bad taste, as seen in a 1935 photograph by Man Ray (see p. 33, fig. 30). Lagerfeld's humorous extension of Chanel's advocacy of fake jewelry, however, has another stratum of deception: the necklace is, in fact, a halter that sustains the weight of the dress while allowing for a plunging back décolletage. Without it, the front of the dress, despite its covered appearance, would risk slipping and jeopardize the wearer's modesty.

Lagerfeld frequently presented his collections in the exalted setting of the Ritz Paris, where Chanel lived for thirty-four years—from 1937 until her death in 1971. His black satin dress from Chanel's autumn/winter 1996–97 haute couture collection (pl. 142) was shown in the Imperial and Windsor Suites, the latter named after the royal couple. Like that of the trompe l'oeil dress, its iconography is tiered and multivalent, acknowledging the rich historical narratives of the fashion house as well as the singular and inimitable self-presentation of its founder: executed by Maison Lesage and requiring 800 hours of

workmanship, the embroidered sleeves and pockets cite Byzantine- and Renaissance-inspired costume jewelry, with their assortment of faceted and cabochon semiprecious stones in a cacophony of colors produced by the *maisons* Gripoix and Goossens for Chanel; and the pockets reference Gabrielle Chanel's practice of plunging her hands into her pockets to achieve her trademark "debutante slouch."

The dress from Chanel's spring/summer 1996 haute couture collection (pl. 144), which was also shown at the Ritz Paris, is similarly imbued with memories of the house's founder. Reflective of her timeless modernity, the dress—made from gold lace and embroidered by Maison Lesage with gilt metal and polychrome paillettes, entailing 300 hours of work—is a facsimile of a gown worn by Chanel in a photograph taken by Cecil Beaton at the Ritz in 1937 (see p. 33, fig. 31). This simulacrum not only establishes a dynamic slip between the past and the present—between Chanel's modernity and Lagerfeld's postmodernity—but it also confirms, once and for all, Lagerfeld's interpretive succession to the house of Chanel. The ensemble from Chanel's autumn/winter 1996–97 haute couture collection (pl. 148) represents a simulation of a different kind: the coat is made from black organza applied with strips of silk tulle gathered, crocheted, and dyed (in ten different dye baths in a range of colors from brown to black) to resemble a mink fur coat, the erstwhile sartorial symbol of wealth and power. Lagerfeld's duplicity is calculated: his intention is to draw attention to the hidden value of the haute couture and to highlight the extraordinary and unparalleled workmanship of the métiers in service to the couture, in this case Maison Montex and the 250 hours spent on creating the illusion (the coat presaged Chanel's announcement in 2018 that it would stop using fur and exotic skins in its fashions and instead focus its research and development on textiles and leathers generated by agri-food industries). Despite the conspicuous value of the mink coat from Fendi's autumn/winter 2005–6 collection (pl. 149), its status as an object of luxury is similarly asserted—and ultimately assured—by its artisanry, specifically the technical innovation of piecing fur on the bias. Lagerfeld reverses the strategy he employs in the Chanel coat: rather than using fabric to imitate fur, he uses fur to imitate fabric.

Reflective of the institution of the haute couture, the "canonical line" represents the "trickle-across" movement of fashions moving horizontally between individuals of similar social and economic standing, while the "countercultural line" represents the "trickle-up" movement of fashion trends that start on the street and move upward into high fashion. Lagerfeld both reveled in and excelled at this reversal of fortune, this inversion of the socioeconomic order, particularly in his collections for Chanel. Sometimes his references to the street are general, focusing on specific items of dress symbolic of a universal sense of youthfulness, such as the miniskirts in the ensembles from Chanel's spring/summer 1994 and autumn/winter 1994–95 collections (pls. 152, 154)—micro-mini versions of the iconic Chanel suit. Effectively, they are seasonal variations of the same ensemble: the former rendered in lightweight wool bouclé; the latter, in synthetic faux fur. With its cropped jacket revealing the midriff, the latter also evokes the stereotypical "streetcorner" winter wardrobe of the prostitute, an avowal of Lagerfeld's promotion of a classless fashion, fueled by his belief that true style was not to be found in the haughty reiteration of social fashion but rather in the enlightenment of fashion ideas.

This conviction is one of the motivating factors behind Lagerfeld's countercultural inspirations—in addition to his desire to imbue his work with a frisson of streetstyle subversion and subcultural transgression. For Chanel's spring/summer 1991 collection (pl. 158), Lagerfeld references the casual, carefree, pleasure-loving surfer subculture famously described in Tom Wolfe's 1968 essay "The Pump House Gang." Suggestive of a neoprene wetsuit, the ensemble comprises a pair of black Lycra leggings and a jacket entirely embroidered with sequins, disclosing such typical Chanel details as buttons with the double-*C* logo and contrasting grosgrain ribbon to define the jacket's perimeters and articulate its structural seaming. With his tongue firmly in his cheek, Lagerfeld described his attempt to "hang ten" as "the city surfer, because it's perfect for diving into the nightlife from Paris to Rome to London to New York," per a January 1991 American *Vogue* article. Hip-hop was the inspiration for the ensemble from Chanel's spring/summer 1994 collection (pl. 156). Coined "rapper-deluxe gear" by Suzy Menkes in the *New York Times*, it features a double-breasted white wool jacket and baggy, oversize, knee-length denim shorts held up with suspenders—à la TLC—that are stamped with "CHANEL" in a nod to hip-hop's promotion of logomania.

For his spring/summer 2011 collection, Lagerfeld looked to punks and specifically the punk practice of deconstruction, expressed in torn, ripped, and slashed clothes, visual symbols of destitution, disaffection, and dispossession encapsulated in the punk clarion cry of "No Future." Lagerfeld's interest in punk's tears, rips, and slashes, however, was for their decorous rawness, their aesthetic of decay and poverty, rather than for any political associations, as seen in the ensemble comprising a pair of white tweed jeans and iconic Chanel jacket in *devoré* tweed artfully pierced with holes (pl. 160). "It was as though Lagerfeld had taken scissors to Chanel—or maybe unleashed a cloud of ninja moths," Tim Blanks declared in an October 4, 2010, American *Vogue* review. The jacket, in fact, is a tour de force of workmanship, with each laser-cut hole carefully positioned and finished to prevent fraying. In Lagerfeld's hands, the aesthetic of poverty has been transformed into the aesthetic of luxury, underscored in his retention of one of the most recognizable hallmarks of a Chanel jacket: the braiding outlining its perimeters, which he has extended to its body; "otherwise it would fall apart," the designer explained in an October 8, 2010, Chanel press interview. It was precisely this understanding of the structure of clothing that made Lagerfeld such an accomplished deconstructionist.

CANONICAL LINE

138 140 142 144 146 148 149

COUNTERCULTURAL LINE

152 154 156 158 160 161 162

EXPLOSION

150

SKETCHES

137 139 141 143 145 147

151 153 155 157 159

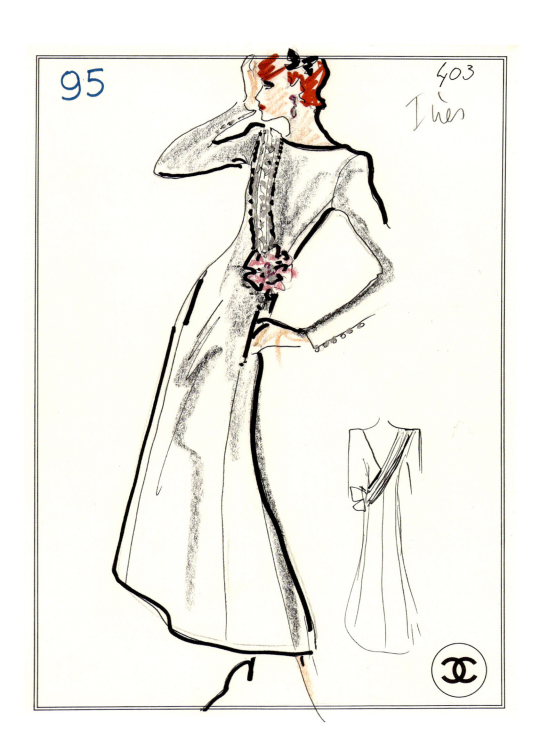

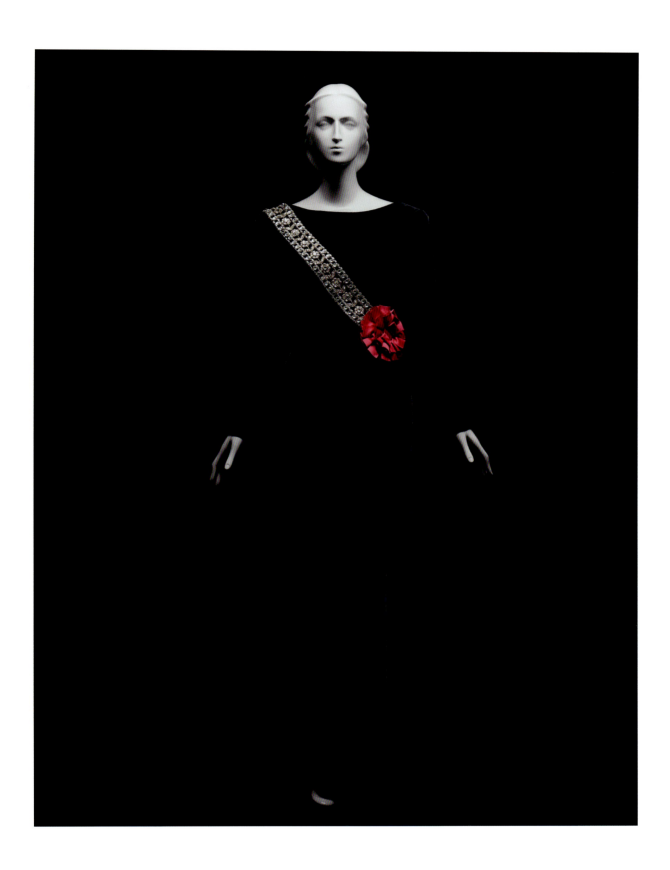

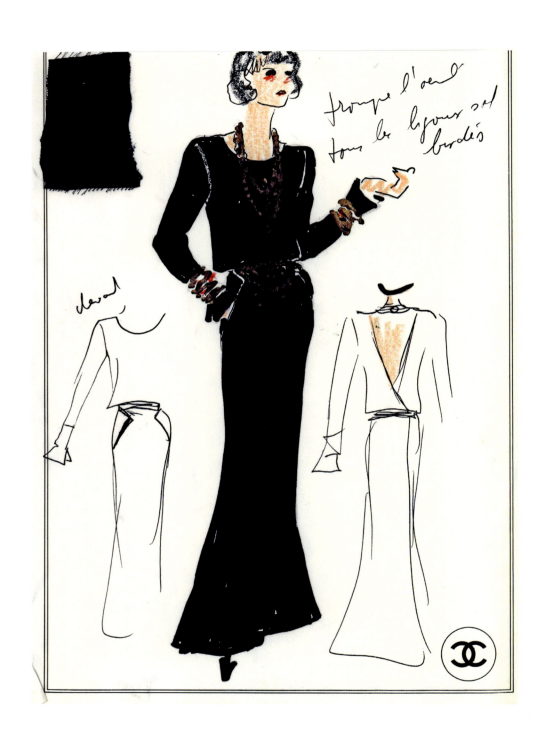

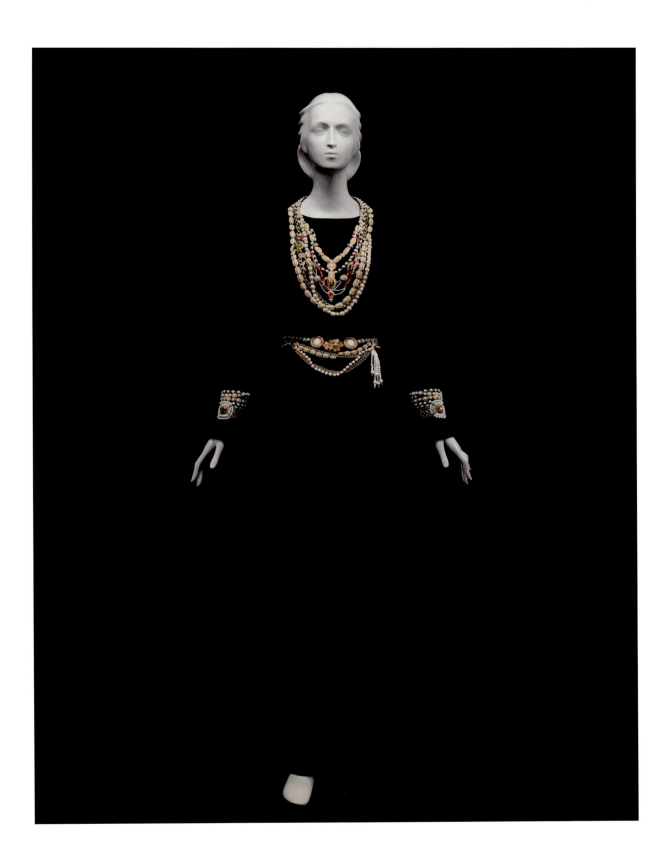

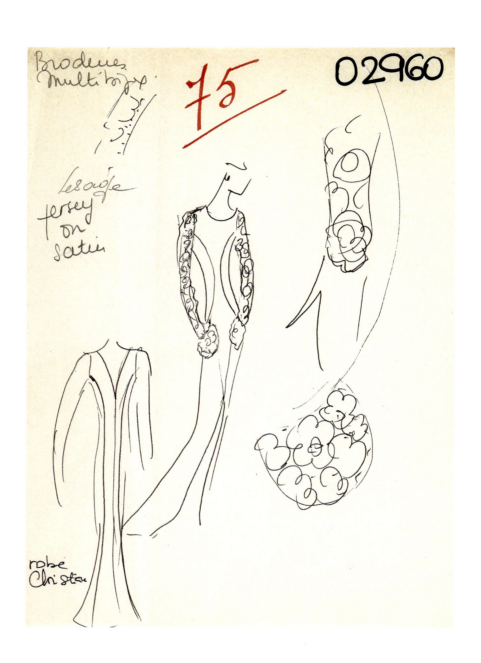

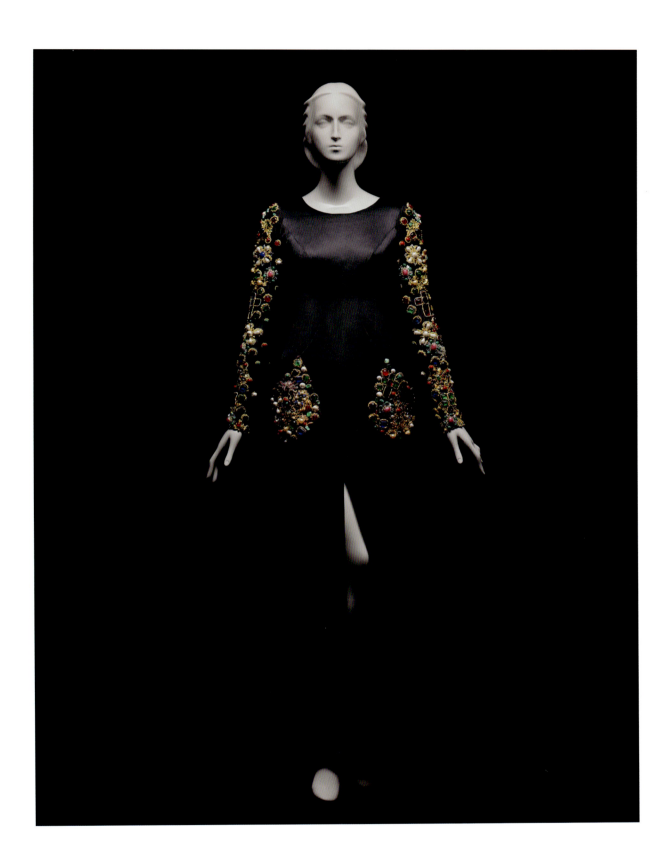

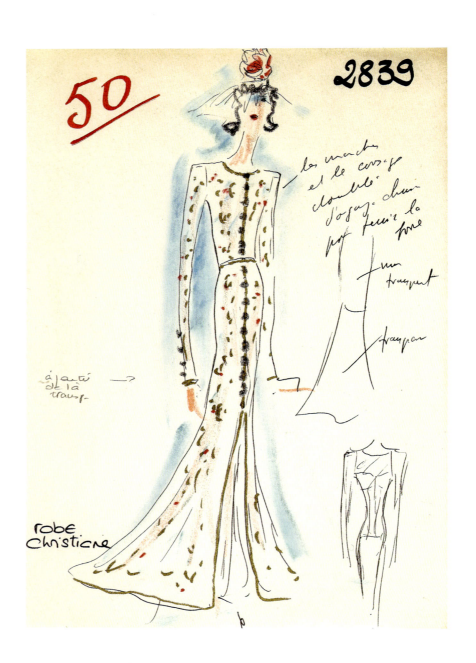

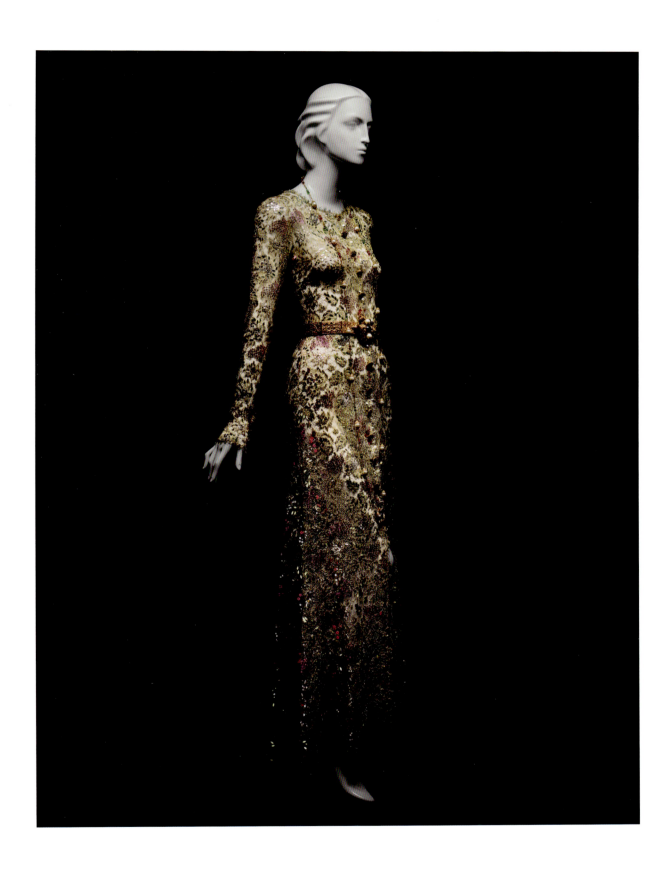

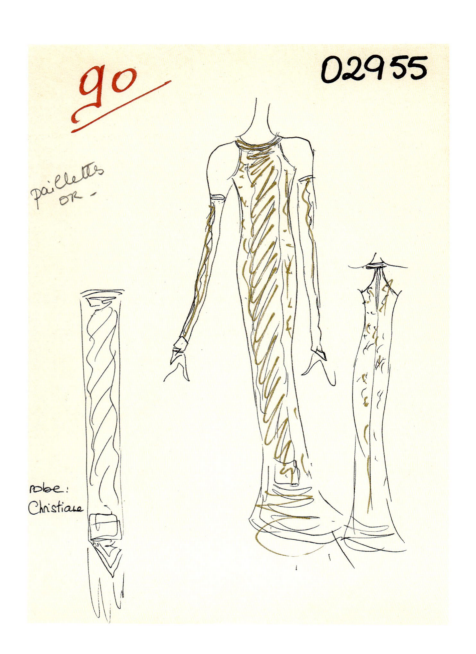

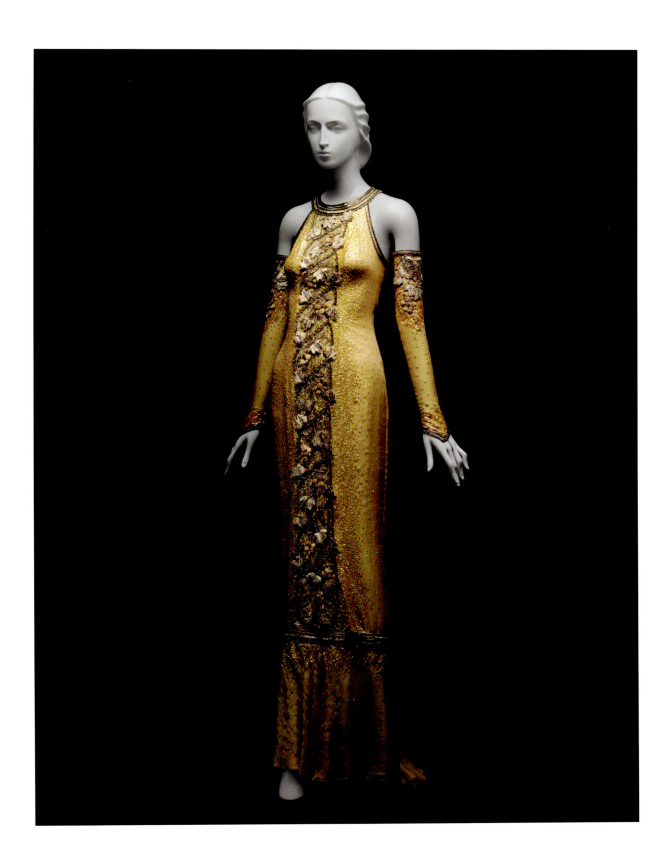

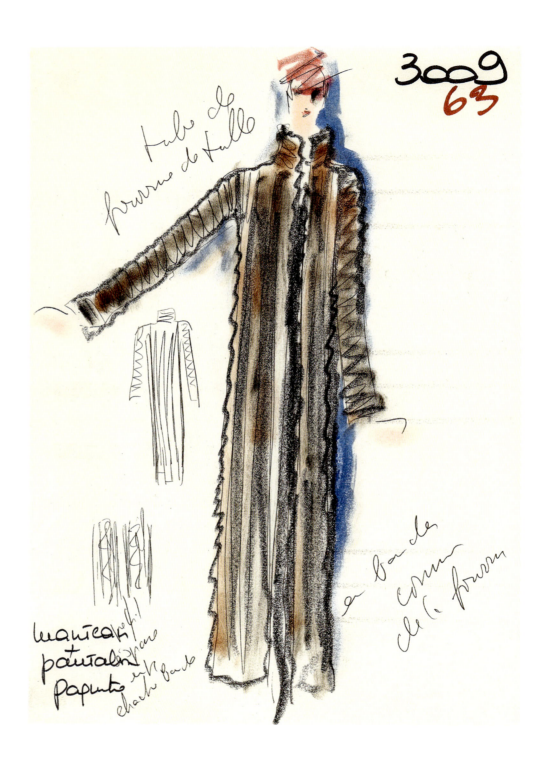

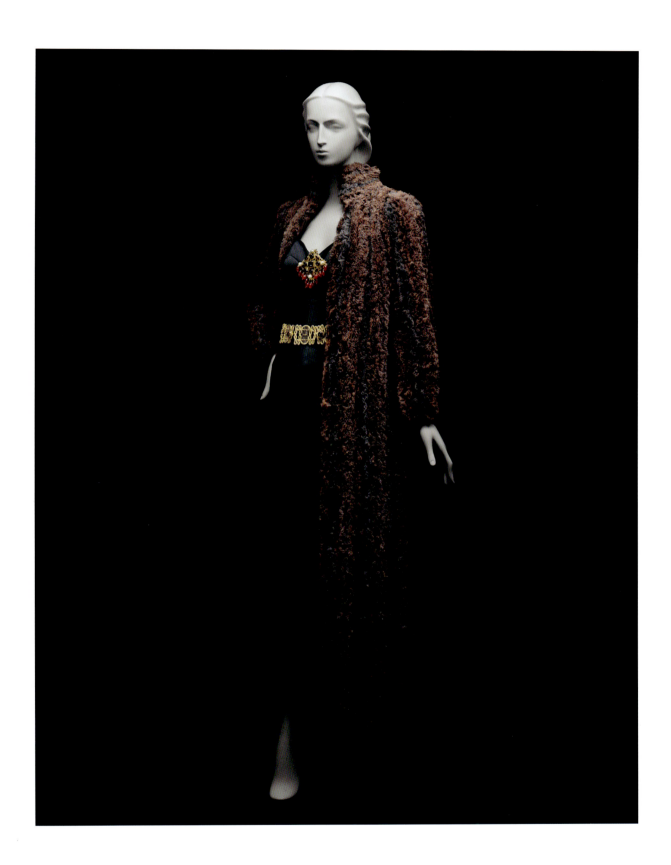

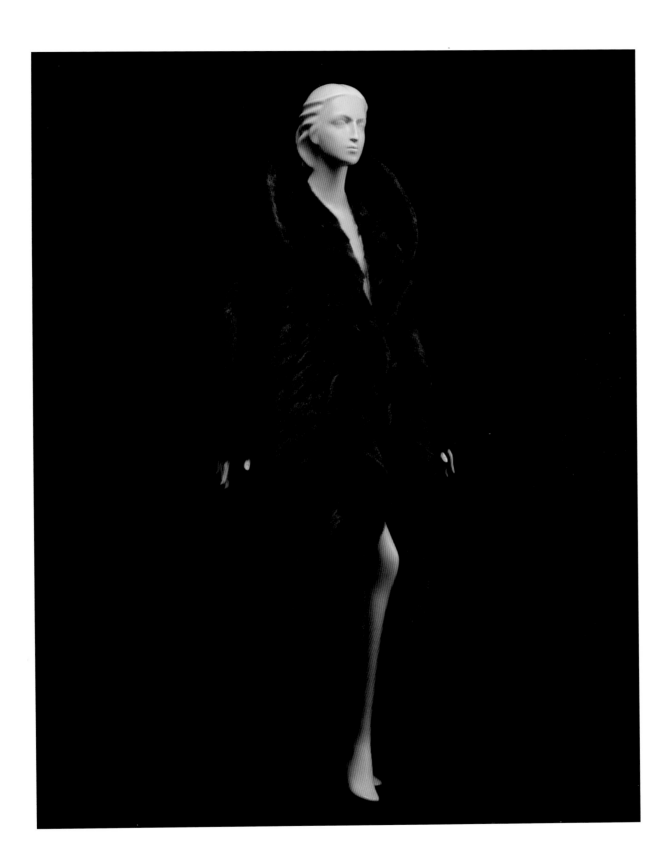

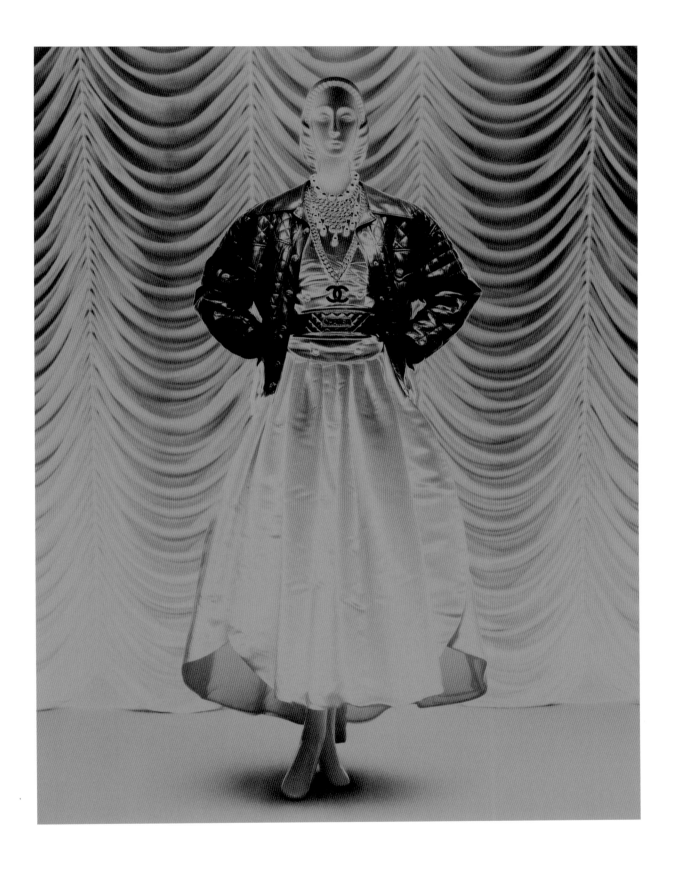

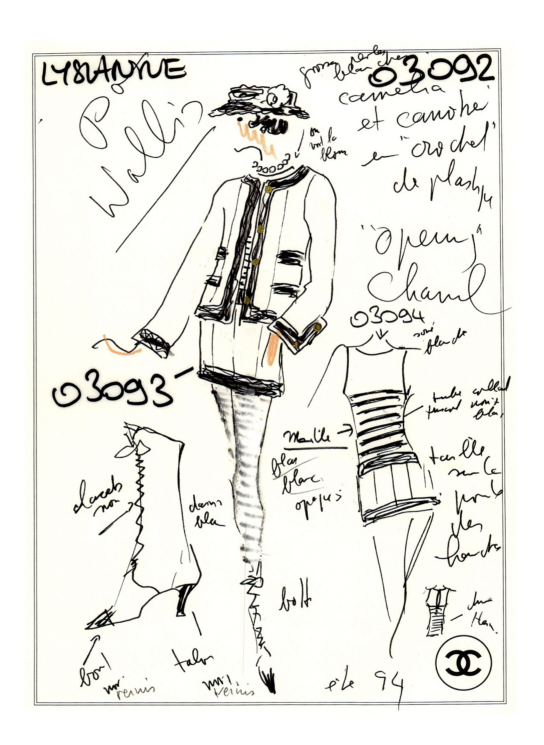

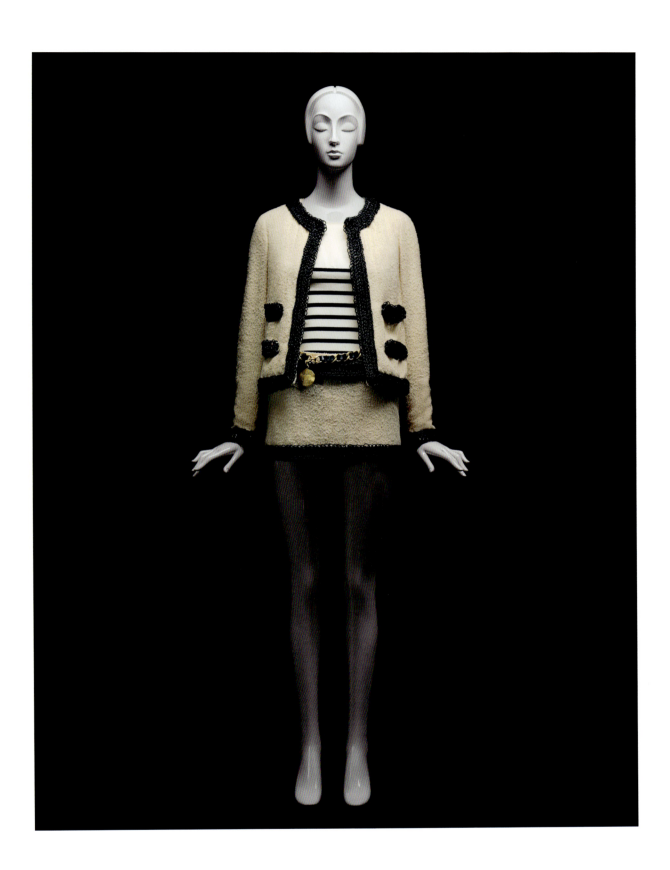

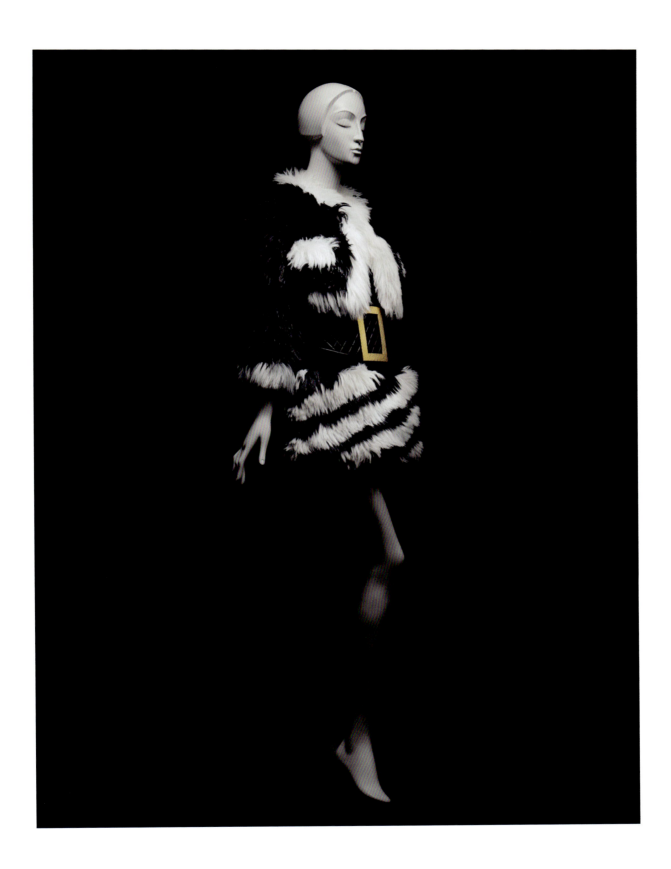

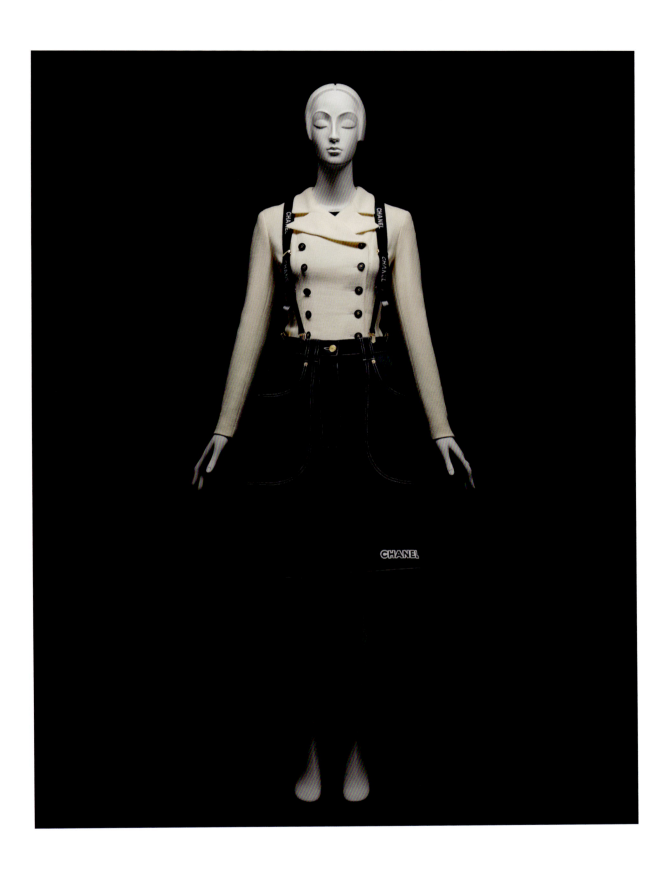

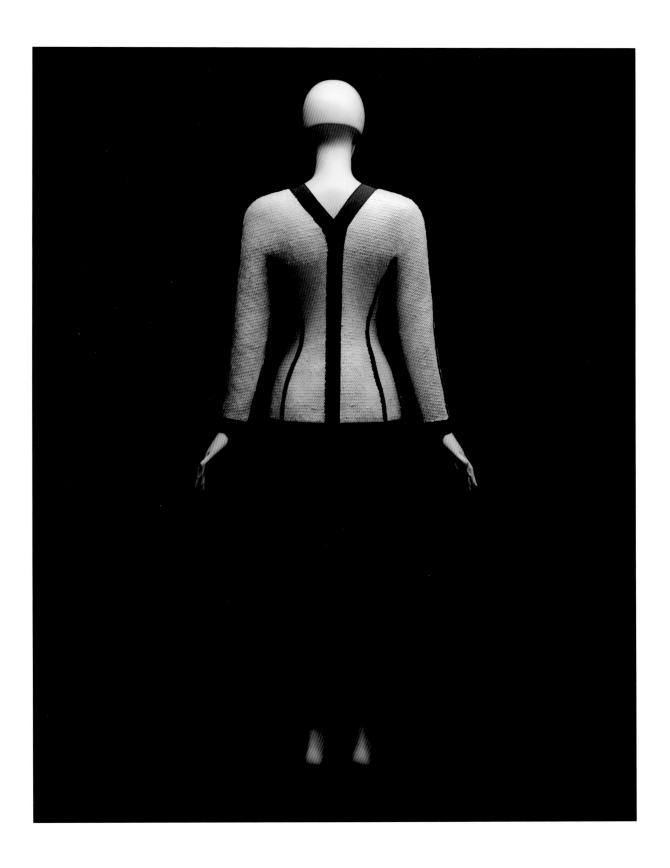

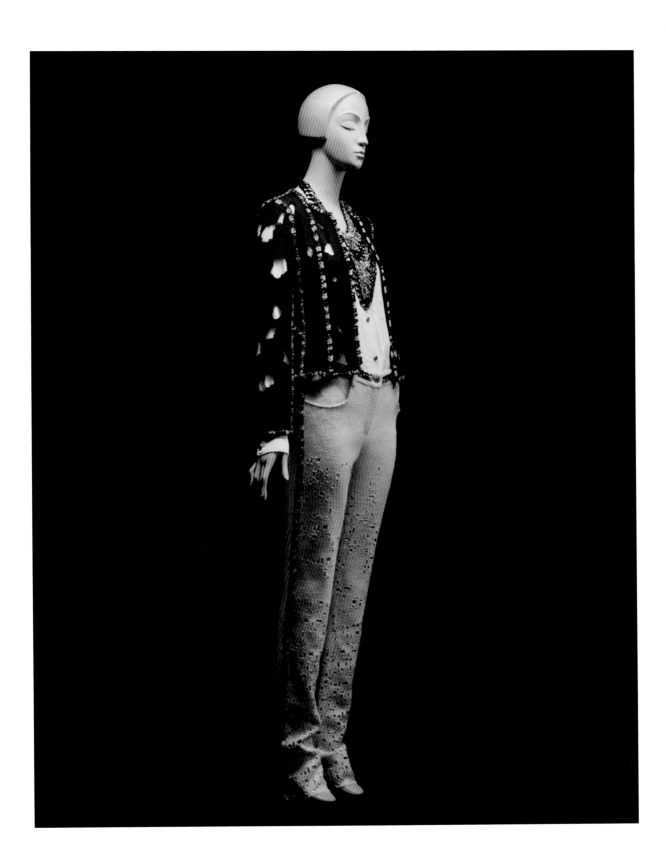

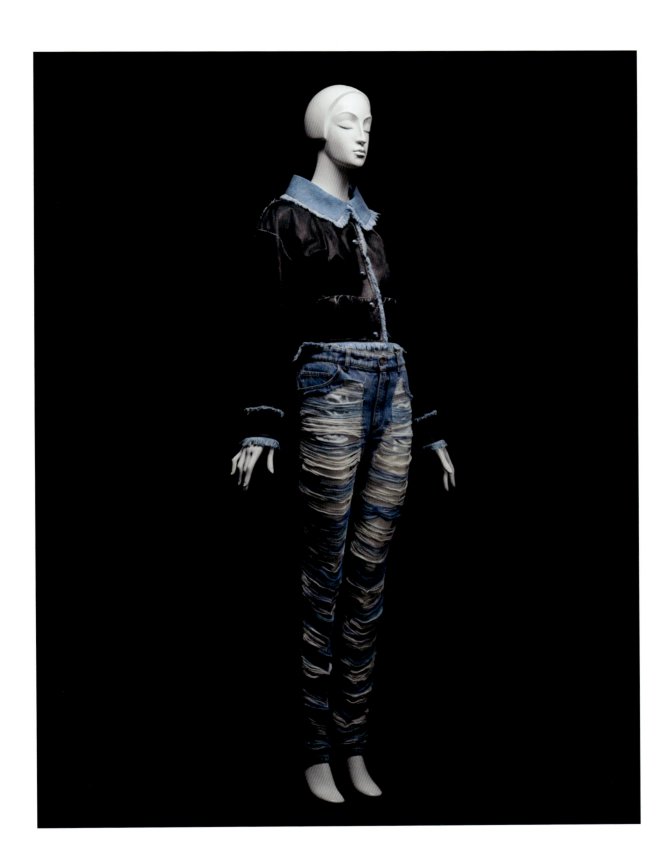

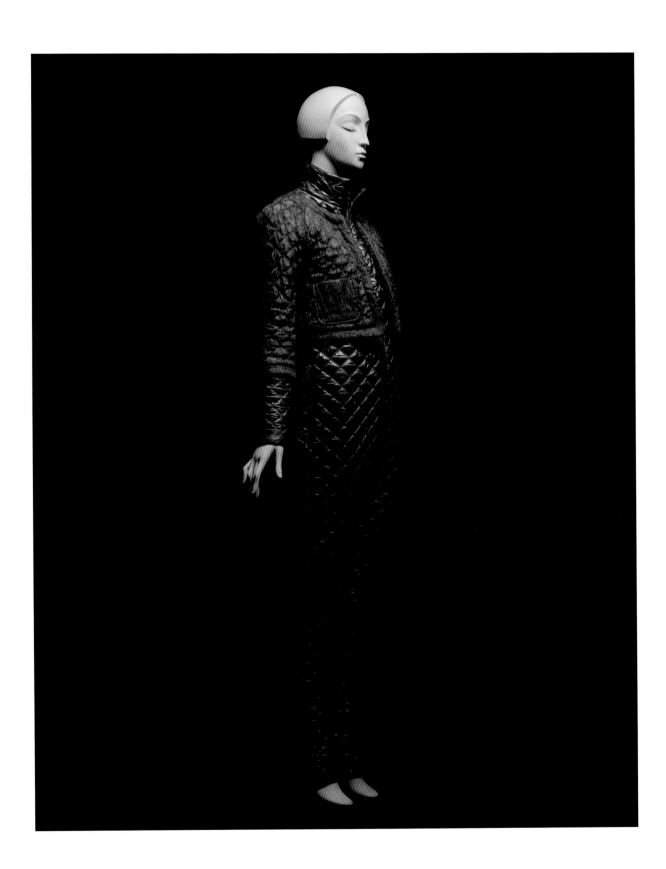

VII

ARTISANAL LINE

MECHANICAL LINE

Perhaps the most significant and profound expression of Karl Lagerfeld's artistic largesse was his equitable embrace of the handmade and the machine made, which involve processes that, in terms of technical production, have traditionally separated the institutions of the haute couture and the prêt-à-porter (ready-to-wear). For Lagerfeld, the hand and the machine were creative tools—rather than contradictory or adversarial instruments—that helped to refine, perfect, and ultimately advance his craft. "There are things the human hand can't do, and there are things the machine can't do," the designer explained in a 2016 interview published in the exhibition catalogue *Manus x Machina: Fashion in an Age of Technology*. "I use both because they are available. I mix the very best of the human with the very best of the machine. It's the mix that is interesting." However, as the fashions in the "artisanal line" and "mechanical line" demonstrate, while Lagerfeld often employed both hand and machine techniques in the production of his garments, he sometimes promoted the aesthetics of one over the other with the intention of either reinforcing or challenging the cultural and symbolic meanings behind the hand/machine dichotomy, including its ideological underpinnings and hierarchical implications.

The "artisanal line" begins with a suit from Chanel's 2003–4 "Cinq à Sept" métiers d'art collection (pl. 164), which is based on the French expression *l'heure bleu* (the blue hour), meaning twilight, Lagerfeld's favorite time of day, when there is neither full daylight nor complete darkness. It is an apt metaphor for the designer's métiers d'art collections more generally, which exist at the interstices between the haute couture and the prêt-à-porter and between the handmade and the machine made, as evident in the suit that was sewn by machine and embroidered by hand with pearls and shredded tulle, requiring 400 hours of workmanship by the artisans at Maison Lesage. Lagerfeld conceived the métiers d'art collections, the first of which was launched in 2002, to preserve and promote the artistry of the specialized *petites mains* workshops in service to dressmaking that Chanel had been acquiring since 1985—ultimately uniting them in 1997 under Les Métiers d'art de Chanel run by a subsidiary called Paraffection (which loosely translates as "for the love of"). The collections not only highlight but fetishize handwork, as Lagerfeld alluded to in an interview for *Chanel News* (November 26, 2014): "It's made in an artisan way, in the very best sense of that word, because in artisan there is 'art.' The art of doing things well. An applied art. And that is truly wonderful."

Lagerfeld's emphasis on the artistry of the *petites mains* workshops channels the rhetoric of Denis Diderot and Jean le Rond d'Alembert's *Encyclopédie, ou Dictionnaire raisonné des sciences, des arts et des métiers* (*Encyclopedia, or Systematic Dictionary of the Sciences, Arts, and Crafts*). Published in France between 1751 and 1772, the treatise places the métiers associated with dressmaking on the same ethical footing as the arts and sciences, which had been regarded as the noblest forms of scholarly activity since Greek antiquity. Through his métiers d'art collections, Lagerfeld extends the mantle of Diderot and d'Alembert by detailing the technical masteries and absolute control requisite for these enabling arts. By the time he presented his last (sixteenth) métiers d'art collection—his 2018–19 "Paris-New York" collection (pl. 67)—Chanel had established its own *encyclopédie* of twelve *savoir-faire maisons*: Desrues (costume jewelry and buttons; acquired 1985); Lemarié (feathers and artificial flowers; acquired 1996); Michel (hats; acquired 1997); Massaro (shoes; acquired 2002); Lesage (embroidery; acquired 2002); Goossens (goldsmithing and silversmithing; acquired 2005); Guillet (corsage and artificial flowers; acquired 2006); Atelier Montex (embroidery; acquired 2011); Causse (gloves; acquired 2012); Barrie Knitwear (cashmere; acquired 2012); Lognon (pleating; acquired 2013); and Lanel (embroidery; acquired 2013).

It was in his couture collections, however, that Lagerfeld most fully embraced the technical and creative ingenuity of the *petites mains* workshops, especially those dedicated to applied decoration. "For me, haute couture without embroidery does not exist," he exclaimed in an April 2004 American *Vogue* article. Lagerfeld never regarded embroidery as mere luxe augmentation but rather as a capability intrinsic to the garment, as seen in the ensemble from Chanel's spring/summer 2009 haute couture collection (pl. 166). Principally an all-white collection, it was an ode to paper—an homage also reflected in the set staged in Paris's Pavillon Cambon Capucines, which *WWD* described as "a floral paradise crafted from 4,000 meters of plain paper . . . that looked like . . . a walk-in version of David Pelham's ingenious pop-up book *Trail*" (January 28, 2009). (*WWD* also reported that the set boasted 6,700 blossoms and that it took 40 people 15 weeks to create.) "Paper is the material I prefer to all others on earth," Lagerfeld explained in the design house's show notes. "It is the starting point of a drawing, and the conclusion of photography. There is something about the physical contact with paper that I just can't explain. [It] is a very simple material, [but] Maison Lesage transformed it into the most precious material."

This preciosity is tangible in the ensemble in plate 166, the papery quality of which is enhanced by the crispness of the squared-off shoulders and the symmetry of the A-line skirt with inverted V-shaped pleat, crafted with scissored precision. Both the bolero (inspired by nineteenth-century berthas) and the dress are entirely embroidered with tiny paillettes and seed beads, resembling the most delicate and exquisite patisserie confection dusted in sugar. The embroidery involved 700 hours of handwork, while the organza dress and jacket took the atelier *tailleur* 340 hours to complete. A similar tour de force accomplishment is reflected in the white silk net dress from Chanel's spring/summer 2006 haute couture collection (pl. 168). According to Lagerfeld, the collection was partly inspired by the exhibition *China: The Three Emperors* at the Royal Academy of Arts, London (November 12, 2005–April 17, 2006), an influence apparent in the bodice's three-dimensional floral embroidery of pearlescent paillettes executed by Maison Lesage that is reminiscent of openwork white jade (see p. 33, fig. 32). The bodice's organicism is complemented by the bell-shaped skirt of dyed white ostrich feathers created by Maison Lemarié, with the shape of each feather articulated like a puffed-up snowy owl. In total, the dress required 740 hours of craftsmanship.

As at Chanel, the practice of luxury at Fendi is sustained by hand skills that speak of mastery, subtlety, and etiquette. To reinforce the artisanal opulence of the Fendi ateliers, and to celebrate Lagerfeld's fiftieth anniversary as creative director of the house, Fendi launched its first haute fourrure collection in the autumn of 2015. "It's a new start," Lagerfeld explained in the *New York Times*, "it's time to do the highest level of couture fourrure . . . to find new ways to use something that could be considered limited in the way you could use it" (March 3, 2015). Fendi's virtuoso technical achievements are palpably apparent in the ruffled, cotton-candy-like cape from Lagerfeld's autumn/winter 2016–17 haute fourrure collection (pl. 169), which Vanessa Friedman in the *New York Times* described as "an eye-popping visual discourse on the art of the possible" (July 10, 2016). Made of wispy, gossamer-thin mohair hand crocheted to resemble lace, it is trimmed with hand-dyed mink and appliquéd with hundreds of hand-cut organza flowers from Maison Lemarié, which prompted J. J. Martin to proclaim in an October 2016 *Harper's Bazaar* article that Lagerfeld had "combined the delicacy of the Paris ateliers with the wizardry of Fendi's master furriers." Like the progression of day into evening, the colors of the mohair and mink morph from white to pink to black.

The Empire-line dress in plate 170—also from Fendi's autumn/winter 2016–17 haute fourrure collection—is another masterpiece of artisanal execution and imagination. Similarly constructed from hand-crocheted, lace-weight mohair that looks like it has been spun by a golden orb–weaving spider, the dress features a delicate cobwebby surface animated with an ethereal garden of blooming willow trees. This white-on-white relief is echoed in the wedding dress from Fendi's autumn/winter 2017–18 haute fourrure collection (pl. 171), which is a study in lace. As *WWD* cautioned, "lest anyone question [lace's] relevance to a fur house, the Fendi team researched new techniques to inlay it with shaved mink, adding fur and feathers for three-dimensional effect" (July 7, 2017). In the wedding dress, shaved mink flowers are appliquéd to the lace skirt, echoing in relief its floral repeat pattern. Shaved mink flowers are also applied to the tulle bodice, creating a tour de force trompe l'oeil lace effect. Perhaps the most striking display of illusory lace, however, is the lattice-worked cape, which consists of 9,000 miniature, pieced-together discs of shaved mink that took 1,200 hours to sew by hand. The lace-like dress from Chanel's spring/summer 1997 haute couture collection (pl. 173) was no less labor intensive. Made from horsehair backed with organza fashioned into a complex pattern of camellias, and embroidered with clear crystals by Maison Lesage, it required a total of 1,680 hours of handwork: 180 hours by the atelier *flou* and 1,500 hours by Lesage.

While the examples of lacework in the "artisanal line" emphasize the aesthetic of the hand, those in the "mechanical line" accentuate that of the machine. The dress from Fendi's spring/summer 2009 collection (pl. 181) not only highlights the machine aesthetic, but it bears no trace of the hand in its fabrication and construction. Made from black polyester that has been entirely machine sewn, it features an extended and exaggerated synthetic organza "jabot" that has been laser cut to resemble lace. In contrast, the dresses from Chanel's spring/summer 2013 and autumn/winter 2014–15 haute couture collections (pls. 183, 185) promote the aesthetic of the machine, but they include both hand- and machine-worked production techniques. The former is made from machine-sewn white scuba knit bonded with black cotton lace from Maison Sophie Hallette that has been finished by hand, while the latter features black and silver lace that has been machine sewn, hand painted with black silicone, and hand embroidered by Maison Montex. Similarly, although the dress from Chanel's autumn/winter 2018–19 haute couture collection (pl. 187) advances the machine aesthetic through the aluminum film sandwiched between two layers of black lace, it has been sewn by machine and finished and embroidered by hand. The "explosion" dress from Chanel's autumn/winter 2014–15 haute couture collection (pl. 174) marries the aesthetic as well as the practice of the machine and the hand: its bodice is hand embroidered with small concrete cubes by Maison Montex that took three years to develop and entailed 250 hours of work, and its skirt is machine knit with iridescent silver sequins.

Often in his promotion of the machine aesthetic, Lagerfeld strove to problematize the associative values that have traditionally been applied to the hand/machine dichotomy, namely, the hand signifying exclusivity, spontaneity, and individuality, and the machine implying inferiority, dehumanization, and homogenization. The suit from Chanel's autumn/winter 2015–16 haute couture collection (pl. 178) purposefully challenges these assumptions. Made by the Belgian company Materialise, the suit was created using selective laser sintering, an additive manufacturing technique that employs a laser to sinter a powdered material together, one layer at a time, to create a solid structure. "My idea was to take the most iconic suit of the twentieth century and make a twenty-first century version, which, technically, was impossible and unimaginable in the period it was invented," Lagerfeld explained in the *Manus x Machina* interview. "I wanted to change it, update it by using the newest and most advanced technology." However, the top as well as the lining and braiding at the suit's pockets and perimeters were embroidered by Maison Lesage, entailing 1,785 hours of handwork. This complex amalgam of hand and machine techniques not only unravels the mythologies of the hand-machine conundrum, but it also produces a garment of exceptional conceptual originality and outstanding technical ingenuity.

ARTISANAL LINE

164 166 168 169 170 171 173

MECHANICAL LINE

176 178 179 181 183 185 187

EXPLOSION

174

SKETCHES

163 165 167 172 175

177 180 182 184 186

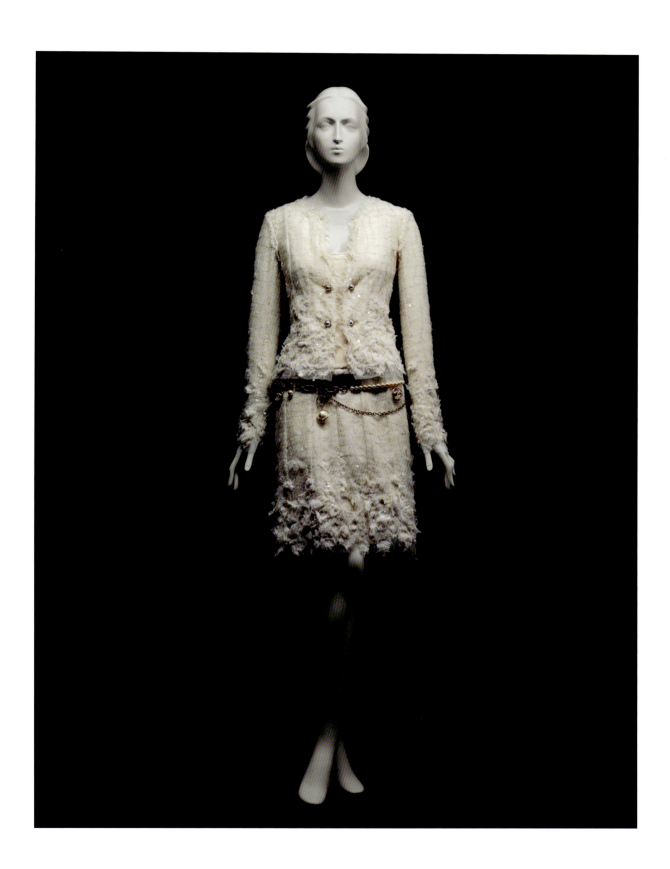

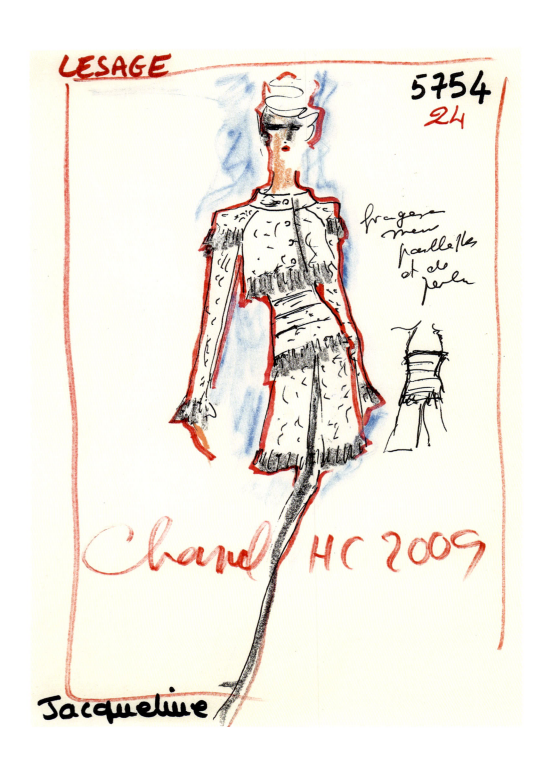

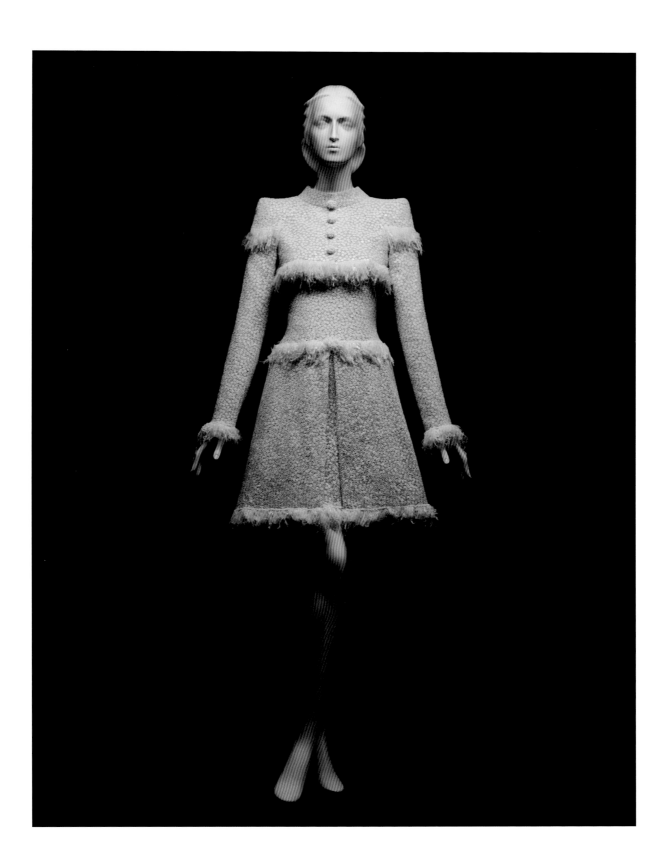

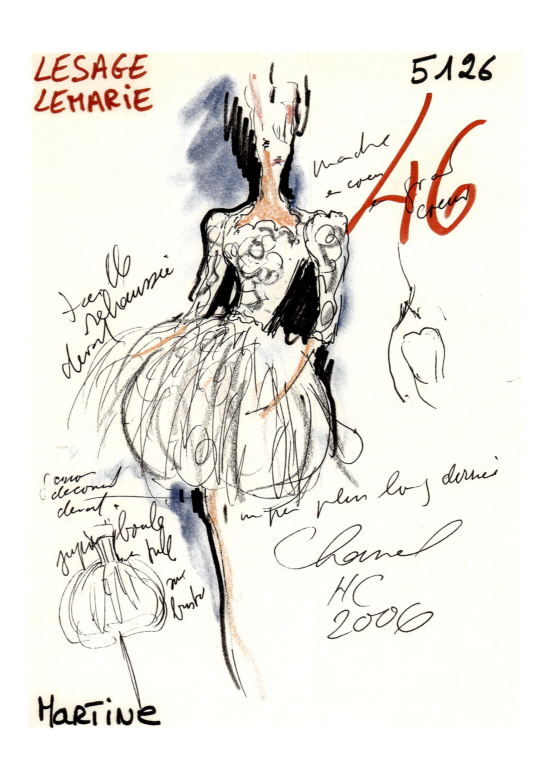

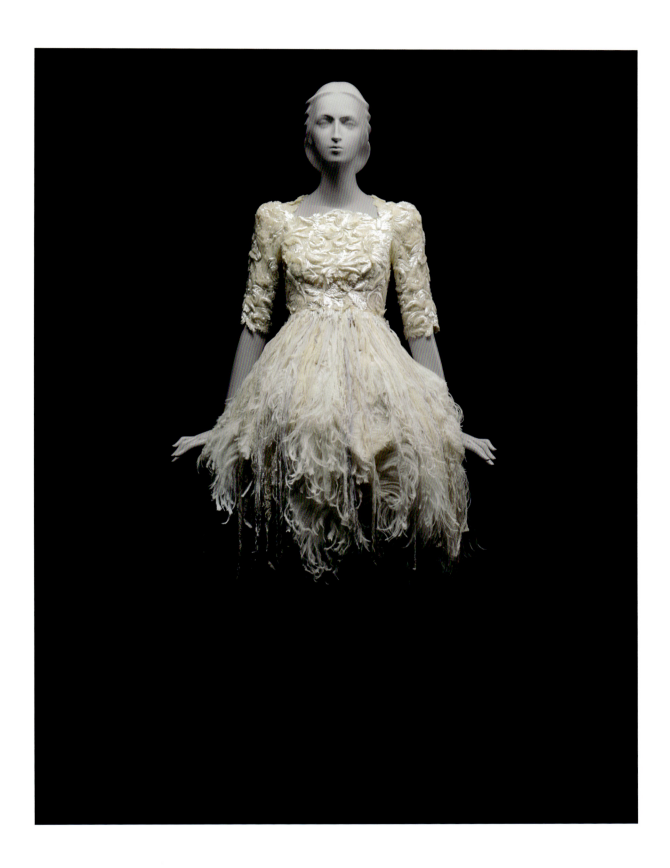

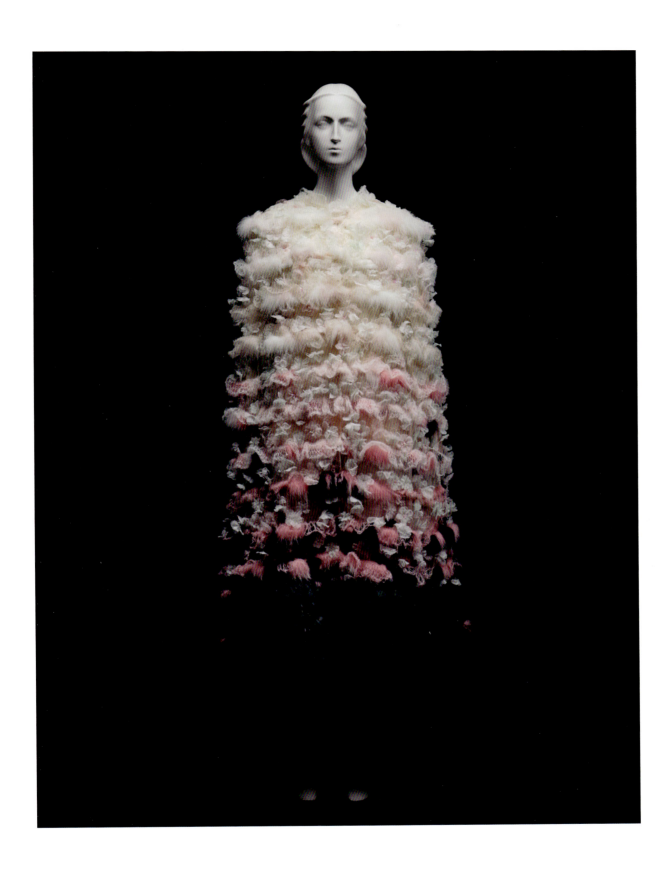

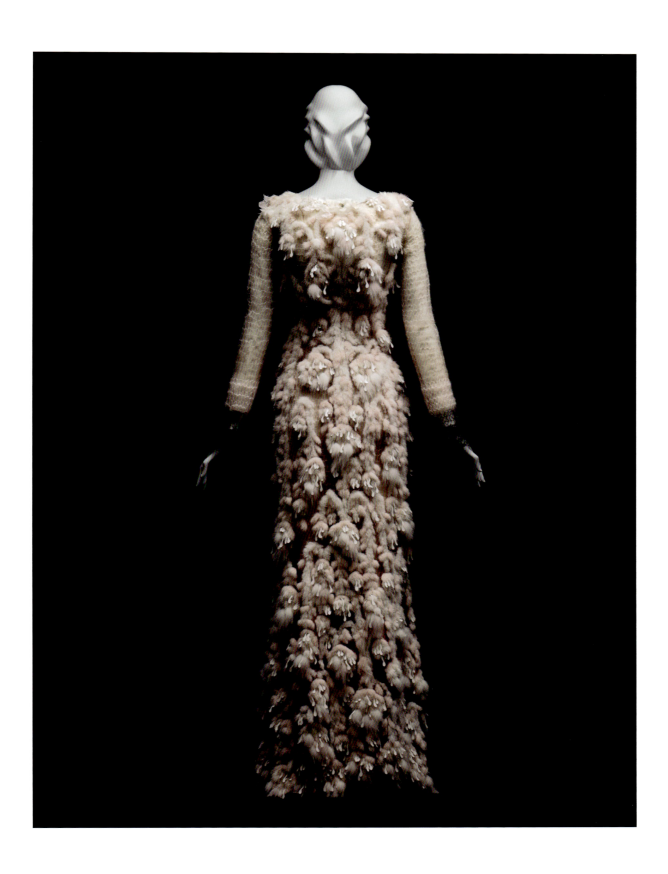

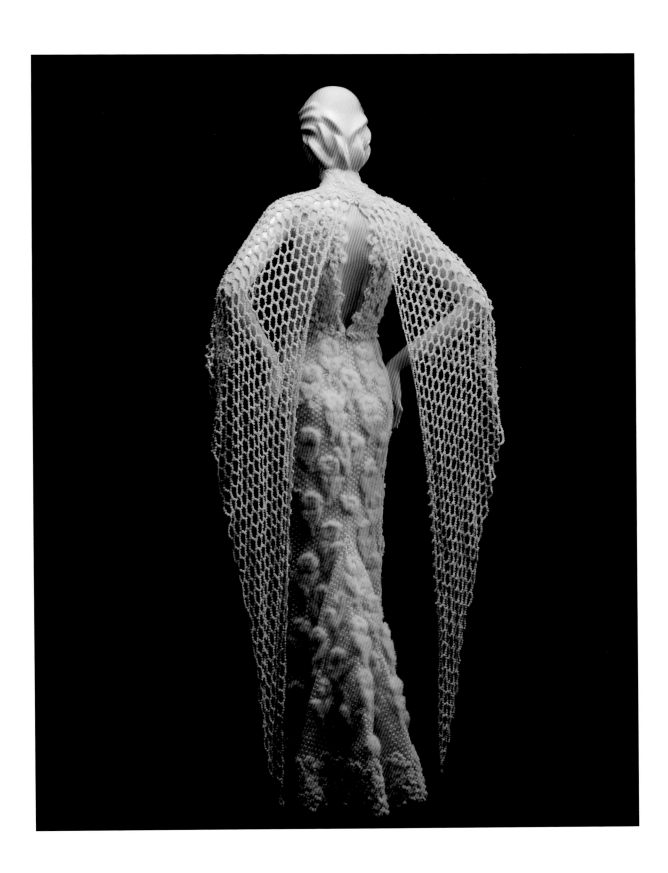

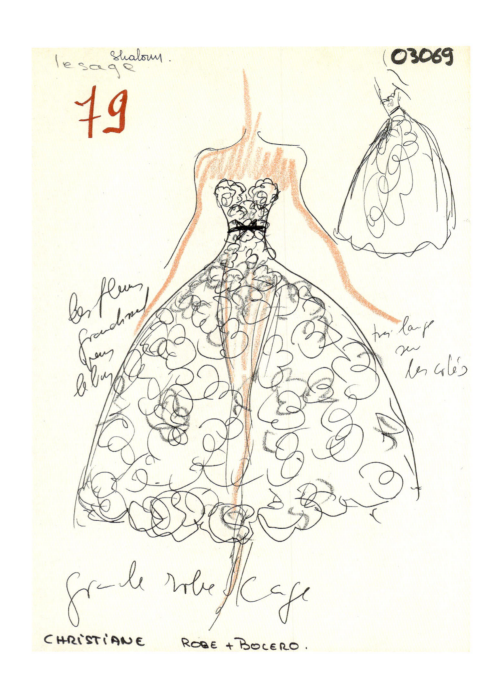

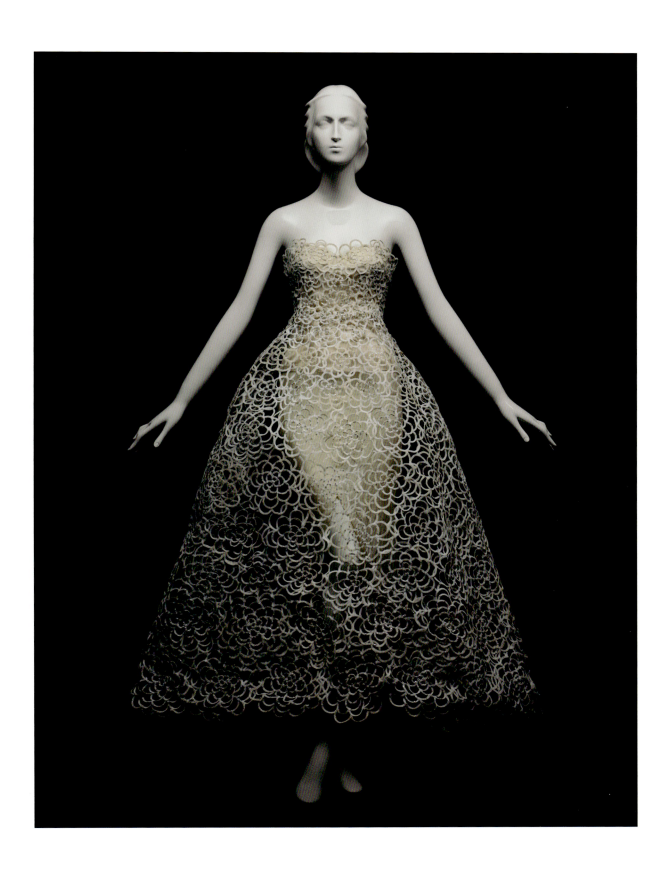

163 *Sketch of CHANEL suit jacket*, 2003–4 métiers d'art

164 House of CHANEL (French, founded 1910). *Ensemble*, 2003–4 métiers d'art. Jacket of ivory silk crepe, overlaid with ivory cashmere knit, embroidered with silver silk-and-metal thread and clear sequins, and trimmed with ivory silk tulle, ivory silk chiffon, clear seed beads, and bugle beads; dress of ivory cashmere knit and silk crepe, overlaid with ivory cashmere knit, embroidered with silver silk-and-metal thread and clear sequins, and trimmed with ivory silk tulle, ivory silk chiffon, clear seed beads, and bugle beads; belt of gold metal and simulated pearls

165 *Sketch of CHANEL ensemble*, spring/summer 2009 haute couture

166 House of CHANEL. *Ensemble*, spring/summer 2009 haute couture. Bolero and dress of white silk organza and polyester tulle embroidered with white sequins and seed beads, and trimmed with white crystals, white silk yarn, white tulle, and white ribbon

167 *Sketch of CHANEL dress*, spring/summer 2006 haute couture

168 House of CHANEL. *Dress*, spring/summer 2006 haute couture. White silk tulle, organza, and chiffon embroidered with white sequins, white ostrich feathers, and strips of blue and white silk chiffon

169 FENDI (Italian, founded 1925). *Cape*, autumn/winter 2016–17 haute fourrure. White, pink, and black mohair crochet trimmed with pink mink fur, appliquéd with polychrome silk organza flowers, and embroidered with pink paillettes and clear crystals

170 FENDI. *Dress*, autumn/winter 2016–17 haute fourrure. White, pink, and black tulle-backed mohair crochet trimmed with dyed mink fur and appliquéd with white silk organza flowers and clear crystals

171 FENDI. *Dress*, autumn/winter 2017–18 haute fourrure. Pieced white shaved mink fur, white silk tulle embroidered with white silk thread and appliquéd with white shaved mink fur, and white cotton lace appliquéd with flowers of white shaved mink

172 *Sketch of CHANEL dress*, spring/summer 1997 haute couture

173 House of CHANEL. *Dress*, spring/summer 1997 haute couture. Cream silk organza and white silk tulle overlaid with cream horsehair in camellia lace motif, embroidered with clear crystals

174 House of CHANEL. *Dress*, autumn/winter 2014–15 haute couture. Gray silk twill embroidered with pink and gray iridescent sequins, gray concrete cubes, pink and white crystals, silver bugle beads, aluminum, and silver leather, and gray cotton net embroidered with pink and gray sequins

175 *Sketch of CHANEL ensemble*, spring/summer 2017

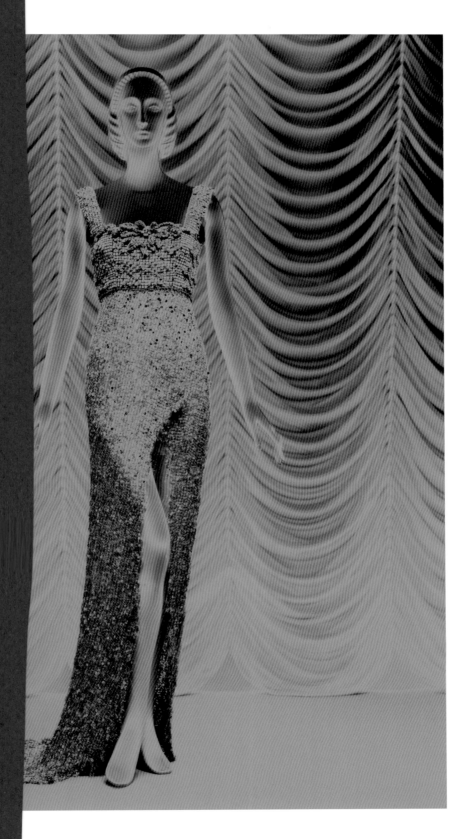

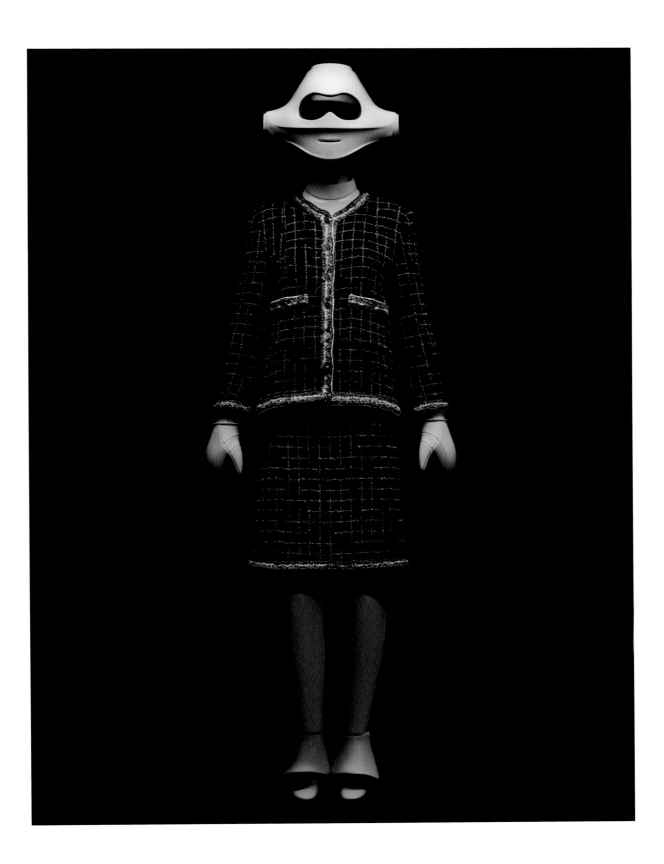

7058

Jacqueline

Noir

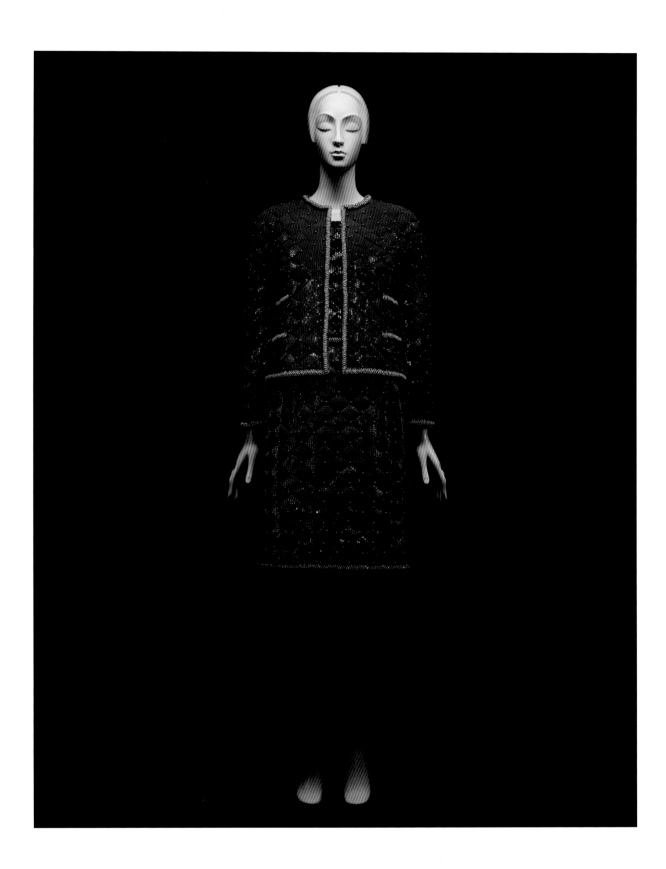

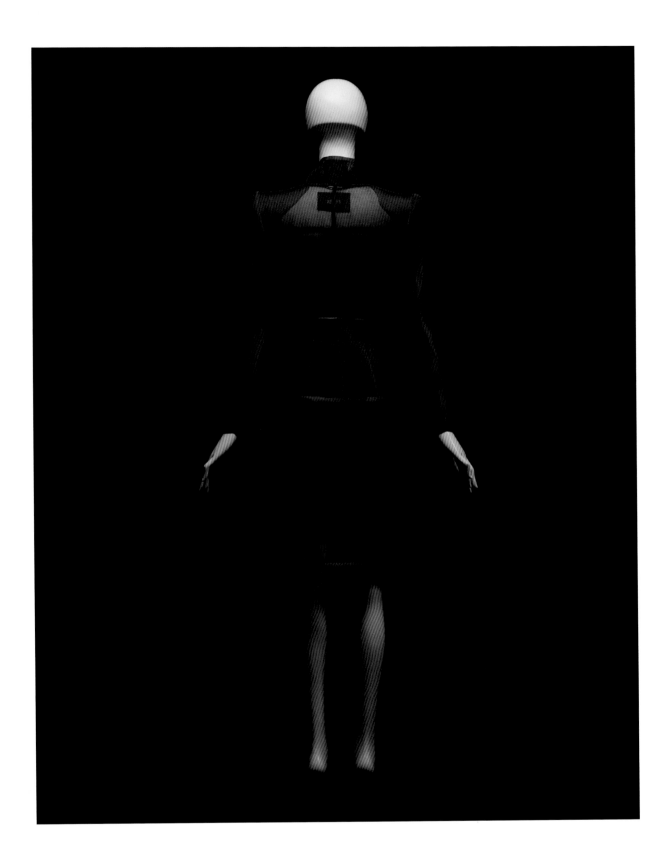

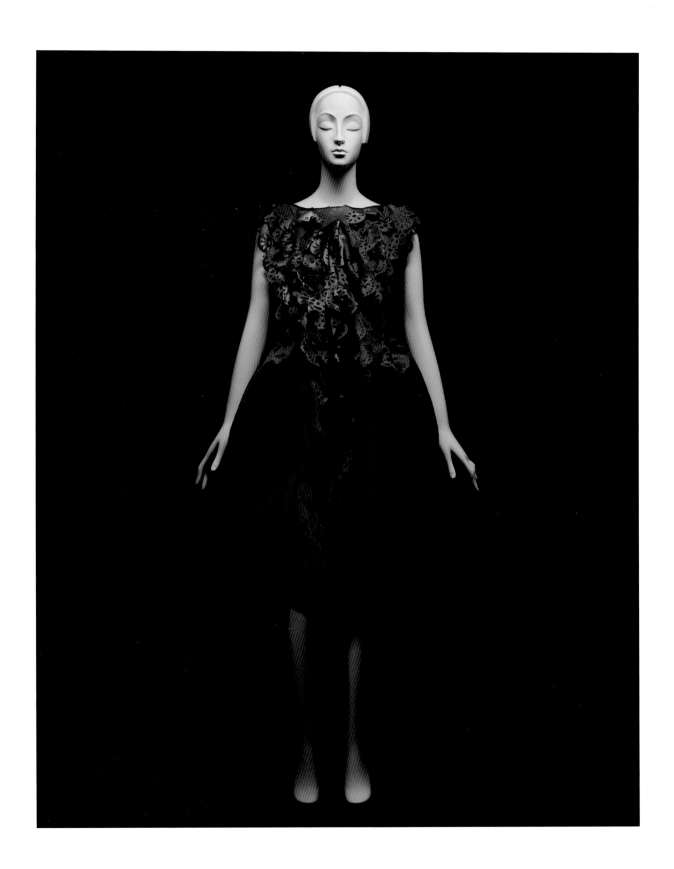

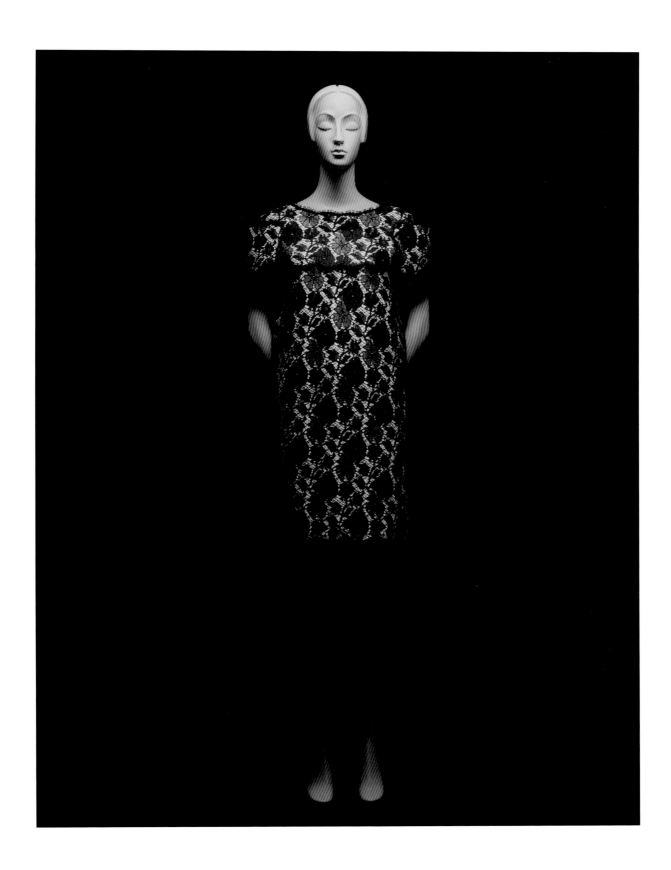

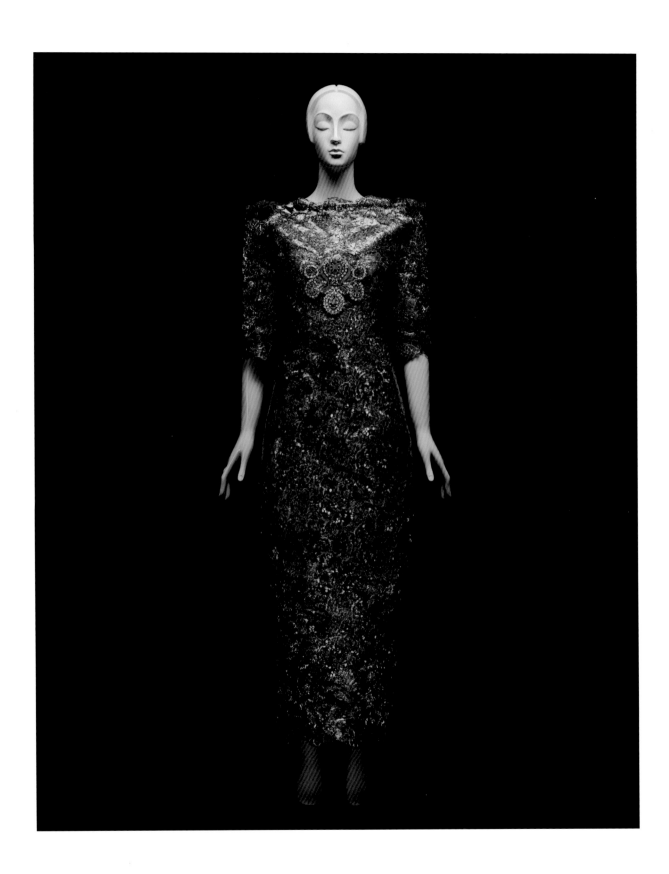

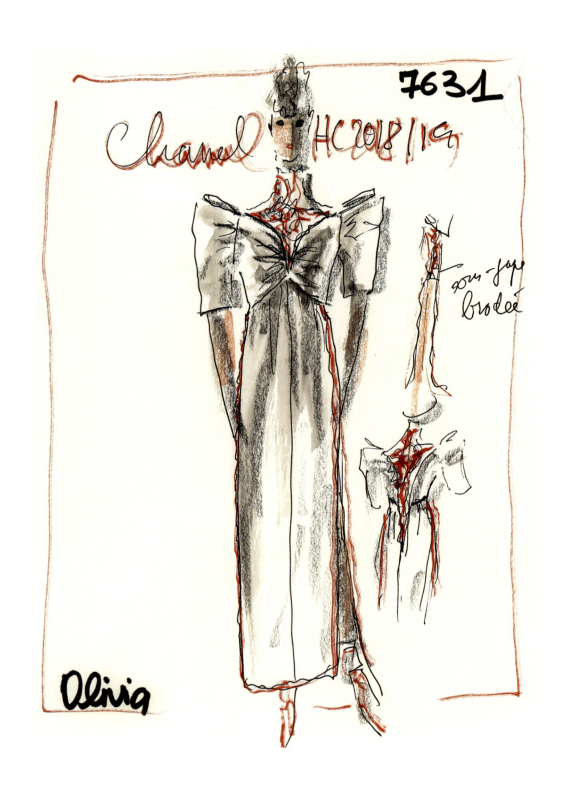

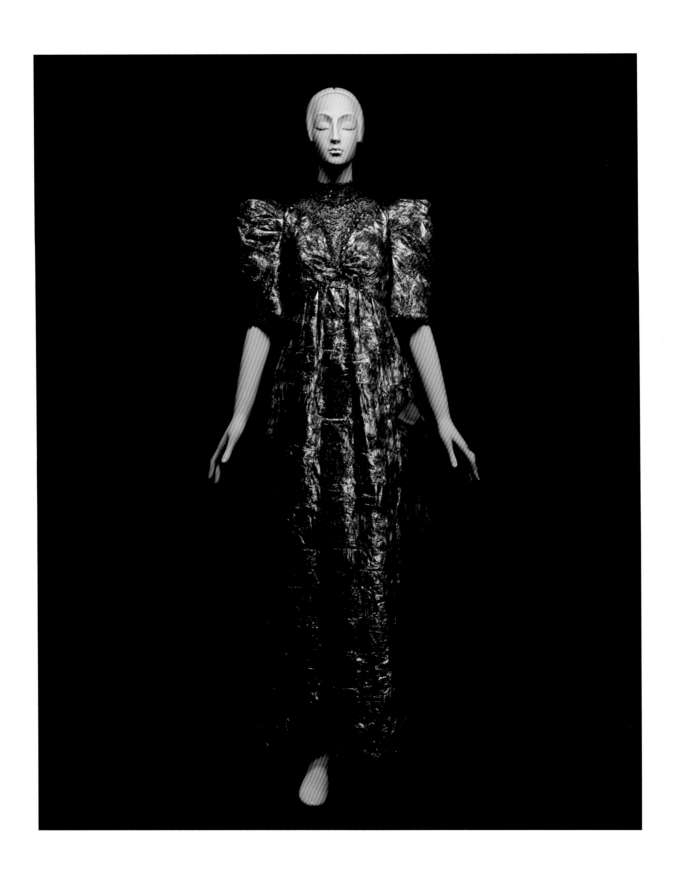

The "floral line" is both an extension and a continuation of the "artisanal line," focusing as it does on one of the most refined and rarefied of the métiers in service to dressmaking: that dedicated to the production of *parurier floral*, or artificial flowers. For many connoisseurs of costume, artificial flowers are emblems of the triumph of the art of fashion. In a story that is perhaps apocryphal, Diana Vreeland ordered an assistant visiting Paris in the aftermath of World War II to bring her back an artificial rose made for the haute couture. By the quality of such a token, the legendary fashion editor would know that the artisanry remained in the creations of fashion's epicenter. Apparently satisfied with her rose, Vreeland declared that the haute couture was indeed renascent. For Karl Lagerfeld, the ateliers specializing in floral garnitures provided him with an outlet to simulate nature's abundant beauty, which he exploited to its full potential by offering a splendid and seemingly inexhaustible plethora of botanical representations. The painter Georgia O'Keeffe, who was no stranger to the singular beauty of flowers, opined that "nobody sees a flower—really—it is so small—we haven't time." As seen in his fashions in the "floral line," however, Lagerfeld asks—sometimes politely and sometimes insistently—that we take the time to look at the botanicals crafted by the skilled artisans for whom Mother Nature is their sole muse.

As with his use of applied decoration more generally, the flowers that bloom on Lagerfeld's garments are not after-the-fact decorations but their enabling principles. Often, Lagerfeld's fertile gardens of floral apparel blossom with a specific flower, as with the dress from Fendi's autumn/winter 2016–17 haute fourrure collection (pl. 193) that, channeling the poetic lyricism of William Wordsworth, is an ode to the daisy in all its purity, innocence, and freshness. Made from jacquard organza, the dress is appliquéd with hand-cut mink and organza daisies created in the Fendi and Lemarié ateliers, respectively—"[t]he best of Made in Italy meets the best of Made in France," as the design house's show notes declared, "giving life to an osmosis process of mutual and incredible artisanal enrichment." The dress from Fendi's autumn/winter 2017–18 haute fourrure collection (pl. 194) manifests a similar cross-fertilization, with hand-cut mink and organza anemones appliquéd onto lace with an openwork floral pattern optically effecting a meadow's variegation. Intentionally, the anemones equivocate between naturalism and stylization, reflecting the title of the collection, "Flowers from Another World"—mutations seemingly picked from Impressionist and Postimpressionist flower fields. The collection was shown at the Théâtre des Champs-Élysées, where Igor Stravinsky premiered *Le Sacre du printemps* (*The Rite of Spring*) on May 29, 1913, which Lagerfeld alluded to in his set that included a scrimmed backdrop hand painted with an enchanted forest recalling Nicholas Roerich's original set designs. As *WWD* noted, "You half expected Vaslav Nijinsky to come bounding out in wings" (July 6, 2017).

In the dress from Fendi's spring/summer 2009 collection (pl. 189), Lagerfeld references the Polish Russian ballet dancer more directly. Comprising a nude tulle dress appliquéd with roses hand painted in shades of white, pink, and red that wrap around the body like art nouveau tendrils, the dress was inspired by the costume designed by Léon Bakst for Nijinsky in the title role of the ballet *Le Spectre de la Rose* (*The Spirit of the Rose*), immortalized in a poster by Jean Cocteau that depicts Nijinsky in the moment he leaps through a window at the ballet's conclusion (see p. 33, fig. 33). Based on an erotic verse by Théophile Gautier, the ballet—written by Jean-Louis Vaudoyer, choreographed by Michel Fokine for the Ballets Russes, and premiering in the Théâtre de Monte-Carlo on April 19, 1911—tells the story of a young girl who dreams of dancing with the spirit of a souvenir rose from her first ball. Lagerfeld represents his souvenir roses in flattened forms, as if they have been pressed between the pages of a secret diary—intimate keepsakes of a thwarted love affair or forbidden passion. The balloon-shaped, watercolor-pink "grenade" cape (pl. 191) from Chanel's spring/summer 2010 haute couture collection—titled "Neon Baroque" and described by Suzy Menkes in the *International Herald Tribune* as "a box of macarons projected into cyberspace" (January 27, 2010)—presents a similar compressed impression. A feat of technical virtuosity, the cape comprises 1,300 hand-pleated satin camellias by Maison Lemarié that have been sewn by hand one on top of the other in graduating sizes from neckline to hemline, requiring 700 hours of workmanship.

The camellia was Gabrielle Chanel's signature flower, as the lily of the valley was for Christian Dior. An integral motif in her modernist stylistic vocabulary, it represented an assertion of authorial authenticity almost as immediate and as recognizable as Coco Chanel's initials in the form of two interlocking *C*'s. Ever adept at reinterpreting Chanel's authoritative and apotropaic system of signs, Lagerfeld employs the camellia in a variety of inventive ways that never risks the danger of predictability. While Chanel often limited her use of her favorite flower to corsages to accent her dresses and add drama and distinction, Lagerfeld deploys it as both metaphor and metamorphosis, as demonstrated in the dress from Chanel's autumn/winter 2012–13 haute couture collection (pl. 196), which was shown in the Salon d'Honneur of the Grand Palais, Paris, the hall having been transformed into a winter garden lined with white camellias. Made of pink organza lavishly embroidered with pink camellias—the hue inspired by Marie Laurencin's paintings of the 1910s and 1920s—the dress unites flower and woman, with floral and feminine beauty mirroring one another. The camellia in nature is a beautiful form, but Lagerfeld's contrived camellias were meticulously hand cut and hand painted by Maison Lemarié, requiring 700 hours of workmanship, resulting in flowers that are purposely governed and distilled beyond natural beauty to achieve a self-conscious artifice in which no element is left to chance or to nature's carelessness.

In the wedding dress from Chanel's autumn/winter 2005–6 haute couture collection (pl. 198), Lagerfeld imagines a bouquet of camellias that literally surrounds and subsumes

his bride, realizing the nineteenth-century illustrations of Walter Crane's "masque of flowers" and J. J. Grandville's *"fleurs animées"* (flowers personified) (see p. 34, fig. 34). The designer set an exacting task for Maison Lemarié: the white camellias are represented in different stages of bloom from neck to hem, simulating nature's enrichment and its promise of everlasting renewal. In total, the dress consists of 2,500 silk camellias in 8 different sizes, requiring 850 hours of handwork. Lagerfeld's wedding dress from Chanel's spring/summer 2015 haute couture collection (pl. 200) transforms his bride into an exuberant hothouse of lush and sensual flowers: "They're flowers that don't exist," Lagerfeld explained in the design house's show notes. "It's a vision of an earthly paradise, an imaginary greenhouse." Comprising 3,000 flowers in organza, Rhodoid, chiffon, and silk embellished with rhinestones and iridescent beads, the dress is worn with a short-sleeved tunic entirely embroidered with sequins as if covered in morning dew. Lagerfeld proudly proclaimed that the dress entailed 2,700 hours of workmanship—800 hours by the atelier *flou* and 1,900 hours by Maison Lemarié. The flowers are rendered in "pop-up-storybook" configurations, reflecting the set that formed the backdrop to the collection in the Grand Palais: a circular botanical greenhouse containing mechanical, origami paper plants that miraculously blossomed into vibrantly colored exotic flowers when "watered" by the male model Baptiste Giabiconi, who was dressed as a gardener. "There are 300 machines here under our feet," Lagerfeld explained in a January 27, 2015, review in American *Vogue*, "one to make each flower work." (Apparently, it took six months to create the mechanical blossoms.) The tropical garden evokes the jungle scenes of Henri Rousseau, the self-taught naive painter who claimed that he had "no teacher other than nature." *WWD* described this joyous tableau of nature's abundance and fashion imagination as Lagerfeld's "Eden of Haute, a bucolic paradise filled with wonders of the *flou* and flora varieties" (January 27, 2015).

According to Lagerfeld, the idea for the set was inspired by the landmark exhibition *Henri Matisse: The Cut-Outs* at Tate Modern (April 17–September 7, 2014). It was not the first time that the French artist's cutout compositions, which he referred to as "drawing with scissors," had provided inspiration for the designer: Chanel's autumn/winter 2008–9 collection features a suit made of clear plastic appliquéd with black plastic cutout forms (pl. 212). The forms, as well as their spatial configuration, closely resemble those of an ensemble dating to about 1927 by Mariska Karasz (see p. 34, fig. 35) in the collection of The Metropolitan Museum of Art's Costume Institute. Ostensibly Lagerfeld's source, Karasz's ensemble is made from navy blue silk with an appliqué of cream silk and features a cutout flatness also reflected in Lagerfeld's adaptation. The suit from Chanel's autumn/winter 2008–9 collection anchors the "geometric line," which includes garments featuring decorative strategies reflective of Matisse's principle of the economy of line, the two-dimensional planarity of which stands in stark contrast to the three-dimensional organicism of the "floral line."

Opening the "geometric line" is a dress from the spring/summer 2004 collection of Lagerfeld's eponymous label (pl. 203) that is indebted to the mediaphilic sensibilities of the Pop Art movement. Made from silk crepe, it is hand painted with letters and numbers rendered in Futura, a sans-serif typeface designed by Paul Renner and released in 1927. Based on simple geometric forms—near perfect circles, squares, and triangles—that channel the modernity of the Bauhaus, the font epitomizes the minimalist aesthetic characteristic of Lagerfeld's label. For Lagerfeld, fashion was not the mute, unversed art that some critics imagine. Rather, like the designer himself, it is literate and intelligent, capable of conveying letters and linguistic form, as his "alphabet" dress loudly and loftily proclaims. Reconciling textile and text, the dress also projects a Barthian rhetoric: arranged in alphabetical order, the letters *KL* take on the weight and import of the designer's initials—a sign, at once boastful and fetishistic, recognized and appreciated by only the most astute and observant of logophiles. At the same time, the dress is inscribed with another form of personal expression, reflecting as it does Lagerfeld's voracious appetite for books and the written word, which led him to establish in 1999 his Librarie 7L, a bookshop dedicated to art, design, photography, and architecture (7L stands for 7, rue de Lille in the seventh arrondissement of Paris). Speaking of his insatiable bibliophilia in *The World According to Karl: The Wit and Wisdom of Karl Lagerfeld*, the designer commented, "Reading is the biggest luxury in my life, the thing that makes me happiest."

Just as the dress from Lagerfeld's eponymous label expresses the textual tendencies of Pop Art, that from Fendi's spring/summer 1997 collection (pl. 205) reflects the planar propensities of Cubism. The bold black-and-white zigzag pattern is formed through intarsia knitting that, similar to the woodworking technique of the same name, yields panels that appear to be inlaid or joined together like a jigsaw puzzle. Its dynamic diagonals simultaneously revel in flatness and reveal the figure, reconciling the analytical, two-dimensional lines of geometric forms with the sensual, three-dimensional lines of the human form. Lagerfeld expresses this resolution formally by interworking the black and white threads, creating a blurred effect at the borders. The same result can be seen on another dress from the collection (pl. 207), the pattern of vertical lines and forms of which anticipate those that distinguish the coat from Fendi's pre-spring 2014 collection (pl. 208). While the design of the latter was inspired by the world of informatics—specifically digital circuit boards—fittingly reflected in its laser-cutting technique, that of the former was inspired by the work of the Orphic Cubist artist Sonia Delaunay, explicitly a pochoir from the portfolio *Sonia Delaunay: ses peintures, ses objets, ses tissus simultanés, ses modes* (*Sonia Delaunay: Her Paintings, Her Objects, Her Simultaneous Fabric, Her Fashions*) (ca. 1925; see p. 34, fig. 36). The pattern's graphic impact is heightened by its central placement on the body, which conveys a "look-at-me" bravado and self-assurance akin to a slogan T-shirt, projecting an authority that is no less enigmatic and epigrammatic.

The ensemble from Chanel's autumn/winter 2003-4 haute couture collection (pl. 210) projects a similar self-assurance, stemming as much from its visual power as from its erudite source: Aleksandr Rodchenko's 1915 *Line and Compass Drawing* (see p. 34, fig. 37), one of a series of nonobjective compass-and-ruler drawings in which the Russian artist explores the expressive possibilities of mechanically created lines and their relationship to flat areas of black or color. While the ensemble reflects the faceted geometry and overlapping structures of the original drawing, Lagerfeld refutes both its flatness and its mechanical mode of production by rendering his version in paillettes, seed beads, and silk thread hand embroidered by the artisans at Maison Lesage, which required 100 hours of workmanship. Lesage also executed the graphic embroidery on the ensemble from Chanel's autumn/winter 2016–17 haute couture collection (pl. 214), which similarly disavows the flatness of its original source: Aubrey Beardsley's 1894 illustration *The Climax* (see p. 34, fig. 38), depicting a scene from Oscar Wilde's play *Salomé* (1891), in which Salomé prepares to kiss the severed head of John the Baptist. The embroidery on the jacket and the bustier of the dress—an endeavor that required 630 hours of handwork—was drawn from the background composition of concentric circles in *The Climax*, the circles representing stylized peacock feathers, a signature motif of Beardsley and, more generally, the Aesthetic movement, of which the illustrator was a leading proponent. This merging of the natural and the geometric is also reflected in the "explosion" ensemble from Chanel's autumn/winter 2017–18 haute couture collection (pl. 201), a marriage between the aesthetic sensibilities of Edouard Manet and Sonia Delaunay. It, too, is a union between the exquisite artisanry of the *maisons* Lesage and Lemarié, the former executing the pattern of circles and semicircles embroidered with paillettes on the bodice, and the latter creating at the waist and shoulders the three-dimensional flowers made of goose feathers hand painted to mirror the colors of the paillettes. In total, the dress necessitated 803 hours of craftsmanship.

FLORAL LINE

189 191 193 194 196 198 200

GEOMETRIC LINE

203 205 207 208 210 212 214

EXPLOSION

201

SKETCHES

188 190 192 195 197 199

202 204 206 209 211 213

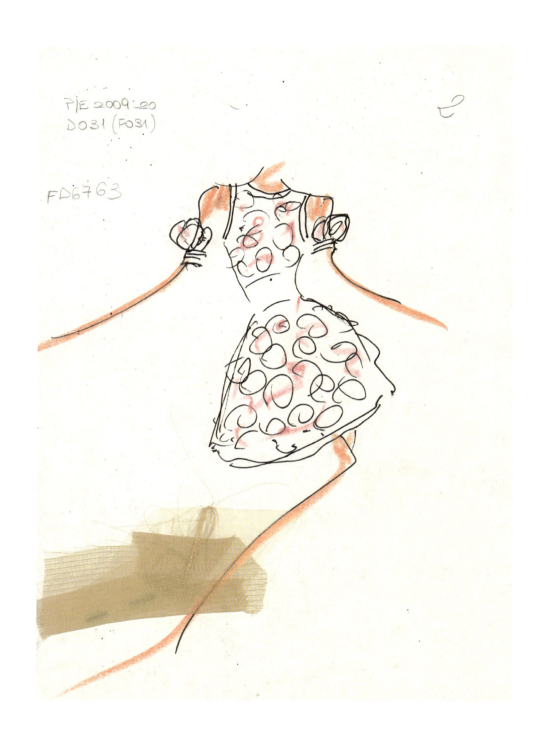

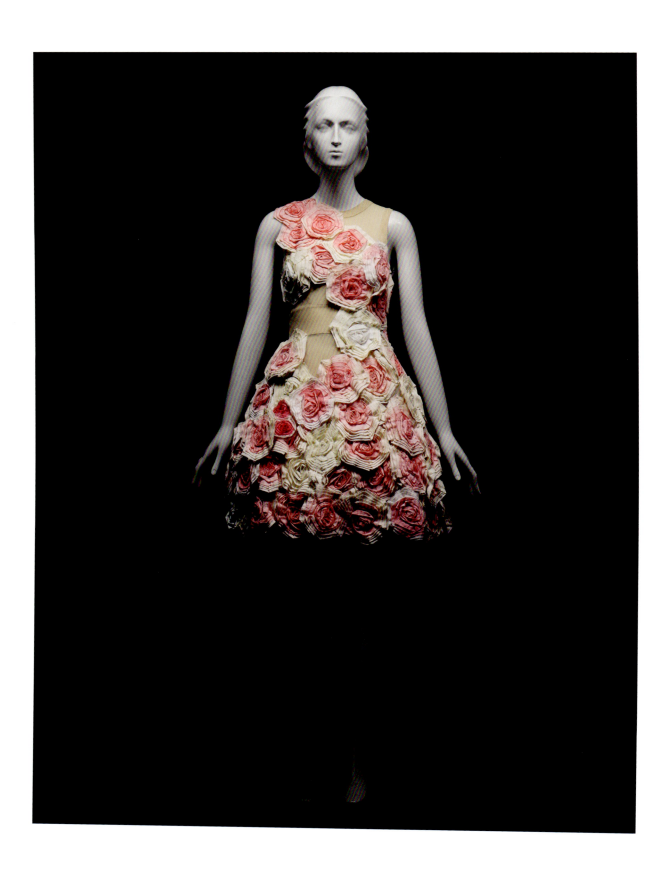

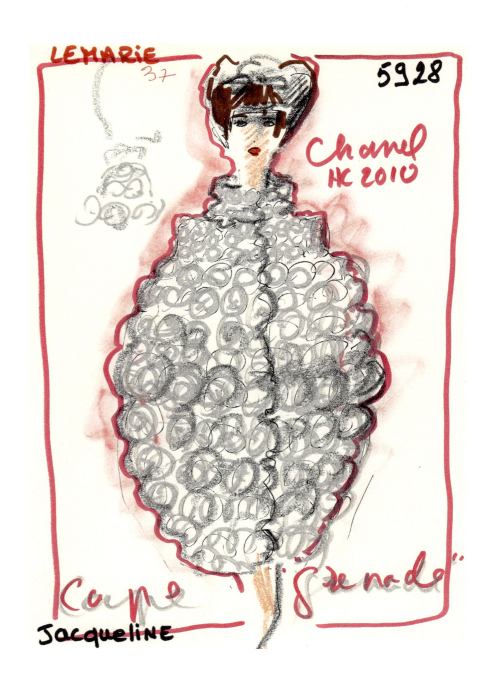

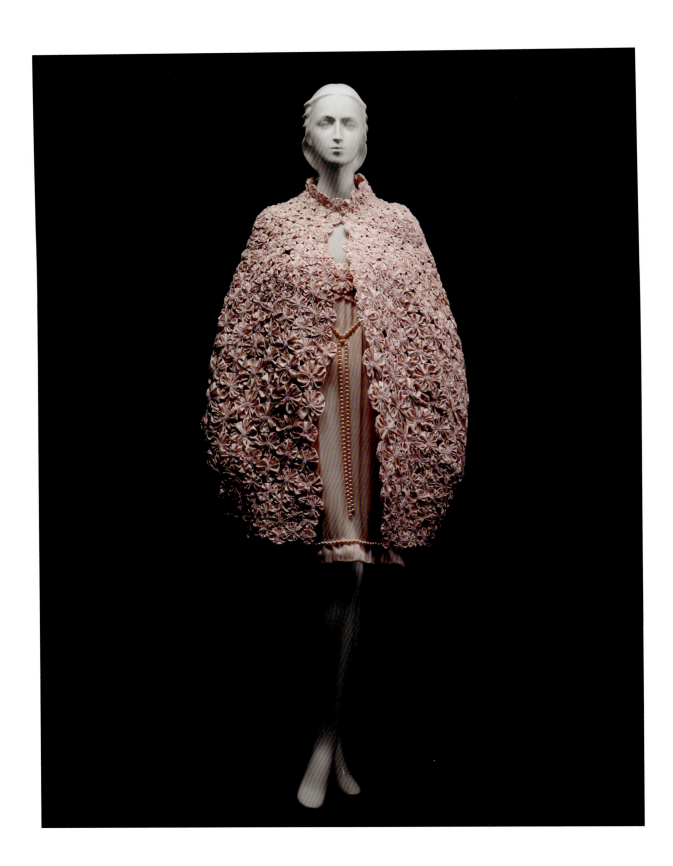

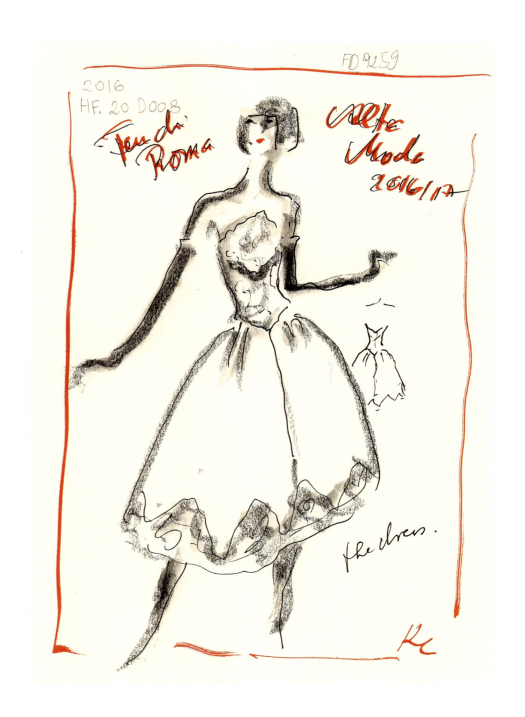

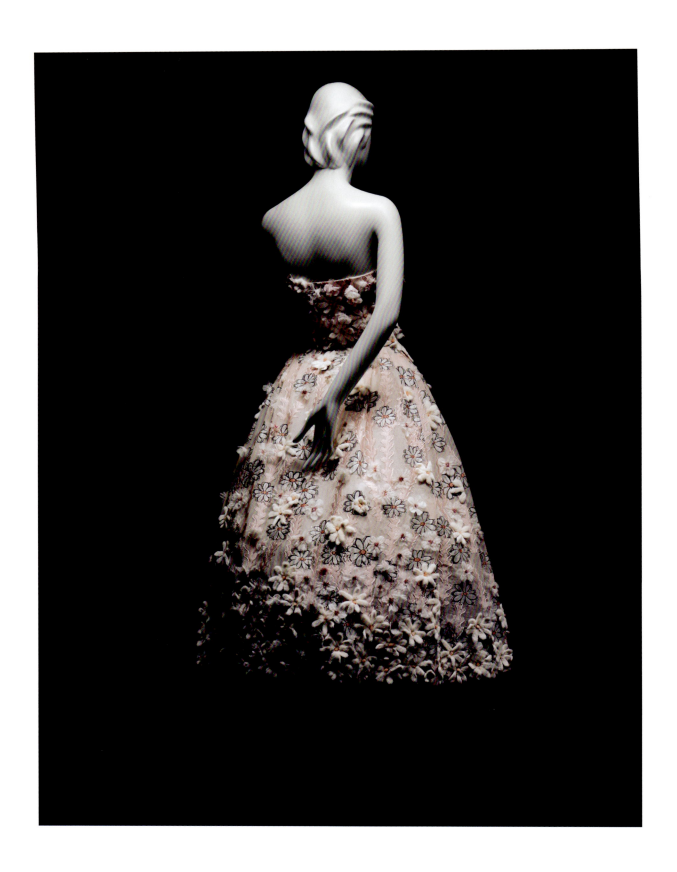

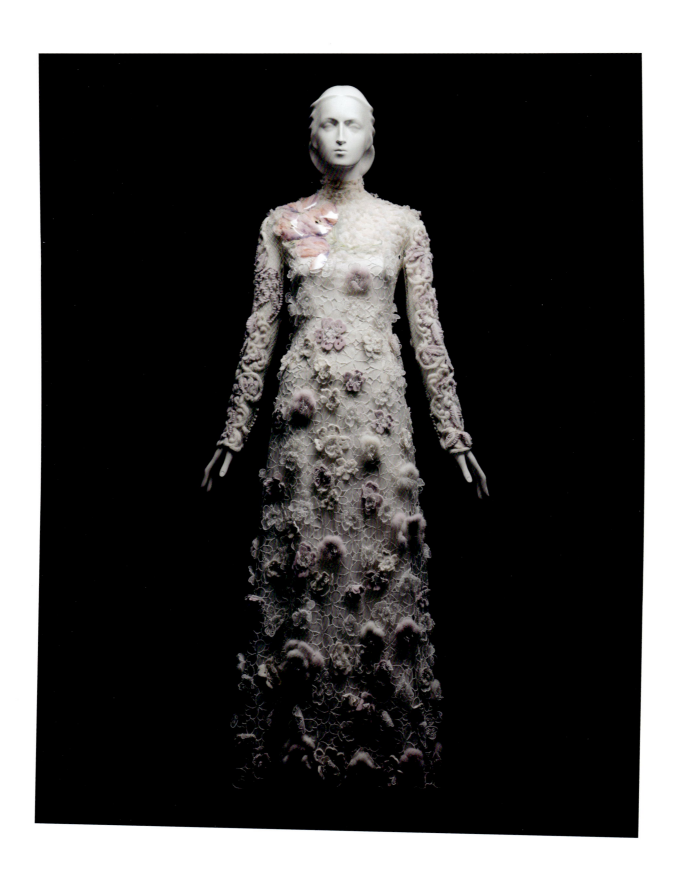

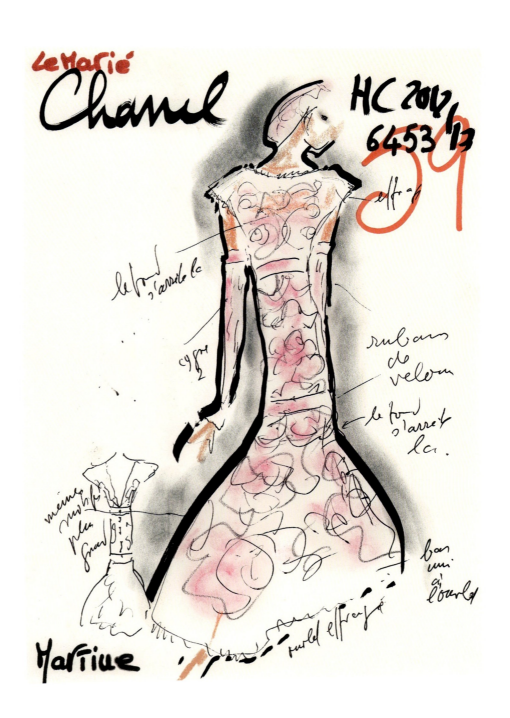

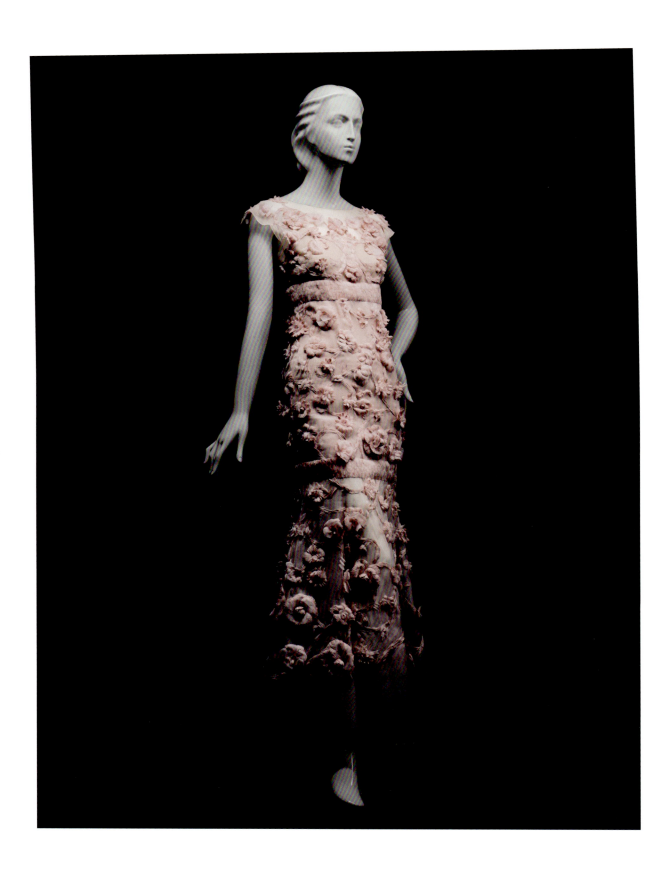

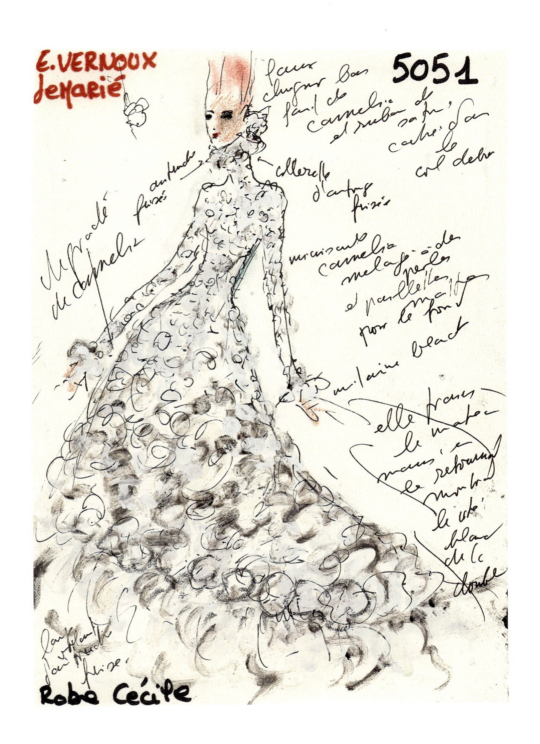

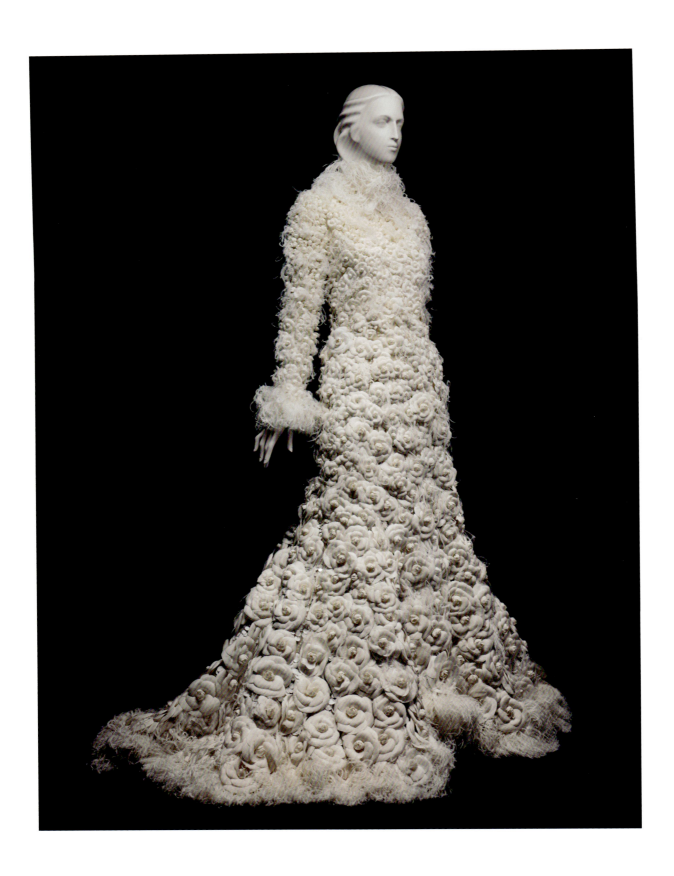

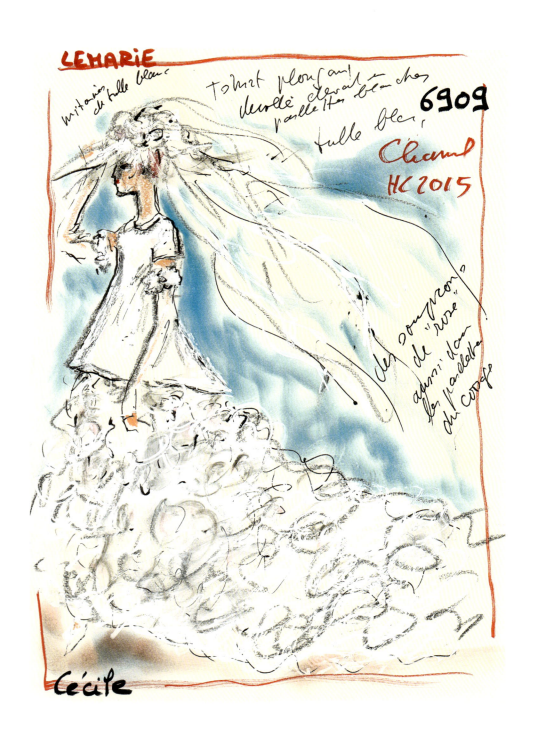

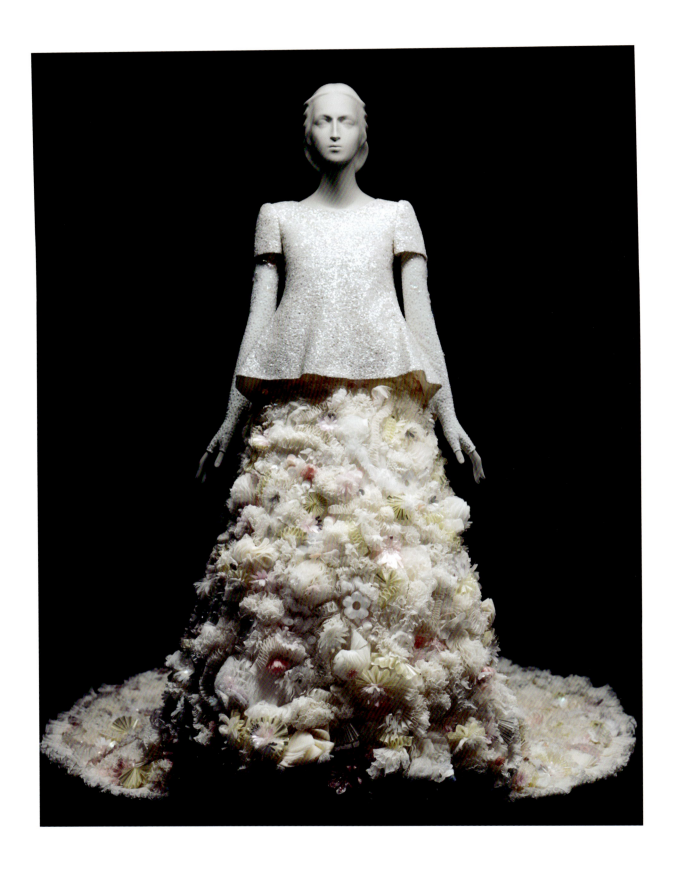

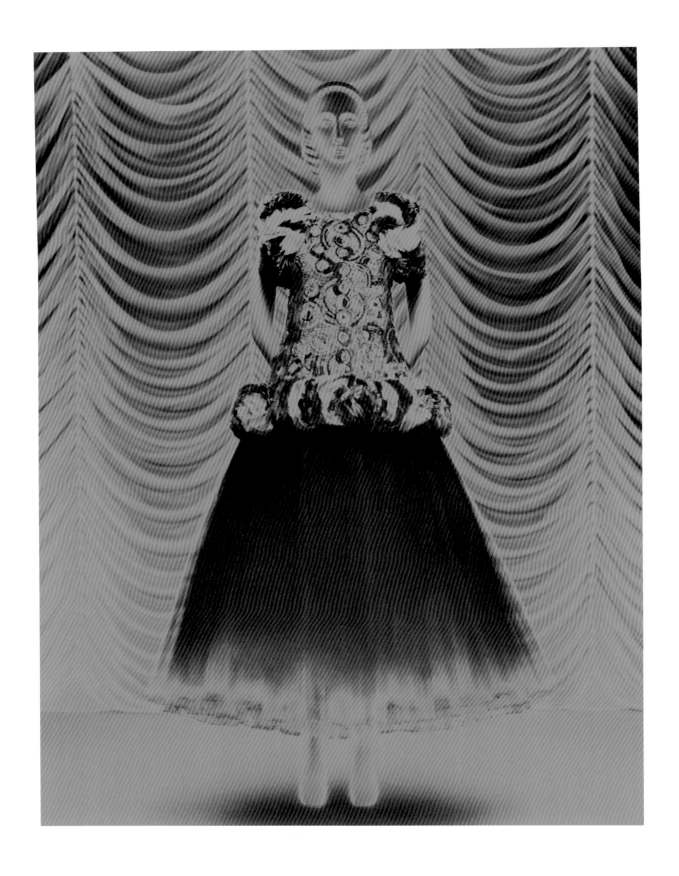

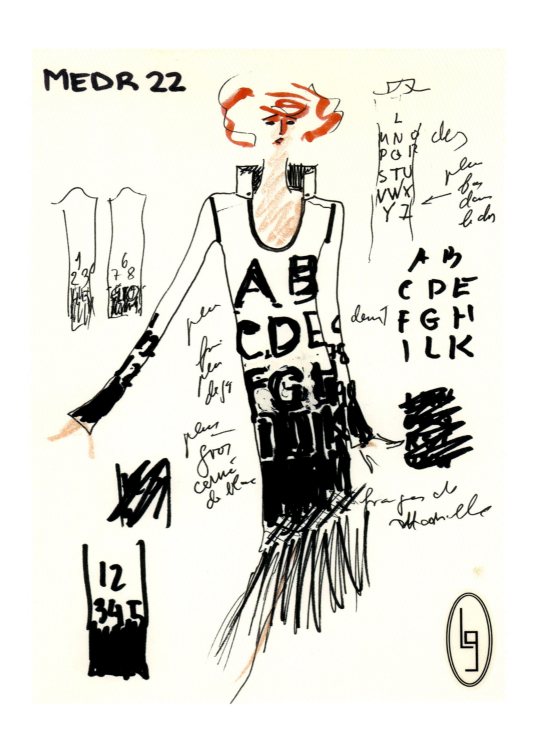

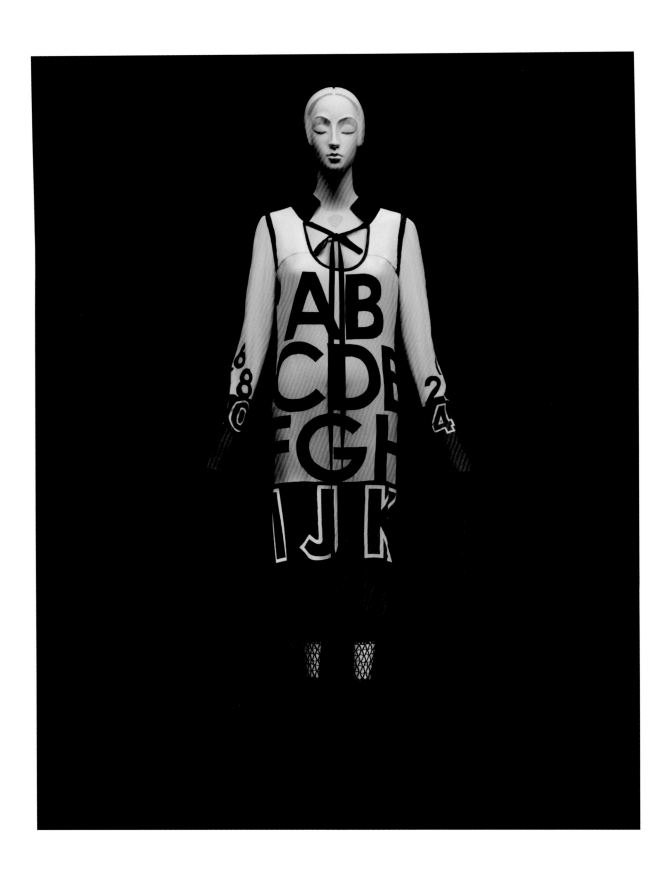

P/E 1997-20
D012 (F012)

530

aime S/S

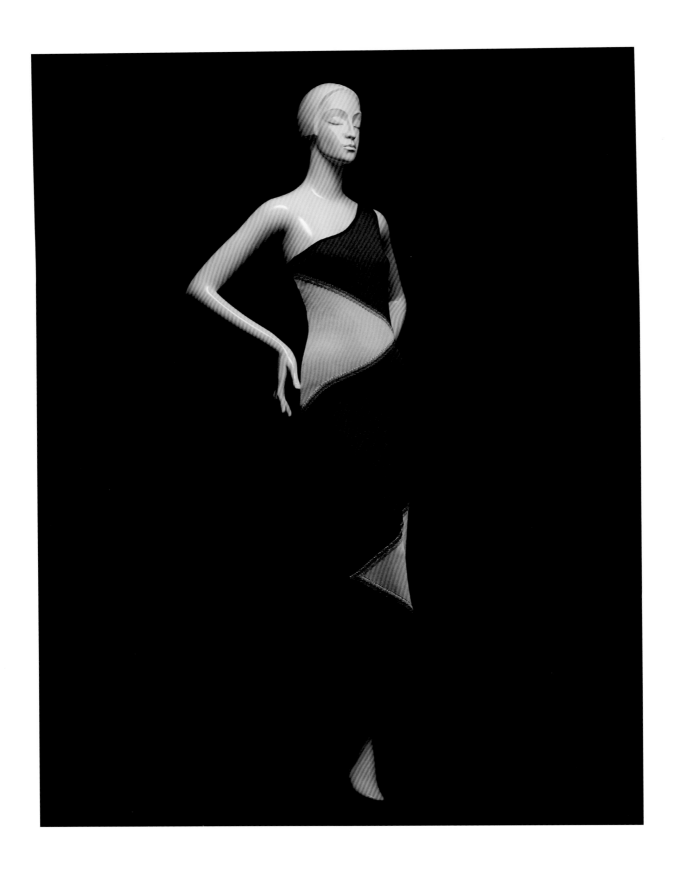

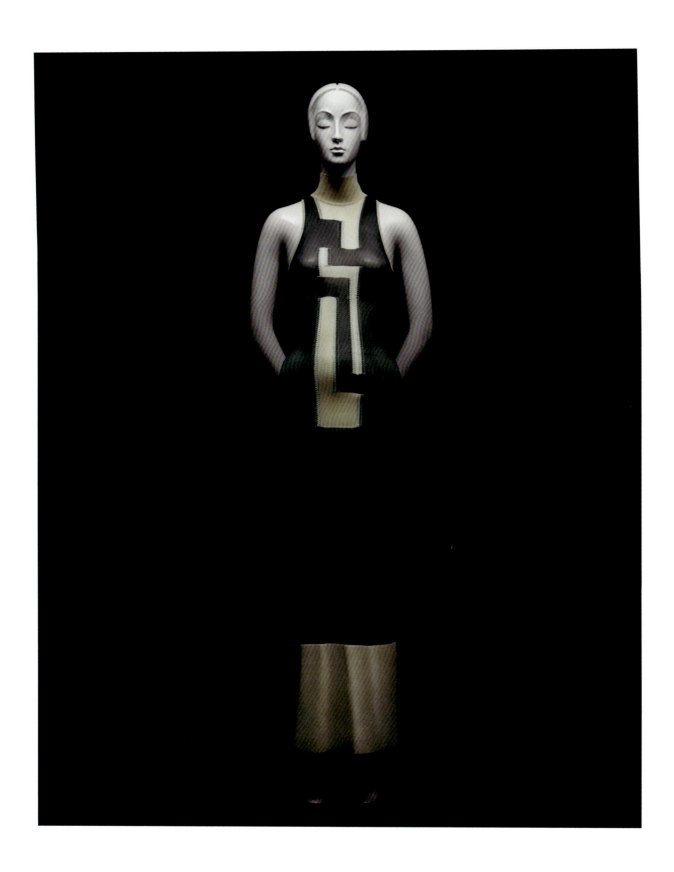

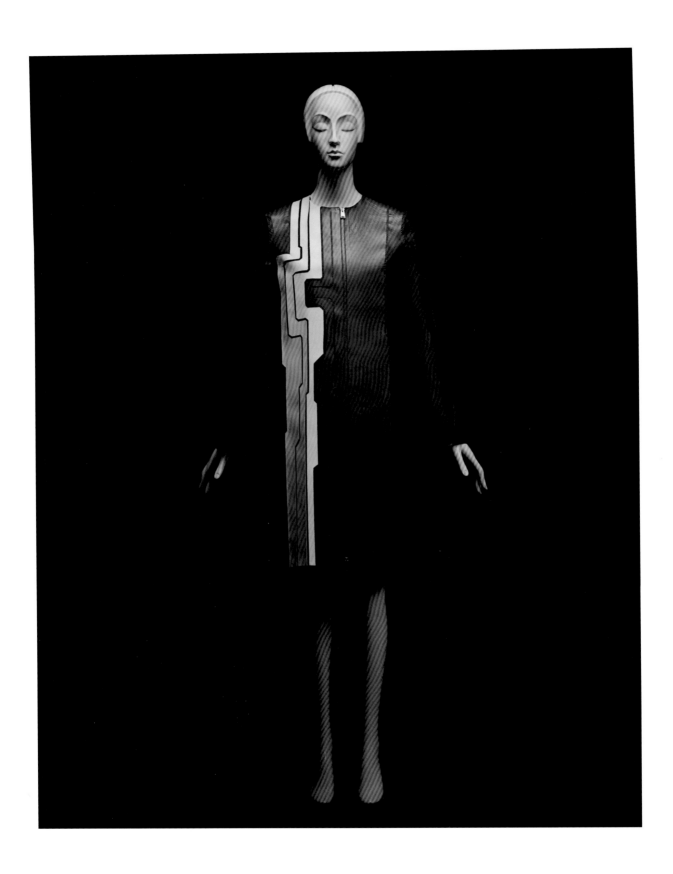

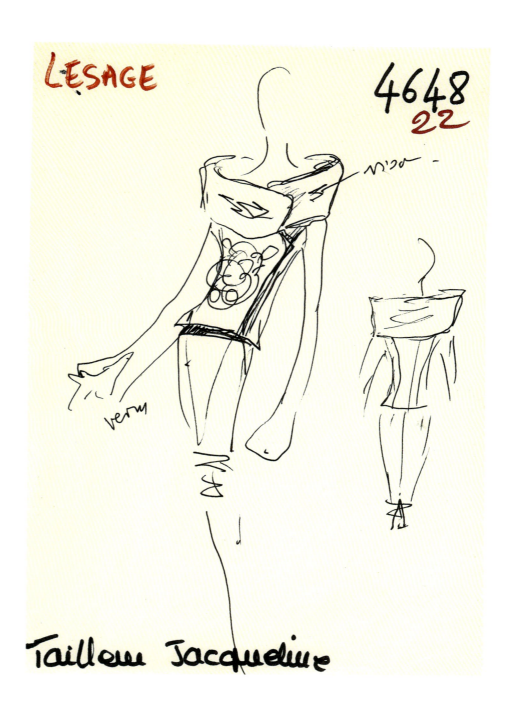

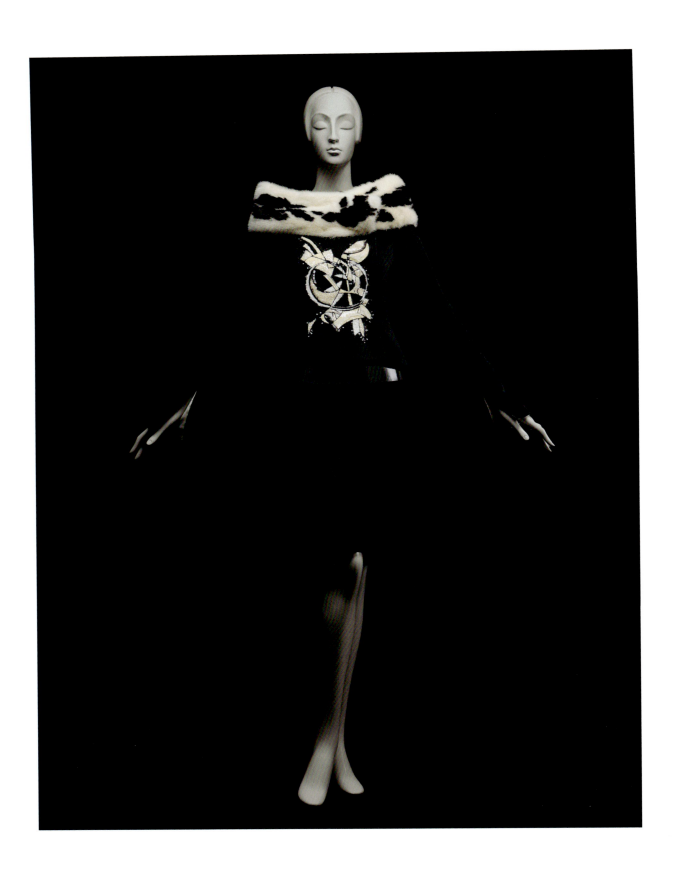

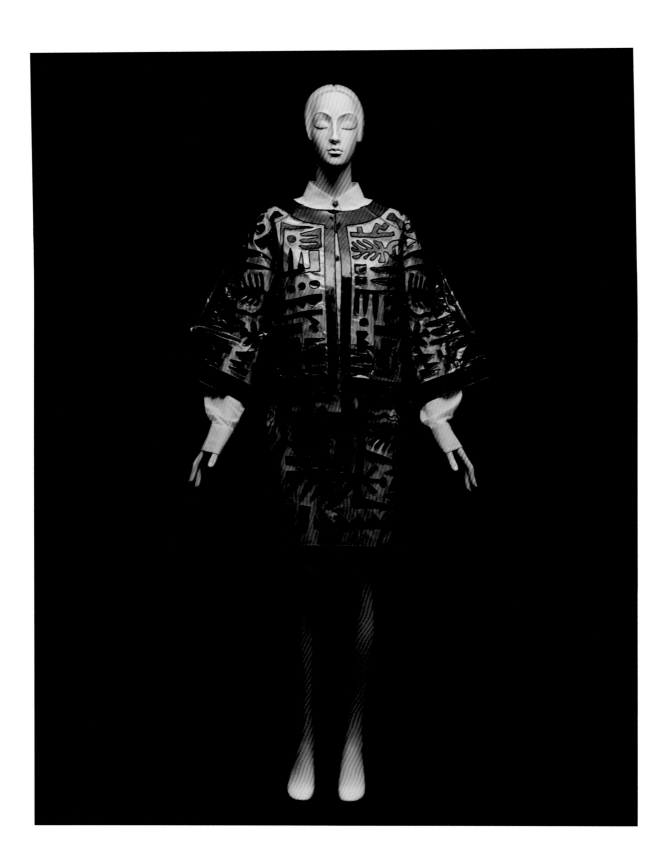

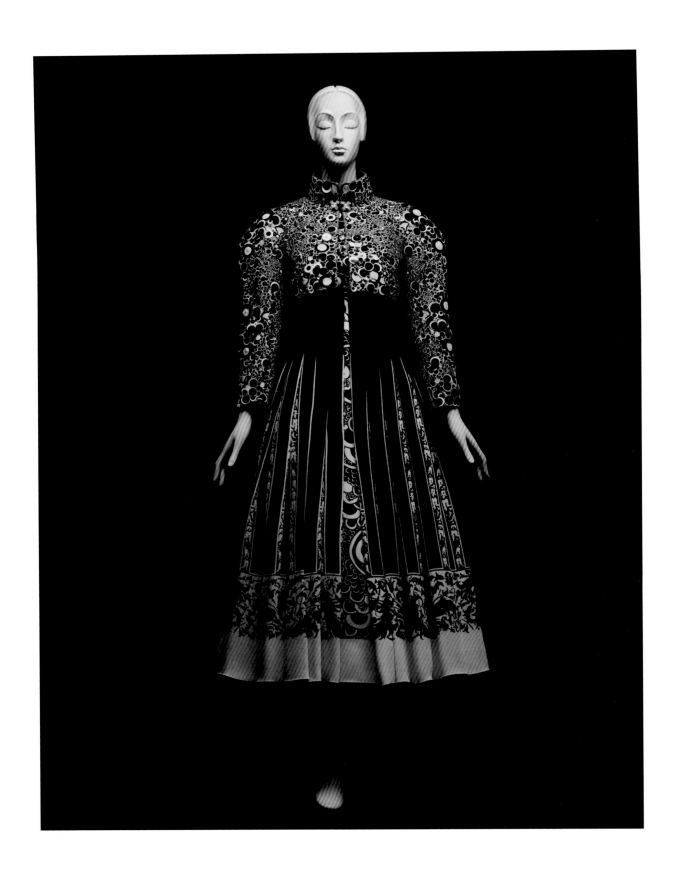

FIGURATIVE LINE

ABSTRACT LINE

Karl Lagerfeld held the strong opinion that fashion was a form of self-expression that reflected the artistic and cultural zeitgeist. He was adamant, however, that fashion was not art and that fashion designers were not artists. "We are artisans. Fashion is an applied art," he asserted in an interview for the *New York Times* (March 3, 2015). Like the German philosopher Immanuel Kant, who thought that fashion stemmed only from human vanity and social competition, Lagerfeld believed that the line between fashion and art was both immutable and immovable. According to the designer, his sole ambition was to make clothes that could be worn on the body and in the street. "I don't [make] work for the archives," he proclaimed in an interview for American *Vogue* (September 1991). "To make a dress that goes to the museum—that's not fashion, that's not life, that's not a dress." For Lagerfeld, fashion was not only intensely practical but irrevocably commercial, comprising a system and culture that was radically different from that of art. However, despite being deeply skeptical of the supposition that art and fashion are made of, animated by, and heading toward the same criteria, he often looked to fine art for both inspiration and information. As the "figurative line" and the "abstract line" demonstrate, Lagerfeld's connections between art and fashion ranged from the narrative to the non-narrative, and from the representational to the non-representational.

The "figurative line" begins with a silk charmeuse dress from Chloé's autumn/winter 1967–68 collection (pl. 215) featuring an image inspired by one of Lagerfeld's most respected and repeatedly referenced artists, Aubrey Beardsley (see pl. 214). Hand painted by Nicole Lefort, it reveals a detail from an illustration on the title page of volume three of *The Yellow Book* (October 1894; see p. 34, fig. 39), a British quarterly literary periodical published between 1894 and 1897, of which Lagerfeld owned a complete set. Beardsley was its first art editor, and he is credited with the idea of the yellow cover, which imitates the wrapped jackets of illicit French fiction of the period. The title page depicts a dichotic representation of the "new woman," expressive of both feminine and masculine characteristics. Dressed in the height of fashion, the woman on the left embraces the feminine ideal of the 1890s, while the woman on the right rejects it by adopting the masquerade of Harlequin from the Italian commedia dell'arte. The silk crepe dress, titled "Rachmaninoff," from Chloé's spring/summer 1973 collection (pl. 217) also features stock characters from the commedia dell'arte that Lefort hand painted and Lagerfeld collaged with reductive decorative elements from the luxurious bathroom in French fashion designer Jeanne Lanvin's Paris apartment at 16, rue Barbet-de-Jouy (see p. 34, fig. 40). Conceived by French interior designer-decorator Armand-Albert Rateau in 1920, and now in the collection of the Musée des Arts Décoratifs, the bathroom—constructed from marble, stucco, and antique green patinated bronze—combines geometric forms with plant and animal motifs that reveal classical and East Asian influences.

Lagerfeld's source of inspiration for the Fendi autumn/winter 2016–17 haute fourrure collection was more lyrical: illustrations from children's fairy tales. Titled "Legends and Fairy Tales," the enchanting, otherworldly collection celebrates the ninetieth anniversary of the founding of the design house and was presented at the Trevi Fountain in Rome. As a stream poured from under the feet of Oceanus, models strode through the fountain's basin as if walking on water, treading on plexiglass that formed a translucent runway across the pool. In her review for American *Vogue*, Nicole Phelps extolled that "it will go down as one of the most majestic show venues ever" (July 7, 2016). Alluding to a famous scene from Federico Fellini's 1960 film *La Dolce Vita*, Lagerfeld concurred: "I think this [is] the most interesting happening at the fountain since Anita Ekberg" (*WWD*, July 7, 2016). Lagerfeld's point of departure for the collection was the Danish artist Kay Nielsen's illustrations for the 1914 book *East of the Sun and West of the Moon*, a compendium of fifteen fairy tales gathered by the Norwegian folklorists Peter Christen Asbjørnsen and Jørgen Engebretsen Moe as they journeyed across Norway in the mid-nineteenth century. "It was in a way the mood of my childhood," the designer explained about his source of inspiration (American *Vogue*, July 7, 2016). Pieced and appliquéd in fur or rendered as prints, jacquards, and embroideries, several of Nielsen's illustrations appear on garments in the bewitching, dreamlike collection. Titled "Lassie and the Prince," the dress in plate 219 features an image that references one of Nielsen's drawings for the story "The Lassie and Her Godmother" and was created by British illustrator Kate Baylay especially for the Fendi collection (see p. 34, fig. 41). The image is both printed and hand painted on silk gazar to reflect the fine lines, delicate colors, and tonal variety of Nielsen's original artwork, which incorporates the influences of Romanticism, Art Nouveau, the Pre-Raphaelites, and Japanese woodblock prints filtered through a chilly Nordic modernism.

In addition to Nielsen's and Baylay's illustrations, the spellbinding Fendi collection also features work by the French artist Charlotte Gastaut, who, like Baylay, created her illustrations specifically for the collection. Gastaut's intricate die-cut drawings are a play on depth and light and shadow, as exemplified in her book *Swan Lake* (2016), which prompted the commissions by Lagerfeld. This quality is shown to full effect in the dress in plate 218, titled "The Young Bride in the Forest" (see p. 34, fig. 42). The dress is executed in velvet jacquard that has been hand painted, a labor-intensive technique developed in association with L'Atelier de Soierie in Lyons, France. Gastaut also created the image that appears on the coat in plate 220 (see p. 35, fig. 43); this variation of plate 218 is rendered in hand-cut, hand-dyed, and hand-sewn pieced mink. Although Lagerfeld claimed—vehemently—to be anti-nostalgic, he betrayed a romantic longing and sentimental attachment to his own past through the recurring motif of trees, which conjured memories of his childhood home in Germany, an estate called Bissenmoor, just outside of

bad Bramsted. Perhaps this memory lay behind the elegiac ensemble from Chloé's autumn/winter 1994–95 collection (pl. 221) that features a printed image inspired by French artist Maurice Denis's 1893 painting *Paysage aux arbres verts* (*The Green Trees*) (see p. 35, fig. 44). Denis's work depicts a mystical procession of veiled young women in a sacred grove, wherein one woman—the "initiated one"—distinguishes herself from the others and joins an angel through whom she can attain the "Absolute," or pure and unconditional faith in God. Despite its ethereality, the landscape portrayed in *Paysage aux arbres verts* actually existed and held personal significance for Denis: it was based on a forest in Loctudy near Perros-Guirec in Brittany, where the artist spent his honeymoon the year he executed the painting—an intimacy that surely would have resonated with Lagerfeld.

Closing the "figurative line" is a silk crepe Empire-line dress from Chloé's spring/summer 1974 collection (pl. 223) that features an image reminiscent of the illustrations of Georges Lepape and George Barbier for Lucien Vogel's *Gazette du Bon Ton* (1912–25); Lagerfeld both admired and collected Lepape and Barbier as much for their representations of the applied arts as for their depictions of the fashions of the period. The image on the "Turin" dress seems to be a composite of decorative and architectural elements taken from Lepape's and Barbier's illustrations, including urns, balustrades, and lattice trellises (see p. 35, fig. 45). It was hand painted by Lefort, whose work also appears on several of the dresses in the "abstract line," which expands and develops upon the artistic influences seen in the "geometric line," including the effect of multidisciplinary artist Sonia Delaunay's pioneering use of the Orphism art movement's bright colors and pure abstraction. For the "Lahore" ensemble from Chloé's spring/summer 1971 collection (pl. 230), Lagerfeld was inspired by Delaunay's "rhythm and color" paintings (see p. 35, fig. 46), which express her concept of *Simultanéisme* (Simultanism): a mode of art that rejects the representation of figures in favor of the "simultaneous contrast" of colors. The same vibrant colors, geometric shapes, and rhythmic patterns of Delaunay's "simultaneous" paintings are reflected in the coat from Fendi's autumn/winter 2000–2001 collection, titled "Inlaid Polychromes." The coat is made of shaved, hand-dyed mink inlaid with a complex pattern of circles, squares, and rectangles that is repeated in the printed silk foulard lining, establishing a "continuous exchange between color and geometry," as the design house show notes explain.

With its flat planes, cylinders, mutable optics, and dynamic motion that transfigures three-dimensional representation into two-dimensional abstraction, Cubism held a particular fascination for Lagerfeld maybe because, at its core, it is magnanimous, like the designer himself. Cubism is never pompous, striving, or affected—all the reasons Lagerfeld rejected the stamp of artist: "I don't have the self-proclaimed label 'artist.' Very pretentious," the designer explained in an interview for the *New York Times* (March 3, 2015). "If other people say it, it's very flattering, but if you start to say it yourself, you better forget about it." For the dress from Chloé's autumn/winter 1971–72 collection (pl. 232), Lagerfeld was inspired by the French artist Albert Gleizes, the self-proclaimed founder of Cubism who, along with Jean Metzinger, wrote the first major treatise on Cubism, *Du Cubisme* (1912). Hand painted by Lefort, the image on the dress is based on Gleizes's 1916 gouache *Danseuse Espagnole* (*Spanish Dancer*; see p. 35, fig. 47). Depicting a flamenco dancer, Gleizes breaks down the figure of the *bailaora* into a series of planes and geometric shapes in bright, contrasting colors that Lefort executes in psychedelic blue, pink, and yellow. Another dress from the same collection (pl. 234), also painted by Lefort, reveals influences from Juan Gris's 1917 painting *Harlequin with a Guitar* (see p. 35, fig. 48). Cubist painters often depicted Harlequin, whose checkered costume lent itself to dynamic intersections of geometric planes; Gris portrayed the character in approximately forty works made between 1917 and 1925.

As we have seen, Lagerfeld was fond of the trickster Harlequin and his tendency to act on whim and passion, perhaps because he represents the opposite of the designer himself. "I only like people who get high, who drink and smoke and do all the things I don't do," he remarked in *The World According to Karl: The Wit and Wisdom of Karl Lagerfeld*. The dress from Chanel's 2002–3 "Satellite Love" métiers d'art collection (pl. 235) was inspired by the watercolor *Costume pour Arlequin* by Valentina Khodasevich (see p. 35, fig. 49), a painter and stage designer closely associated with the Russian avant-garde, as reflected in her rendering of the Harlequin's bodysuit: a harmonious arrangement of geometric forms inspired by Constructivism. Dating to 1921, the drawing is likely a costume design for one of Sergei Radlov's productions for the Folk Comedy Theater in Petrograd, where Khodasevich worked from 1920 to 1922. Although Lagerfeld converts Khodasevich's practical bodysuit into a luxurious evening dress entirely embroidered in paillettes applied by Maison Lesage in the Lunéville technique over the course of 1,200 hours, he faithfully transposes the harmonious placement of geometric shapes on the body. Lagerfeld frequently took inspiration from the Russian avant-garde, whose abstractions often animate the surface of his designs for Fendi, Chloé, Chanel, and his eponymous label. In some instances, this influence is general and indirect, while in others it is precise and unequivocal, as with the "explosion" ensemble from Chanel's 2008–9 "Paris-Moscow" métiers d'art collection (pl. 224). The ensemble depicts a painted backcloth by the Cubo-Futurist artist Natalia Goncharova for scene two of Sergei Diaghilev's redesigned production of *L'Oiseau de feu* (*The Firebird*) (see p. 35, fig. 50), which premiered at the Lyceum Theatre in London on November 25, 1926. The image, which is knit into the hem of the coat and embroidered onto the front of the muff, features a stylized Russian cityscape of towers and minarets that reflects the synthesis of traditionalism and avant-gardism characteristic of Goncharova's work for the Ballets Russes.

Goncharova's art spanned a range of styles—namely, Primitivism, Impressionism, Fauvism, Cubism, Futurism, and Rayonism, which she cofounded with her life partner, Mikhail Larionov. Perhaps it was this open-mindedness that appealed to Lagerfeld, who viewed with both suspicion and derision fine art's obsession with taxonomies and their corresponding hierarchical arbitrations. This myopia, as well as what he perceived as the volatility of the contemporary art market and the gullibility of contemporary art collectors, was the catalyst behind his spring/summer 2014 collection for Chanel, which was presented at the Grand Palais in Paris against a backdrop of a clichéd, white-walled art gallery exhibiting seventy-five original artworks by Lagerfeld—many that were riffs on Chanel's house codes, and some with red dots next to their titles, as if they had been sold. "The idea came from people who overreact to art today," he told *WWD* (October 2, 2013). "It's all become a little too much." Titled "Chanel Art," the collection was shown to the strains of Jay-Z's "Picasso Baby" and included the silk dress in plate 227, the print of which was inspired by a color chart produced by Talens called "Couleurs à l'huile Rembrandt" (see p. 35, fig. 51); the color chart also inspired a coat from Fendi's autumn/winter 2000–2001 collection (pl. 229). "The prints are like brush strokes," Lagerfeld explained in the design house's show notes. "There are more than 150 colors." Was the collection a riposte to fine art's age-old biases against and prejudices toward fashion? Were the fashions presented elevated by the artworks on display and seeking their privileges, or vice versa? Was Lagerfeld drawing a parallel between the commerce of fashion and the commerce of art, or was the show in itself simply a Warholian expression of artful commerce? In an interview with *Crash* magazine, Lagerfeld was at once obtuse and plainspoken: "[The art world is] afraid we'll desacralize everything in their trash can" (winter 2013). According to the designer, a "New York gallery wanted to exhibit everything but we had to decline. A collector wanted to buy two pieces but we couldn't do it." Lagerfeld, it seems, believed that neither his artworks nor his fashions belonged in a museum; such a suggestion was antithetical to his conviction that both forms of creative expression were part of our everyday lived experience, forever changing and forever evolving.

FIGURATIVE LINE

215 217 218 219 220 221 223

ABSTRACT LINE

225 227 229 230 232 234 235

EXPLOSION

224

SKETCHES

216 222 226 228 231 233

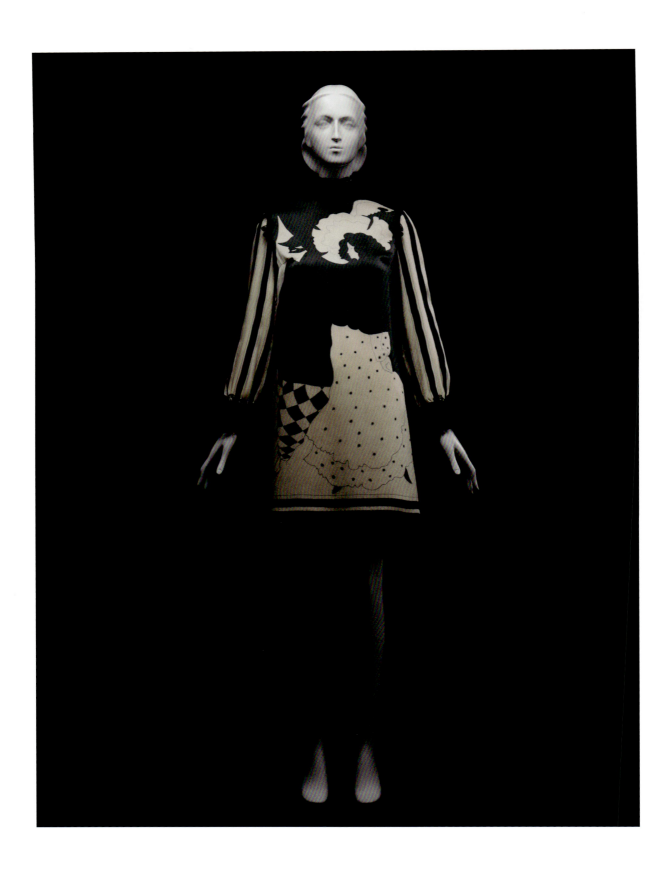

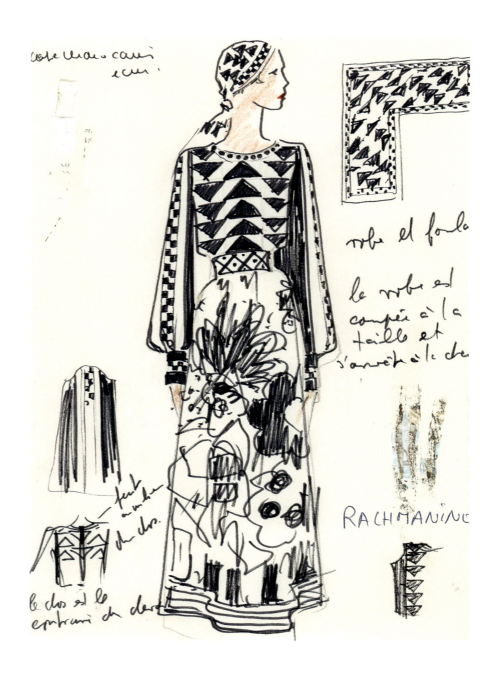

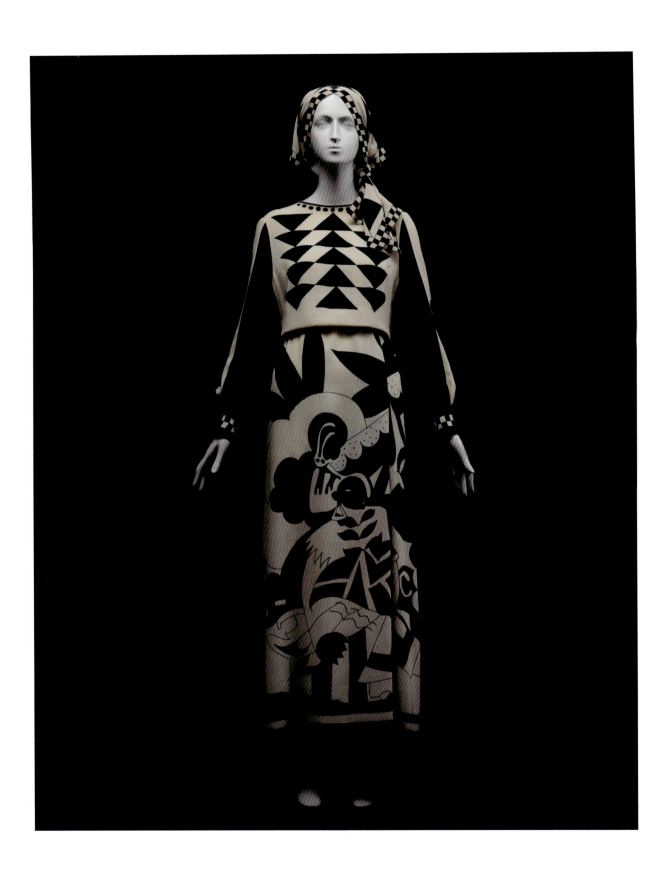

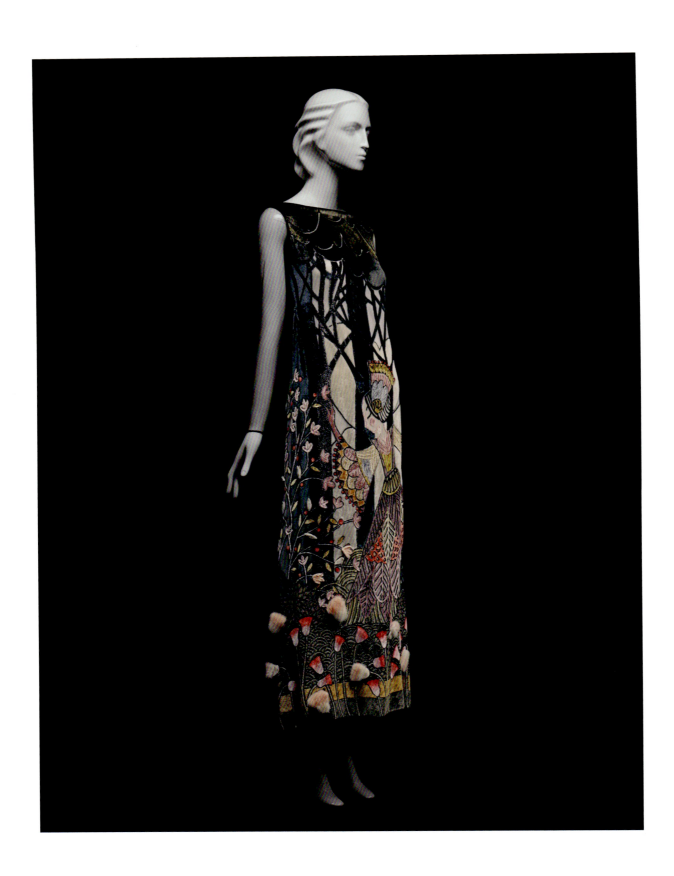

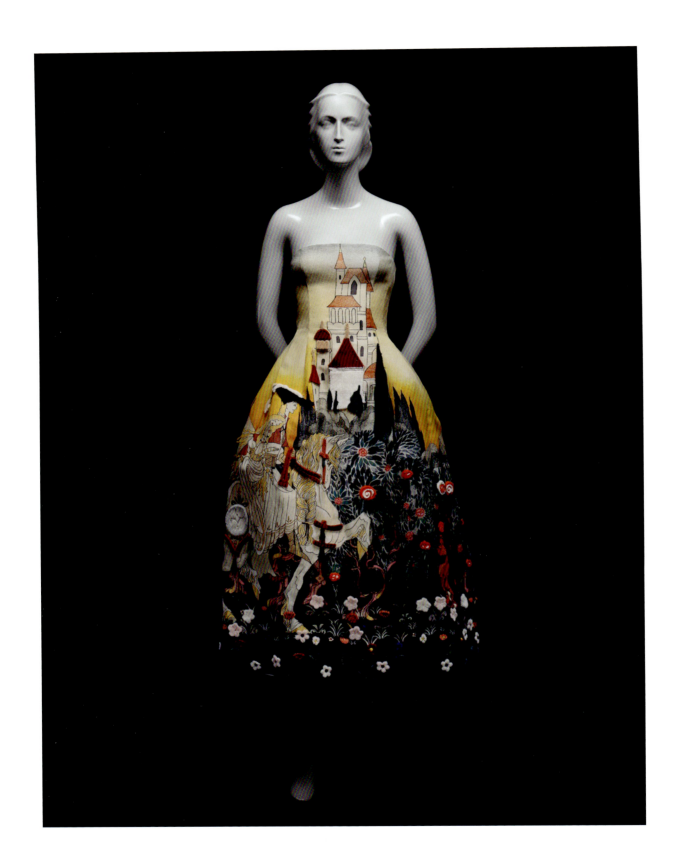

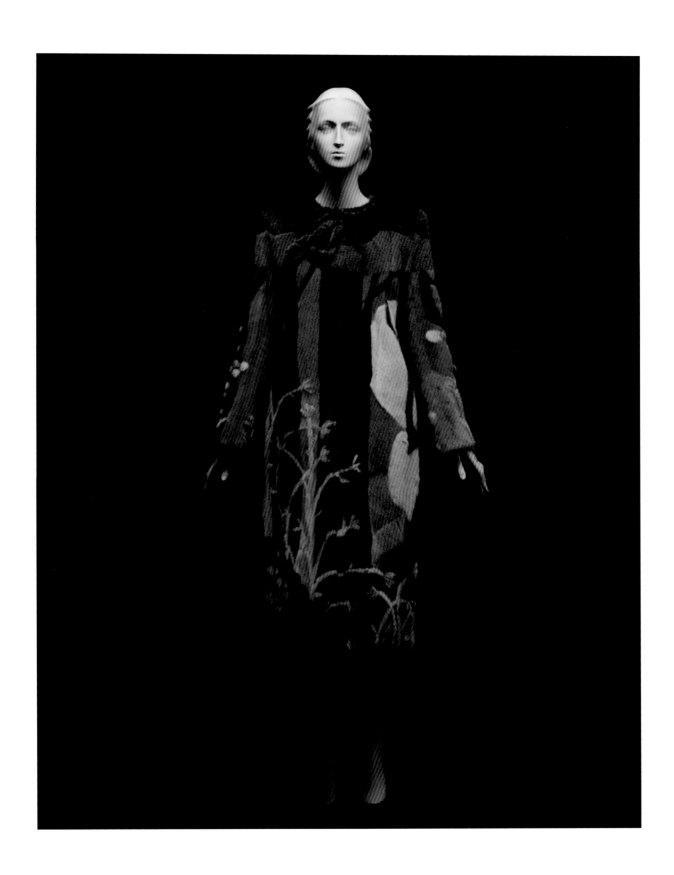

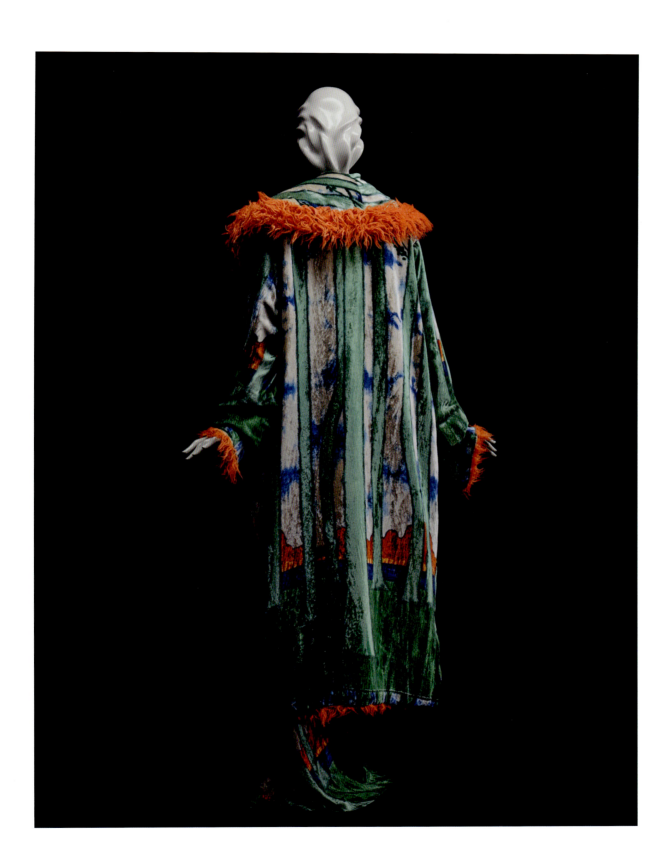

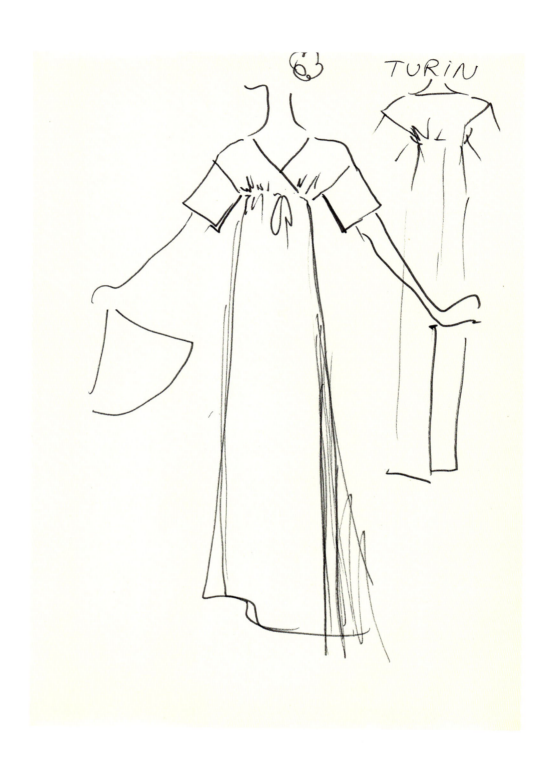

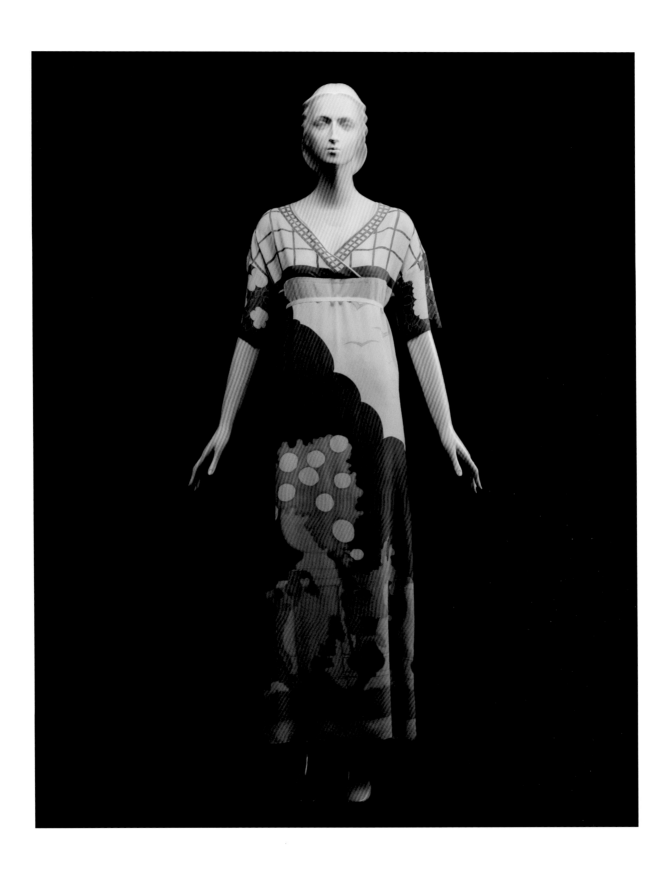

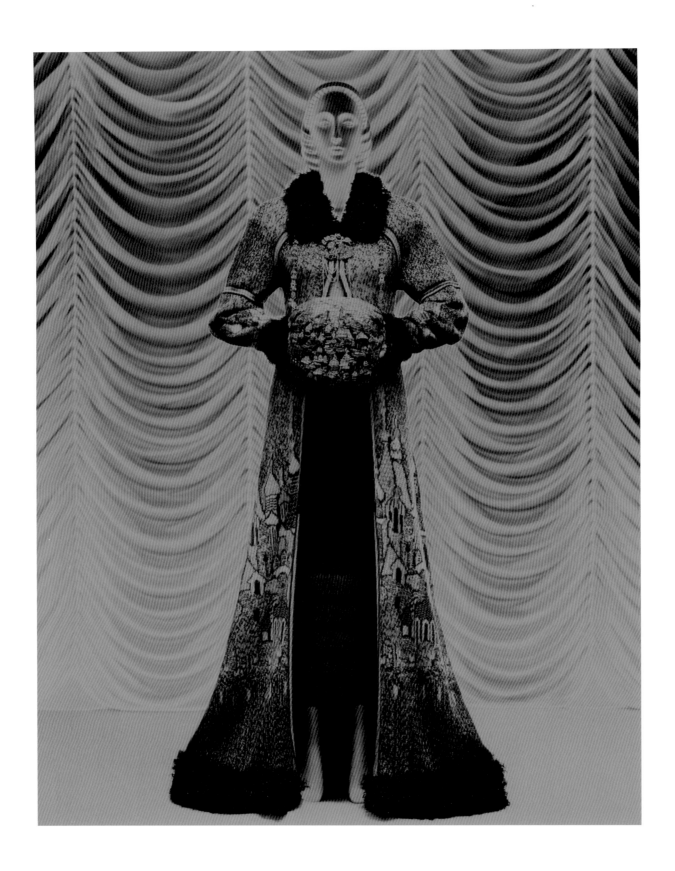

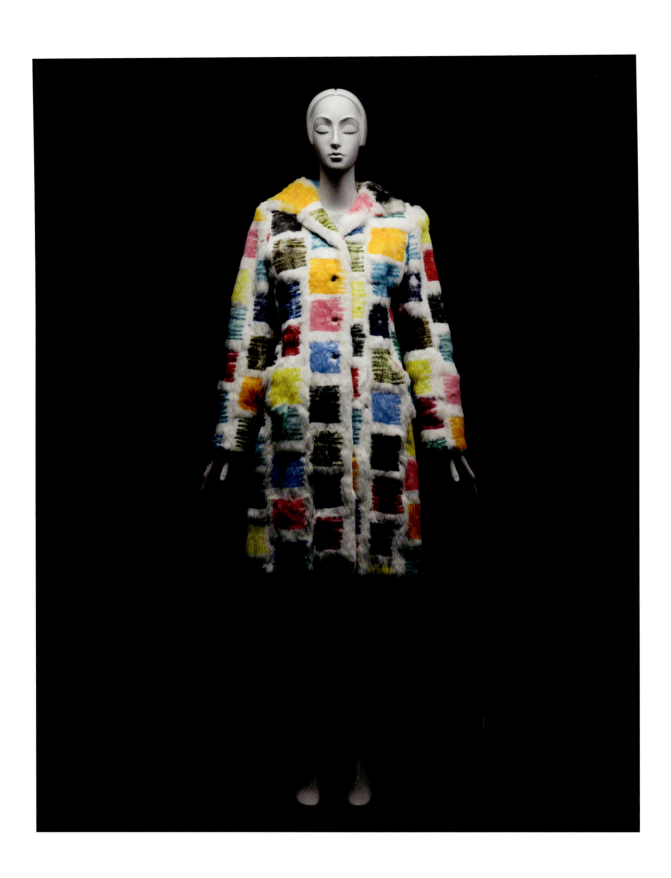

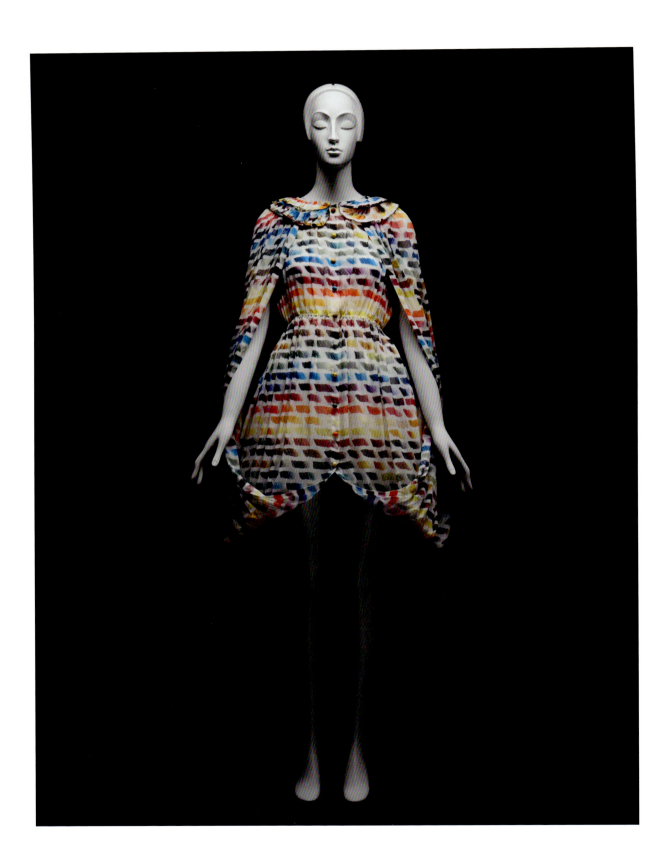

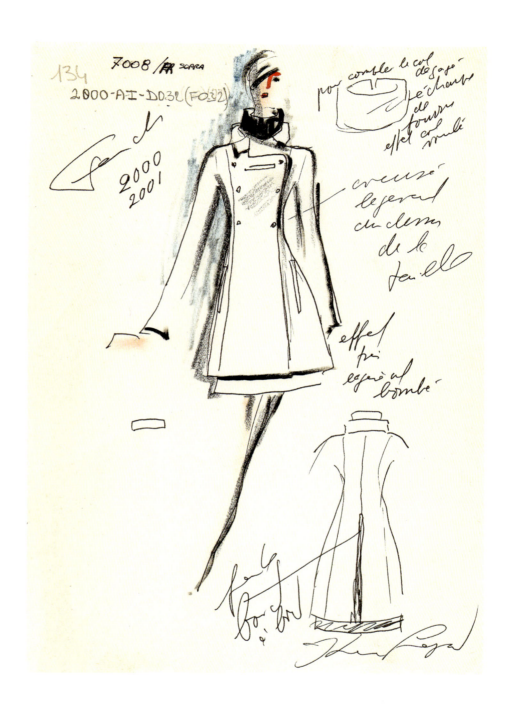

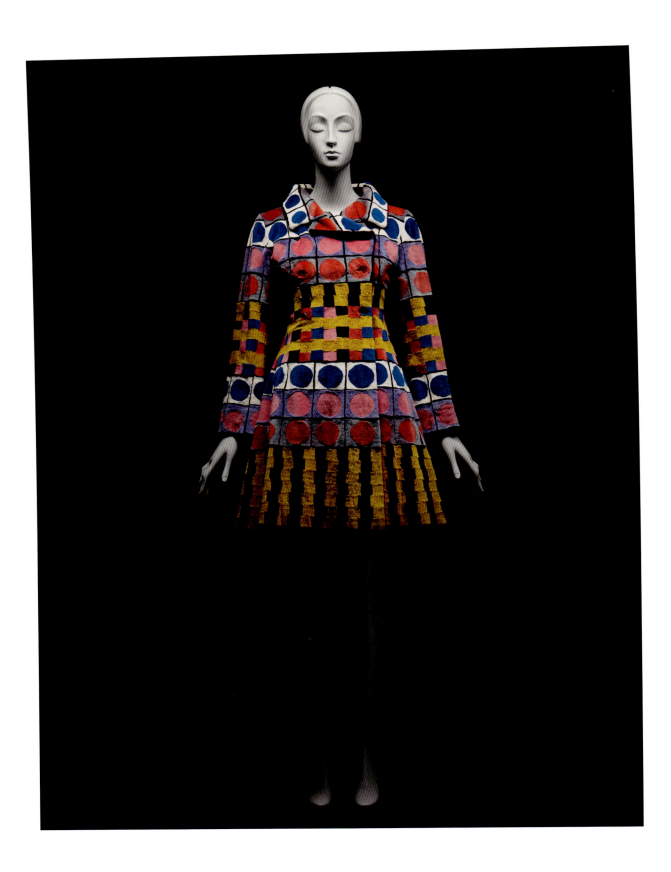

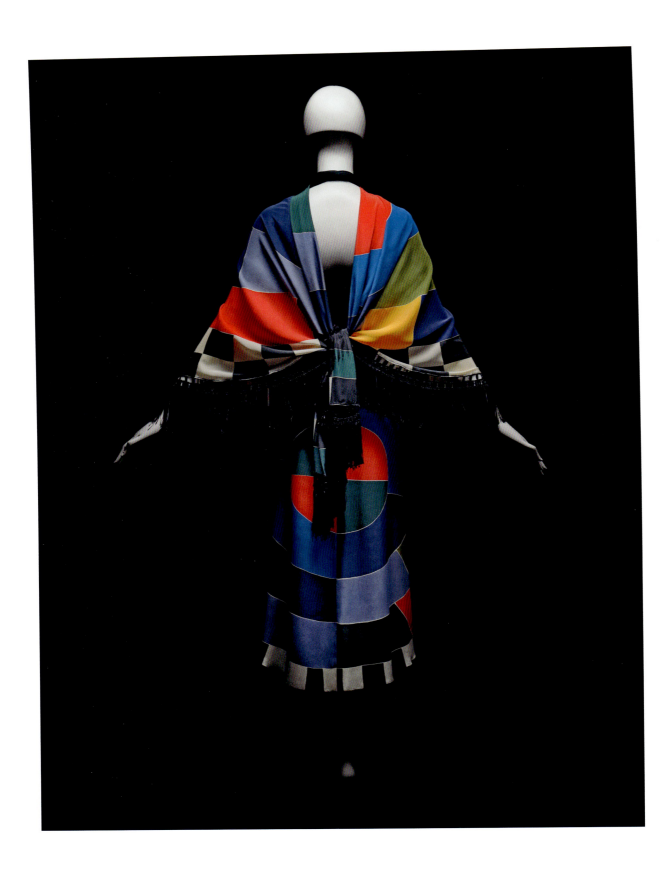

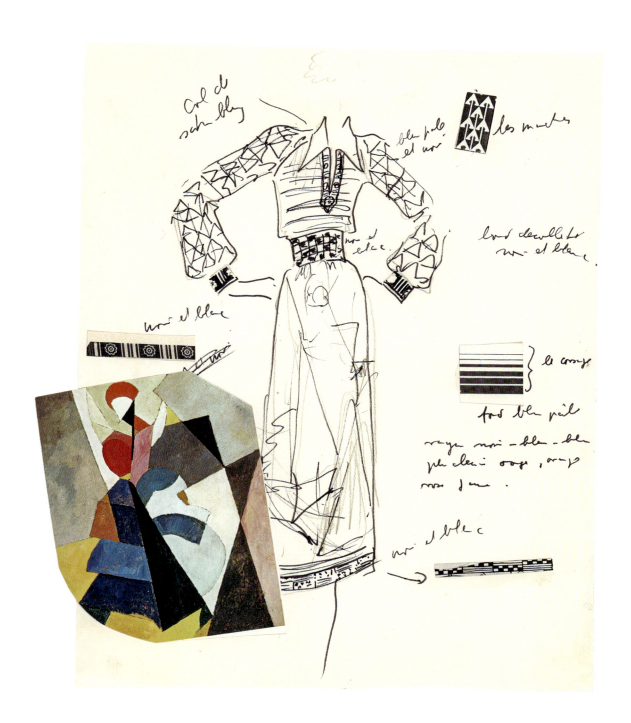

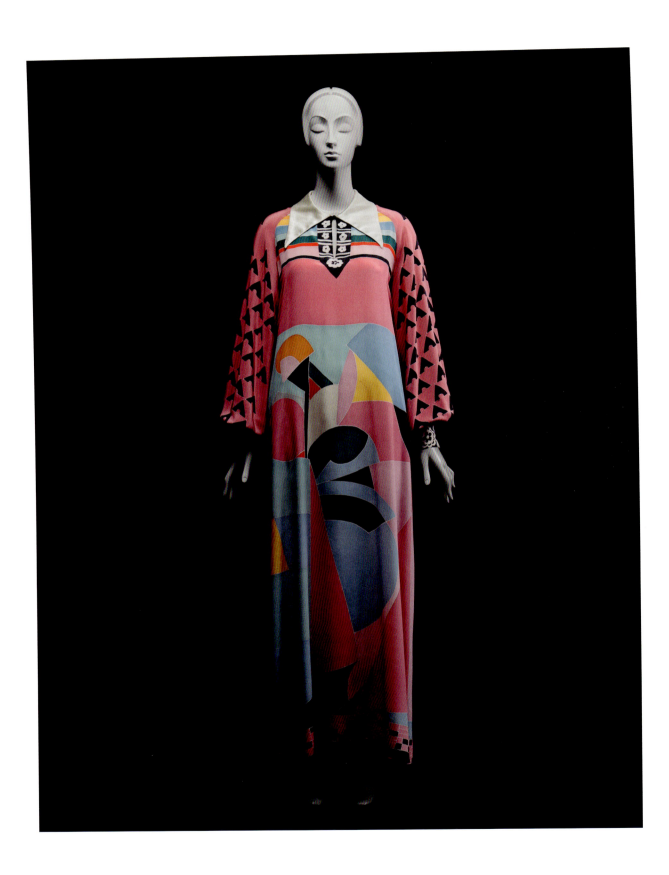

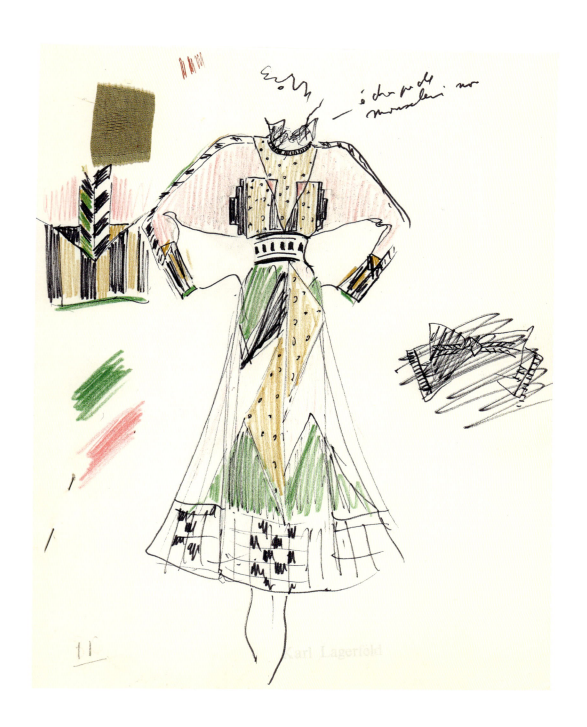

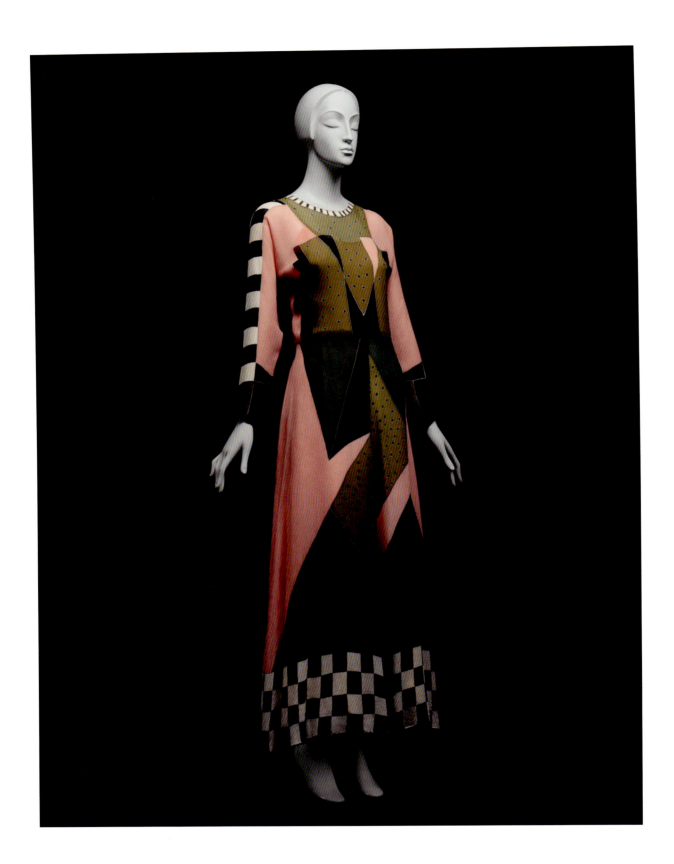

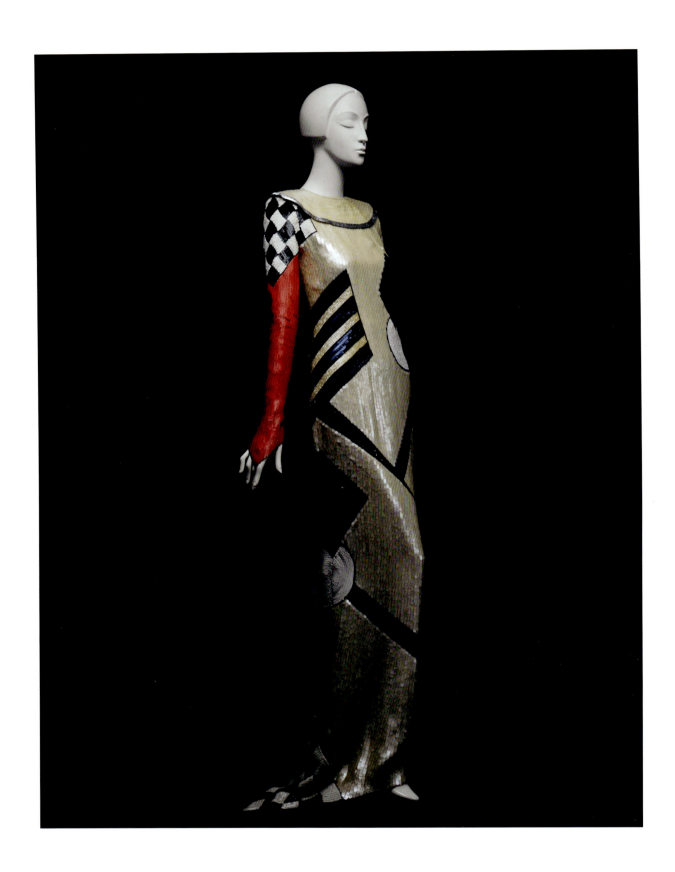

X

THE SATIRICAL LINE

Karl Lagerfeld's affinity for the eighteenth century extended beyond his couture inspirations and collecting practices to his own persona, modeling himself less on aristocratic and gentlemanly archetypes such as the philosophe, homme de lettres, and *homme du monde* but more on the eighteenth-century definition of wit, both as an abstract concept and as a form of behavior. In his *Dictionary of the English Language* (1755), the English writer Samuel Johnson outlined eight interpretations of wit: (1) "the powers of the mind, the mental faculties, the intellects"; (2) "imagination, quickness of fancy"; (3) "sentiments produced by quickness of fancy"; (4) "a man of fancy"; (5) "a man of genius"; (6) "sense, judgment"; (7) "sound mind, intellect not crazed"; and (8) "contrivance, stratagem, power of expedients." Lagerfeld embodied all these seemingly contradictory descriptions, and especially what Johnson regarded as the fundamental foundations of wit: knowledge, judgment, imagination, and novelty. These elements appear in all the preceding "lines" but perhaps no more audaciously as in the "satirical line," in which Lagerfeld manifests his wit in visual epigrams rendered in lavish embroideries that employ a variety of Surrealist strategies.

The "satirical line" begins with two black silk crepe dresses from the autumn/winter 1985–86 collection of Lagerfeld's eponymous label (pls. 236–37), both embroidered by Maison Lesage with *objets de luxe* that might be found in the well-furnished hôtel particulier of any prominent *maîtresse de maison*. The dress in plate 237 is embroidered with an eighteenth-century gilt-bronze clock similar to the one depicted in Jean-François de Troy's painting *La Lecture de Molière* (*Reading from Molière*; ca. 1728), which is at once Proustian and Woolfian in its symbolic significance. According to *Vanity Fair*'s "Proust Questionnaire," Lagerfeld's favorite "hero of fiction" was Virginia Woolf's Orlando, perhaps because he/she lives a life that comes close to being eternal: "I hate the idea of death—I prefer to disappear," was Lagerfeld's response to the Proustian question, "How would you like to die?" (September 2005). The designer undoubtedly appreciated Woolf's rejection of conventional time with its divisions between the past, present, and future, for he, like Woolf, believed in the Bergsonian concept of the simultaneous existence of all time, in which the past exists alongside the present. However, Lagerfeld's exquisitely embroidered clock—rendered in sequins and bugle beads—has a more direct reference to Woolf's *Orlando*: its hands are set at 12 o'clock, the time cited in the final sentence of the novel: "And the twelfth stroke of midnight sounded; the twelfth stroke of midnight, Thursday, the eleventh of October, Nineteen hundred and Twenty Eight." For the wearer of Lagerfeld's dress, time stands still: she lives in a state of permanent suspension—a sense of time that is at once palpable and abstract.

Embroidered on the other dress from the collection (pl. 236) are two decorative cords inspired by eighteenth-century gilt-bronze mounts, specifically those running down the attenuated cabriole legs of rococo *tables à ecrire*, or writing tables: the top of the cord reflects the corner mount; the bottom, the shoe or sabot. Letter writing was a much-practiced and fashionable activity among the literate in eighteenth-century Europe and one that Lagerfeld ardently shared; in his Paris apartment on the quai Voltaire, he had four tables reserved for specific usages: sketching, invoices, business correspondence, and private correspondence. The dress unites his passion for writing and his fervent love for eighteenth-century decorative arts, a biographical inscription that also has Surrealistic associations, specifically the ironic displacement of seemingly autonomous objects. It recalls the Italian designer Elsa Schiaparelli's infamous 1936 "Desk Suit," with its fictive drawers at the neck, chest, waist, and hips, inspired by Salvador Dalí's concept of the "City of Drawers," as represented in his 1936 sculpture *Venus de Milo with Drawers*. If Schiaparelli's "Desk Suit" tames the naked eroticism offered by Dalí, Lagerfeld's "desk dress" subdues it even further. Nevertheless, he retains some of the lasciviousness of Dalí's corporeal conceit by placing the embroidered gilt-bronze mounts directly over the wearer's legs. However, unlike Schiaparelli's transference between furniture and fashion, Lagerfeld's fusion is deliberately abstruse: it is not a joke to be enjoyed by everyone but, rather, one reserved for the connoisseur—comic relief for the aficionado of eighteenth-century decorative arts.

Lagerfeld's satirical synthesis of the surreal and the historical assumes a more democratic level of appreciation in the silk crepe column dress embroidered with a candlestick (pl. 244), also from his eponymous label's autumn/winter 1985–86 collection. While the form of the candlestick is based on a model by eighteenth-century rococo designer Juste-Aurèle Meissonnier, it can nevertheless be enjoyed by the pundit and non-pundit alike. However, Lagerfeld subdues the exuberant asymmetry and whirlwind motion of Meissonnier's original to establish a more direct association between the form of a candlestick and that of a woman's body. In true Surrealist fashion, when grafted onto the female figure, the candlestick becomes a surrogate for a woman, speaking of metaphor and metamorphosis. It evolves into a living form activated by the human figure; as its obdurate solidity is rendered flexible by the body, it comes to life like an animated cartoon, invoking images of Lumiere, the suave, charismatic candelabra in Disney's 1991 film *Beauty and the Beast*. At the same time, Lagerfeld's candlestick also evokes the somnambulant world of Surrealism, as reflected in René Magritte's 1930 painting *La Clef des songes* (*The Interpretation of Dreams*), in which a candle appears with other quotidian objects renamed to suggest a dreamlike subversion of reason (the candle is retitled *le Plafond*, "the ceiling"). Schiaparelli packaged her perfume "Sleeping" in a flacon shaped as a candle that, like Lagerfeld's candlestick, suggests nocturnal reverie and the transition from day to night, from the real to the imagined, and from the conscious to the subconscious.

As seen in Magritte's painting, Surrealism possesses a magnanimity that reveals itself in the democratic embrace of the humdrum and commonplace, a gesture sanctioned by the Surrealist movement's Dada progenitors. Lagerfeld shared this egalitarianism, for as much as he reveled in the rarefied, he also marveled at the mundane, as seen in his "Light Bulb"

dress from Chloé's spring/summer 1996 collection (pl. 245). Wonderfully misappropriated but in perfect harmony with the dress, the utilitarian light bulb is transfigured into alchemical embroidery executed by Maison Montex, dissolving its essential functionalism into superfluous ornamentation in this playful homage to Thomas Edison. Lagerfeld extends his tongue-in-cheek (mis)appropriations of vernacular objects and their redefined and non-contextualized displacements in his "shower dresses" from Chloé's autumn/winter 1983–84 collection (pls. 242–43), resulting in a humorous disruption of scale as well as status and association. Through his boldly inventive and beautifully executed embroideries, Lagerfeld cleverly converts the everyday into the exceptional, reconciling the ordinary and the extraordinary, the unremarkable and the remarkable. Unlike his "Light Bulb" dress, however, the ornamental embroideries on his "Bain" (pl. 242) and "Brise" (pl. 243) dresses, accomplished by the *maisons* Lanel and Chaste, respectively, are functional as well as decorative: the "handles" of the showerhead serve as straps that support and hold up each dress.

Most forms of dress afford limited opportunities for the satirical and Surrealist display of transposed and transformed objects, but the sheath dress presents a perfect canvas for this ironic and arresting interplay. In addition to its simplicity, the sheath dress clings to the curves of the body, offering clothing the potential to express metaphor and metamorphosis, which Lagerfeld exploits to its fullest in his "Angkor" dress from Chloé's spring/summer 1983 collection (pl. 240). The dress is embroidered with a violin by Maison Vermont, the violin's shape simulating a woman's sternum, breasts, waist, and hips. Lagerfeld transforms the wearer into a stringed instrument, an objectification that recalls Man Ray's 1924 photograph *Le Violon d'Ingres* (*Ingres's Violin*), a portrait presenting model and actress Kiki de Montparnasse as a surrogate for a musical instrument. Lagerfeld similarly imbues the guitar with gender in the dress in plate 241, also featured in Chloé's spring/summer 1983 collection. Reversing the metaphor of his "Angkor" dress, Lagerfeld uses the guitar—embroidered by Maison Lanel—to define the wearer's spine, hips, and derriere. Comparing a woman to an inanimate object is a conventional and commonplace vulgarism in Surrealism and one that Lagerfeld satirizes in his two sheath dresses. As with the embroidery in his "candlestick" dress, the embroideries here are animated by the body, converting his fictive violin and guitar into living instruments, parodying the idiom "to be played like a fiddle."

In his "Cintre" dress from Chloé's spring/summer 1984 collection (pl. 239), Lagerfeld satirizes the expression "to be a clothes hanger," presenting the hanger as an analogue to the human body, a surrogate for the living figure on which it hangs. His dress features embroidery by Maison Lanel depicting a trompe l'oeil sheath dress hung from a clothes hanger. Playing with the body's geometry, Lagerfeld aligns the hanger with the shoulders in a conventional Surrealistic provocation. The otherwise flat trompe l'oeil dress is given both form and life by the wearer, whose body it outlines. This elision between the real and the imagined and between perception and deception is furthered in Lagerfeld's sheath dress from Chanel's autumn/winter 1984–85 collection (pl. 238). The dress is embroidered with Gabrielle Chanel's iconic 2.55 quilted handbag with interwoven gold and leather chains slung nonchalantly over the right shoulder and resting on the hip. Trompe l'oeil is only effective if the duplicity is convincing—if there is some degree of realism and authenticity. The exquisite detailing of the embroidery executed by Maison Vermont makes Lagerfeld's deception plausible. The designer's subterfuge, however, does not end with simply tricking the eye, for the trompe l'oeil handbag cleverly conceals a pocket—an act of sartorial double jeopardy typical of Lagerfeld's visual witticisms.

Lagerfeld's greatest deception, however, was his own self-presentation, which, after years of self-study, ossified into a uniform in the early 2000s that was as instantly identifiable and recognizable as the uniform that Chanel fashioned for herself in the mid-1950s. As with Chanel, Lagerfeld looked to the dandy for his self-styling, adopting the principles of rigor and restraint, severity and strictness, and precision and perfectionism established by George "Beau" Brummell, the prototypical dandy of the late eighteenth and early nineteenth centuries (see p. 30, fig. 4). This exactitude, which extended to Lagerfeld's dietary and physical regimen, revealed itself in slim-cut jackets by Hedi Slimane (pl. 256) and high-neck shirts by Hilditch & Key (pl. 258). It was a look that was at once modernist and historicist, an artful mash-up that extended to his accessories: ties by Hilditch & Key (pls. 260, 264); fingerless gloves by Causse and Chanel (pl. 250); jewelry by Chrome Hearts (pl. 246); and a range of fans (pl. 252) and sunglasses (pl. 248) that, like his powdered ponytail, predate his early-aughts uniform. The color palette that Lagerfeld preferred was just as specific as the components of his wardrobe: black and white, a manifestation of Charles Baudelaire's description of the nineteenth-century dandy as the "Black Prince of Elegance." Lagerfeld, whose self-proclamations were as self-conscious as his self-presentation, described himself as "a black and white person," as noted in *The World According to Karl: The Wit and Wisdom of Karl Lagerfeld*.

In classic dandy fashion, Lagerfeld's meticulously constructed image and carefully considered words established a visual and verbal coherence that prioritized style over substance. It is precisely this privileging that underlies Lagerfeld's deception, for it allowed him to operate on the level of surfaces, deflecting deeper meanings or probing analyses. "With me there's nothing below the surface," he was fond of saying. Ultimately, Lagerfeld's globally recognized black-and-white uniform was a cloak of invisibility, making it possible for him to hide in plain sight and pass incognito on the world stage. To deepen the deceit, Lagerfeld deliberately lent himself to caricature: "I am like a caricature of myself," he proudly proclaimed. "Like a mask. For me, the carnival of Venice lasts all year" (*The World According to Karl*). Channeling Andy Warhol, another dandy, Lagerfeld presented this caricature as a commercial experiment through various representations of his black-and-white look, primarily in collections for Chanel (pls. 259, 261, 263, 265) and his eponymous label (pls. 249, 255, 257). The apogee of this Warholian experiment, however, was his 2004 collaboration with the high-street chain H&M (pls. 251, 253). "[H&M] is a fashion phenomenon and I like to be a part of those things," Lagerfeld explained in *WWD* (September 17, 2004). "Also, I like the idea of my name being used on a broad scale." The thirty-piece capsule collection, which comprised designs for men as well as women and even featured a unisex fragrance called "Liquid Karl," was limited to a black-and-white color palette and included jackets, shirts, and accessories—ties, rings, sunglasses, fingerless gloves—based on Lagerfeld's personal wardrobe.

To enhance the intimacy—and duplicity—of the association, Lagerfeld starred in the advertising campaign alongside the model Erin Wasson, wearing what seemed to be his own clothes but what were in fact pieces from the H&M menswear collection. In one of the images, Wasson models the cornerstone of the collaboration: a white T-shirt printed with a graphic representation of Lagerfeld's face and shoulders (pl. 251), signed by the designer, fulfilling his infamous comment, "I am a living label. My name is Labelfeld not Lagerfeld." The public reception of the collection was overwhelming, as reported in the *WWD* article "Mad for Karl: Fights Break Out Over New H&M Line" (November 15, 2004). Lagerfeld himself was surprised by the response, later reflecting, "I never expected it to make such a splash" (*H&M: The First Ten Years Designer Collaborations*). The broad appeal of the collaboration simultaneously iconized and magnified Lagerfeld's name and image, which the designer continued to promote in his designs for Chanel, Fendi, and his eponymous label. Accessories, in particular, were an effective vehicle for self-promotion, as seen in the "Karlito" charm from Fendi's autumn/winter 2014–15 collection (pl. 247), which (re)presented Lagerfeld as a "dolly" or "puppet" reduced to the elements of collar, tie, sunglasses, and ponytail. While propagandistic, the metal mesh bag from his own label's spring/summer 2009 collection (pl. 249) betrays a vulnerability that the designer rarely succumbed to in life: his distinctive sunglasses, which form the handles of the bag, are without their protective lenses. "The emotions expressed by the eyes, they're not something I really want to put on the market," Lagerfeld confessed in *The World According to Karl*. "That's why I wear dark glasses."

SATIRICAL LINE

236 – 266

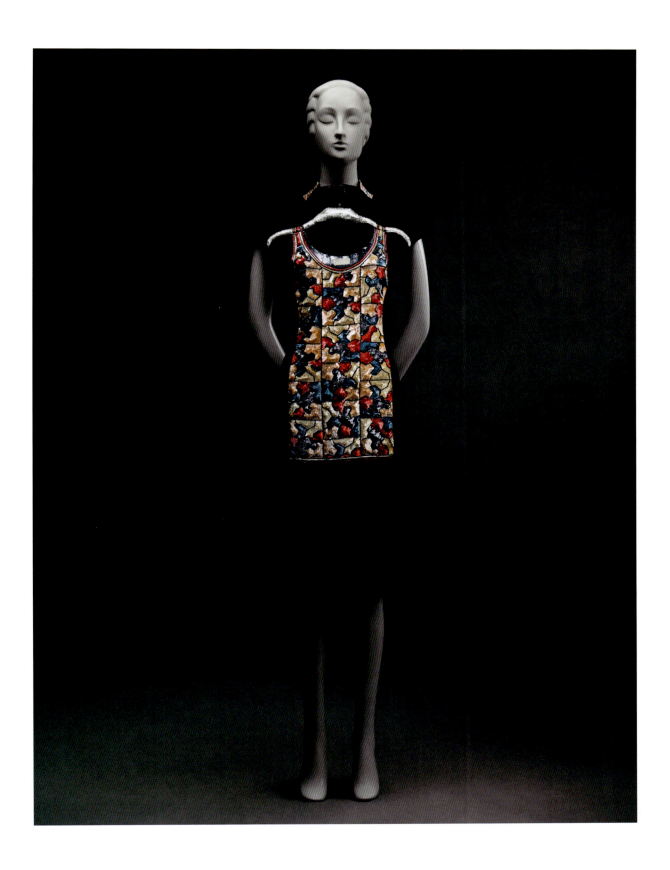

239

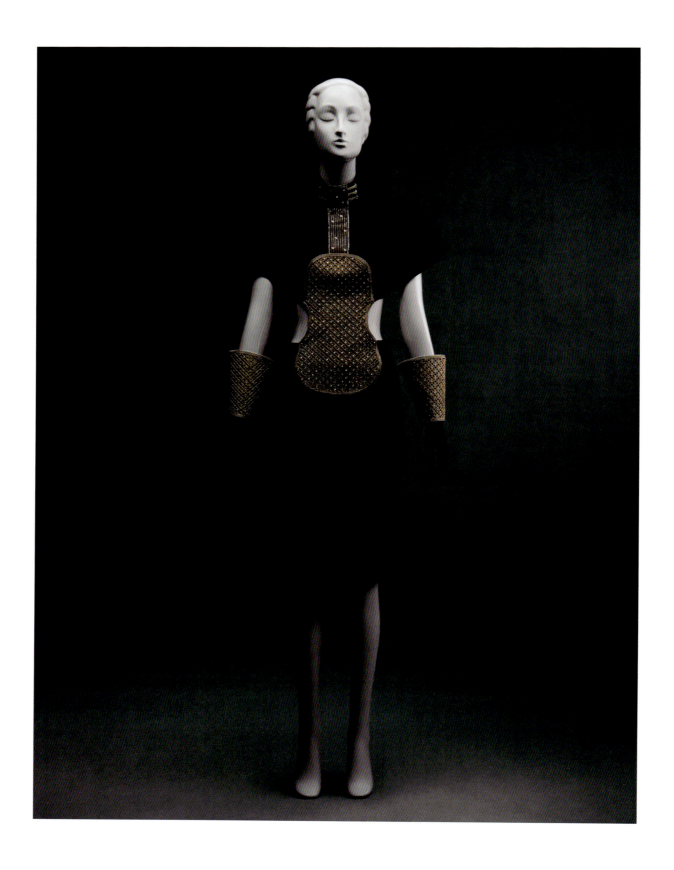

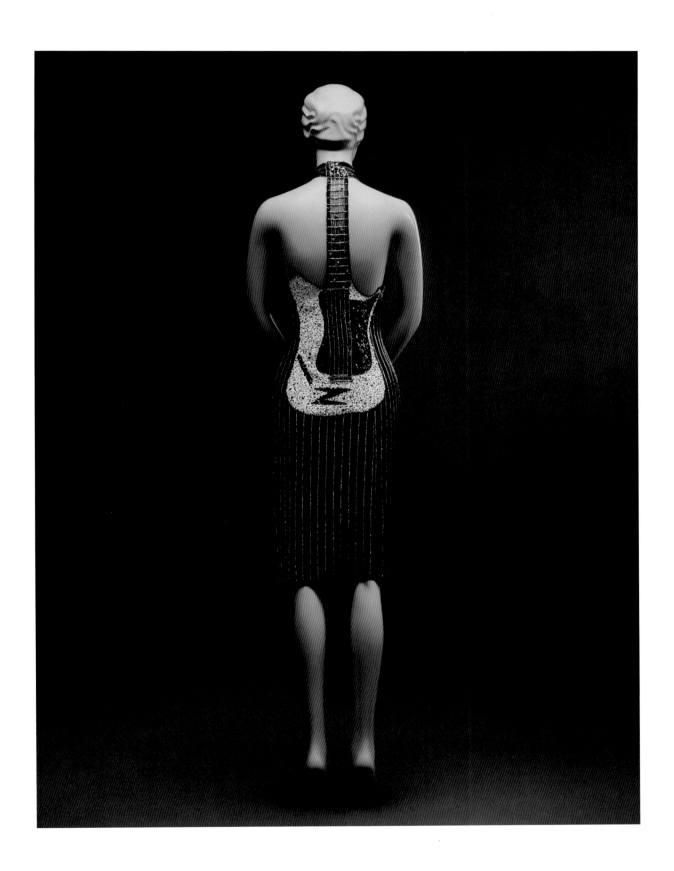

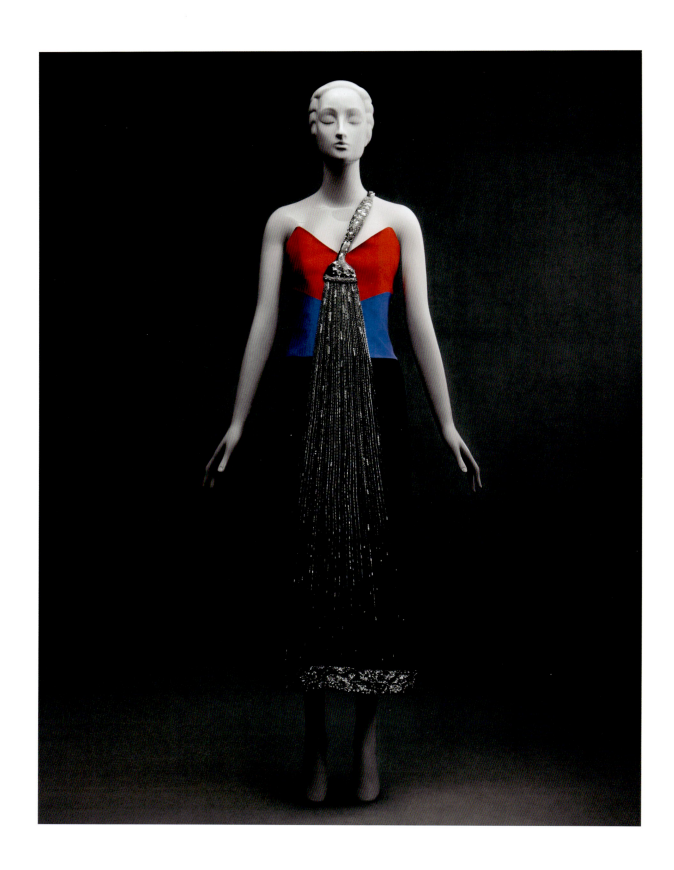

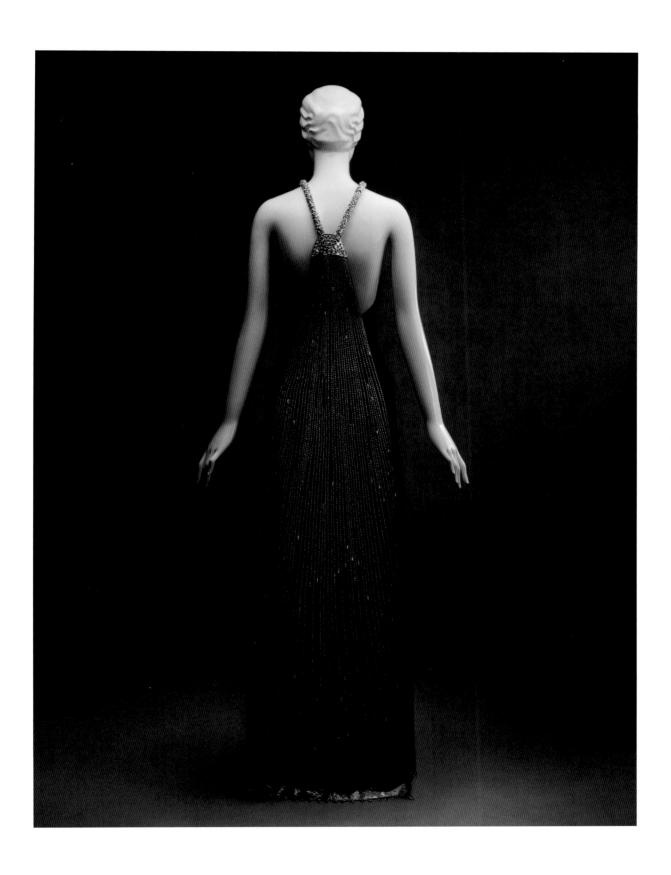

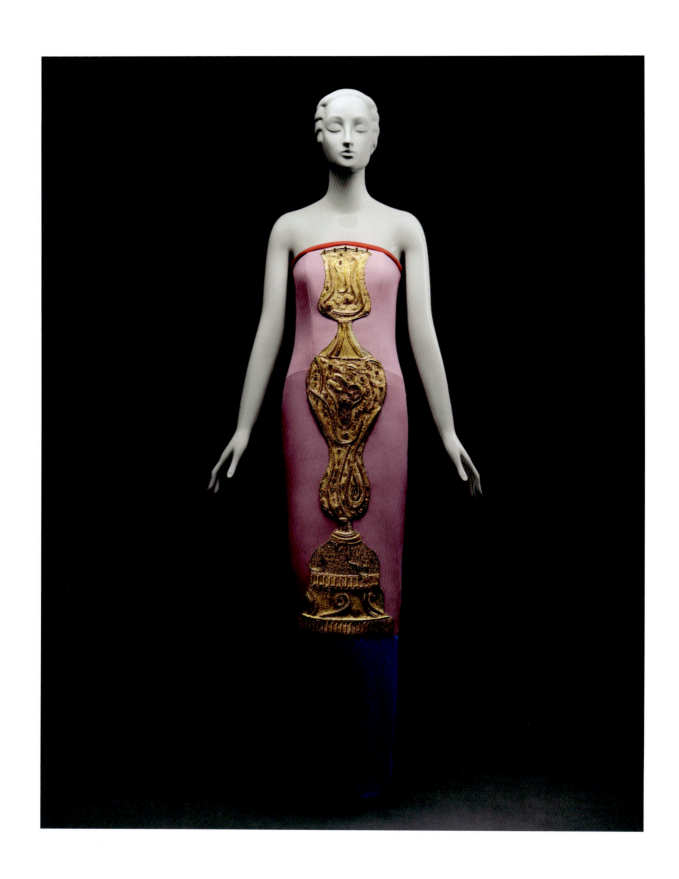

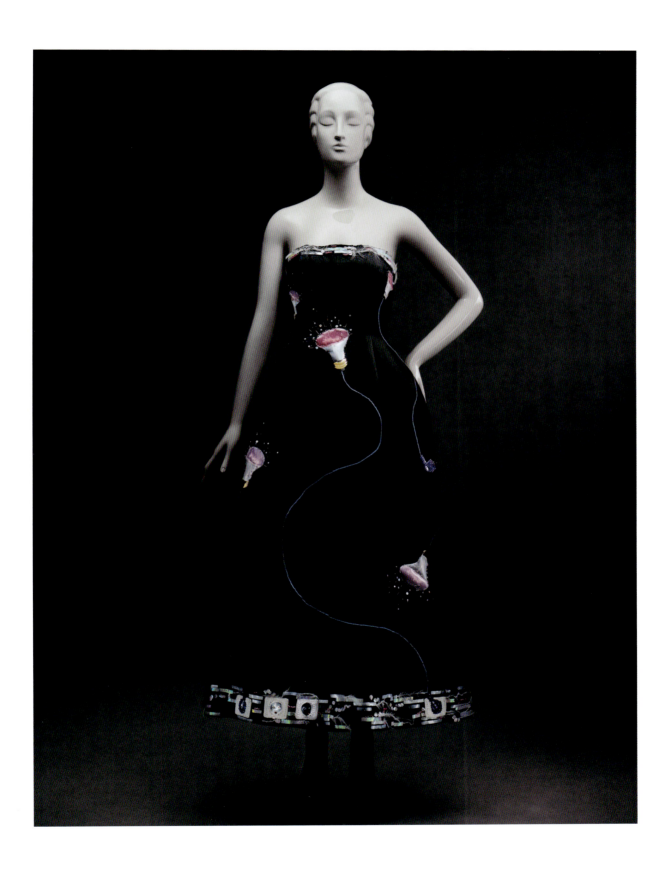

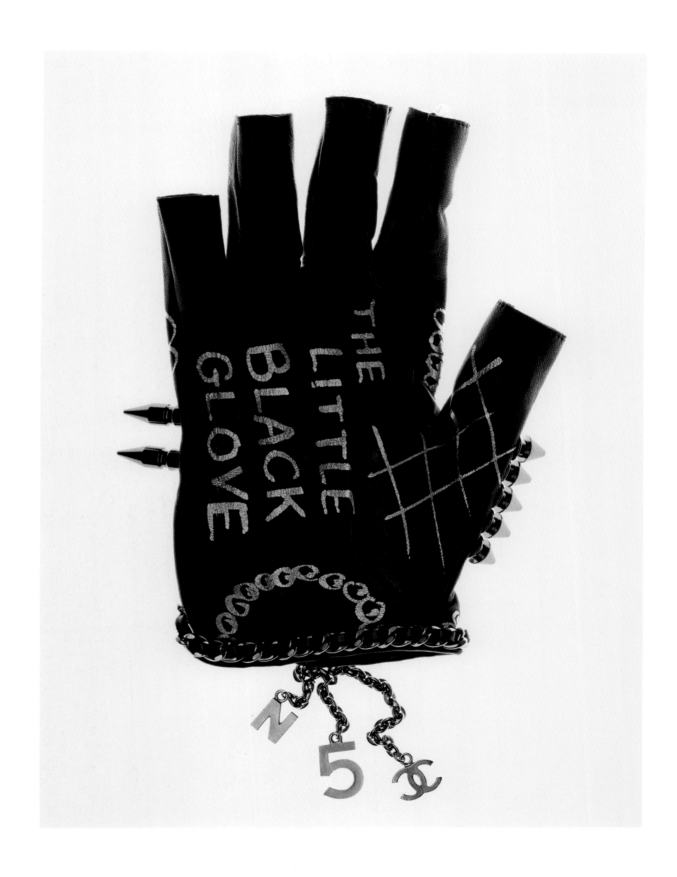

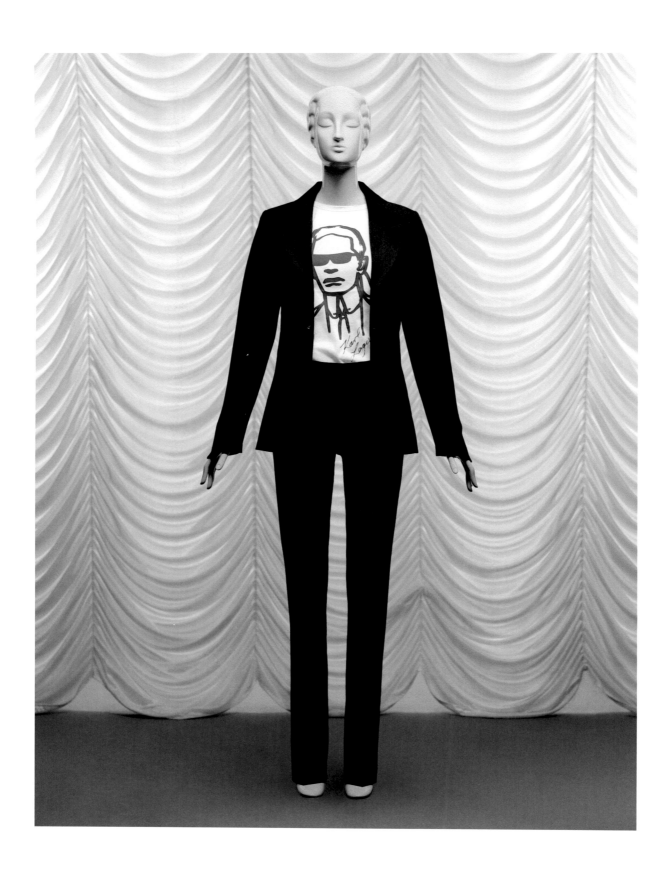

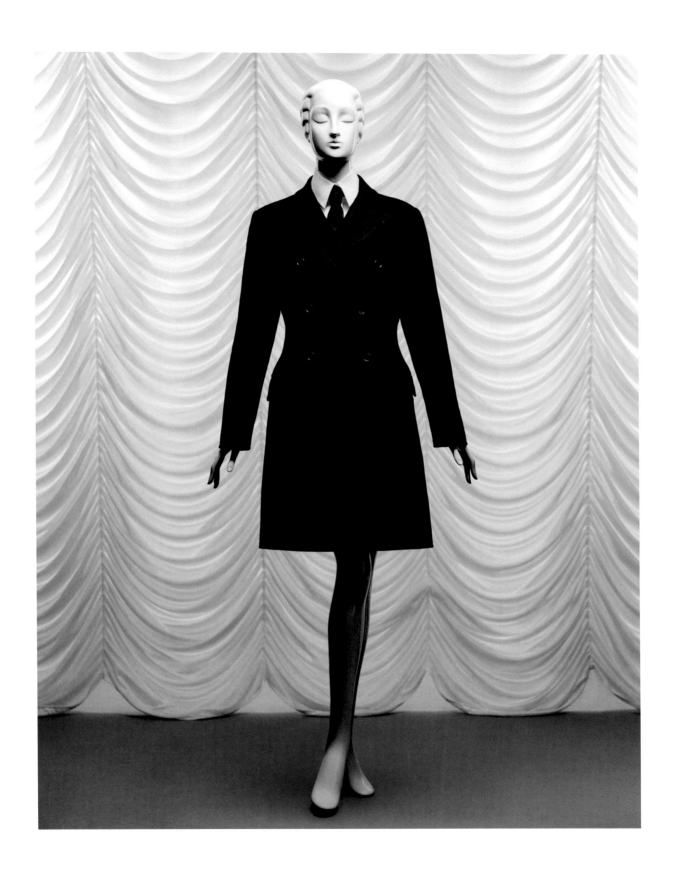

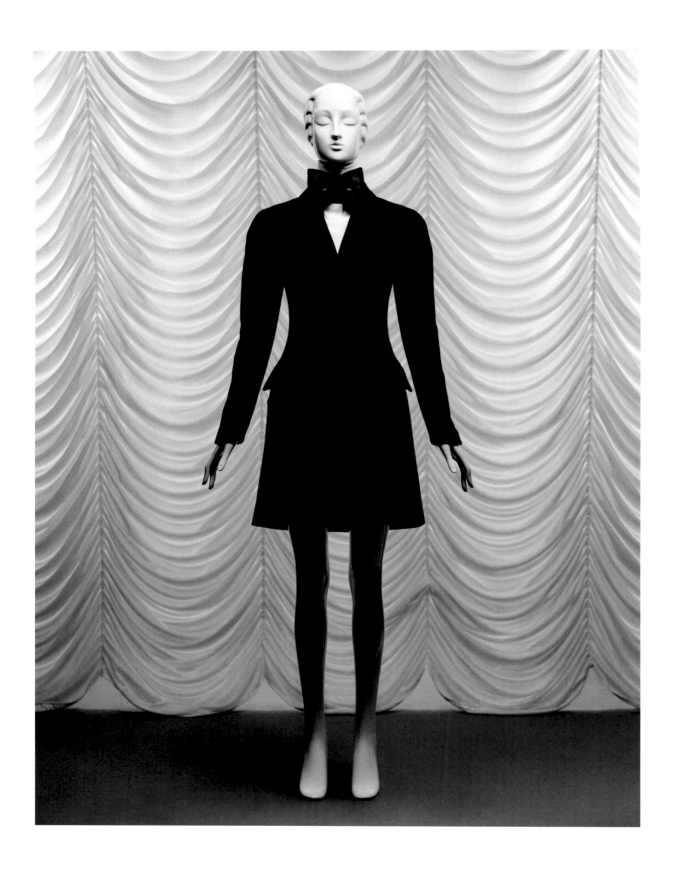

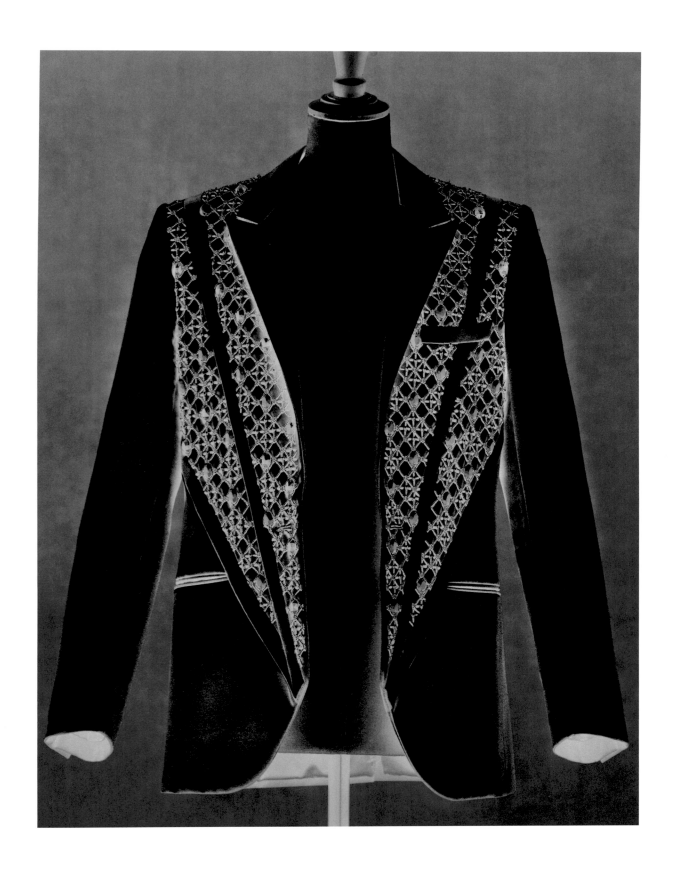

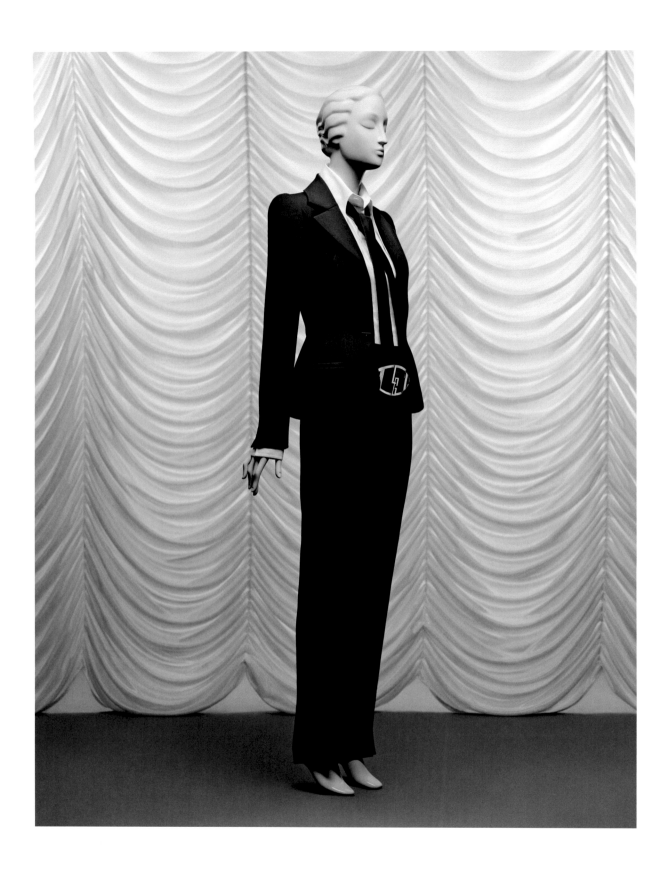

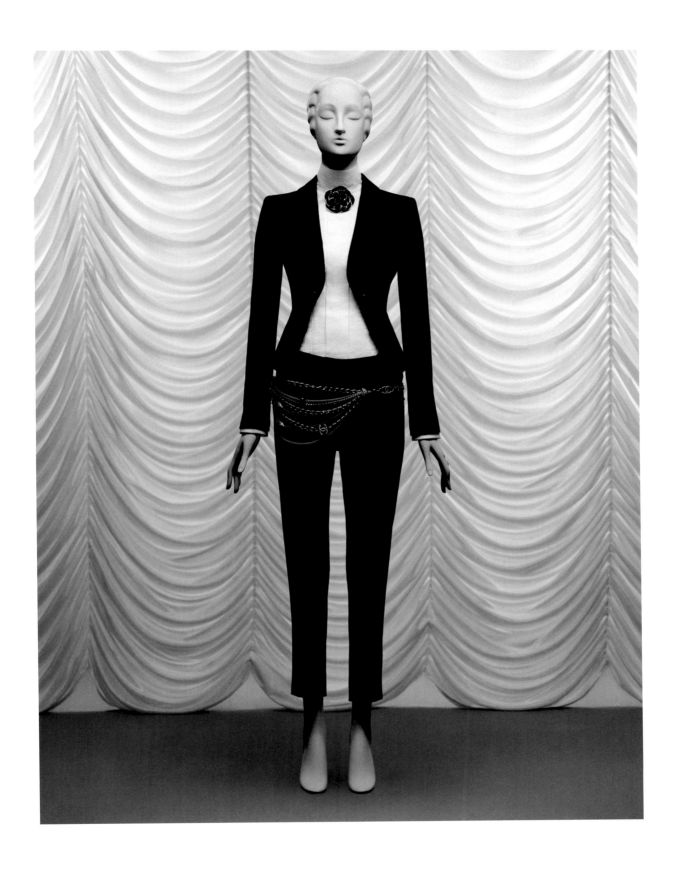

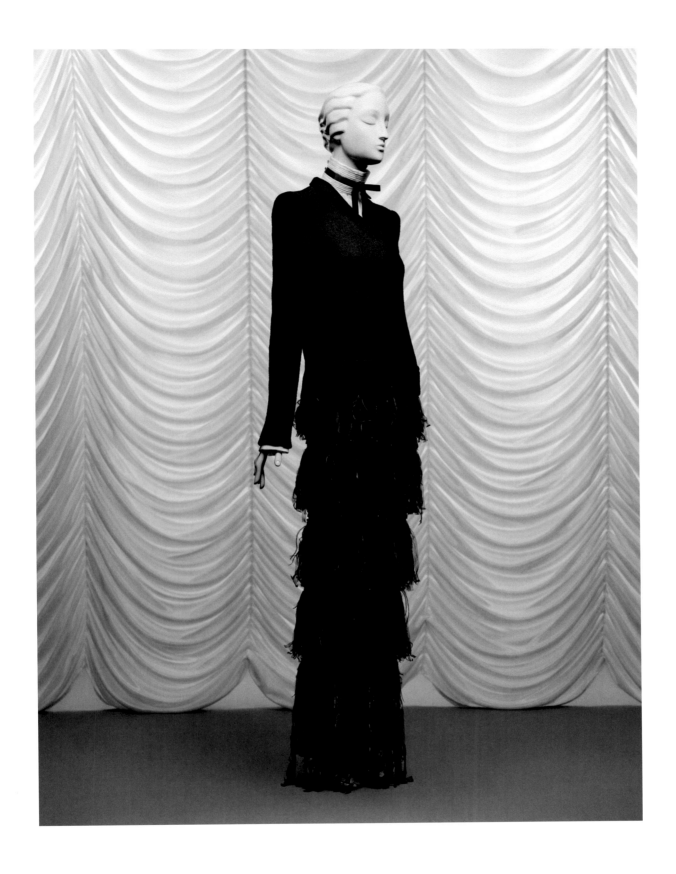

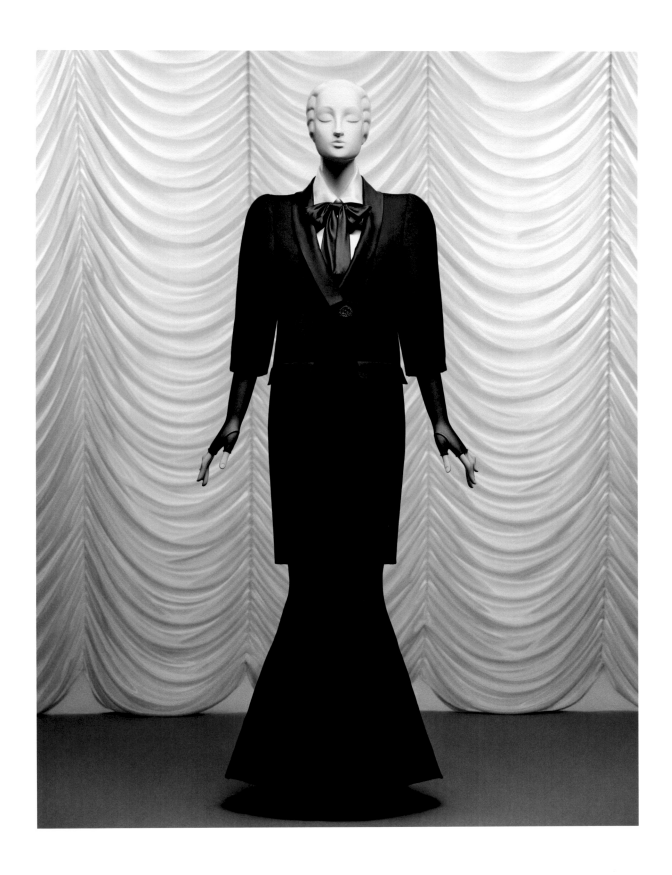

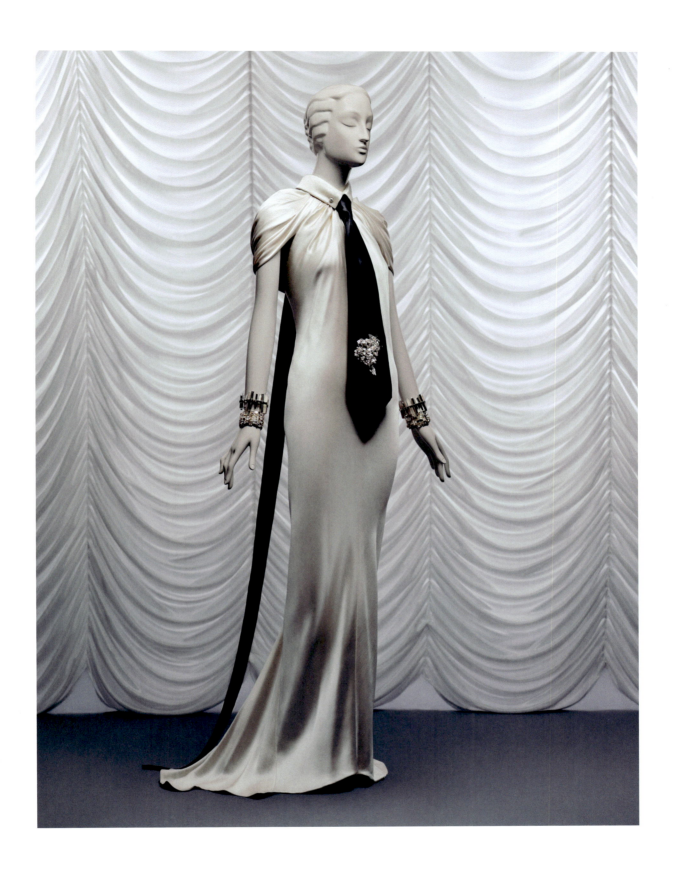

3	DIRECTOR'S FOREWORD
4	SPONSORS' STATEMENTS
7	THE INTERNATIONAL WOOLMARK PRIZE, 1954
9	PREMIÈRES D'ATELIER Interviews by Loïc Prigent: Anita Briey and Nicole Lefort, CHLOÉ Stefania D'Alfonso, FENDI Olivia Douchez and Jacqueline Mercier, CHANEL Anita Briey, KARL LAGERFELD
25	REFLECTIONS Anna Wintour Patrick Hourcade Amanda Harlech Tadao Ando
30	INSPIRATIONS
36	ACKNOWLEDGMENTS
38	SELECTED BIBLIOGRAPHY
39	CREDITS

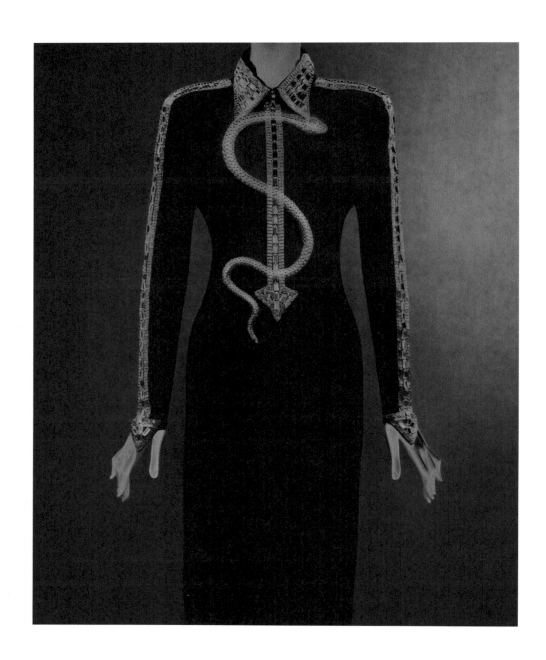

DIRECTOR'S FOREWORD

Few fashion designers have been the focus of a major monographic show at The Met, the last being Rei Kawakubo six years ago. With this new exhibition and catalogue, we highlight the extraordinary work of Karl Lagerfeld, whose career spanned sixty-five years—a feat remarkable in itself given the capricious nature of fashion. But beyond the length of his career, what made Lagerfeld so singular was the breadth of his creativity and the scope and variety of his output. He designed with extraordinary ingenuity and versatility, developing collections for several houses and for diverse audiences, establishing the blueprint for the contemporary fashion designer. In many ways, Lagerfeld was the definitive designer of the late twentieth and early twenty-first centuries, bringing to fashion an expertise that bridged the gap between art and commerce. To celebrate and better understand the work of this prolific and endlessly inventive artist, we proudly present this exhibition and accompanying catalogue that center on Lagerfeld's unique creative process.

Andrew Bolton, Wendy Yu Curator in Charge of The Costume Institute, brings his usual critical eye to bear on recurring aesthetic themes that unite the designs Lagerfeld made for the six houses he worked for throughout his career—namely, Balmain, Patou, Chloé, FENDI, CHANEL, and his eponymous label, KARL LAGERFELD. In the logistical planning of the exhibition, Bolton was supported by his remarkable team in The Costume Institute, expertly guided by Mellissa Huber, Associate Curator. We are also fortunate to have several prominent contributors to this endeavor who were involved with Lagerfeld personally and professionally, including Amanda Harlech, who was a close companion to the designer over many years and was known as his "outside eyes" and confidante. She served as creative consultant to the project and contributed an essay to this catalogue. The eminent architect Tadao Ando used his experience designing a house with Lagerfeld—a commission that, unfortunately, was never realized—to conceive of and design the exhibition spaces and to write his incisive observations for this publication. The director Loïc Prigent filmed the fascinating interviews with Lagerfeld's *premières d'atelier*, and he documented the making of the toile that won the designer the International Woolmark Prize in 1954. Finally, Patrick Hourcade, who curated Lagerfeld's immense art collection, provides insight into the designer's artistic tastes and inspirations.

This ambitious project would not have been possible without the sponsorship of design houses CHANEL, FENDI, and KARL LAGERFELD. In addition to their critical financial support, they opened their archives, along with Chloé, to The Met's curatorial team, which was crucial to realizing this far-reaching exhibition and catalogue. Once again, I want to express my deep gratitude to Condé Nast for its continued support, which is bolstered by the extraordinary contributions of expertise and creativity by incomparable Met Trustee Anna Wintour, who reflects on her friendship with Lagerfeld in this catalogue. And finally, I would like to thank the staff of The Costume Institute, and many other Museum departments, as well as the interns and freelancers who all contributed to the success of this complex endeavor. It is due to the work and dedication of these talented and engaged people that the output of this iconic designer can reach and inspire a broad audience interested in the intersection of creativity, fashion, and art.

 Max Hollein
 Marina Kellen French Director
 The Metropolitan Museum of Art

SPONSORS' STATEMENTS

CHANEL

Eighteen years after the exhibition *Chanel* debuted at The Metropolitan Museum of Art's Costume Institute, highlighting the history of the House and its contribution to defining and affirming the modern woman through its clothing, CHANEL is pleased to support the exhibition *Karl Lagerfeld: A Line of Beauty*, dedicated entirely to the work of couturier Karl Lagerfeld.

Emblematic creative director for the CHANEL Fashion House from 1983 until his passing in February 2019, Lagerfeld was an extraordinary creative individual who, through his inspiration and collections for the House, reinvented the brand's codes, first imagined by Gabrielle Chanel.

Creating "a better future with enlarged elements of the past," according to Goethe's phrase he liked to quote, Lagerfeld extended the spectrum of CHANEL's stylistic vocabulary, crossing the House's identifying elements with his own aesthetic universe. Drawing from a vast array of cultural references, his designs were notably inspired by two of his favorite eras: modernism and the eighteenth century.

The sumptuously refined silhouettes and accessories of his collections never ceased to exalt the exceptional know-how of CHANEL's ateliers and Maisons d'art, which he nourished with continual inspiration. Lagerfeld's unrivaled gift was perfectly articulated in his final CHANEL Métiers d'art collection, "Paris-New York," presented in December 2018 at The Met's Temple of Dendur.

Garments, accessories, catwalk sets and scenography, advertising and editorial photos, films, books—Lagerfeld forged his own myth as the first creative director of a luxury brand to think of fashion design in all its individual facets and as a whole. He placed himself alongside Gabrielle Chanel as the second founder of CHANEL Fashion, leaving a strong and coherent legacy that is now being reinterpreted by Virginie Viard, who spent more than thirty years at his side.

CHANEL is pleased to support this exhibition that sheds light on the work of a designer of genius who marked the history of fashion and changed the destiny of the House forever.

FENDI

FENDI is pleased to support *Karl Lagerfeld: A Line of Beauty*, The Costume Institute's spring 2023 exhibition at The Metropolitan Museum of Art.

Over the course of his fifty-four-year tenure at FENDI, Karl Lagerfeld played a vital role in shaping the history of the Roman House, producing a legacy of unprecedented invention and groundbreaking design, as well as becoming a beloved member of the Fendi family.

"The bond between Karl Lagerfeld and FENDI is fashion's longest love story," said Silvia Venturini Fendi, Artistic Director of Menswear and Accessories. Hired in 1965 by the Fendi sisters, Lagerfeld transformed the family's House into a playground of creativity over the next five decades, his extraordinary and boundless imagination powering the metamorphosis and fueling the longest relationship between a fashion house and a designer.

Fearless experimentation with precious materials has driven the creation of FENDI's collections since Adele and Edoardo Fendi founded the brand in 1925. Then came the couple's five daughters—Paola, Anna, Franca, Carla, and Alda—who invented a new way to collaborate in fashion, welcoming to the House a pioneering young German designer named Karl Lagerfeld in 1965, who would revolutionize and lead FENDI through five decades of pure, unwavering innovation.

In September 2020, Kim Jones became Artistic Director of Couture and Womenswear, and Delfina Delettrez Fendi—representing the fourth generation of Fendis at the House—joined as Artistic Director of Jewelry, further emphasizing that FENDI stands for Family. Today, FENDI is synonymous with quality, tradition, experimentation, and creativity, a tribute to Lagerfeld's legacy at the House.

This exhibition celebrates that same vision, tracing Lagerfeld's stylistic vocabulary and exploring the unique working methodology that inspired such freedom. FENDI is proud to play a role in revealing that story.

KARL LAGERFELD

As the custodian of Karl Lagerfeld's legacy, the House of KARL LAGERFELD carries his name forward and breathes his passion, intuition, and creativity into all that it does. The Costume Institute's monumental exhibition *Karl Lagerfeld: A Line of Beauty* traces the evolution of his designs throughout his six-decade career, exploring his passion for sketching and the progression of his sketches from two-dimensional renderings to three-dimensional garments.

An embodiment of culture, Karl was globally renowned for his cutting-edge, aspirational, and relevant approach to style. He was one of the most celebrated and iconic designers of the twenty-first century, and his visionary creativity expanded beyond fashion to include illustration, photography, costume design, architecture and interiors, styling, publishing, and more.

As the creative director of his signature brand, KARL LAGERFELD, Karl elevated and blended androgyny, black and white palettes, and sharp lines, creating a world and an aesthetic that were unmistakably his own. The House remains guided and inspired by its founder's own words: "Embrace the present and invent the future." *Karl Lagerfeld: A Line of Beauty* is an extraordinary occasion to bring together two icons: The Metropolitan Museum of Art, a landmark to history, art, and culture, and Karl Lagerfeld, the luminary designer.

The House of KARL LAGERFELD is pleased to celebrate and support this exhibition, which reflects on Karl's creativity, celebrates his innovation, and explores his impact on fashion's future.

1 Karl Lagerfeld's sketch for his "Longchamps" coat, 1954
2–7 Film stills of Valérie Poullard, Balmain's *modéliste en cheffe*, or head patternmaker, working from Karl Lagerfeld's 1954 Woolmark Prize sketch to re-create a half toile of the coat, 2022. Film directed by Loïc Prigent

THE INTERNATIONAL WOOLMARK PRIZE, 1954

Drawings and photographs document the rigorous "Longchamps" cocktail coat that garnered Karl Lagerfeld the first-place prize in outerwear at the prestigious International Woolmark Awards in 1954. Lagerfeld was living in Paris at the time and attending fashion illustration classes with Andrée Norero Petitjean, who submitted the competition entry on her student's behalf. His sketch was chosen from a reported pool of six thousand applicants. The exposure that came with this accolade was invaluable to the ambitious and highly focused young designer.

The year 1954 was also noteworthy for the Woolmark Prize, as two of the recipients went on to establish influential careers in fashion: alongside Lagerfeld, Yves Saint Laurent took first place in the dress category. Colette Bracchi designed the award-winning suit. These designs for suit, coat, and dress were produced within the workrooms of several leading French couturiers of the era including, respectively, Jacques Fath (founded 1937), Pierre Balmain (founded 1945), and Hubert de Givenchy (founded 1952). From this earliest moment, Lagerfeld distinguished himself from the group. His coat design was considered in the round and included details for a plunging décolletage at the back in counterbalance to the high front neckline, which was cut in one with the sleeve and fastened with a buckle at center front.

Unlike his peers, Lagerfeld visited the Balmain ateliers to attend the fittings for his garment, ensuring superior execution and highlighting an integral aspect of the way he would learn and work throughout his career. Although the designer never sewed, Lagerfeld collaborated closely with his atelier staff at every house, developing a deep and abiding respect for their skills. This early collaboration for Woolmark led to Lagerfeld's first full-time job, at the house of Balmain, where he designed for the "Florilège" boutique line from 1955 to 1958.

In preparation for the exhibition *Karl Lagerfeld: A Line of Beauty*, the contemporary house of Balmain, now under the direction of Olivier Rousteing, produced a re-creation of the "Longchamps" toile to convey the ingenuity of Lagerfeld's original design in three dimensions.

Film still from *Karl Lagerfeld Sketches His Life* (2013),
directed by Loïc Prigent

PREMIÈRES D'ATELIER

INTERVIEWS BY LOÏC PRIGENT

The following edited interviews, and associated videos for the exhibition, were conducted by the French fashion filmmaker Loïc Prigent in November 2022 at Karl Lagerfeld's Paris bookstore and studio space, Librairie 7L. Prigent first met Lagerfeld in March 1997 and began to film him that October. Between May and July of 2004, he spent extensive time in the Chanel ateliers, discreetly capturing the collaborative ethos and remarkable levels of craftsmanship that occur behind the scenes of the couture house. This footage was developed into the acclaimed 2005 television series *Signé Chanel*. Prigent continued to follow Lagerfeld over the years, foregrounding his accomplishment as a draftsman in the documentary *Karl Lagerfeld Sketches His Life* (2013) and in footage for the special publication *Fendi: By Karl Lagerfeld* (2015), which marked the designer's fifty-year anniversary with the Italian fashion house. Prigent chronicled Lagerfeld and his team up until the designer's last haute couture fittings at Chanel in 2019.

Lagerfeld produced voraciously—and across hierarchies—throughout his lifetime, conceiving of haute couture, ready-to-wear, outerwear, accessories, cosmetics, theatrical costume, decorative arts, interior design, and even toys. Despite the prolific range of his endeavors, he always initiated the design process through illustration. Whether working in the traditional haute couture ateliers of Chanel, with its divisions of *flou* (dressmaking) and *tailleur* (tailoring), or developing a capsule collection for the global retailer H&M, Lagerfeld's creations would always originate with a sketch. These drawings functioned as the primary method of communication between the designer and the makers with whom he collaborated; every line, mark, and errant notation inscribed his sketches with critical information. The women featured in the following pages worked with him over a period of many years, and in a variety of environments, and some even moving between fashion houses at his invitation. As *premières d'atelier*, they oversaw the process of patternmaking and modeling toiles (three-dimensional pattern drafts in muslin fabric) within their respective studios at Chloé, Fendi, Chanel, and for Lagerfeld's eponymous house. They collaborated closely with the designer and their atelier teams on the initial fittings and fabrication, often utilizing surprising materials or techniques that tested their skills in unprecedented ways. The creative arc culminated in the execution of the completed ensemble, which was then fitted on a model and presented on the runway.

These recollections provide exceptional insight into Lagerfeld's practice, illuminating the ways in which he worked across different houses and, perhaps even more significantly, the manner in which he interacted with his design team. Lagerfeld was keenly aware that his reliance on his workrooms was a reciprocal contract, as he explained in *Le Journal du Dimanche*: "When someone in the atelier has a difficult time making up one of my designs, even though I have never sewn, it is up to me to find the solution in three seconds. Otherwise, you completely lose respect in the eyes of the *première d'atelier*" (January 16, 2000). Though the following stories belie a much stronger relationship—and one presumably immune to such fickleness—Lagerfeld's extraordinary work ethic, the mutual respect that flourished within his ateliers, and his intricate knowledge of design are among his enduring legacies.

All interview film stills by Loïc Prigent, 2022

PREMIÈRES D'ATELIER

ANITA BRIEY AND NICOLE LEFORT

CHLOÉ

ANITA BRIEY I'll tell you, life is strange. Karl ended up with Chanel. I started with Chanel. I joined Chanel in 1955; I was sixteen. I was very young. I really learned so much about the beautiful art of couture, because at the time there was no ready-to-wear. In 1955 there was the famous Le Sentier district, as it was called, where many of the textile suppliers and artisans for fashion resided. At Chanel we mainly dressed the nobility—princesses, countesses, duchesses, and all that. Some film celebrities too. But it was fashion from another period. I had a wonderful *chef d'atelier* who, I was told, had detected a gift in me for toile making. Monsieur André Huguet. He was an amazing leader in every way. When our beloved boss left, I preferred to leave Chanel. One day shortly after, when I was making a tuxedo jacket with a very thin collar, a person arrived who asked to see the new boss, who was not there at the time. She looked at me making my toile and said, "But it's lovely what you're doing." I thanked her. I didn't know her. She asked me, "Do you know how to make toiles?" I said, "Yes." Then she said, "Would you be interested in a job as a toile technician?" Well, that was a stroke of luck! She asked me for my phone number. When she called, she was with Mr. Jacques Lenoir from Chloé. He was quite direct. "Are you a *toiliste*?" I said, "Yes, sir." "Are you looking for a job?" I said, "Yes," and he said, "Come and see me." I told him I was at work. He said, "Me too, but it's now or never." He was like that, Mr. Lenoir. He was charming but very direct! As Chloé was just a stone's throw away from rue La Boétie, on place Saint-Philippe du Roule, I was there in ten minutes. I did a trial run for a month. I stayed there with Karl for eighteen years, until he was kind enough to ask me if I wanted to follow him to start his own house, Karl Lagerfeld, in 1984.

At Chloé I discovered another way of working that was really enriching. Haute couture is made very finely. At Chloé you could say that it was almost haute couture but with modern tactics. There was a lot of talk about the French fashion designer André Courrèges at the time. Chloé was starting to do ready-to-wear, in parallel with couturiers like Courrèges. So I learned the speed, but we worked differently than what I'd done before. There, I became a patternmaker. I made all the patterns in toile for the models.

NICOLE LEFORT I started as a textile artist at Chloé almost at the same time as Karl did, in the fall of 1966. I had studied painting, like many other young people from my generation. I began making scarves as a student, and later, when encouraged to share my creations, I called Chloé and Dorothée Bis looking for work. When I was invited to Chloé, the director, Mr. Lenoir, immediately called Karl into the room. It was funny because Karl had made a dress that looked like the dress and the drawing that I had brought! That's how we hit it off immediately.

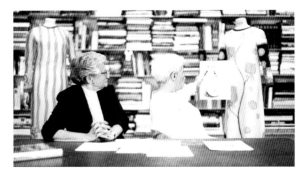

Karl asked me to make two dresses for the spring/summer 1967 show: the "Astoria" [pictured above, right] and the "Venus." I remember Monsieur Lenoir saying to me, "You made the dream dresses for the collection." Afterward, things were different, and I became like part of the team and worked with Karl for many years. He was the only designer whom I worked with at Chloé.

I used to go to Karl's home, and he would choose what we were going to work on. On certain dresses it might be Aubrey Beardsley–inspired motifs. We worked with three-dimensional references like the Émile Gallé vases. Then we did Art Deco. It changed all the time, and it was very pleasant. Karl would create the drawing. Afterward, in the studio, they would make the toile. Then I was given the toile, which I would trace onto paper first, so I could draw the artwork around the pattern to engineer it to fit the design of the garment. I would come up with the colors, and when it was agreed, we would make the model for the fashion show. If it was successful, the model was made multiple times. There are dresses that have been very popular. "Aubrey," for example, from the autumn/winter 1967–68 collection [pl. 215] was enormously successful from the beginning. The "Astoria" Beardsley-themed dress with the butterflies sold well; maybe 100 or 150 were produced. They all came out of my workshop—that's important to me—and there were no prints. Everything was hand painted.

The technique is called *serti*. The design is drawn on tracing paper with India ink, so it is visible when placed beneath the textile. Afterward, the worker stretches the fabric over a frame with tacks and uses gutta [a thermoplastic latex resist derived from the Malaysian gutta-percha tree] to trace the outline of the designs onto the fabric. We would take the paper out of the frame and stretch the fabric again with pins. Then we painted directly onto the textile within the spaces outlined in gutta. The gutta prevents the pigment from melting and spreading. Afterward, the fabric was rolled in paper and placed in a steamer to heat set, which took a few hours. It was then sent to Chloé, and Anita would manage to assemble it more or less successfully—I mean, she would put it together well, but it depended on our drawing and if we had placed the motifs and their connections correctly within the seam lines. With Karl we realized a lot of different techniques. It was wonderful because he was very inventive. We got on very well.

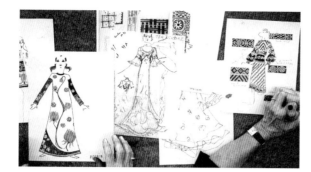

AB This dress is easy to make. All the hard work here is done by Nicole! As a patternmaker there's nothing simpler: one front, one back, and two sleeves. It's all in the painting.

NL I had my own studio and workshop, which was necessary. So after Karl gave me the sketches, I would draw the designs in my studio. Often, in painting, there are *sertisseuses* [artisans who specialize in *serti* and similar textile production practices] because it is a very specific technique. With Karl there was always something new. That's what I liked. We used to spray glue and sprinkle glitter. Karl would say, "That's good, Nicole. What do you think?" At one point he came up with the idea of using gold. I had never done gold settings before, so I went to buy some gold powder. Sometimes we were lucky and it worked. I liked to try new things, so we got along very well on that side. It's very easy, the *serti* technique—there's nothing easier in painting. Karl asked for so many different things, and that was great. With Karl I progressed. I moved beyond just making scarves.

The pink dress, "Terpischore" [pictured above], is from the spring/summer 1974 collection for Chloé. These were the dresses inspired by the famous Gallé vases. Starting from there, Karl would make a sketch. Then, afterward, we made a lot of sketches based on Gallé vases. There are thousands of Gallé vases to choose from; you can find almost any type of decoration. It was Karl who ultimately chose, which was helpful. I've created at least seven or eight of them in different designs and colors. Often, the fashion shows had a theme. So in spring 1974 it was Gallé vases, Meissen porcelain, or French porcelain. We would also make porcelain drawings and similar things like that. That was how it always worked with me and Karl. I don't know how they worked in sewing. We would decide the creative direction, and then the documentation came. He had a great, great deal of source material. It was very rich for me! He would say, "On this one, you're going to use this pattern, these colors, these people," and it was based on references. We always started with documents. It wasn't all at once, but the references would build and come together. Because the textile base is similar, the "Terpischore" dress is also made with the *serti* technique. Anita further worked on it after it was painted, as we inserted cotton beneath some of the motifs.

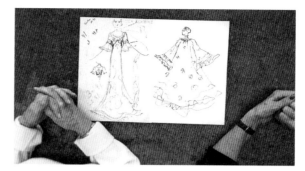

AB Yes, all the *bourrelets*, or quilted parts on the bodice of the dress, have cotton padding that has been stitched inside.

NL When I talk about drawing motifs, I'm always first drawing on paper. Afterward, I would transfer it to fabric. The fabric is stretched over a tambour frame to make it taut, like a drum, and then we would follow the design with gutta. Almost anyone can do that part. Gutta is transparent; it can be white, black, ochre. I did some of the mixing myself to find interesting shades. The applied color is not the same as the final color; it is duller before going into the oven. Sometimes the gutta would run. So when it bubbled, we added a little flour. It's like cooking. It's nothing extraordinary.

AB Yes, it's extraordinary! If I may, Nicole, you're not selling your quality of work. You were doing this freehand, with the brush, and sometimes, unfortunately, if there was a little drop that fell, we'd have to start all over again. I and René, the head of the workshop, were obliged, unfortunately, to control that. But when you were asked to paint the garments quickly, because Karl had decided near the end of planning, the settings were not always dry.

NL There was sometimes a bubble in the pigment. But that's also the charm of it.

AB So, poor thing, you would have to do it again—freehand! She's an artist here.

NL No, Karl was a creator, and I was a good realizer! I am good at executing ideas. He was very creative.

AB But I'm sorry, you're an artist! She did wonderful things.

NL Let's say I was lucky. I was very lucky. With Karl, we understood each other. It was good. That's it.

AB He was very close to the workshop. He would bring us little cakes from Dalloyau. You know, simple things. It was at Chloé that I first met Karl.

PREMIÈRES D'ATELIER

STEFANIA D'ALFONSO

FENDI

My name is Stefania D'Alfonso, and I am the *première* of the fur atelier at Fendi, where I am responsible for all models and also oversee product development, from drawing to final execution. I studied to be a *modelista* for five years at a professional school and began working at Fendi in 1995, after being introduced to them by the manager of a sartorial atelier they worked with. The head of the fur workshop at Fendi invited me to work in this area of the company, and I am always grateful to him because it has been a beautiful adventure.

When I started working at Fendi, Karl was already mythical. I had studied his work at school, so I was a little intimidated to meet him. His work fascinated me from as far back as I can remember! The way that he presented his ideas and his creative gestures was a ritual, starting with the arrival of his first drawings. It was truly wonderful to watch him draw, and it was a formative experience to have him turn to me as the person who could execute his designs.

Karl visited the atelier often and spent a lot of time there, as he wanted to see his work physically, materially. Our full team today is made up of forty people, but in the past it was a bit smaller. When Karl arrived, a core team of about twenty people would meet with him. This group developed his drawings and made the models for the collections. The production group had more people.

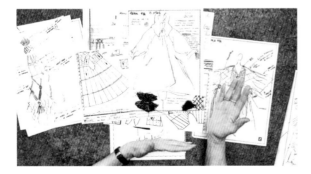

In those years Karl's drawings arrived in our studio by fax. Usually he would send a drawing that indicated how to create the structure of the garment, showing its proportion and volume, with notes that guided its construction. It is important when working with fur to assemble several skins, attaching one to the other to make a mélange. The first thing we did was figure out how to translate the drawing into a wearable garment. There is a processing number by Karl indicating the colors and furs to use. He also noted that the sleeves will be in mink and that there should be thirteen bars, with a range of twelve numbers referring to the various processes and references to the colors.

The history of this collection from autumn/winter 2012–13 is wonderful. I carry it in my heart. Karl often sent us drawings, or reference images, and not figures. In this case he sent images of orchids, as he envisioned an orchid as the overarching creative concept. This was executed beautifully in an actual garment. We translated it in lynx, but look at it—it is also an orchid! Karl showed that an orchid could actually become a coat, and that is how he imagined the entire collection. It was quite a challenge for a modeler like me.

When I first saw these drawings, I thought, "Oh Mama! Now what am I going to do?" This was the usual reaction. Every time I received drawings from Karl, I had to think about how I could realize them. The drawings for this collection arrived as I was finishing another job, so I scattered his beautiful sketches across the table in front of me, where I could study them as I finished the other work. This helped me to internalize his concept and understand his vision.

We never discussed the drawings with Karl until we reached the next step, when our first toile was ready. So the first step for us was to enter his world and translate it into three dimensions in our own interpretation. I always believed, whether it is appropriate or not, that we are the practical part of the creative process. The designer has the dream and it is shared with us so we can make it a reality.

After we interpreted Karl's design, we would show him the model and get his feedback. He was our maestro, and we hoped that he considered it sublime! One couldn't help being proud when we made him happy, but sometimes it didn't go that way. We might have misinterpreted the concept or not quite understood his intentions or instructions. When this happened he stood up, approached the model, and showed us how to correct it, explaining what he envisioned. "More volume" or "less volume." Thankfully he always ended up saying, "*Tres jolie!*" I can assure you he had great respect for our work.

Karl would add his references to the drawings; for instance, he always included a header with the year. "Srl" refers to our department of fur, and next to this we would typically note the final length of the coat, which is a dimension from the very beginning. Other figures indicate that the main body of the coat is in fox, and there are thirteen/twelve (which refers to the construction presented to us), and indications of the colors for our sample. This drawing also notes Karl was satisfied by the sample, which was made in silver fox in the following colors: black, silver-yellow, and sea blue.

If it wasn't always clear from the drawings how the garment could be made in fur, Karl helped us understand how it could be physically crafted in the atelier. It is still done like this today with every drawing. For this coat Karl showed us that the main focus was the orchid concept. This required masterful workmanship. I'm the modeler, but there were many superb artisans working on it, doing an extraordinary job. The effect is like an intarsia or mosaic consisting of various pieces of skins from a variety of furs that are each cut into thin strips of half a centimeter or less, which are then sewn onto a larger fabric base. This creates a finished garment that is just as beautiful inside and outside. That was the hallmark of Karl, his revolution. Karl completely restructured the world of fur by stripping away the structure underneath and removing everything that was unnecessary. Karl's contribution was showing the world that a fur garment could be made much lighter. This changed the way things were done, but it might not have happened this way because it had always been easy to satisfy customers for fur, even without all of this work.

Karl's brilliance that he brought to Fendi was to show that it could be different. It's a stupendous coat, inside and out, and the first one made in this way.

Developing the finished model was a team effort. After receiving Karl's material, Fendi did research and developed solutions to make the finished product as close as possible to the drawing. Ultimately, Fendi's artisans contributed a major part. We never said no to Karl, even when it was an enormous challenge. Perhaps we received images where Karl wanted the material to have the effect of shells, and I had to figure out how it could be done. From "Wow, how can we make a textile look like a shell?" to "Is it ready to show him? Absolutely, yes!"—the entire process reflected the beauty of this work.

Here is another well-known drawing of one of our most iconic articles of clothing from the autumn/winter collection of 1971–72. When Karl drew this design, I was still a student, and I studied it in books. We still reproduce this model today in many iterations. We've turned it into a sable vest, rather than using tinted mink or chinchilla. We've also made it in various colors, simply left it as it is, or turned it into a coat instead of a cape. I worked on new versions of this coat when I started at Fendi, basing them on Karl's original design. It became *his* coat. I had to give the new versions similar proportions and balance the structure with his design while adding sleeves. It's not simple to achieve this balance while maintaining the garment's classic features. Achieving that balance became my contribution as a modeler.

In 1971 this garment was revolutionary, as it's completely deconstructed. In one iteration we added a lining simply for beauty, which is not something that we always do, because if we don't put in a lining, then all the work beneath can be revealed. Additionally, the finished coat can also fit into a suitcase more easily. Until this point fur was not made this way, and this is important because fur was heavy—it buried you. Karl showed that fur could be made as "clothing," although not exactly for daily use or for the average person, because that isn't economically possible. Fur became a fashion garment. Before this, fur had a practical use, or was a status symbol, and it wasn't viewed within the context of fashion.

Karl knew a lot about making models and the workmanship they required. He usually designed both the front and the back of a garment because he understood that the back had to fall in specific ways. He thought it out well in advance and knew exactly what needed to happen in this spiral. We always spread Karl's drawings out on the table where they could be understood, internalized, and followed as we worked, because no lines or strokes on his drawings were random. I could not always understand them at first, and only after looking at them multiple times did they begin to fully make sense.

Karl spoke to me through his drawings, more than with words. This was our working relationship. The drawing communicated—and communicated very well! We made our model from the drawing. A detail on this drawing shows the relationship between every single line, each of which refers to a single skin of mink. It's also interesting that the reverse side, the leather side, is just as beautiful and could be worn on the outside because it displays the dexterity, craftsmanship, and wisdom of the remarkable artisans who made it. This was Karl's revolution. Why hide the inside? Why should this interior work be covered? Why should a lining weigh down the garment when it can still be beautiful, light, and gorgeous? It's still his drawing, his garment.

This drawing is from a wonderful project for autumn/winter 1993–94 that I wish I had participated in. Karl created a remarkable garment, which today would be called upcycled because it was made from all the remnants that were not used in the standard coats in the collection. These leftover materials—wool and furs—were twisted and combined with other remnants, transforming them into something completely new: a revolutionary garment. Karl showed how to refashion the materials in his notes. His drawing was inspired by hanging pendants on curtains. At the time no one had imagined making something like this.

How does one interpret this drawing as a garment? First, one of the artisans must translate the drawing into a technical diagram, or pattern. Karl also made notes on the sketch for the workers in the atelier about the fur, trimmings, leather, and mesh—the different elements that make up the details of the fur tassels. Karl always added comments or specifications to help us. I don't think Karl ever wanted to shock anyone with his work, but maybe he wanted to make them smile.

This next sketch is a technical drawing used by the person who cuts the pattern pieces in the sartorial atelier. It contains a spec sheet for the cutter to follow and notes the subdivisions of fur types, which is very, very important, because we have to construct the coat from existing types of fur. The species of fur or leather, such as mink or lynx, only comes in pieces of certain sizes. Assembling and joining the sections, or strips, is called *rigatura*. Every rectangle that is on this drawing indicates a different skin and the junctions between one skin and another.

To piece the skins together is a tremendously complicated job, requiring a very skilled artisan. A skin isn't made like a textile, with a standard size or dimension. The finished seams in the garment, where the fur pieces are joined, may not always be visible but must be done masterfully, with experience and thought. Everything has to be made in a harmonious manner. We have many layers of technical instructions for planning the work so that the model maker, the cutter, and the assembler of the garment can figure out how it must be produced. What I construct could be called the "mother" of the final garment, in a sense. To me, it's a jubilant job.

In my opinion Karl didn't use traditional drawing implements for colors. I think he used makeup to achieve a powdery effect that was very distinct from crayon or pencil. This is brilliant because it shows the subtle, nuanced shades that he wanted: tints that are a little powdery.

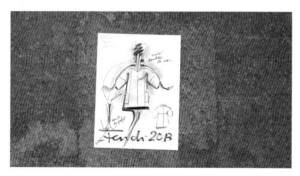

This drawing originated for clothing, for the Fendi spring/summer 2013 collection, and shows how Karl conveyed his fundamental instructions. It shows a double disruption of the ridges that outline the side view of the sleeve. The drawing also indicates the colors Karl wanted and the height for the model. The design could then be used for fur but also repurposed for textiles—though, with fur, the leather has structure that supports the lines and the shape of the outer garment, but fabric can be more complicated and may need reinforcements.

There's a detail on the back side of the garment, so Karl drew both sides. Both the front side of the sleeve as well as the back side are depicted, along with instructions for the cut of the shoulder. This helps the modeler create the shape and volume exactly as he wanted. If Karl hadn't made this cut and indicated these details in this manner, the line would have taken another form.

Karl placed the seam very precisely, in a specific position that makes the figure look slimmer. He was a maniac about the proportion of cuts! If we had made the seam lower and not exactly in the proportion indicated in the drawing, the garment would have been more stocky, fuller, and less slender. It's a garment that doesn't even touch the body. It's as if it's floating, fluttering—exactly how he wanted.

The person who interpreted the drawing to realize the result Karl wanted had to be very skilled. The sensation that this garment does not quite take the form of the body wearing it is created through the mastery and professional ability of the people who made the actual garment. This same drawing put in the hands of ten modelers would have resulted in ten totally different interpretations. What's important, in my view, is that there was a "marriage" between the Fendi atelier and Fendi Karl—a union of the two that worked.

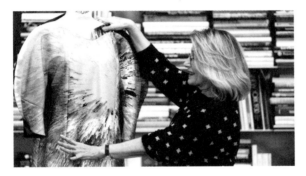

When Karl was happy with the final model of the design, he would say, "*Tres jolie!*" or "*Tres, tres jolie!*" And when he said *tres* three times in a row, he was very happy! He often added that the finished product was better than he could have imagined. So "*Bravi!* Congratulations to everybody" meant that he was very happy, and he would say that a lot with great pride.

The *premières* always attended the runway shows and watched from backstage, so I was there as the *première* of the sartorial area for the autumn/winter 2018–19 collection. Silvia Venturini Fendi, Karl, and other people from the fashion office would also watch backstage with us. Being behind the scenes with Karl at a runway show was a very exciting and emotional time. Although I've been doing this work for forty years, it was always truly special. These moments clarified why we do all this work. There would be absolute silence, as if in a church, and then all of a sudden the space would explode with joy. It was incredibly moving. Definitely!

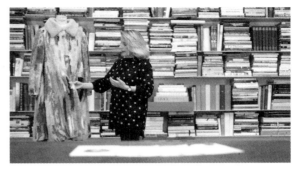

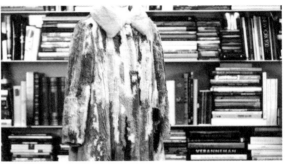

This coat received excellent reviews, which were well deserved because it was truly an extraordinary job and one that epitomizes Karl's vision. With the support of the Fendi atelier, he designed a fur coat without the fur. Though it may appear to be fur, it's actually silk. The trompe l'oeil effect was created by joining together many bands of fringed chiffon and georgette. It required an insane amount of artisanal work. Honestly, I have to say that with my work, it is either all or nothing. For this garment Karl was very focused on the fact that what you think you see is not always reality. This concept had interested him for a long time, as he explored a similar idea with the orchid that is also a coat.

This garment was shown during Karl's last fall fashion show for Fendi, at the Palazzo della Borsa. It's the only example from the collection that is completely made in this way. Even those who saw it on the runway, in real life, didn't always understand what it was made of. Creating a complex piece like this requires superb craftsmanship and many hands working together. While there are no techniques that haven't already been invented, it comes down to how you use what already exists in the marketplace. For example, little strips of georgette, like the ones used for this piece, were generally used for finishing collars, on the borders, or along the hems. Our atelier worked with georgette in a different way, using it along the outer ridges and applying it to a base of fabric with cuts that slant, which meant that each band had to be sewn atop a sloping base with perfection. It required great expertise that can only be done by a master of the craft.

My best memory of this show was the moment Karl returned backstage after his runway exit, and he looked for me in the front. He came right over to me and hugged me. "Brava, brava, brava," he said, and I must say it's an incredibly powerful memory. This wasn't something that Karl said easily, so he must have truly felt it. The hug from him happened often after the fashion shows, but this one was particularly emotional and especially strong. To receive this recognition and to have this connection at that moment, seeing how my work was in relation to his instructions—it was truly wonderful.

PREMIÈRES D'ATELIER

OLIVIA DOUCHEZ
AND JACQUELINE MERCIER

CHANEL

OLIVIA DOUCHEZ I'm the head of one of the haute couture *flou* workshops at Chanel. In couture you have two very different specialties: *tailleur* and *flou*. *Flou* is everything that is fluid and light. It is all dresses, including wedding dresses and evening dresses, that are made in materials like mousseline and lace, such as this pink dress from the spring/summer 2019 haute couture collection. *Tailleur* is for the garments that are a bit more structured, like coats and jackets that are produced in heavier materials like tweed and wool, and pieces with sleeves in general.

I arrived at Chanel in July 2015, in time to work on the "Casino" collection for the autumn/winter 2015–16 haute couture season. We made a lot of dresses in velvet, which is a material that is a bit of a black sheep for seamstresses. I had worked with velvet, but there, and with a new team at Chanel, it was pure rock and roll! We made some sublime dresses. When it's the first one, you usually remember it, but this collection was really special! I have extraordinary memories. There are seamstresses in the workshop that like to work with velvet—they have a knack for it—so we can make very beautiful things.

When Karl came with the sketches, Virginie Viard was always by his side. He would assign models to all the *premières* by handing us the sketches—usually in sets of two or three, but no more than that. As we went along, every two days we had a new series of sketches to work from. Sometimes it was predetermined. Virginie and Karl knew that I liked to make dresses with great volume and with petticoats, so often he'd assign those pieces to me. Karl gave us the design, but he also gave us a lot of oral explanation. His sketches were very precise. We immediately understood a lot of things by looking at the sketch. It's also helpful to have the spirit of the collection, the theme, and to know what he wanted to do and to show. Sometimes Virginie would show us the runway layout and explain the collection theme beforehand, and I'd do a little bit of research. It saved us time, but it was also interesting to really understand what Karl had in mind in order to come up with toiles that were quite advanced and accomplished.

I think that Karl was drawing the collection as it was being made. Once we'd taken the sketches, things moved very, very quickly! In general, we would set up the toiles immediately—within one day. The day after we presented the finished toiles, he would give us sketches again. Seeing the dresses being realized gave him ideas too, so the collection was made as we went along over five or six weeks. We would receive the sketches over two or three weeks maximum, and Karl was clever because he would give us the sketches where there was extensive embroidery work first, and the last sketches were things that he knew we could create with less time.

When I first receive a sketch like this, I see a pretty princess dress. I feel a little shape in it through the pencil strokes, in the ruffle bottoms. I can feel from the volume that it could be lace, but we'll decide on the fabrics at the first fitting when we try on the toile. It says here "three-flounce skirt" and "little balloon sleeves." Sometimes it wasn't easy to read Karl's handwriting, and you really had to decipher. I think there were some sketches where I never entirely knew what was written on them!

There's a number at the top: "77 26." The first sketch is 77 00, 77 01, 77 02, and so on. That gives you the quantity. Seventy-seven is the collection, and twenty-six is the number that was distributed during the collection. So I know that this is the twenty-sixth sketch that was given out, but it is not necessarily its number for the show. This is the number that we work with throughout the making of the collection. On the day of the accessorizing, Virginie and Karl would make the running order, and then they would assign another number.

Karl would often frame his sketches like this. I liked it; it gives the drawing a little bit of a kick. I loved his drawings. He would use a lot of different techniques to draw, even one with cosmetics. Once, when there was a bit of glitter on a drawing, I remarked to him that it looked like makeup. He said, "Yes, it's eye shadow." I thought it was nice—it looked just like watercolor or pencil. On the left side of the sketch, at the top, you can see the back of the dress. When Karl drew buttons, it was precise. You can also see the bow details on the shoulders. It was rare that he changed a design. In Karl's sketches you could also feel the spirit of the makeup and the hair—the red lipstick, the smoky eyes. He already had an extremely exacting idea of what everything was going to look like in the end.

When we prepared the toile for this sketch, we also prepared a pattern. That's the first step we take. Generally, when we make a pattern, if the dress is symmetrical and the right and left sides are the same, we prepare a half pattern. Then, for the fitting, we will prepare a whole toile. When we would show the whole toile to Karl at this first fitting, then we would choose the fabrics. Here we had more or less understood that it was lace, but it could have been any textile that we chose. In the back of the studio, we had all the fabrics that had been selected for the collection, so we could choose from among them. It could have been a different pink fabric, for example.

The card at left has the button that we chose during the fittings. We usually chose details like this when the dress was well advanced—once it was already made in fabric—in order to select a button that would match the textile perfectly. This is the lace that we chose from the collection. It's a beautiful lace that's been finished by an artist. You can't really tell from a glance, but when you look closely, you can see that it's entirely hand painted.

When we had the whole toile prepared for the first fitting, we showed Karl the volume. At that moment he could very well say to me, "Olivia, give it more volume," or "I want less, there's too much," or "The proportion of the ruffles I don't think is right. Make it longer," or "Make it shorter." I see that I have put small lines on this sketch, which means he told me to shorten the dress a little bit.

The first fitting on toile is really very important. We validate a lot of things, and we especially confirm the proportions, because afterward we'll start with the fabric. Once the dress is put together—that is to say, at this stage you can't just start all over again because you've made a mistake. The toile fittings would last a long time—even longer than when the design is made in fabric.

Karl had a very specific approach to shaping the waist. He liked the dresses to fit a little high, not really at the natural waistline. That's why the slope on this dress is quite gentle and not very marked at that level. He also liked the "slim-hipped" fits that sat below the waist. Here you have the high waist, and the top of the hips is quite low. This silhouette is part of Karl's identity as a designer. You can see that in a lot of his models, this lengthening of the torso. If you look closely at the collections, you'll find it frequently. It was his trademark, at least at Chanel. His idea was to slim the figure. I think it does.

You can see the row of buttons here from Karl's sketch reflected perfectly on the model. Note how the neckline of the dress is a little bit square. In haute couture it's rare to make a straight back or to make straight finishes when working with lace. We always use the edge of the lace—what we call the *dents* [teeth] of the lace—which make a pretty finish. It is a whole inlay that is prepared by hand. In general, you will never see a seam with lace. We follow the pattern by inlaying and hand sewing so that the seam disappears. We place the fabric flat, surface to surface, and sew it. After it's been stitched together, we cut out the top and bottom pieces, and all that's left is the lace, as if it were made without a seam. It's the magic in lace! I love lacework.

We used to place a bustier in many dresses, but Karl didn't want one for this dress, so it's just on silk tulle. This holds the lace a little bit, and on the inside, there's a tulle petticoat to give it volume.

Chanel haute couture labels are very special. You know it's the collection model if it's a big label like this one that reads "Chanel Sample." This one also has the text "Haute Couture PE 2019," indicating the season, which is written in pen by the hands of the seamstresses. It's important for the model number to stay consistent. The couture customer will have a much smaller Chanel label in their garment with folded edges. We also use an order number that corresponds to the customer that is hidden inside. That way, if the customer comes back a few years later to make alterations, we can locate the order, find her pattern, and find the fabrics—everything that is linked to the dress. It's very important to keep this little label!

This dress is from the autumn/winter 1986–87 haute couture collection. With the first glance at Karl's sketch, I see a very pretty mermaid dress. You can tell it's going to be something very "Chanel" with that quilting. At this point there's no color, but you can tell that it's probably going to be embroidered. I see that the dress is quite fluid with something very airy, very light to create nice volume at the bottom for movement when walking. You can already feel these details in Karl's sketch. On the back he's indicated that the quilting will connect. In the lower part, there is a series of buttons. It's very precise. The same goes for the top of the collar. There are cutouts in the quilting and also in the bottom of the sleeves. It's a very close-fitting dress. The name of the model was noted afterward, because at this stage we wouldn't know who is going to wear the dress. It also says "Colette." Colette is the name of the *première d'atelier* at the time—the sketches always have the name of the *première d'atelier* and the model number on them.

The embroidery work on this garment is absolutely beautiful and creates a very nice quilting effect. The entire back is connected. This is the opening of the dress at center back, but you can hardly see it because it closely follows the embroidery and all the lozenges that comprise the quilting. The row of buttons at the bottom of the dress are well drawn. Karl also added little lozenges at the hem, though they're not on the drawing, which means he must have added them during the fitting. Sometimes he would change little things like that when he suddenly had an idea. Karl had plenty of ideas all the time! Regardless, the whole look of the drawing, the shape of the dress, everything that he drew we understood. There were two scenarios: either he drew with a fabric sample already in mind, or he drew the silhouette and we chose the textile at the first fitting.

I've heard him say things like, "I love it. Yes, it's exactly what I imagined, what I wanted, what I thought." He had a lot of emotions that he would convey. You could feel it when he liked something. You could also sense when he didn't like something. He would ask, "Can you change that? Would you do it differently?" and we would. Everything was quite fluid.

Karl had a great pencil stroke. He could draw anything freehand, in front of anyone, at any time. It was beautiful, and you could understand it very well. We were able to do very precise things thanks to his sketches and arrive at the fitting prepared with things that never went too badly! Whenever we had to make alterations, Karl would always explain clearly and say, "Olivia, move this seam, and do it like this." Once, in the very beginning after I had first arrived at Chanel, I remember that I saw him get up to show me something on the model. I was surprised by this, even a bit panicked. Everyone noticed that I was stressed and told me, "Don't worry, everything is fine." However, I quickly learned that Karl was a very, very nice person who was extremely respectful of the ateliers and of the people who worked with him. I never saw him say anything out of line, get angry, or make a nasty comment. He spoke very tactfully, and he knew his job extremely well. Sometimes, when I would ask him to add a seam somewhere because technically it was complicated not to have one in a particular spot, he would say, "Yes, yes, do it." He would then take the sketch from me and add the seam to it and say, "I should have put it there." He understood very well what I was asking of him. That's why he was such a professional. It's great to work with someone like that, who knows his work so consummately. He knew the fabrics. He knew how they would fall. He knew exactly what he was doing. For a *première* and the team behind her, it was really easy to work with a designer like that.

JACQUELINE MERCIER At the time, I was the head of one of the haute couture *tailleur* workshops at Chanel. My role was to make Karl's ideas come true. He drew, I realized. My first contact with Karl was not actually at Chanel. It was at Chloé, where I worked with him previously. I have a very good memory of my first fitting with him. He had asked me to make a toile to compare with his sketches, and after I made the toile, we did the fitting in front of him. It went very well, and after that, no problem, we continued. That was over twenty-three years ago. I stayed at Chloé with Karl for three years, and then he brought me to Chanel when he left Chloé. Our working relationship went on for more than twenty-five years. That's not bad!

We have a team of about thirty *premières mains*, or "first hands," ladies who make the models. We are dedicated to making sure

that every garment is as perfect as possible in the end. During the collection period, there's the toile. This first assemblage is made entirely of muslin. Once the toile was created and Karl had chosen the fabric, we would cut the pattern from the material he selected. During the first fitting, everything is made by hand. After that there will be a second fitting where it will be much more advanced or almost finished, we will say. During the last fitting, the garment is completely finished. Essentially, we have one toile fitting and three fabric fittings. Each can be fifteen minutes to half an hour, or even an hour. It entirely depends on the model. It is much longer when we conduct the toile fitting, as we search for the material to use and we often try several tests. A single fitting for one model can sometimes take an hour.

This suit is from the spring/summer 2003 collection. The jacket is fitted with a very round, narrow, smooth shoulder for a small build. The seam is above. Karl asked us to make a dart in a place where there was initially no seam in order to make the shoulder as round as possible. The garment fits over the shoulder like a second skin, which you can see on his sketch.

From the sketch it was also clear that this would be a very light, very fluid suit. I expected that Karl would choose a similarly light material to create it. When you read the description on the drawing, Karl specifies what he wants to achieve in this model. He wanted tulle fringe—which confirms that it needs to be a very lightweight suit—on a frayed mousseline. The hem is frayed too. Karl wanted a little band around the suit, which was topstitched and frayed as well. From this drawing and notes, we already have a sense of what we were going to do. First, we would determine the shape, and afterward, during the fitting, Karl would tell us what he wanted in terms of finishing.

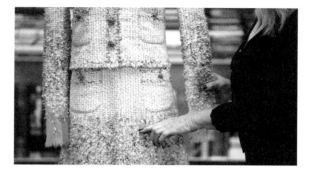

When Karl draws his silhouettes, he brings out the contours. It helps us with the silhouette and also creates a beautiful drawing that we'll be excited to make. When Karl would draw his models, I think he would see them in 3D, completely finished in his mind. This is an incredibly beautiful suit. You can see the lightness from Karl's notes within the garment. This decoration of this suit is all accomplished through embroidery technique—everything is made of fabric. Yarns from the textile were first removed, entirely by hand, and then placed on tulle. The embroidery is so delicate that the difference between the fabric and the tulle is difficult to see, creating the impression that it's one continuous piece. However, there was a huge amount of work involved to unravel the fabric in this way. One thread was removed after the other. Then one by one the embroiderers put them back on.

This piece was made before I arrived at Chanel. It was for the autumn/winter 1986–87 haute couture collection. The former head of the atelier whom I replaced, Mr. Paquito, made this suit. He was a highly skilled tailor who had previously worked at the couture house of Pierre Balmain. Karl brought him to Chanel when he first arrived in 1983. Mr. Paquito worked in the ateliers at Chanel for a very long time, like me.

Karl's drawing is a representation of the classic jacket at Chanel. In this instance, it's been designed with allover embroidery. Karl used the codes of Chanel, such as the quilting and the application of braids that wrap around the neckline, pockets, and along the hem of this jacket. When I first saw this sketch, it immediately reminded me of another "classic" model that I had made with Karl: an extraordinary 3D-printed suit for the autumn/winter 2015–16 haute couture collection [pl. 178]. The base of the jacket is in silk and organdy and was embroidered with sequins by Lesage, but the "quilted" overlay was 3D printed from polyamide. It's a fantastic example of how a classic Chanel jacket can be updated using new technology. High fashion is modern!

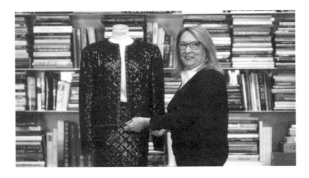

The two models, from 1983 and 2015, have over thirty years between them but look very similar. However, this one is much softer because the "quilting" has been embroidered, whereas the 3D-printed model that I worked on with Karl was much more rigid but still wearable. The shoulder is long but very round and smooth. It's all roundness, Karl's shoulders.

Karl is very loyal, and he is incredibly respectful of the people around him. He was such a perfectionist, and working with him made our team learn and grow continuously. Things like a 3D-printed jacket in couture were previously unimaginable before Karl, but he really pushed us to surpass ourselves. He regularly had us work with other unusual materials like wood and concrete. It's awesome using new technology in couture. Working with Karl made us always reach beyond our known possibilities. To create that way is extraordinary.

This dress from the autumn/winter 2002–3 haute couture collection is not entirely tailored, but it's not entirely *flou* either. Sometimes the two heads of the ateliers *flou* and *tailleur* will work on a model together. Madame Christiane, from *flou*, made the whole back section with the ruffles. On the other hand, all the front components with a slightly more rigid structure that are tailored were made by me. This followed the theme of the collection, which was about contrasts. We don't have the people to do *flou* in our workshops, and the *flou* ladies don't have the staff to execute tailoring work either. They are two different methods and two different techniques—similar to this garment. There's the strict side, the more austere side, which you can see in the bodice, and then the skirt explodes below the waist, full of volume and lightness.

To slim the silhouette and lengthen the body, Karl would almost never emphasize the natural waistline when fitting a garment; he always started from a point above. This was very characteristic of Karl. When I first came to work with him, we always tended to fit at the waist, and all the time he made me go up. Eventually, I realized that it was something very specific to what he wanted. It's really about achieving the elongated silhouette. And if you look, it's true! If you start to fit a garment to the natural waist, it's much heavier, and right away we would have the volume of the hip. Whereas here he brings us to a higher point between the chest and the actual waist. Everything is smooth along the side line. It lengthens the silhouette, and it slims the body and creates very nice bustlines.

Sometimes when Karl would give us a sketch, if the garment was represented from the side and from the back, one shoulder might be a bit round and the other one could be pointed. In those scenarios, it was up to us. He might have explained by saying, "I want a rounder shoulder, a smaller shoulder, a higher or flatter shoulder, or a more pointed or square shoulder," when he gave us the sketch. If he didn't specify, we had to choose, and at the moment of the fitting, he would make the decision: either he liked it or it would change. He would grant us a freedom in interpretation, and we worked together well because we knew his cuts—what he wanted—and could remain faithful to that.

The bodice fits very close to the body, almost somewhere between a wool dress and a little suit top, but it's not a difficult pattern. With Karl each line was thought out. When he draws us a sketch, he has already anticipated the technique. Sometimes if we would see something and initially think it's not possible, it's too complicated, I learned with Karl to never say no, to try, and to do my research. Indeed, three quarters of the time, we succeeded. When we didn't succeed, we would go to him and explain and he always understood. He would find a solution around the problem so we could achieve the same idea, either by adding a cut or through another detail, and we would always come up with a compelling final result.

We all knew Karl's history and the houses where he had previously worked. He wasn't just a designer; he was very technical. For me, he had the vision of how to make the models and also understood how it was done. All the cuts had an importance, a meaning, a reason to exist. Karl drew all the way to the end. Every sketch is in Karl's handwriting. That's extraordinary. He was really a great man. He taught us many things, including to bring out the best in ourselves through our work. If at the end of a fitting, Karl told us, "Your model is magnificent, it's more beautiful than my sketch!" then we knew we had accomplished true magic. It was always immensely gratifying.

PREMIÈRES D'ATELIER

ANITA BRIEY

KARL LAGERFELD

As a child I used to make evening dresses for my dolls with little drapes around the breasts, just like the French couturier Jacques Fath did. I remember telling my mother, "Mum, I'll work at Jacques Fath one day." I didn't care much for school. I only wanted to sew, but there were no opportunities where I grew up in Burgundy. After I completed my certificate of studies at the age of fourteen, I began to take dressmaking classes with a woman who ran a small school in Auxerre. It was amazing. We would go to her home, where she taught us all of the basics. She taught us the correct way to take dimensions, such as the chest circumference and hip measurements. This may sound trivial, but centimeters can slip! The hip is wider at the bottom than at ten centimeters from the waist. She taught us the importance of noting all these things. We learned the right way to sew on a button; she gave us a strong foundation.

I started with Karl at Chloé in 1966, and we worked together there for eighteen years. In 1984 I left Chloé to help start Karl's eponymous company on the Champs-Élysées as the head of his atelier. We began with just one other person who worked with me at the atelier and then had to quickly advertise to recruit some more staff. The premises were not yet complete at the start, so I was initially working on the floor to draft patterns and make the first toiles until someone came by to install everything. However, it was a wonderful time of great memories and happiness because Karl was by our side.

Working at the Karl Lagerfeld atelier was different than working with Karl at Chloé. As the management was different, each house had its own distinct atmosphere. In the Karl Lagerfeld workshop, we had a lot of fun because of Karl. The studio was adjacent to the workshop. When Karl would arrive at the studio, if it was too quiet, he would ask, "What's going on? We can't hear them in the studio." This happened several times. He even bought us a radio with cassettes because he liked to create a good atmosphere and to know that we were in the right mood to work. Perhaps he thought, "If they are happy, they're going to work harder." And he wasn't wrong! When Karl made me head of the workshop, I promised myself to behave in the same way that my first atelier head at Chanel had. He had always said to us, "I don't need to know what's going on between you. I just want the work to be ready on time, full stop." I did the same thing at Karl Lagerfeld, and I had nothing but happiness from the ladies and gentlemen who worked with me.

I recognize several of Karl Lagerfeld's obsessions with this garment from the autumn/winter 2006–7 season. It's a simple silhouette actually, but it's all in the little details. Karl loved details! At Karl Lagerfeld we used a lot of flat fabrics—unlike at Chanel—and we rarely used woolens and tweeds. When you are working with a beautiful tweed, you don't need to do a lot of sewing. The fabric is already so beautiful by itself that you notice the silhouette and the material more. When we worked with plain fabrics, Karl would put horizontal, vertical, and diagonal lines into the design. He loved cuts! That was what was particularly interesting about his work at Karl Lagerfeld.

This coat has a high collar that's made of leather with a fur lining that can be on the inside or the outside. Here, it's on the inside. Karl notes everything. He's indicated all the parts where there is leather: on the forearm and the pocket, he's drawn little strips of leather. It was up to us to imagine the size. That's essentially what a *toiliste* is for, in short. A detail in Karl's work that might seem completely banal is very important. If he put six buttons between the breast and the waist on his drawing, then when working on the Stockman dress form, my cut—I did it by eye—would fall right in with six buttons like Karl had drawn. He was great. When you're working, these details that seem quite trivial help a lot. The forearm is made of leather too, and the soft fur will give some flexibility to the garment, especially for the sleeve. Karl loved very narrow sleeves, so you'd have to calculate accordingly. He thought of everything, everything, everything! He even noted the detail of the smaller front snaps on the sleeves to ensure that I wouldn't put the same snaps on the center front of the coat and the sleeves. Karl would sometimes correct me and note, "Anita, my sleeve is a bit bigger in the drawing," or "My collar is less pointed than yours." But, on the whole, I still had very few alterations, because I have a good eye.

The detail for the back of the garment is drawn on the side of the sketch. This coat is fitted close to the body, and Karl knew exactly where to put the seams. In addition to the middle back seam, he placed two seams that were parallel to the center back to really slim the body. I see that the vertical seam stops at the upper part of the back, where there's a sort of yoke, if you like. Karl explained that this yoke was like a flap because it's unattached at the bottom—it lifts up. I could have thought that Karl had put a horizontal seam on the drawing for me, but he had the delicacy to point that out to me in his notes. That's how refined he was.

This collar is very ordinary in fact. It's a high collar, about eight centimeters in height. On this model you can feel that it's a bit softened from being on the hangers; it would have originally stood up stiffer than this. There's no fur in this instance. Instead, it has little transparent strips, like a kind of ribbon, and notice how the yoke is unattached at the bottom and can lift up. Karl had wanted to create a very small shutter effect. We call them *bavolets* in sewing terms, these narrow flaps. This reflected his preference at that moment, but we also made yokes that went up much higher. It depended on the collection, on the trend of the day. Karl also loved narrow sleeves. Very narrow sleeves. They can be a bit of an elephant trunk sometimes! They are simple but refined in their details. For example, Karl liked the sleeve to fall neatly over the fingers of the hand, to hide the knuckles so you could only see the fingertips coming out. Karl loved this.

He drew a lot — oh my, I think so. In the beginning Karl liked to see the toiles quickly. He wanted to see what the garment would look like so he could draw the next thing, basically. I was lucky enough to be in good health overall. I worked for hours and hours, and I was an early riser, so he had everything quickly! If I sometimes told him that I could only do a half toile for the next day, he was still delighted because it gave him an idea to work with so he could continue his theme.

This design is from the autumn/winter 2008–9 collection. The sleeve is very complicated; the top of it is like a cross. Karl really pushed us to try some difficult cuts. Here, he noted use of *bourrelets*, or rolls of fabric, and a *baleine*, or corset stay. The stay had to be placed in the seam above the waist in order to make the jacket look good and fit like that. It's not at the natural waist, but it must have pleased Karl to place this there, as it gave a certain stiffness to the garment and made it taut. Karl also stipulated that the stay stop at the edge of the underflap, as the jacket is closed with hidden buttons located there. He was very detail oriented; Karl considered everything.

Karl Lagerfeld was the king of cutting! Making toiles with him was a joy. Though we were human, like everybody else, it was really rare that we would say, "It's only 5 o'clock," or "It's only 6 o'clock." Instead, we would say, "Oh, no. It's already 4 o'clock!" We were fascinated when we were there, and we enjoyed making all these challenging patterns.

It's a high collar, but the neck is very open. Karl loved very high collars and often liked them to be at least seven, sometimes eight centimeters high. That was his thing. You can see on the jacket how the corset stay stretches the garment a lot. Without it, there wouldn't be that stiffness to it, even though the jacket is tight. The *bourrelets* are nicer than when there's just cotton padding. It looks very nice, but can you imagine all the time it takes to do this when you are making the toile? You don't often look at the clock when working on pieces like this.

It's quite unusual to have a sketch like this, with so many cuts. It's not everyone's jacket. It was nonetheless torturous! That's why we never got bored working with Karl. It was always necessary to try to do your best to make it look like his design.

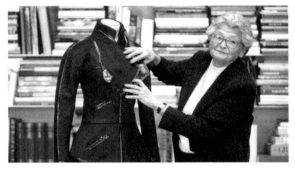

My guess is that Karl was initially planning to put some kind of short little scarf with fur or fake fur on this jacket from the autumn/winter 2010–11 collection. When it was finished, it ended up being vinyl. Karl always puts his details on the sketch: the edges are notched, and he makes it clear that all these little strips are in varnish. What else does he tell us?

That this jacket is to be worn with super-tight jeans, obviously, and that it should be very soft, because the design is worn so close to the body. He also noted that he wants a small vent to give fullness to the bottom of the basque. If it had been in one piece, it would have been more biased. Here, with this small cut, it's moderate but at the same time achieves that fullness. The collar is still very high, and the pockets lie flat, but they are real. With Karl nothing was ever fake! They all had to be real; even if you could only put half a finger in it, the pocket needed to open. He hated what was fake. Everything was true; nothing was false. Karl wanted to make sure that all the details were correct. This jacket is a beautiful piece of work, as they used to say.

As head of the atelier, I made the toiles and I had a person who helped me; there were usually two model makers. I had three that I worked with during my years at Karl Lagerfeld, but whether it was with Renée or Hélène or Christine, my colleagues and I were constantly amazed by Karl. We had to work very quickly around the time of the collection presentations. Sometimes, when I was feeling a bit of fatigue, I might have told Karl that I was struggling to create a movement or an idea, and he would kindly get up from his desk and explain how to do it. He always knew the trick to find, even though he had never learned to sew. Sometimes I was even surprised. I thought to myself that in his former life he must have worked in an atelier! Karl knew things that I had to sew at Chanel for ten years to learn. My colleagues and I were sometimes speechless by the things that he knew. We would say to each other, "Gosh, imagine if he *had* known how to sew." He would have been an exceptional first hand if he had been employed in a workshop.

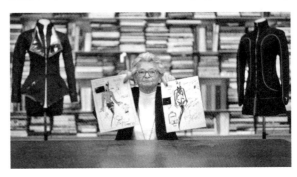

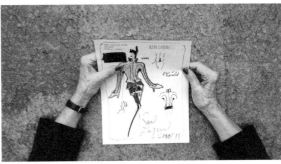

This jacket from the autumn/winter 2010–11 collection looks very simple, but it's more complicated than it appears. The basque turns over in the same spirit as the prior jacket but is two-tone with a red underside. Otherwise, it's relatively sober, but there are lots of details. There are cutouts with bicolored gussets. The bottom of the sleeve also has an interesting feature: there's a little pocket that you could fit a metro ticket into. It's a charming detail!

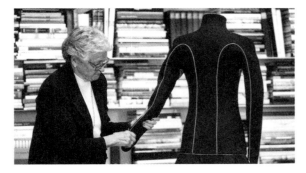

There's a seam down the center back of the jacket, and because the sleeves are cut like a kimono, in one with the bodice, we have a series of vertical panels that are joined together. On one side of the back alone, we can count four pattern pieces here. When we return to the front, the cut is just as complicated. I'd say that complex cuts were part of the vocabulary that defined the Karl Lagerfeld brand. Even the cuts at Chanel didn't change much when Karl took over the jackets—the richness is in the material. He used so many different colored yarns and such sublime materials that there wasn't a need for overly complicated shapes. I think that Karl had a great time at Karl Lagerfeld working with these flatter materials that had more stretch to them. When you look at his drawings, you can tell he was having fun; there are pencil strokes in all directions. And for us, it was enriching. We didn't have time to get bored.

I started working when I was sixteen and retired at sixty-nine. In total I had forty-two years working with Karl. I'm happy to talk about Karl because I loved working with that man. I really loved him. And he was very courteous to all the ladies in the workshop. Karl wrote a lot of letters to me several times a year, and I've kept everything, from the first letter to the last. He would send lovely letters with baskets of flowers at every collection. I can't tell you what I went through carrying the baskets; they were so heavy—and from Lachaume! He would send them on May 1 for Labor Day and for New Year's Day in January. When I had a little bit of a health problem, he sent flower baskets with letters to the clinic. For me, he has always remained the same in his behavior. He was always pleasant to work with and gallant with the ladies of the workshop. He would always hold the door of the lift. He would gift the ladies a Chanel bag from time to time. These are small things, but it means a lot to a woman who sews all her life to receive a Chanel bag that she can't always afford. Karl was incredibly generous, and it was very nice to work in those conditions.

Karl Lagerfeld by Annie Leibovitz for *Vogue* US, September 2018.
© Annie Leibovitz, Trunk Archive

REFLECTIONS

ANNA WINTOUR

The designer Karl Lagerfeld died four years ago, but his influence in fashion will endure for generations to come. In preparing to feature Karl's extraordinary work in this catalogue, Andrew Bolton, Wendy Yu Curator in Charge at The Costume Institute, looked to the painter William Hogarth's "line of beauty": the idea that an ever-twisting, ever-changing line captures more energy and life than a straight one. It's hard to imagine a better description of Karl's transformative path for more than sixty years—or a fuller approach. His work, like his life, was unpredictable and yet definitive at every turn.

Karl was my true friend for many decades. We shared adventures and humor and confidences in good times and during difficult ones. But more than anything, I admired him as a designer. My most vivid memories are of him surrounded by paper and books, hard at work sketching: a thousand swirling pencil lines that added up to a creative life. From Fendi to Chanel and Karl's own label, his genius was always to be updating his previous goals, always pivoting, always absorbing new information without losing the long sweep of his direction. He had total freedom—sometimes even capriciousness—but he wove it, like loose thread, into a unity that grew with time.

His career was filled with paradoxes. Karl was the king of commerce, but he was also fashion's great intellectual. He did extraordinary things for some of the industry's esteemed heritage houses, yet he was always at the front edge of the new and hungry for the next thing. He became the most renowned fashion celebrity ever—a man more recognizable and more quoted than many of the famous people he dressed—but he was also an intensely private person.

Karl prized his solitude and working hours, which would regularly run to 2 or 3 A.M. He was not a morning person. He loved nothing more than reading alone, taking inspiration in everything from the week's news to eighteenth-century decorative arts and the philosophy of David Hume. He piled books everywhere he went, as if to mark out his path; in one of his many residences, a table laden with volumes collapsed straight through the floor from its weight.

Karl was a linguist, a photographer, an interior decorator, a collector, a filmmaker, and a philanthropist, among many other things, and when he arrived at parties, it was often with a startling display of wholly unexpected skills. I can recall one evening, years ago, when Karl neatly rolled up the exquisite carpet from Versailles's Salon de la Paix, pulled the dauntingly debonair Oscar de la Renta onto the floor, and danced a perfect tango in the classic style. For years we kept a standing dinner date in Paris on the first Sunday of every fashion week, often joined by our mutual friend Amanda Harlech, but we never spoke about our work during those meals. Karl was witty and irreverent and seemed to have an endless supply of risqué jokes—in other words, he was a dream dinner companion.

How all of Karl's paradoxical pieces fit together, how they add up to a single line of lifelong work from one artist's imagination, was a deep mystery, even for those of us who knew and loved him. This exhibition, I'm pleased to note, brings that whole into focus for the first time. Karl often liked to say that he was alarmed at the idea of his clothes appearing in a museum: he was a craftsman, not an artist, he insisted, and I think he loathed the idea of fashion standing still long enough to be admired at a backward glance. But the truth is that whenever we asked Karl whether we could include his pieces at The Costume Institute, he was moved and happy to oblige. The Metropolitan Museum of Art meant so much to him, and our visitors know how active he was in the community. This catalogue is a guide to the man and his work, a guide that Karl—even Karl—would have loved.

REFLECTIONS

PATRICK HOURCADE

Between his two strong hands, Karl nervously crumpled the sheet of paper that he had just drawn on and threw the ball into the wastebasket. "I can't do it!" he concluded. A creative breakdown was unfolding amidst the planning for Chloé's fall 1976 collection at l'Hôtel Pozzo di Borgo, Karl's home just after his move from place Saint-Sulpice. The decor at place Saint-Sulpice was bourgeois chic, very *Gazette du Bon Ton*, and inspired by the films of Marcel l'Herbier. The Saint-Sulpice apartment had large bare walls, high windows draped with veils, gilded furniture, and white satin upholstery punctuated by Art Deco vases by Jean Dunand. In contrast, at l'Hôtel Pozzo Karl found himself surrounded by Versailles-style boiseries, curtains of brightly colored taffeta, and basket sofas with voluptuous cushions.

The iconic Art Deco decor of place Saint-Sulpice, sublimated in Horst's photographs, had been the perfect environment to conjure a style featuring an Oskar Schlemmer–inspired silhouette of broad shoulders, snug sizes, and flexible crepes printed with infinity motifs. L'Hôtel Pozzo's baroque, Madame de Pompadour decor was of quite a different imagination. Fortunately, the next day we left for the castle in Grand-Champ where the atmosphere was just as eighteenth century but calmed by the countryside. There Karl found the style that evoked a lighter spirit and would change his career. Whereas his Art Deco woman was a graphic idol, his woman of the Enlightenment was freer in her movements. Everything then became more supple, more fluid for Karl. The body was in attendance, and the body guided the style.

When Kitty d'Alessio took over Chanel's studio in rue Cambon, she immediately understood Karl's remarkable power to adapt to different styles and, as such, allowed him complete autonomy. He had spent years designing for different brands with total freedom. His brain functioned like a smartphone with many apps. When a journalist asked him what Gianfranco Ferré was going to create the next season at Dior, Karl took his pen and drew the look that Gianfranco would produce a few weeks later. From the sculptural Schlemmer silhouette to the Chanel baguette bag, Karl transformed his style at Chanel in two collections.

But he also had another valuable resource: his "style laboratory-studios" at, for example, Chanel and Fendi, where young people came and brought new, offbeat approaches to fashion, as demanded by Karl. This fashion was not one driven by the lifestyle of good taste. His assistants were numerous, diverse, and more inventive than those of his contemporaries, and Karl knew how to stimulate them, how to play with the broadest range of expression. Karl was the guide, but the studio was the engine. And if today the studio has triumphed in the fashion world, it is thanks to Karl.

AMANDA HARLECH

Karl shone like a Sun King in the City of Light, Paris. We think we know the rock-star designer with dark glasses and powdered ponytail who was surrounded by his sleek court, friends, throngs of paparazzi, and fans. But behind the indelible cipher he mastered for himself, instantly recognizable throughout the world, another Karl watched intently from the shadows: the elusive Karl who dreamt up his prolific, extraordinary collections in night visions, sketching what had woken him in a notebook he kept beside his narrow bed, tumbled with embroidered linens. Twilight, *l'entre chien et loup* of evanescent possibility, was his element, where familiar ghosts would walk and color ebbed in the light of a full moon, where shadows and half tones evoked layers of mille-feuille mousseline, their edges delicately frayed, existing in an almost imperceptible world, like an Edward Steichen landscape. He described his own photographs as "pictures of an idealized reality where the dream world meets the truth halfway. They bear witness to a world where things are still intact and in order, a world I want to preserve, at least visually." It is as if Karl sensed the spirit of things—the geist. It is this spirit energy he invested into his sketches, each one drawn to express an exquisitely primed attitude, as if the sketch had come alive.

I can remember going for the first time to see him at his home at 51, rue de l'Université, l'Hôtel Pozzo di Borgo—his eighteenth-century epicenter of refinement—and sensing that beyond the dazzling curation of brocades, tapestries, artworks hung as in the duc de Choiseul's bedchamber (a scene Karl copied from a Louis Nicolas van Blarenberghe–painted snuff box), bronzes, and curving Louis XV furniture glowing in the candlelight reflected in myriad mirrors and gilded *boissonnerie*, there was a highly charged, vertical sensibility open to every resonance, every quarter tone of change and meaning. Karl was so alert to the flickering strangeness within beauty that he seemed to exist in a parallel dimension. On a vast circular table, poetry books lay open amid a chaos of magazines, towers of historical biographies and eclectic books ranging from Greek armor to the latest furniture design, sketches, sketch pads, his Shu Uemura eye-shadow palettes, silver goblets of chocolates, and felt pens. Emily Dickinson, Catherine Pozzi, Rilke—these were my first coordinates for mapping Karl's emotional landscape, which was profound, elegiac but transfixed by the power of perception. Decades later, in Saint-Tropez, he gave me what he said was one of his favorite books, *The Sense of Beauty* by George Santayana: "Our ideas emerge for a moment from the dim continuum of vital feeling and diffused sense, and are hardly fixed before they are changed and transformed, by the shifting attention and the perception of new relations, into ideas of really different objects."

Like Hermann von Keyserlingk, Karl was always dressed impeccably: stiff collars to balance the pitch of a lapel and the width of a tie, an assemblage of Belperron and diamond pins, necklaces of pearl, fingerless gloves, sometimes a black diamond, always his mother's lapis signet ring, and his lucky watch fastened above his wrist. And like Keyserlingk, whom he adored, his creative style was associative and evocative. He played with ideas and word images like a precocious artist philosopher—a mythic Proteus who understood change by metamorphosing into the new.

And yet within the pyrotechnics of self-transformation, collections for different houses with very different voices, his chapters of homes, Karl did return to his beginning. His last house, Villa Louveciennes near Versailles, became his German intellectual home, a Vilhelm Hammershøi vision of quietness. It reminded me of his childhood home, Bissenmoor, an elegant white villa with wide steps leading into an overgrown park of hydrangeas and trees, like the garden in Alejandro Amenábar's film *The Others*, which he loved so much.

We shall not cease from exploration
And the end of all our exploring
Will be to arrive where we started
And know the place for the first time.

— T. S. Eliot, "Little Gidding," 1942

1 Sketch by Tadao Ando for Studio Karl Lagerfeld
2, 3 Sketch for the proposed exhibition design for *Karl Lagerfeld: A Line of Beauty*
4 Plan of the proposed exhibition design for *Karl Lagerfeld: A Line of Beauty*
5, 6 Diagram of the proposed exhibition design for *Karl Lagerfeld: A Line of Beauty*

REFLECTIONS

TADAO ANDO

It was in the early nineties when a large, foreign package arrived at my office. Signed, with a distinct stroke, was a name: Karl Lagerfeld.

"Could it be *the* Karl Lagerfeld?" I pondered as I opened the envelope. Contained inside were many books and a letter written in the same distinguishable handwriting. It was indeed a request from Lagerfeld for me to design a house and a studio; his passionate words expressed his sincere appreciation for art and architecture.

Subsequently, he invited me to his place in Paris. It was a grand stone mansion unified by vintage French furniture. Upon arrival I felt an apparent dissonance between my sensibilities in concrete architecture and Lagerfeld's taste. But I soon came to abandon my doubts as we delved deeper into conversations about our professions. "As an artist I am better at creating what is ephemeral," he said. "Good fashion is created by constantly destroying what exists. By contrast, the architect's job is to create eternal spaces. I myself create things that are transient. That may be why I like architecture that lasts for eternity."

Lagerfeld described his work as fleeting, yet his feats in the fashion world communicate a universal sense of beauty fundamental to humanity. His humble personality, well-informed thoughts, and inspired approach to design moved me to accept his commission.

The residence I proposed to Lagerfeld was composed of a long, flowing geometry that gently rested on the topography, becoming one with nature. I had imagined it as a frame within which the creative works of his daily life could awaken. Lagerfeld was ecstatic when he heard the idea. However, the development of the land in Biarritz, France, was not approved, and the project did not come to fruition. Nevertheless, the residence remained on our minds for some time. Even after several years, Lagerfeld noted in an interview that he was "working on a house with Ando." I also mention the project when asked about my relationship with the fashion industry and with Lagerfeld. In fact, within my monograph Studio Karl Lagerfeld stands alongside my realized works. It will forever remain a significant project in my mind.

Recently, I received a commission to once again design for Karl Lagerfeld. It was from The Metropolitan Museum of Art in New York, and their request was to create a space for an exhibition that gives voice to Lagerfeld's legacy. In approaching such a daring endeavor, I found inspiration in the vast collection of drawings he left behind. The palimpsest of lines told a story of an astute observer of the present who also revered and delighted in traditions of the past. I remembered his pure and free sensibility, born out of his youthful spirit, and the calm and collected intelligence that gave life to his audacious yet sophisticated personality.

The design of the exhibition, embodied by the intersection of a serpentine line with a straight line, is a manifestation of Lagerfeld's multifaceted nature. The serpentine line symbolizes his bohemian and dynamic character—his free will—while the straight line illustrates his preference for serene rationality, a trait of a serious designer. The two lines cross, overlap, and crush against each other, creating tension and expansion that amplify the experience of the space, offering a glimpse into the introspective world of Karl Lagerfeld.

I wonder what he would say if he were here today.

I wonder what he would have done with this space.

Working on this project offered me the opportunity to talk with an old friend one last time.

INSPIRATIONS

The following pages include items that inspired Karl Lagerfeld's work (identified by plate number) featured in Book Two.

(BOOK ONE)
Gerhard Schliepstein (German, 1886–1963). *Lamp*, 1920. Enameled earthenware, H. 13⅜ in. Private collection

(PLATE 7)
Designed by Paul Poiret (French, 1879–1944), illustrated by Georges Lepape (French, 1887–1971). *Lassitude* (detail), from *Gazette du Bon Ton*, November 1912. The Metropolitan Museum of Art, New York, The Irene Lewisohn Costume Reference Library

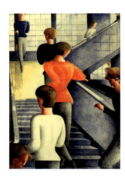

(PLATE 16)
Oskar Schlemmer (German, 1888–1943). *Bauhaus Stairway*, 1932. Oil on canvas, 63⅞ × 45 in. The Museum of Modern Art, New York, Gift of Philip Johnson (597.1942)

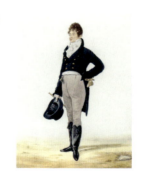

(PLATES 26, 41, 256 & 258)
Robert Dighton (British, ca. 1752–1814). *Portrait of George "Beau" Brummell (1778–1840)*, 1805. Watercolor, 12¾ × 9¼ in. Private collection

(PLATE 28)
Frank E. Geisler and Adolph Baumann (American, active 1913–1914). *Denise Poiret at the Plaza Hotel, New York*, 1913. Musée des Arts Décoratifs, Paris

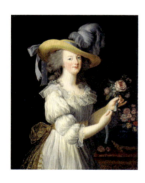

(PLATE 36)
Elisabeth Louise Vigée-LeBrun (French, 1755–1842). *Marie Antoinette in a Chemise Dress*, 1783. Oil on canvas, 35⅜ × 28⅜ in. Hessische Hausstiftung, Kronberg

(PLATE 32)
Georges Lepape (French, 1887–1971). *Longchamp (I) Elle a gagné!* (detail), from *Gazette du Bon Ton*, 1915. The Metropolitan Museum of Art, New York, The Irene Lewisohn Costume Reference Library

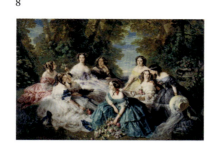

(PLATE 40)
Franz Xaver Winterhalter (German, 1805–1873). *Empress Eugénie Surrounded by the Ladies of Her Court*, 1855. Oil on canvas, 9⅜ × 13¾ ft. Musée National du Château de Compiègne (16-568258)

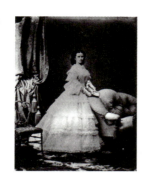

(PLATE 38)
Ludwig Angerer (Austrian, 1827–1879). *Empress Elisabeth from Austria*, 1860

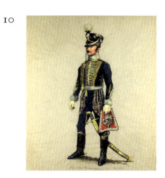

(PLATE 45)
Walter von Looz-Corswarem (German). *Prussian Military Costume: Hussar, 1808–15*, 1900s. Pen and ink, brush and watercolor on thin wove paper, 21 × 17⅛ in. The Metropolitan Museum of Art, New York, Bequest of Adele Simpson, 1993 (1993.1025)

(PLATE 60)
Louis XV ormolu-mounted tulipwood and Chinese lacquer cabinet. French (ca. 1750). Tulipwood and gilt and polychrome lacquer, 71 × 85 × 18 in. Private collection

(PLATE 60)
Boris Lipnitzki (Russian, active France, 1887–1971). *Coco Chanel (1883–1971), couturière française*. Paris, 1937

(PLATE 63)
Eugène Rubin (Russian, 1906–2001). *Le drape a l'hindoue de Chanel*, *Femina* (detail), June 1939

(PLATE 67)
Beadnet dress. Egyptian, Old Kingdom, Dynasty 4, reign of Khufu (2551–2528 B.C.). Faience, 17⅜ × 44½ in. Museum of Fine Arts, Boston, Harvard University—Boston Museum of Fine Arts Expedition (27.1548.1)

(PLATE 74)
Frances McLaughlin-Gill (American, 1919–2014). Madame Grès evening gown, *Vogue Paris* (detail), October 1952

(PLATE 72)
Boris Lipnitzki (Russian, active France, 1887–1971). *"Oedipe Roi" de Jean Cocteau, d'après Sophocle. Costume de Chanel. Jean Marais (1913–1998)*, July 1937

(PLATE 86)
Isaac Oliver (French, active England, ca. 1565–1617). *A Young Man Seated Under a Tree*, ca. 1590–95. Watercolor on vellum laid on card, 4⅞ × 3½ in. Royal Collection Trust (RCIN 420639)

(PLATE 88)
Boris Lipnitzki (Russian, active France, 1887–1971). *Serge Lifar as Vestris in a costume designed by Gabrielle Chanel*, 1939. Collection of H. de Beaumont

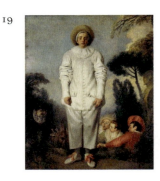

(PLATE 90)
Jean-Antoine Watteau (French, 1684–1721). *Pierrot*, ca. 1718–19. Oil on canvas, 72½ × 58⅝ in. Musée du Louvre, Paris (MI 1121)

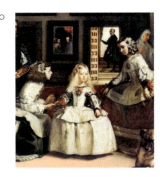

(PLATE 92)
Diego Velázquez (Spanish, 1599–1660). *Las Meninas, or The Family of Felipe IV* (detail), 1656. Oil on canvas, 10½ × 9 ft. Museo del Prado, Madrid (P001174)

(ORNAMENTAL/STRUCTURAL)
Adolph von Menzel (German, 1815–1905). *Voltaire in the Court of Frederick II of Prussia at Sanssouci*, 1850. Print on panel, 23⅝ × 19¼ in. Private collection

(PLATE 111)
Palace of Versailles, Billiard Room of Marie-Antoinette, designed by Jacques Gondoin in 1779

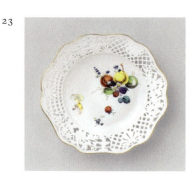

(PLATE 115)
Meissen Porcelain Factory (German, founded 1710). *Dessert Plate*, ca. 1750–60. Porcelain, Diam. 9⅞ in. Rijksmuseum, Amsterdam, 1960 (BK-17475-4)

(PLATE 117)
Vincennes Manufactory (French, founded 1740). *Cage*, 18th century. Painted iron and porcelain, H. 19⅞ in., Diam. 14⅛ in. Musée des Arts Décoratifs, Paris (inv. 53447)

(PLATE 119)
Mathieu Criaerd (French, 1689–1776). *Encoignure*, 1743. Oak frame, vernis Martin, and silvered bronze, 36½ × 25⅜ × 18½ in. (overall). Musée du Louvre, Paris, Gift of Richard Penard y Fernandez, 1951 (inv. OA 9533)

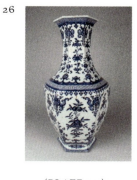

(PLATE 121)
Hexagonal vase with Rococo-style flowers. Chinese, Qing dynasty (1644–1911), Qianlong period (1736–95). Porcelain painted in underglaze cobalt blue (Jingdezhen ware), H. 27¼ in. The Metropolitan Museum of Art, New York, Gift of Paul E. Manheim, 1966 (66.156.1)

(PLATE 124)
Alberto Giacometti (Swiss, 1901–1966). *Spoon Woman*, 1926–27; cast 1954. Bronze, 56⅝ × 20¼ × 8½ in. Solomon R. Guggenheim Museum, New York (55.1414)

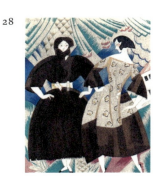

(PLATE 134)
Charles Martin (French, 1848–1934). *Hindoustan* (detail), from *Gazette du bon genre*, 1920. Pochoir. The Metropolitan Museum of Art, New York, The Irene Lewisohn Costume Reference Library

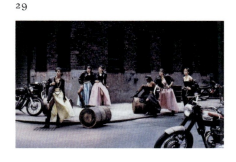

(PLATE 150)
Peter Lindbergh (German, 1944–2019). Helena Christensen, Stephanie Seymour, Karen Mulder, Naomi Campbell, Claudia Schiffer, Cindy Crawford, American *Vogue*, September 1991

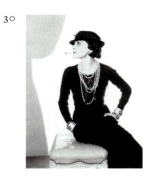

(PLATE 140)
Man Ray (American, 1890–1976). *Coco Chanel in Little Black Dress*, 1935

(PLATE 144)
Cecil Beaton (English, 1904–1980). *Coco Chanel*, 1937

(PLATE 168)
Openwork incense burner and cover with scrolling peony design. Chinese, Qianlong period (1736–95). Jade, H. 5⅛ in. The Palace Museum, Beijing (Gu100440)

(PLATE 189)
Jean Cocteau (French, 1889–1963). *Poster Advertising Nijinsky with the Ballets Russes, Théâtre des Champs-Élysées, Paris 1913*, 1913 (printed). Color lithograph, 74⅜ × 50¾ in. Victoria and Albert Museum, Given by Mademoiselle Lucienne Astruc and Richard Buckle in memory of the collaboration between Diaghilev and Gabriel Astruc (S.562-1980)

(PLATE 198)
J. J. Grandville (French, 1803–1847). *Camelia*, from *Les fleurs animées*, 1847. The Metropolitan Museum of Art, New York, The Irene Lewisohn Costume Reference Library

(PLATE 212)
Mariska Karasz (American, born Austria-Hungary, 1898–1960). *Ensemble* (detail), ca. 1927. Silk. The Metropolitan Museum of Art, New York, Gift of Katherine J. Judson, in memory of Jeanne Wertheimer, 1977 (1977.284.2a, b)

(PLATE 207)
Sonia Delaunay (French, born Ukraine, 1885–1979). Design from plate 4, from *Sonia Delaunay: ses peintures, ses objets, ses tissus simultanés, ses modes*, ca. 1925. Pochoir on paper, 21⅞ × 14⅞ in. (overall). The Metropolitan Museum of Art, New York, The Irene Lewisohn Costume Reference Library

(PLATE 210)
Aleksandr Rodchenko (Russian, 1891–1956). *Line and Compass Drawing*, 1915. Pen and ink on paper, 10 × 8¼ in. A. Rodchenko and V. Stepanova Archive, Moscow

(PLATE 214)
Aubrey Vincent Beardsley (British, 1872–1898). *The Climax*, 1894. Line block print on Japanese vellum, 13½ × 10¾ in. Victoria and Albert Museum, London, Given by Michael Harari, in memory of his father, Ralph A. Harari (E.436-1972)

(PLATE 215)
Aubrey Vincent Beardsley (British, 1872–1898). Title page of volume 3 of *The Yellow Book* (detail), 1894

(PLATE 217)
Armand-Albert Rateau (French, 1832–1938). Bathroom design for the French couturière Jeanne Lanvin, 1920. Musée des Arts Décoratifs, Paris

(PLATE 219)
Kate Baylay (British, born 1989), after Kay Nielsen (Danish, 1886–1957), 2016

(PLATE 218)
Charlotte Gastaut (French, born 1974). *Haunted*, 2016. Digital illustration

(PLATE 220)
Charlotte Gastaut (French, born 1974). *Lost*, 2016. Digital illustration

(PLATE 221)
Maurice Denis (French, 1870–1943). *Paysage aux arbres verts*, 1893. Oil on canvas, 18¼ × 16⅞ in. Musée d'Orsay, Paris, 2001 (RF 2001 8)

(PLATE 223)
George Barbier (French, 1882–1932). *Falbalas et fanfreluches* (detail), 1922. Pochoir. Private collection

(PLATE 230)
Sonia Delaunay (French, born Ukraine, 1885–1979). *Colored Rhythm*, 1959. Gouache, pastel, and graphite on paper, 22⅜ × 30⅝ in. The Metropolitan Museum of Art, New York, Gift of William Benenson, 1991 (1991.402.6)

(PLATE 232)
Albert Gleizes (French, 1881–1953). *Danseuse Espagnole*, 1916. Ink, gouache, and tempera drawing, 7⅝ × 9¾ in. MAPFRE Guanarteme Foundation (FM000284)

(PLATE 234)
Juan Gris (Spanish, 1887–1927). *Harlequin with a Guitar*, 1917. Oil on panel, 39½ × 25⅝ in. The Metropolitan Museum of Art, New York, Gift of The Alex Hillman Family Foundation, 2008 (2008.468)

(PLATE 235)
Valentina Khodasevich (Russian, 1894–1970). *Costume pour Arlequin*, 1921. Watercolor and crayon, 14 × 8¾ in. Nikita Lobanov-Rostovsky Collection

(PLATE 224)
Designed by Natalia Goncharova (Russian, 1881–1962). *Backcloth*, ca. 1926 (painted). 33½ × 51½ ft. Victoria and Albert Museum, London (S.455-1980)

(PLATE 225)
Couleurs à l'huile Rembrandt. Poster on oil enhanced canvas, 29½ × 24 in. (framed). Private collection

ACKNOWLEDGMENTS

I am grateful to the many people who provided generous support for the exhibition *Karl Lagerfeld: A Line of Beauty* and this associated publication. In particular, I am fortunate to have had the advice and encouragement of Daniel H. Weiss, President and Chief Executive Officer of The Metropolitan Museum of Art; Max Hollein, Marina Kellen French Director of The Met; Quincy Houghton, Deputy Director for Exhibitions; Andrea Bayer, Deputy Director for Collections and Administration; Whitney W. Donhauser, Deputy Director and Chief Advancement Officer; Inka Drögemüller, Deputy Director for Digital, Education, Publications, Imaging, Library, and Live Arts; Stephen A. Manzi, Chief Development Officer for Individual Giving; Lavita McMath Turner, Chief Diversity Officer; and Anna Wintour, Met Trustee, Global Editorial Director, *Vogue*, and Chief Content Officer, Condé Nast. I would also like to thank Penélope Cruz, Michaela Coel, Roger Federer, and Dua Lipa, cochairs of The Costume Institute Benefit. I offer my special gratitude to CHANEL, FENDI, and KARL LAGERFELD for sponsoring the exhibition, catalogue, and this year's Costume Institute Benefit, and to Condé Nast for its longtime sponsorship of The Costume Institute's exhibitions. Their generosity has made these projects possible.

Sincerest thanks to exhibition creative consultant Amanda Harlech and designer Tadao Ando and his team, including Alex Iida, Sota Kanzan, Kazutoshi Miyamura, and Masataka Yano. I am immensely grateful to filmmaker Loïc Prigent and his colleagues Natacha Morice and Perrine Altman for the captivating interviews and video content that they produced for the exhibition, and I especially appreciate the recollections that the *premières d'atelier* Anita Briey (Chloé and KARL LAGERFELD), Stefania D'Alfonso (FENDI), Olivia Douchez (CHANEL), Nicole Lefort (Chloé), and Jacqueline Mercier (CHANEL) shared from their respective experiences working with Karl. Thanks also to the design team at SAT-3, including Tyler Dusenbury, Stefan Klecheski, and Alan Lucey, for their support in realizing this project.

Special thanks to my colleagues at The Met who worked on the exhibition: Tom Scally, Buildings General Manager; Taylor Miller, Buildings Manager for Exhibitions; Alicia Cheng, Head of Design; Chelsea Garunay, Maanik Singh Chauhan, Clint Ross Coller, Tiffany Kim, and Alexandre Viault of the Design Department; Gillian Fruh, Senior Manager for Exhibitions; Douglas Hegley, Chief Digital Officer; Melissa Bell, Paul Caro, and Kate Farrell of the Digital Department; Meryl Cohen, Chief Registrar; Becky Bacheller of the Registrar's Office; and John Meroney of the Director's Office.

The Publications and Editorial Department, under the direction of Mark Polizzotti, Publisher and Editor in Chief, is responsible for Museum publications, including this exceptional volume. Tremendous thanks to Gwen Roginsky, who oversees The Costume Institute books, along with an expert publication team that includes editorial manager Elizabeth Levy and editor Jane Takac Panza; production managers Nerissa Dominguez Vales and Sue Medlicott; as well as Cheryle T. Robertson, Rachel High, and Briana Parker. I would also like to thank Rory McGrath, Oliver Knight, Paul Bergès, and Louise Camu, at OK-RM for the beautiful design and art direction of the book. Sincere thanks to Julia Hetta for her extraordinary photographs and to her photo team, including Kylie Coutts and Max Bernetz, Tyler Strawhecker, Logan Khidekel and Daniel Weiner of PRODn, and Mary Howard Studio, as well as to August Rehnberg for his outstanding retouching. We are also grateful to Dana Heis, Annemiek Ter Linden, and Yael Peres at Art & Commerce for their help in organizing the shoots. We were fortunate to work with Rob King and Mark Robson at Alta Images on the photography of the flat artwork reproduced in this book in addition to the preparation of all images and pages for printing. Special thanks to Eric Wei and his colleagues at Artron Art Printing Limited for their expertise and management of the printing and binding. Thanks also to essayist Patrick Hourcade for his insightful contribution to this publication.

As always, my colleagues at The Costume Institute have been invaluable every step of the way. I extend my deepest gratitude to Tae Ahn, Michael Downer, Alexandra Fizer, Joyce Fung, Amanda Garfinkel, Bethany Gingrich, Alyssa Hollander, Mika Kiyono, Stephanie Kramer, Julie Tran Lê, Christopher Mazza, Marci K. Morimoto, Jacqueline Novak, Rebecca Perry, Glenn O. Petersen, Melina Plottu, Laura Scognamiglio, Elizabeth Shaeffer, Shelly Tarter, Anna Yanofsky, and Tracy Yoshimura. I especially want to thank Mellissa J. Huber, Associate Curator, who worked closely with me in the realization of this book and exhibition; she and Kai Toussaint Marcel meticulously compiled the information for the timeline, which Mellissa wrote.

I would also like to express my sincere appreciation to the docents, interns, volunteers, and fellows of The Costume Institute: docents Sarah Baird, Peri Clark, Ronnie Grosbard, Francesca Gysling, Ruth Henderson, Dorann Jacobowitz, Betsy Kahan, Linda Kastan, Susan Klein, Mary Massa, Charles Mayer, Ginny Poleman, Eleanore Schloss, and Charles Sroufe; interns Nathalia Moran, Nathalie Silva, and Talia Spielholz; and fellows Kris Cnossen and Lilien Lisbeth Feledy.

For the ongoing support of Friends of The Costume Institute, chaired by Wendi Murdoch and cochaired by Eva Chen, Sylvana Ward Durrett, and Mark Guiducci, I am especially grateful. Sincerest thanks also to Lizzie and Jonathan Tisch for their constant friendship and encouragement. And a special thank-you to Wendy Yu for endowing this position at The Costume Institute.

I would also like to thank colleagues from various departments at The Metropolitan Museum of Art for their assistance, including Marissa Acey; Young Bae; Ann M. Bailis; Alexis Belis; Peter Berson; Eric Breitung; Jennifer Brown; Rebecca Capua; Suhaly Bautista Carolina; Linsen Chai; Kimberly Chey; Jennie Choi; Skyla Choi; Marie Clapot; Kathrin Colburn; Sharon H. Cott; Francesca D'Alessio; Cristina Del Valle; Elizabeth De Mase; Deepesh Dhingra; Christopher DiPietro; Kate Dobie; Michael Doscher; Izabella Dudek; Linda Forchetti; Jourdan Ferguson; William Scott Geffert; Clara Goldman; Nora Gorman; Leanne Graeff; Deborah Gul Haffner; Maxwell K. Hearn, Douglas Dillon Chair; Steven Hellman; Seán Hemingway, John A. and Carol O. Moran Curator in Charge; Jason Herrick; Heidi Holder, Frederick P. and Sandra P. Rose Chair of Education; Lela Jenkins; Marci L. King; Daniëlle Kisluk-Grosheide, Henry R. Kravis Curator; Aubrey L. Knox; Amy Lamberti; Claire Lanier; Sarah E. Lawrence, Iris and B. Gerald Cantor Curator in Charge; Aichi Lee; Lewis Levesque; Matthew Lytle; Victoria Martinez; Rebecca McGinnis, Mary Jaharis Senior Managing Educator, Accessibility; Constance C. McPhee; Grace Mennell; Iris Moon; Darcy-Tell Morales; Amy Nelson; Maria Nicolino; Nadine Orenstein, Drue Heinz Curator in Charge; Sarah M. Parke; Morgan Pearce; Sarah Pecaut; Angela Pecci; Elizabeth Perkins; Mario Piccolino; Lisa Pilosi, Sherman Fairchild Conservator in Charge, Department of Objects Conservation; Mehgan Pizarro; Leslye Saenz; Frederick J. Sager; Rebecca Schear; Gretchen Scott; Jessica M. Sewell; Jenn Sherman; Marianna Siciliano; Kenneth Soehner, Arthur K. Watson Chief Librarian; Soo Hee H. Song; Jason Sun, Brooke Russell Astor Curator of Chinese Art; Sarah Szeliga, Leonard N. Stern Associate Visual Resource Manager; Yu Tang; Pierre Terjanian, Arthur Ochs Sulzberger Curator in Charge; Kate Thompson; Limor Tomer, Lulu C. and Anthony W. Wang General Manager of Live Arts; Kate Truisi; Kristen Vanderziel; Neils Veras; Kenneth Weine; John L. Wielk; Elizabeth Zanis; Anna Zepp; and Philip Zolit.

I am extremely grateful to our lenders: CHANEL (Anne-Charlotte Beaussant, Stéphane Bedhome, Laurence Delamare, Patrick Doucet, Laurène Flinois, Hélène Fulgence, Ellie Hawke, Rebekah McCabe, Madeleine Meissirel, Odile Premel); Chloé (Sophie Chiaradia, Nadege Griffit, Catherine Lebrun, Ascher Sabbah, Geraldine Sommier); Chrome Hearts (Hollis De Laney, Stephanie Reynolds, Laurie Lynn Stark, Richard Stark); FENDI (Maria Elena Cima, Letizia De Stefano, Maria Sole Henny, Cristiana Monfardini, Alessio Rufolo, Elena Tomei, Nicoletta Vaccarella, Gabriela Walker, Ashley Ward); H&M (Megan Aguilar, Alexandria DeVillers, Kendall Neuner, Lauren Riezman, Donald Schneider); KARL LAGERFELD (Sophie de Langlade, Caroline Lebar, Clara Munch, Pier Paolo Righi); Colby Mugrabi; Richard Noura; Palais Galliera (Miren Arzalluz, Marie-Ange Bernieri, Alexandre Samson); and Sandy Schreier. Special thanks go to Olivier Rousteing and his atelier staff and colleagues at Balmain (Julia Guillon, Valérie Poullard, Marie Valot) for reproducing a toile of Karl Lagerfeld's International Woolmark Prize coat design from 1954.

For their support of research, thanks to our colleagues at Centre national du costume de scène (Delphine Pinasa, Garance Torreilles); Diktats (Antoine Bucher, Nicolas Montagne); FIT Special Collections and College Archives (April Calahan, Samantha Levin, Karen Trivette); French Cultural Center, Boston (Clémence Bary Boloré); The Humane Society (PJ Smith); Opéra de Monte-Carlo (Jean-Charles Allavena, Emilie Bouneau, Sandra Ingargiola, Eliane Mezzanotte, Vincent Payen); Opéra national de Paris (Coralie Cadène, Michèle Delgutte, Eric Grebille); Patou (Sebastian Riegger); PETA (Sadie Buckles, Danielle Katz, Lindsey Taylor); The Robert and Penny Fox Historic Costume Collection (Clare Sauro, Michael Shepherd, Monica Stevens Smyth); and Woolmark (Elin Arnott, Sofia Hisakuni). I especially appreciate the generous access that Jean de Mouy provided to the Patou family archives and thank Keda Black, Anne-Sophie Lasso, Charles Piot, and Emmanuelle Polle for their assistance and hospitality. I am grateful to DK Display (Neal Rosenberg); France Display Corp. (Lisa Cipriano); Frank Glover Productions (Margaret Karmilowicz); Librairie 7L, Paris (Coralie Gauthier); and Magasins Sennelier (Sophie Sennelier, Virginie Tassier). Thank you also to Benjamin Klemes, Michelle Ralph-Fortón, and Madison Williams.

Special thanks to Leila Ali, Raul Avila, Keith Baptista, Remi Berger, Hamish Bowles, Eaddy Kiernan Bunzel, Rose Carlisle, Ingu Chen, Olivier Cheng, Concetta Ciarlo, Fiona Da Rin, Ashley Duch, Celia Ellenberg, Carolina Gonzalez, Mark Holgate, Parker Hubbard, Samer Jannan, Sébastien Jondeau, Sergio Kletnoy, Hildy Kuryk-Bernstein, Olive Leatherwood, Willow Lindley, Brooke McClelland, William Middleton, Jessica Nichols, Chioma Nnadi, Max Ortega, Sophie Pape, Juan Costa Paz, Aurelie Pellissier Roman, Virginia Smith, Sam Sussman, Kerry Taylor, Sache Taylor, Jill Weiskopf, Anna-Lisa Yabsley, and Tenley Zinke.

For their ongoing support, I would like to extend my deepest and heartfelt thanks to Paul Austin; Harry and Marion Bolton; Miranda, Ben, Issy, and Emily Carr; Alice Fleet; Harold Koda; Alexandra and William Lewis; Shannon Bell Price; Jessica Regan; Rebecca Ward; and especially Thom Browne.

I would like to dedicate this book to Bethany Matia, a valued colleague and beloved friend of The Costume Institute, who left us far too early.

Andrew Bolton
Wendy Yu Curator in Charge of The Costume Institute

SELECTED BIBLIOGRAPHY

Arts décoratifs du XXᵉ siècle provenant des collections Karl Lagerfeld. Sale cat. Christie's, Paris, December 13, 2001.

Baatz, Kristin, and Madelaine Levy, eds. *The First Ten Years: Karl Lagerfeld, Stella McCartney, Viktor & Rolf, Roberto Cavalli, Comme des Garçons, Matthew Williamson, Jimmy Choo, Lanvin, Sonia Rykiel Versace, Marni, Maison Martin Margiela, Isabel Marant, Alexander Wang, Designer Collaborations.* Stockholm: H & M, 2014.

Bacqué, Raphaëlle. *Kaiser Karl: The Life of Karl Lagerfeld.* Translated by Caroline Beamish. Suffolk, U.K.: ACC Art Books, 2020.

Balmain, Pierre. *My Years and Seasons.* Translated by Edward Lanchbery and Gordon Young. London: Cassell, 1964.

Capella, Massimiliano. *Il Teatro alla Moda: Costume di Scena, Grandi Stilisti: Armani, Capucci, Coveri, Fendi, Ferretti, Gigli, Marras, Missoni, Ungaro, Valentinio, Versace.* Turin, It.: Allemandi, 2010.

Cénac, Laetitia. *Chanel: The Making of a Collection.* New York: Abrams, 2019.

Cirillo, Ornella. *Mario Valentino, a History of Fashion, Design and Art.* Milan: Skira, 2017.

Clark, Judith, Hugh Haughton, and Elizabeth Wilson. *Chloé: Attitudes.* Paris: Chloé International SAS, 2012.

Collection Karl Lagerfeld: Arts décoratifs du XXᵉ siècle. Sale cat. Sotheby's, Paris, January 1, 2003.

Collection Lagerfeld. Sale cat. Christie's, Monaco, April 28–29, 2000.

Collection of Fashion Plates from the Library of Karl Lagerfeld, 1860–1910. The Metropolitan Museum of Art, New York.

Drake, Alicia. *The Beautiful Fall: Lagerfeld, Saint Laurent, and Glorious Excess in 1970s Paris.* New York: Little, Brown and Co., 2006.

Hogarth, William. *The Analysis of Beauty: Written with a View of Fixing the Fluctuating Ideas of Taste.* London: J. Reeves, 1753.

Hourcade, Patrick. *Karl: No Regrets.* Translated by Robert Burns. Paris: Flammarion, 2021.

Kaiser, Alfons. *Karl Lagerfeld: A Life in Fashion.* New York: Cernunnos, 2022.

———, ed. *Karl Lagerfeld: Karlikaturen.* Göttingen, Ger.: Steidl, 2019.

Karl Lagerfeld's Estate: Succession Karl Lagerfeld. Vols. 1–3. Sale cat. Sotheby's, Cologne, April 29–May 6, 2022.

Koda, Harold, Andrew Bolton, and Rhonda K. Garelick. *Chanel.* Exh. cat. New York: Metropolitan Museum of Art, 2005.

Lagerfeld, Karl. *Chanel Art.* Göttingen, Ger.: Steidl, 2014.

———. *Chanel's Russian Connection.* Göttingen, Ger.: Steidl, 2009.

———. *Karl Lagerfeld: Off the Record.* Zurich: Scalo, 1995.

———. *Lagerfeld's Sketchbook: Karl Lagerfeld's Illustrated Fashion Journal of Anna Piaggi.* New York: Weidenfeld & Nicolson, 1986.

———. *Work in Progress.* Göttingen, Ger.: Steidl, 2011.

Lagerfeld, Karl, and Tadao Ando. *Tadao Ando—Vitra House.* Göttingen, Ger.: Steidl, 1998.

Lagerfeld, Karl, and Carine Roitfeld. *The Little Black Jacket: Chanel's Classic Revisited.* Göttingen, Ger.: Steidl, 2013.

Lagerfeld, Karl, and Gerhard Steidl. *Fendi by Karl Lagerfeld.* Göttingen, Ger.: Steidl, 2015.

Langkjær, Michael A. "Baroque and *Bildung* in the Creative Practice and Personal Style of Karl Lagerfeld—Towards a Biographical Reinstatement of the Individual Designer." *Fashion Theory* 25, no. 5 (2019): 633–61.

Matheopoulos, Helena. *Fashion Designers at the Opera.* New York: Thames & Hudson, 2011.

Mauriès, Patrick. *Chanel défilés: L'intégrale des collections de Karl Lagerfeld.* Paris: La Martinière, 2016.

Memphis: La collection Karl Lagerfeld. Sale cat. Sotheby's, Monaco, October 13, 1991.

Middleton, William. *Paradise Now: The Extraordinary Life of Karl Lagerfeld.* New York: HarperCollins, 2023.

Mower, Sarah, Marc Ascoli, and Gaby Aghion. *Chloé: Attitudes.* New York: Rizzoli, 2013.

Old Master Paintings from the Lagerfeld Collection. Sale cat. Christie's, New York, May 23, 2000.

Ottavi, Marie. *Karl.* Paris: Robert Laffont, 2021.

Prigent, Loïc, dir. *Karl Lagerfeld Sketches His Life.* 2012; Strasbourg, Germany: ARTE GEIE, 2013.

———. *Signé Chanel.* Season 1, episodes 1–5. Aired September 26–30, 2005, on ARTE.

Procter, Simon. *Lagerfeld: The Chanel Shows.* New York: Rizzoli, 2019.

Rasche, Adelheid, ed. *Coats!: Max Mara, 60 Years of Italian Fashion.* Milan: Skira, 2011.

Sahner, Paul. *Karl.* Munich: mvg Verlag, 2015.

Stoppard, Lou. *Chloé Catwalk: The Complete Collections.* London: Thames & Hudson, 2022.

Talley, André Leon. *The Chiffon Trenches: A Memoir.* New York: Ballantine Books, 2020.

Thawley, Dan. "A World First: Karl Lagerfeld Fashion Exhibition Opens in Bonn, Germany." *Vogue,* March 25, 2015. www.vogue.com/article/larl-lagerfeld-fashion-exhibit-modemethode-bonn-germany.

ARCHIVES CONSULTED

Balmain Archive
CHANEL Patrimoine
Chloé Archive
FENDI Archive
KARL LAGERFELD Archive
Patou Family Archive

CREDITS
All objects are designed by Karl Lagerfeld (French, born Germany, 1933–2019) unless otherwise noted.

LOANS TO THE EXHIBITION
Courtesy CHANEL: pls. 1–2, 4–16, 19–26, 29–30, 35–47, 49–50, 59–68, 71–76, 79–80, 83–94, 96, 100–101, 103–6, 110–39, 141–48, 150–68, 172–78, 182–87, 190–91, 195–201, 209–14, 224, 226–27, 235, 248, 250, 252, 254, 258–65, 266 [hand fan]; Courtesy CHLOÉ: pls. 3, 27–28, 31–34, 55–58, 81–82, 97, 215–17, 222–23, 230–34, 240 [cuffs], 243, 266 [dress]; Courtesy Chrome Hearts: pl. 246; Courtesy Colby Mugrabi: pl. 245; Courtesy FENDI: pls. 48, 51–52, 54, 69–70, 77–78, 98–99, 102, 107–9, 149, 169–71, 179–81, 188–89, 192–94, 204–8, 218–20, 225, 228–29, 247; Courtesy H&M: pls. 251, 253; Courtesy KARL LAGERFELD: pls. 17–18, 202–3, 236, 244, 249, 255, 257; Courtesy Richard Noura: pl. 237; Courtesy Sandy Schreier: pl. 242

WORKS IN THE COLLECTION OF THE METROPOLITAN MUSEUM OF ART
pl. 95: The Metropolitan Museum of Art, New York, Gift of Mouna Ayoub, 1996 (1996.129a–f, i); pl. 140: The Metropolitan Museum of Art, New York, Gift of CHANEL, in honor of Harold Koda, 2016 (2016.632); pl. 221: The Metropolitan Museum of Art, New York, Gift of Chloé Inc., 1995 (1995.432.4a, b); pl. 238: The Metropolitan Museum of Art, New York, Promised Gift of Sandy Schreier (L.2018.61.37); pl. 239: The Metropolitan Museum of Art, New York, Promised Gift of Sandy Schreier (L.2019.48.2); pl. 240 [dress]: The Metropolitan Museum of Art, New York, Purchase, Gould Family Foundation Gift, in memory of Jo Copeland, 2022 (2022.105); pl. 241: The Metropolitan Museum of Art, New York, Purchase; pl. 256: The Metropolitan Museum of Art, New York, Purchase, Friends of The Costume Institute Gifts, 2022 (2022.153a–d)

PHOTO CREDITS
Alamy Stock Photo, Süddeutsche Zeitung, Image by Max Scheler: p. iii (1972 top and bottom); AP Photo, Image by Jacques Langevin: p. iv (1983 top); AP Photo, Image by Olivier Saillant: p. viii (2013 bottom); AP Photo, Shutterstock, Image by William Stevens: p. iv (1984 top); © 2023 Artists Rights Society (ARS), NY / Image RMN-Grand Palais. Art Resource, NY / Photo by Hervé Lewandowski: p. 35, fig. 44; © Estate of George Barbier, Artists Rights Society (ARS), NY / ADAGP, Paris, 2023. From Hiroshi Unno, *George Barbier: Master of Art Deco*, PIE International, Tokyo, 2011, p. 106. Image © The Metropolitan Museum of Art: p. 35, fig. 45; Bridgeman Images (XCF256514): p. 30, fig. 4; Image Cecil Beaton Archive © Conde Nast: p. 33, fig. 31; © Philippe Chancel. From Hélène Guéné, *Decoration et haute couture: Armand Albert Rateau pour Jeanne Lanvin, un autre art déco*, Les Arts Décoratifs, Paris, 2006, p. 126. Image © The Metropolitan Museum of Art: p. 34, fig. 40; Film still courtesy CHANEL, Produced by ARTE GEIE, Story Box Press, DERALF: p. 8; Image courtesy CHANEL: p. v (1987); © ARS, Comité Cocteau, Paris / ADAGP, Paris 2023. Digital Image 2023 Victoria and Albert Museum, London (S.562-1980): p. 33, fig. 33; © ARS, Comité Cocteau, Paris / ADAGP, Paris 2023. Image by Boris Lipnitzki, Roger-Viollet. All Rights Reserved: p. 32, fig. 16; Image by Giovanni Coruzzi, Bridgeman Images: p. iii (1978); © Estate of Sonia Delaunay. From *Sonia Delaunay: ses peintures, ses objets, ses tissus simultanés, ses modes*, Librairie des Arts Décoratifs, Paris, [1925?], pl. 4. Image © The Metropolitan Museum of Art: p. 34, fig. 36; © Estate of Sonia Delaunay. Image © The Metropolitan Museum of Art: p. 35, fig. 46; Image © Eric Dessons, JDD, SIPA (JDD_jdd1430734, 1902191437): p. vi (1999); Image courtesy Fashion Institute of Technology, SUNY Gladys Marcus Library, Unit of Special Collections and College Archives (US.NNFIT. SC.209.3.25 LagerfeldFendi.001): pl. 53; From Jean-Louis de Faucigny-Lucinge, *Legendary Parties, 1922–1972*, Vendome Press, New York, 1987, p. 43. Image © The Metropolitan Museum of Art: p. 32, fig. 18; From *Femina*, June 1939, p. 28, Photo by Eugène Rubin. Image © The Metropolitan Museum of Art: p. 31, fig. 13; Image courtesy FENDI: p. 34, fig. 41, pp. iii (1977), v (1985), vii (2007); © Charlotte Gastaut. Image courtesy FENDI and the artist: p. 34, fig. 42, p. 35, fig. 43; Getty Images, AFP, Image by Pierre Guillaud: p. v (1986 and 1987 bottom); Getty Images, AFP, Image by Patrick Kovarik: p. vii (2012 top); Getty Images, AFP, Image by Loic Venance: p. viii (2013 top); Getty Images, Image by Catwalking: p. ix (2016 top); Getty Images, Corbis Historical, Image by John van Hasselt, Corbis: p. iv (1984 bottom); Getty Images, Corbis Historical, Image by Vittoriano Rastelli: p. ii (1965); Getty Images, Gamma-KeyStone, Keystone, France: pp. i (1954), ii (1959); Getty Images, Hulton Archive, brand-staetter images, Image by Ludwig Angerer, later fall 1860: p. 31, fig. 9; Getty Images, Paris Match Archive, Image by Manuel Litran: p. v (1991 top); Getty Images, Paris Match Archive, Image by Paul Slade: p. i (1958 top and bottom); Getty Images, Penske Media, *Women's Wear Daily*: p. ii (1969); Getty Images, Penske Media, *Women's Wear Daily*: p. iv (1983 bottom); Getty Images, Picture Alliance: p. iii (1973); Getty Images, Premium Archive, Image by Jurgen Schadeberg: p. iv (1981); Getty Images, WireImage, Image by Mike Marsland: p. viii (2012 bottom and 2015 bottom); Getty Images, WireImage, Image by Eamonn McCormack: p. vii (2009); Getty Images, WireImage, Image by Daniele Venturelli: p. vii (2006); Getty Images Entertainment, Image by Victor Boyko: p. ix (2016 bottom); Getty Images Entertainment, Image by Sean Gallup: p. vi (2004); Getty Images Entertainment, Image by Pascal Le Segretain: p. ix (2019); Getty Images Entertainment, Image by Daniele Venturelli: p. viii (2015 top); © Succession Alberto Giacometti / Artists Rights Society (ARS), NY 2023. Image The Solomon R. Guggenheim Foundation / Art Resource, NY: p. 33, fig. 27; © Albert Gleizes, 2023 Artists Rights Society (ARS), NY / VEGAP, Madrid, 2022 / MAPFRE Foundation (FM000284): p. 35, fig. 47; Natalia Goncharova © 2023 Artists Rights Society (ARS), NY. Digital Image © 2023 Victoria and Albert Museum, London (S.455-1980): p. 35, fig. 50; From J. J. Grandville, Alphonse Karr, Taxile Delord, and Raban, *Les fleurs animées*, Garnier frères, Paris, 1867. Image © The Metropolitan Museum of Art: p. 34, fig. 34; From Rose-Marie Herda-Mousseaux, ed., *La Fabrique du luxe: Les marchands merciers parisiens au XVIIIe siècle*, exh. cat., Musée Cognacq-Jay, Paris, 2018, p. 42. Image © The Metropolitan Museum of Art: p. 32, fig. 24; From Rose-Marie Herda-Mousseaux, ed., *La Fabrique du luxe: Les marchands merciers parisiens au XVIIIe siècle*, exh. cat., Musée Cognacq-Jay, Paris, 2018, p. 68. Image © The Metropolitan Museum of Art: p. 33, fig. 25; Image courtesy Internet Archive: p. 34, fig. 39; Invision, AP, Shutterstock, Image by Evan Agostini (10013986a): p. ix (2018); From *Karl: Succession Karl Lagerfeld*, sale cat., Sotheby's, Monaco, December 3–5, 2021, p. 169. Image © The Metropolitan Museum of Art: p. 32, fig. 21; © Valentina Khodasevitch. From John E. Bowlt, *L'Avant-garde russe et la scène 1910–1930: une sélection de la collection N. D. Lobanov-Rostovsky*, exh. cat., Éditions Plume, Paris, 1998, p. 94, cat. 206. Image © The Metropolitan Museum of Art: p. 35, fig. 49; © Georges Lepape, Artists Rights Society (ARS), NY / ADAGP, Paris 2023. From *Gazette du Bon Ton*, November 1912. Image © The Metropolitan Museum of Art: p. 30, fig. 2; © Georges Lepape, Artists Rights Society (ARS), NY / ADAGP, Paris 2023. From *Gazette du Bon Ton*, nos. 8–9, summer 1915, pl. 4. Image © The Metropolitan Museum of Art: p. 31, fig. 7; © Boris Lipnitzki, Roger-Viollet. All Rights Reserved: p. 31, fig. 12; © Man Ray 2015 Trust / Artists Rights Society (ARS), NY / ADAGP, Paris 2023. Image courtesy of Banque d'Images, ADAGP / Art Resource, NY: p. 33, fig. 30; Image © The Metropolitan Museum of Art: Book One (all images), p. 30, fig. 6, p. 31, fig. 10, p. 33, fig. 26, p. 34, figs. 35, 38, p. 35, fig. 48; © Museo Nacional del Prado / Art Resource, NY: p. 32, fig. 20; Image © 2023 Museum of Fine Arts, Boston (27.1548.1): p. 31, fig. 14; Image © The Museum of Modern Art, Licensed by SCALA, Art Resource, NY: p. 30, fig. 3; Image by Myrabella, Wikimedia Commons (CC BY-SA 3.0): p. 32, fig. 22; Image © and courtesy of Peter Lindbergh Foundation, Paris: p. 33, fig. 29; From *Poiret: King of Fashion*, exh. cat., Metropolitan Museum of Art, New York, 2007, p. 27. Image © The Metropolitan Museum of Art: p. 30, fig. 5; From *Poiret: King of Fashion*, exh. cat., Metropolitan Museum of Art, New York, 2007, p. 220. Image © The Metropolitan Museum of Art: p. 33, fig. 28; From Evelyn Sakakida Rawski and Jessica Rawson, *China: The Three Emperors, 1662–1795*, exh. cat., Royal Academy of Arts, London, 2005, cat. 228. Image © The Metropolitan Museum of Art: p. 33, fig. 32; Image © Rijksmuseum, Amsterdam: p. 32, fig. 23; © RMN-Grand Palais / Art Resource, NY. Image by Daniel Arnaudet, on deposit from Malmaison: p. 31, fig. 8; © RMN-Grand Palais / Art Resource, NY. Image by Franck Raux: p. 32, fig. 19; © 2023 Estate of Alexander Rodchenko / UPRAVIS / Moscow / ARS, NY: p. 34, fig. 37; Digital Image © Royal Collections Trust: p. 32, fig. 17; © Gerhard Schliepstein, Artists Rights Society (ARS), NY. From *Karl: Succession Karl Lagerfeld*, sale cat., Sotheby's, Monaco, December 3–5, 2021. Image © The Metropolitan Museum of Art: p. 30, fig. 1; Shutterstock, *Mail On Sunday*, Image by David O'Neil: p. v (1991 bottom); Image courtesy Solomon Treasure New York: p. 31, fig. 11; Image courtesy Sotheby's, Cologne: p. 35, fig. 51; Image © Tadao Ando Architect & Associates. All Rights Reserved: p. 28; From *Vogue Paris*, October 1952, p. 90, Photo by Frances McLaughlin-Gill. Image © The Metropolitan Museum of Art: p. 31, fig. 15.

This catalogue is published in conjunction with *Karl Lagerfeld: A Line of Beauty*, on view at The Metropolitan Museum of Art, New York, from May 5 through July 16, 2023.

The exhibition is made possible by

CHANEL

Major support is provided by

FENDI

Additional support is provided by

KARL LAGERFELD

CONDÉ NAST

Published by The Metropolitan Museum of Art, New York.

Mark Polizzotti, Publisher and Editor in Chief
Peter Antony, Associate Publisher for Production
Michael Sittenfeld, Associate Publisher for Editorial

Publication Management by Gwen Roginsky
Editorial Management by Elizabeth Levy
Edited by Jane Takac Panza
Designed by OK-RM, London
Production by Nerissa Dominguez Vales and Sue Medlicott, The Production Department
Typesetting by Tina Henderson
Project Coordinated by Rachel High

New Photography by Julia Hetta
Image Acquisition and Rights by Cheryle T. Robertson
Additional photography credits appear on page 39.

The Metropolitan Museum of Art endeavors to respect copyright in a manner consistent with its nonprofit educational mission. If you believe any material has been included in this publication improperly, please contact the Publications and Editorial Department.

Copyright © 2023 by The Metropolitan Museum of Art, New York
New photography © 2023 Julia Hetta

Typeset in Mercure, ABYME
Separations by Altaimage, London/New York
Printed and bound by Artron Art Printing (HK) Limited, Shenzhen

Book Three, p. 2: Julia Hetta (Swedish, born 1972). *Composite Image*, 2023. Juxtaposition of CHANEL dress from autumn/winter 1986–87 and CHLOÉ dress from autumn/winter 1983–84. Courtesy CHANEL; The Metropolitan Museum of Art, New York, Gift of Mrs. Peter O. Price, 1999 (1999.335.7)

Book Four, back cover: Illustration Courtesy of Maison Karl Lagerfeld

All rights reserved. No part of this publication may be reproduced or transmitted in any form or by any means, electronic or mechanical, including photocopying, recording, or any information storage and retrieval system, without permission in writing from the publishers.

First printing, 2023

The Metropolitan Museum of Art
1000 Fifth Avenue New York,
New York 10028
metmuseum.org

Distributed by Yale University Press,
New Haven and London
yalebooks.com/art
yalebooks.co.uk

Cataloguing-in-Publication Data is available from the Library of Congress.

ISBN 978-1-58839-758-4